Art in Transit

Studies in the Transport of Paintings

Conference on The Packing and Transportation of Paintings

The conference at the Queen Elizabeth II Conference Centre, London, 9-11 September 1991 and the accompanying workshop held 12-13 September 1991 at the Tate Gallery have been generously supported by the following:

The Henry Moore Foundation
Blackwall Green, Ltd.
Gander and White Shipping, Ltd.
James Bourlets & Sons
Momart, Ltd.
D'Art Kunstspedition GmbH
Rees Martin Art Service
Wingate & Johnston Ltd.
Martinspeed Ltd.
Harsch Transports
Gerlach Art Packers & Shippers
Hasenkamp Internationale Transporte
Propileo Transport
Masterpiece International, Ltd.
Mat Securitas Express, AG
Kunsttrans Antiquitaten

Conference Acknowledgments

This book is published on the occasion of an International Conference on the Packing and Transportation of Paintings, jointly organized and co-hosted by the Canadian Conservation Institute of Communications Canada, Ottawa, the Conservation Analytical Laboratory of the Smithsonian Institution, Washington, the National Gallery of Art in Washington, and the Tate Gallery in London.

Charles Costain, Chairman, *Canadian Conservation Institute, Communications Canada*
Timothy Green, *Tate Gallery*
Charles Gruchy, *Canadian Conservation Institute, Communications Canada*
Stephen Hackney, *Tate Gallery*
Marion F. Mecklenburg, *Conservation Analytical Laboratory, Smithsonian Institution*
Ross M. Merrill, *National Gallery of Art*
Mervin Richard, *National Gallery of Art*
Lambertus Van Zelst, *Conservation Analytical Laboratory, Smithsonian Institution*

While many tasks have been shared among the committee members, responsibility for the detailed planning of the conference has fallen to our colleagues at the Tate Gallery. Special thanks are due to Alexander Dunluce of the Tate Gallery for his support, and to Jo Crook, Tim Green, and Stephen Hackney for their hard work on the conference organization and registration.

I would like to thank all of the individuals who have been involved in bringing the conference and publication to fruition. We are particularly indebted to the speakers at the conference and to the contributors and editors of the publications; their contributions have ensured the success of this endeavor.

Charles Costain

ART IN TRANSIT
Studies in the Transport of Paintings

Edited by
Marion F. Mecklenburg

——Organizing Institutions——

Canadian Conservation Institute of Communications Canada

Conservation Analytical Laboratory of the Smithsonian Institution

National Gallery of Art

Tate Gallery

—— ◆ ——

International Conference on the Packing and Transportation of Paintings
September 9, 10, and 11, 1991, London

—— ◆ ——

National Gallery of Art

Washington

Conservation Division

EDITOR
Janice Gruver

PRODUCTION/DESIGN
Janice Gruver
Michael Skalka

Staff Assistants
Tracy Gilchrist
Pamela Richardson

Editors Office

PRODUCTION
Chris Vogel

DESIGNER
Cynthia Hotvedt

Produced by the Division of Conservation, Ross M. Merrill, Chief of Conservation
and the Editors Office, Frances P. Smyth, Editor-in-Chief, National Gallery of Art,
Washington.

This publication was produced on Ventura Publisher, Windows Edition, using a
Compaq 386/20e PC, CornerStone Singlepage XL monitor, Hewlett Packard LaserJet
series II printer with an Adobe PostScript cartridge. The type is Palatino
camera-ready on 70# Mohawk Poseidon laser paper. Manuscripts were prepared on
WordPerfect 5.0 and 5.1, with some graphics prepared on PageMaker 3.0. Printed by
BookCrafters, Chelsea, Michigan.

ISBN 0-89468-163-X

Cover: *Taking in the Pictures at the Royal Academy,* wood engraving by M. Jackson,
printed in the *Illustrated London News*, 21 April 1886, page 381 (Collection of Ross M.
Merrill). [*Note:* The legend below the illustration incorrectly identifies the institution
as the Royal Academy; it is really The National Gallery, London. This was probably a
stock illustration that may have been reused.]

Contents

Foreword

Special exhibitions offer innumerable unique opportunities. These include the opportunity for the expert to compare works separated for decades or even centuries, and the cultural experience enjoyed by visitors who might never otherwise be able to visit all the individual private collections and museums lending the works of art assembled. Art objects are also shipped for a variety of reasons other than special exhibitions, such as acquisition, examination, or restoration. Although it is often not taken into account that works of art are at risk virtually anywhere they are, there is widespread intuitive recognition that works of art that travel incur risks each time they are moved. The technologies of packing and transport of paintings have been the subject of extensive investigation. Recent research has assessed risk and provided protective methodology for packing and transporting paintings. There is much significant new information on the material properties of paintings and their responses to environment, vibration, shock, handling, and stress incurred from the time they leave their home environments to the time they are returned. This new information is a valuable tool in developing new technology to protect works of art in transit.

Four institutions have worked collectively in bringing this new technical and theoretical information together for this conference. An international cooperative effort by the Canadian Conservation Institute of Communications Canada, the Conservation Analytical Laboratory of the Smithsonian Institution, the Tate Gallery, and the National Gallery of Art has assembled in this publication important information to advance the understanding of the behavior of paintings in the transit environment.

With it, we can hope to fulfill, with ever-increasing expertness, the responsibilities undertaken by all those concerned with both the preservation of our heritage and its cultural, historic, and aesthetic source to society.

J. Carter Brown
Director
National Gallery of Art

Editor's Notes

Widespread interest in temporary exhibitions that require the transport of paintings to multiple venues has generated discussions at every level of the museum profession. Many factors need consideration when a painting is either lent or borrowed by an institution, one of which is the genuine concern for the safety of the object. This in turn produces many questions regarding what actually constitutes risks in transport. As concerns for the safety of transported paintings have grown, so too has a polarity of opinions developed on how to best address these concerns. Some felt that the risks were too high and refused to allow objects in their collections to travel. Others believed that past experience in shipping paintings along with a perceived lack of direct evidence of damage caused by changes in temperature, relative humidity, vibration, or shock to well packed, sound objects was reassuring. The problem was that these diverse philosophies were not supplemented by sufficiently strong arguments to determine which position was correct. Nor was any argument strong enough to influence institutions either allowing or refusing to lend or borrow paintings for exhibitions. The only certainty was, that a stable environment substantially reduced damage to paintings in museums and galleries. Recognizing this, researchers such as Nathan Stolow, Garry Thomson, Kenzo Toishi, and others investigated the potential of packing cases for maintaining stable interior environments and presented information that enabled packing cases with moderately stable environments to be designed despite a varied external climate. What this research did not delineate were the factors and conditions of a work of art that determined its allowable, safe variations in temperature and relative humidity. So the question still persisted, do packing cases, though well designed, provide *sufficient* stability for the safe transport of paintings?

More troublesome was the problem of vibration. Other than a condition where there was no vibration at all, there was no experience or known evidence that *some* level of vibration was hazardous to paintings. Investigators such as Christine Sitwell, Sarah Staniforth, Timothy Green, Stephen Hackney, and others began exploring this question. The difficulties encountered during their research were similar to those relating to temperature and relative humidity. What were the specific relationships between the magnitude of shock and vibration encountered during handling and transport and the damage to the object? Though their efforts still left

many unanswered questions, their research clearly helped provide the impetus for future research projects, including this conference.

This conference begins to answer many of those questions and is, in many ways, the latest step in developing a clearer understanding of the behavior of paintings exposed to the potential rigors of transportation. In other ways, it is considerably more. Another technology, engineering mechanics, is being formally introduced to the museum profession. To most of the audience, the connection between the concepts of mechanics and the problems of shock and vibration in paintings will seem evident, but the connection to temperature and relative humidity effects will be less obvious. The research for this conference reflects the usefulness of both engineering mechanics and packing experience in answering questions concerning the transport of paintings, but it also presents new problems. If the results of this conference are to be useful, they must be understood by the audience, and the information presented must be sufficiently complete to enable researchers to apply it as a foundation for future research. Further, in order to answer a single question, several different aspects of applied mechanics were required. For example, Paul Marcon shows that vibration from the transport environment can be described as being mostly random. Yet, one of the theoretical criteria for damage to an object is that the source vibration must be sustained at a frequency that closely matches one of the natural frequencies of the object and at a sufficiently high magnitude. Therefore, the conclusions regarding the low damage potential to stretched paintings from vibration reflect this lack of frequency match. But equally, it must be shown that the magnitude of any sustained matched frequency vibration that may occur must be high enough to cause stresses in the painting to cause cracking or flaking. This requires both theoretical analysis and experimental modeling; these results are also presented in this conference. An effort has been made to provide continuity for the reader so they may discern the connections between the theoretical considerations, experimental results, and the recommended practical applications.

Substantial information has resulted from this research program and more will be forthcoming. Several of the findings have resulted in providing some correlation between the physical condition of paintings and their response to temperature and relative humidity. There are spin-off benefits also. The research on temperature and relative humidity provides insight about the most appropriate methods of treatment to paintings. Further, temperature, independent of relative humidity, seems to have a greater potential for damage than previously thought. Therefore more emphasis is placed on case insulation. There are still areas where more work is

seriously needed. Aging paints become stiffer than the ones currently being tested and there is evidence that they can become either stronger or weaker, depending on their exposure over time. The actual magnitudes of these changes, when they occur, and their specific significance remain unclear. Additionally, there is evidence that cleaning solvents affect the mechanical properties of artists' materials, and there should be further detailed studies.

The conference is not limited to scientific studies. The discussions on the methodology, specific programs, and philosophical considerations on the transport of paintings help to balance the dialogue between the theoretical and the practical. Much of this conference is devoted to the direct application of the research, and includes information on how to design and construct shipping cases that reduce the effects of impact, retard changes in temperature and relative humidity, and attenuate some of the effects of vibration.

It is hoped the information provided in this publication will serve as the impetus for further research and recommendations toward the best possible care for the transport of paintings. Equally important, it is hoped that the conference will provide information needed to assist in making rational assessments regarding the safe transport of paintings.

Marion F. Mecklenburg
Assistant Director for Conservation Research
Conservation Analytical Laboratory

Acknowledgments

Organizing and executing a research program, conference, and publication of this scale requires the cooperation and assistance of a remarkable number of skilled professionals. Without their continued assistance, critical tasks would never have been accomplished and deadlines would never have been met, but equally important, the program would never have gotten started without the support of the four organizing institutions and their leadership. The directors of these institutions, J. Carter Brown, National Gallery of Art, Washington, Charles Gruchy, Canadian Conservation Institute of Communications Canada, Ottawa, Nicholas Serota, Tate Gallery, London, and Lambertus van Zelst, Conservation Analytical Laboratory of the Smithsonian Institution, Washington, showed remarkable foresight, since early decisions to go forward were made on the expectations of future results in a research discipline relatively new to the international museum community. Their support has been sincerely appreciated.

Special thanks go to Roger Mandle, deputy director of the National Gallery of Art, for his early and continued support of this publication and Frances Smyth, editor-in-chief, National Gallery of Art, for recognizing the importance of providing such a publication.

There are others that also deserve credit for their efforts. Over the last four years there were hundreds of details that required attention and decisions, and keeping track of those details was a thankless task accomplished by Charles Costain at the Canadian Conservation Institute of Communications Canada. His ability to promote continuity to the program was remarkable. Timothy Green from the Tate Gallery, who had the assignment of organizing local arrangements for the conference along with his own duties at the Tate, still found time to conduct research and prepare papers for this publication and the conference. Ross Merrill of the National Gallery of Art, continually demonstrated his organizational skills by always anticipating future needs of the program and helping to resolve difficult problems by providing options and their relative merits.

Thanks have to go to all of the contributors, for without their experience, knowledge, talents, and energy, no new information would be forthcoming and to all the others whose ideas, suggestions, and comments contributed to improve this publication.

At the end of any project such as this, all of the written information ultimately collects on the desks of the editorial and production staff. These are the people who insist on excellence, bring cohesion to the entire production, work impossible hours meeting difficult deadlines, and maintain a quality of quiet confidence throughout their task. As editor, Janice Gruver, clearly led the way in this effort and deserves very special recognition. Additionally, many thanks go to Michael Skalka who worked on production with our editor and constantly provided reassurance by finding solutions to difficult technical problems.

M. F. M.

Introduction

This research project marks a precedent-setting effort of several international institutions jointly addressing a major conservation issue of mutual concern. Over the years, many of our colleagues individually contributed to the body of accumulated knowledge on packing and shipping but no major joint studies were initiated. The cooperative efforts of the Canadian Conservation Institute of Communications Canada, the Conservation Analytical Laboratory of the Smithsonian Institution, the National Gallery of Art, Washington, and the Tate Gallery make this publication and associated conference unique. The directors of the sponsoring research institutions have been quick to recognize the importance of the project and have made the study a key priority. Although cooperative research never evolves effortlessly, the symbiosis of combined expertise focused on the study of a specific issue has produced a publication that leads the way for other topics that could also benefit by concerted joint research.

For generations collections have traveled from venue to venue for exhibition and while museums have been sensitive to the dangers imposed on their collections, only recently has modern technology provided the sophisticated tools necessary to study them thoroughly. Technical developments made during the last decade are at the heart of this research and the resulting publication. Without the development of personal compact computers, this project would not have been possible. The desktop computer has allowed large volumes of data to be rapidly processed and studied. It has provided theoretical modeling of the response of works of art to the stress of their environment. A miniaturized computer called a data logger, has allowed the electronic collection of data on transit conditions, permitting the replication in our museums of the actual conditions of transit. Historically, what has been lacking is a clear understanding of the behavior of the work of art and its tolerance thresholds for environmental variations such as changes in temperature and humidity. This study offers some insights into those issues. While the suggested solutions in this publication and its practical counterpart, the workshop handbook, do not presume to answer all of the questions, the research of the contributors is significant and we trust, will be durable. Since this project has consciously focused on paintings, it is anticipated that additional studies will follow addressing the specific problems of other cultural materials.

The origins of the publications and conference are the culmination of numerous informal discussions among conservators and their colleagues who stressed the need for a thorough study of the problems incurred in transport and the desire for a published reference and guideline by which to proceed. The formalization of theory and research will lead to practical applications for the betterment of art collections housed worldwide. No longer will there be a need to rely on implied relationships and supposition.

Ross M. Merrill
Chief of Conservation
National Gallery of Art

SCIENTIFIC RATIONALE FOR STUDIES ON PACKING AND TRANSPORTATION OF PAINTINGS

An Introduction to the Issues

Charles Costain

ABSTRACT: *This is an introductory paper describing the approach being taken in investigating packing and transportation of paintings. This can be broken down into three major factors: the type of transportation carrier, the fragility of the painting, and the design of the packing case to afford sufficient protection. Various modes of transportation (truck, rail, air, ship) have been extensively monitored and published data exists predicting the vibration and shock environment that a package is likely to experience for any given mode. Data also exists on the characteristics of materials that are used in the construction of packing cases. There is less information on the fragility of paintings; although the sensitivity of paintings on canvas to fluctuations in relative humidity is reasonably well documented, responses to shock and vibration are still being studied using computer models and testing of prepared canvases.*

INTRODUCTION

Preparing a work of art to be safely transported involves many considerations. The approach that researchers at the Canadian Conservation Institute, the Conservation Analytical Laboratory at the Smithsonian Institution, the National Gallery of Art, Washington, and the Tate Gallery have taken in addressing packing and transport is not original; it is a standard approach used in the packaging industry. It is also a very academic approach, which has some strengths and some weaknesses. The major strengths are that it allows us to carry out controlled tests in a laboratory to obtain precise, measurable results that provide protection under most transit conditions. The weakness is that we may not foresee every situation or appreciate every difficulty that may arise.

The purpose of this paper is to break down the problems of packing and transportation into smaller units to explain the approach that we have taken in addressing the subject, and to give an overview of the research topics that will be described in greater detail elsewhere in this publication.

Before deciding how to protect an object, it is useful to briefly consider the agents of deterioration that we are trying to protect against. In considering the agents that can harm museum or gallery objects, Michalski has identified nine agents of deterioration: physical damage (punctures, abrasion, shock, and vibration), thieves and vandals, fire, water, biological agents (insects, mold, vermin, etc.), contaminants (pollution), radiation (including light and ultraviolet), *incorrect* temperatures, and *incorrect* relative humidity.[1] (Note that for the last two factors, incorrect temperature and relative humidity are the active agents; that is, relative humidity itself does not contribute to deterioration, but incorrect relative humidity certainly can.)

In most transit situations, the work of art is enclosed in a packing case, so some of the agents of deterioration may pose less of a threat to the work during transportation than during normal exhibition and storage. For example, a reasonably well-constructed wooden case will provide some protection against vandals, water, fire, insects, external

pollutants, and light. Security against thieves is a larger problem that can only be partially solved by case design. However, designing a case to protect against the risks of shock, vibration, incorrect temperature, and incorrect relative humidity that can occur in transit is a more difficult proposition. Recent research has centered on controlling these four agents within the packing case.

STRATEGY FOR DESIGNING SUITABLE PACKAGING

The problem of safely shipping an object from location A to location B can be broken down into three separate, but related, aspects:

(a) the transportation environment,

(b) the fragility of the object to be shipped, and

(c) the type of packaging material and the package design.

Of these three topics, the threats posed by the transportation environment and the characteristics of packaging material have been extensively studied by workers in other fields, and are relatively well defined. The fragility of works of art in general, and of paintings in particular, is an area that is of unique interest to those who work in the museum field, and thus requires the most active research.

TRANSPORTATION ENVIRONMENT

The term *transportation environment* is used to describe all of the external factors that are present during transit and can affect a package being shipped. It includes, therefore, not only climactic factors, such as temperature and relative humidity, but also physical factors, such as shock and vibration.

When a packing case is shipped, the sender loses control of its environment from the time it leaves the institution until it arrives at its destination. Although no one can predict exactly what will be happening to the case at any given moment, it is possible to predict the general conditions it will be subjected to during its travel, because the packaging industry and the military have accumulated substantial data on various modes of transportation.[2]

Modes of Transportation

Four major modes of transportation are commonly used: road, air, rail, and sea. The shipping of any packing case can be thought of in terms of transportation cycles: the case is loaded into a carrier (truck, airplane, etc.) *(handling phase)*; transported within that vehicle or carrier to a destination *(distribution phase)*; and then unloaded *(handling phase)*. In many cases, several different modes of transportation will be used sequentially, and the shipping history will be made up of a series of these transportation cycles.

Within any given transportation cycle, the handling and distribution phases pose very different risks. The handling phase is usually of relatively short duration, and often consists of the packing case being carried either manually or by a mechanical device. The distribution phase usually covers a long period of time, with the package being stationary within an enclosed, moving carrier throughout.

Shock

Studies have shown that the largest shocks to a package are likely to occur during the handling phase,[3] due to the possibility of the package being dropped, thrown, or knocked over. Although there is no way of knowing whether or not a particular case *will* be mishandled, the size and weight of a packing case can be used to predict the severity of the shock, should an accident occur. This prediction method is based on studies of many pieces being shipped by various means, and allows a shipper to predict a *probable drop height*, which is the maximum drop that a package is likely to experience during handling *if* it is dropped. This is outlined in more detail in the paper "Shock, Vibration, and the Shipping Environment" by Paul Marcon.

During the distribution phase, shocks may

still occur, but they are unlikely to be as severe as the shocks that can occur during the handling phase. The only situation where shocks of a comparable magnitude can be anticipated is if the cargo shifted due to the motion of the carrier; even then, it is very unlikely that the shock would exceed that predicted for during the handling phase.

Vibration

Vibration is most likely to be a problem during the distribution phase of shipping, due to vibration sources such as motors, poorly balanced wheels on trucks, etc. However, researchers have measured the frequency and magnitude of vibrations that are produced by a variety of different types of carriers, making it possible to predict the magnitudes and frequencies of vibration that a container will experience in each of the four principal modes of transportation. This, too, will be discussed in detail by Marcon in his paper on transportation.

Temperature and Relative Humidity

The temperature and relative humidity outside the case will affect the environment inside the case over a period of time. This could become a factor not only during the distribution phase, when the package is in the carrier, but also during the periods of temporary storage that often occur before loading or between transportation cycles.

Climactic data can be used as very conservative guidelines when planning a shipment where there is temperature control within the carrier, although temperatures inside moving vehicles rarely equal the outside air temperature. Temperatures inside stationary vehicles, however, can exceed the outside air temperature by more than 8°C (14°F).[4] Temperatures in many types of carriers are controlled. With mixed cargos, for example in the cargo hold of an airplane, the temperature may be dictated by the requirements of other cargo in the hold. Relative humidity-controlled carriers are rare, therefore the relative humidity around an object is usually controlled by the packing case, if control is necessary.

Couriering

The process of couriering is a special case of transporting artifacts, and should be considered relative to the above discussion on transportation environments. One of the principal advantages of couriering a work of art rather than shipping it is that the handling phase of loading and unloading the package is eliminated, thus greatly reducing the risk of shock. Once the object is in the carrier, the transportation environment is the same, whether it is being shipped or couriered.

FRAGILITY

To scientifically design a package for an object, the fragility of the object and its sensitivity to the agents of deterioration should be known. Past studies by different researchers on the mechanical properties of paintings have been instrumental in explaining how paintings react to changes in relative humidity,[5] but relatively little has been published on the sensitivity of painting materials to shock and vibration or to changes in temperature.

Recent work by Mecklenburg has examined the effect of low temperatures on the properties of painting materials, and this will be reported in "Mechanical Behavior of Paintings Subjected to Changes in Temperature and Relative Humidity."

Shock

Let us consider the manner in which industry determines the susceptibility of an object to shock. A given product, for example a computer, is subjected to shock pulses of increasing value (e.g., dropped from increasing heights) until it is damaged; the magnitude of the largest shock that the computer can withstand without being damaged indicates its fragility. This is a very simplistic description of industry's sophisticated test procedure, but it exemplifies the general approach.

There are two obvious problems to this method when dealing with works of art. First, no two artworks are alike; every piece

differs in terms of the materials that are present, the technique that the artist has used, and the conditions that the piece has been subjected to in the past. Second, a valuable work of art cannot be tested until it is damaged. Therefore, the approach that we have taken is to predict the strength of an object by using computer analysis and by testing model paintings.

Marion Mecklenburg has gathered substantial information on the strengths of various materials, such as canvas, glue, gesso, and paint, that are used in paintings. He uses this information in a sophisticated computer program that can predict the forces generated in a painting when it is dropped or vibrated, or when the temperature or relative humidity change, and can predict when these materials will fail.

The Canadian Conservation Institute has fabricated some model paintings to simulate very fragile paintings. These models consist of canvases and panels covered with a brittle gesso layer, which is fragile and prone to cracking when subjected to shocks or vibrations. Physical drop-testing of these model paintings is used to evaluate the predictions generated by Mecklenburg's computer program. While it is clear that this will give us only an approximation of the fragility boundaries for a sound painting, it is a starting point. The fragility of paintings that have some inherent weaknesses, such as cracks, flaking paint, general loss of adhesion between layers, etc., can also be predicted by computer using model paintings produced in the laboratory.

Vibration

Vibration must also be evaluated as a potential damaging factor during transportation. Although this phenomenon will be explained more fully in the paper by Marcon on "Shock and Vibration and Protective Package Design," there are only certain frequencies that are potentially harmful to an object—these are the resonant frequencies of the object. The sensitivity or fragility of paintings to vibration is also being estimated by using mathe-matical computer models, and by subjecting model paintings to vibration tests in the laboratory.

PACKAGE PROTECTION

Once the data exists to predict the transportation environment and to estimate the fragility of the object, the final step is to design and construct a packing case that will reduce the problems posed by the various agents of deterioration to an acceptable level.

Shock

Protection against shock can be achieved within a package by using a foam to dissipate the energy of the blow and to minimize the effect on the object. However, care must be taken in deciding the type and quantity of foam to use. For example, if a heavy object is packed using a foam that is too soft, there is a risk that the foam will completely compress on impact if the package is dropped, and a large component of that shock will be transferred to the object. On the other hand, if too rigid a foam is used, it will compress very little on impact, and again much of the shock will be transmitted to the object. To help in choosing an appropriate foam, manufacturers publish *dynamic cushioning curves*, which allow the user to predict the level of protection that the object will receive with that foam in a given situation. For example, if the drop height and the weight and dimensions of the painting are known, these curves can be used to select the type and amount of foam needed to achieve the desired level of protection. With practice, this type of calculation becomes quite easy, but it does require access to a large number of dynamic cushioning curves to account for a variety of different packing situations. (See "Foam Cushioning Materials: Techniques for Their Proper Use" by Mervin Richard in this publication.) To make this task simpler, Paul Marcon has designed a circular slide rule that incorporates the information equivalent to

168 dynamic cushioning curves. The use of this tool is described in his paper "A Circular Slide Rule for Protective Package Design."

Vibration

Vibration appears to be less of a threat to paintings in transit than is shock, since levels of vibration are generally low. However, certain steps can be taken to further reduce the risk, such as using a cami lining or backing boards. This is discussed by Tim Green in "Control of Vibration in a Packing Case." Vibration can also be reduced by selecting an appropriate foam for packing paintings, although the basis for most foam selection is protection against shock.

Temperature

The rate of temperature change within a case can be controlled to a certain degree by the use of insulation and by constructing the packing case in such a way that it is fairly airtight. Hermetically sealed cases have been discussed in the literature but are very difficult to achieve in practice and would not appear to offer any real advantage. The amount of insulation necessary depends on the anticipated environment and the duration of exposure. It is possible to measure the rate of temperature change within a case, and then predict the performance of the case with reasonable accuracy.[6] The amount of insulation required depends on the anticipated exterior temperature and the duration of exposure.

Relative Humidity

Good control of the relative humidity near the object and, more importantly of the moisture content of the object within a packing case, can be achieved by wrapping the painting and by using a relatively well-sealed case. Several successful applications of this technique have been reported in the literature.[7] The degree of control of moisture content is related to a number of factors, including the degree of temperature variation within the case, the amount of buffering material relative to the volume of enclosed space, and the wrapping technique and materials used.

CONCLUSION

Sufficient information exists to enable any art institution to use scientific principles to design packing cases that will afford an adequate degree of protection to most sound paintings. The transportation environment and the properties of the materials used in the construction of a packing case are well understood.

The estimation of the fragility of a painting remains a more difficult issue. Computer models and experimental research are being developed to establish levels of protection that are required for various types of materials. Further research and development will provide a greater degree of sophistication and accuracy for ascertaining fragility levels. Conservative estimates of fragility will, however, remain the rule to allow for a wide margin of safety.

Assessing the condition of any given object remains a responsibility of the conservator or curator. Each painting's unique nature and inherent weaknesses will continue to need evaluation by professionals who are sensitive to its individual needs. □

NOTES

1. Stefan Michalski, "An Overall Framework for Preventive Conservation and Remedial Conservation," *ICOM Committee for Conservation 9th Triennial Meeting* Preprints Dresden (1990), 589-591.

2. Fred E. Ostrem and W. D. Godshall, "An Assessment of the Common Carrier Shipping Environment," *General Technical Report FPL 22 USDA*, Forest Products Laboratory (1979); *Military Standardization Handbook: Package Cushioning Design, MIL-HDBK-304B* U. S. Department of Defense, Washington (31 October 1978).

3. *MIL-HDBK-304B* 1978, 9.

4. Fred E. Ostrem and Basil Libovicz, *A Survey of Environmental Conditions Incident to the Transportation of Materials*, Final Report to the USDOT, Office of Hazardous Materials (October 1971), 130.

5. Marion Mecklenburg, "The Effects of Atmospheric Moisture on the Mechanical Properties of Collagen under Equilibrium Conditions," *AIC Preprints of the Papers Presented at the Sixteenth Annual Meeting* (New Orleans, 1988), 231-244; Gerry Hedley, "Relative Humidity and the Stress/Strain Response of Canvas Paintings: Uniaxial Measurements of Naturally Aged Samples," *Studies in Conservation* 33 (1988), 133-148.

6. Timothy Green and Stephen Hackney, "The Evaluation of a Packing Case for Paintings," *ICOM Committee for Conservation 7th Triennial Meeting* Copenhagen (1984) 84/12/1-84/12/6; David Saunders and Richard Clarke, "Monitoring the Environment within Packing Cases Containing Works of Art," *ICOM Committee for Conservation 9th Triennial Meeting* Preprints, Dresden (1990), 416-417.

7. Stephen Hackney, "The Dimensional Stability of Paintings in Transit," *ICOM Committee for Conservation 8th Triennial Meeting* Sydney (1987), 597-600; Saunders and Clarke 1990, 415-422.

ART IN TRANSIT: MATERIAL CONSIDERATIONS

David Erhardt

ABSTRACT: *Packing cases used for the transport of art objects must provide complete and self-contained protection from the external environment, often for long periods of time. The demands placed on the physical properties of the materials used in the fabrication of packing cases are immense. Because of this, other considerations may be overlooked. One such factor is damage caused by the chemical instability of many of the materials that are used. Such damage is a major problem in display and storage cases within the museum. The release of acids, oxidants, solvents, plasticizers, and other additives and degradation products by display and storage materials causes considerable damage which often is not readily apparent. This paper discusses approaches to dealing with this problem in packing cases. Lists of suitable and unsuitable materials, methods of evaluating new or unknown materials, and ways of minimizing damage from the unavoidable use of unsuitable materials are covered.*

THE ENCLOSURE OF OBJECTS

One of the most effective ways of preserving and preventing damage to museum objects is to enclose them and control their environment. The museum building itself is the singlemost important protection against the general environment, even if it is rarely thought of as such. Active control of the internal museum environment provides another buffer to environmental changes and deviations from the conditions considered optimal for the collection. Further, many objects within museums are enclosed while on display or in storage. This provides another layer of protection in addition to containment within the museum. The immediately obvious benefits include protection from theft, pests, breakage, and dust. There are also benefits which are not visually apparent. Enclosing objects helps to buffer both the temperature and relative humidity, and to protect the object from pollution within the museum. This is true even when the climate within the museum is regulated, since there will be sources of pollution or causes of local changes in temperature and relative humidity within the museum which are beyond control. A consideration of only the above factors would lead to the conclusion that objects should be hermetically sealed within cases. Unfortunately, these are not the only factors to be considered. It has been known for some time that many materials release chemical compounds that can damage other objects that are near or enclosed with them.[1] The classic example, of which there are many reported cases, is the corrosion of objects made of lead by organic acids released by wooden enclosures. Even the slow release of noxious compounds over the years can produce substantial damage to objects thought to have been protected adequately. Such factors must be taken into account when considering the enclosure of objects, and the benefits of enclosure should be balanced with the possible problems that can result. This is true even when the materials used in a case have been chosen carefully, because damaging compounds can also be released by the objects themselves.

For art in transit, there is no question as to whether or not to enclose an object. Removed from the museum, the regulated environment, and any display or storage case, not only must the object be enclosed, but the enclosure for periods of time must provide as much protection as the entire museum ma-

trix! The short-term problems caused by the transport of art are immense. Rain, dirt, shock, and extremes of and rapid changes in temperature and relative humidity all pose immediate and significant threats to the integrity of the artwork. Protection from the physical environment becomes the overriding consideration in the transport of art. The requirements for the physical properties of materials used for packing are so demanding that other factors such as chemical stability easily may be overlooked in the search for suitable materials. This is especially true of factors that often are perceived of as being longer-term considerations which are not important for enclosures intended to be used "only for a short time." This paper is an attempt to illustrate the types of damage that chemically unstable materials can cause, to provide guidelines for the choice of safe materials, and to provide methods of minimizing damage when the use or presence of unsafe materials is unavoidable.

THE PHYSICAL REQUIREMENTS, DESIGN, AND FUNCTION OF PACKING CASES

A packing case must provide protection from several types of physical damage. It must provide a physical barrier to dirt and liquid water, absorb shock and vibration, protect the object from light damage, buffer changes in temperature and relative humidity, and protect against external sources of pollution. A combination of proper case design and the use of materials having appropriate properties helps to achieve these objectives. While there is no unique design most suited for the transport of art, certain aspects of the design of any case either are determined by the required functions of the case or are generally accepted as the most effective approach to the problem. For instance, the exterior of the case must be waterproof. Between this exterior layer and the object must be one or more layers that serve as thermal insulation, shock absorbers, relative humidity buffers, and barriers to air movement. A final layer around the object should function as a vapor barrier and minimize the amount of air contained

with the object. Any changes in temperature that reach the interior air space will cause a change in relative humidity. This will result in a transfer of water vapor between the enclosed air and any hygroscopic materials. Hygroscopic materials may be part of the object, or added to buffer the relative humidity of the air space. Reducing the volume of air around the object minimizes the amount of water vapor that must be transferred to maintain an equilibrium between the moisture content of the air and of the object during temperature changes. Keeping the moisture content of the object as constant as possible minimizes any damage due to swelling or shrinking accompanying the gain or loss of water. Thermal insulation reduces the rate at which a change in relative humidity could occur. This provides any humidity buffers that are present enough time to work effectively and to react to limit any changes in the relative humidity of the air.

Materials that serve more than one of these protective functions are preferred, especially if they do so efficiently. Efficiency in this case is a combination of the amount or thickness of material required, its weight, cost, and ease of fabrication. The specifications for materials used in packing cases may exceed or extend beyond those for materials used in display and storage cases in the museum. Materials used for packing cases may have to be especially strong, lightweight, durable, or water-resistant, or to provide a high degree of thermal insulation or shock absorption. These added requirements further restrict the range of materials that are considered suitable for use in the museum. It is not within the scope of this article to consider the physical requirements of materials imposed by their use as packing materials, but rather to emphasize the importance and outline methods of making sure that the materials chosen to protect art in transit are chemically stable and do not themselves cause damage.

DAMAGE CAUSED BY MATERIALS

The classic cases of damage to museum objects caused by the use of unsuitable materi-

als for display and storage include the corrosion of metals and attacks on calcareous objects.[2] Glass, stone, and ceramics can also be attacked.[3] Such damage often is visually obvious, since there is a definite change of form or appearance, and because many inorganic materials do not degrade at all if kept under the proper conditions. In some cases, there may be a relatively slow overall change, such as the darkening of lead white caused by hydrogen sulfide. In many cases, the cause of the damage is known. Much of the observed damage is due to acids emitted by wood, paints, glues, fabrics, and plastics. There are reports in the literature of the direct measurement of the release of corrosives from suspect classes of materials such as wood.[4]

There are fewer reports of damage to organic materials, but the number of reports of damage probably does not reflect accurately the amount of damage that occurs to organic materials. Most organic materials degrade even under the best of conditions, and this degradation may not produce any dramatic change in form or appearance. There may be a gradual change in chemical, optical, or physical properties rather than a dramatic change as from metal to corrosion product. Changes in color, flexibility, strength, acidity, and degree of oxidation or crosslinking are not readily determined. In addition, most organic materials have degraded to some extent before their addition to a collection. Further damage may be difficult to discern. As a complicating factor, the damage caused by unsuitable display and storage materials may be similar or identical to the slow degradation that occurs under optimal conditions. An example is the darkening of paper prints caused by contact with wood backboards, which often occurs in a pattern corresponding to the grain of the wood. If the darkening did not take on the pattern of the grain of the wood, the darkening might simply be attributed to the paper being of poor quality. Except in extreme or unusual cases, there is no simple way of determining how much change is occurring in organic materials, and how much of the change is due to the use of unsuitable materials rather than to normal aging. For this reason, the choice of safe materials and the design and maintenance of proper environmental conditions must be relied upon in order to minimize the damage that can be caused by unsuitable materials.

Some of the damage caused by display and storage materials occurs relatively quickly. Other damage has taken place over periods of years, and was noticed only after the effects were drastic enough that they could not be ignored or attributed to normal aging. Under ideal conditions, art objects would spend only minimal lengths of time in packing cases. Unfortunately, these minimal spans of time often become long stretches. An object may be packed ahead of time, delays in shipping may occur, or the case may be left closed after shipping to allow the internal temperature to equilibrate. In exhibitions shipped to multiple sites, there may be long intervals of time between the closing of one site and the opening of another. And while packing cases are not necessarily designed as either temporary or permanent storage, they may, indeed, serve as such once the object returns home. Often much more money and effort goes into the construction of packing cases than into permanent storage areas, and storage in the packing case may seem a preferable alternative to a return of the object to its old shelf. Though the threat of damage caused by the materials of packing cases may seem to be less severe than that by materials used in permanent storage, it nonetheless must be considered.

CHOOSING MATERIALS

Two basic methods are available for choosing suitable materials for use near museum objects. The safest and least complicated method is to restrict the choice of materials to the classes of materials of well-defined chemistry and composition that have been shown to be safe through use and long-term testing. Otherwise, materials of new, unknown, or untested composition must be rigorously tested for safety and suitability.

At least one list of types of materials that can be classified as generally safe or unsafe has been published.[5] The following is an updated version.

Materials Regarded as Generally Safe for Museum Use

(a) metals

(b) ceramics

(c) glass

(d) inorganic pigments (those that do not contain sulfur)

(e) polyethylene and other polyolefins such as polypropylene

(f) polycarbonate

(g) polystyrene

(h) acrylics

(i) polytetrafluoroethylene (Teflon™)

(j) polyester (polyethylene terephthalate)

(k) cotton and linen (unsized and undyed)

(l) paper and matboard made from rag or lignin-free pulp, especially if buffered or alkali processed

Materials Known to Cause Problems

(a) wood (Contrary to some sources, no wood can be regarded as acid free.)

(b) noncollagenous proteins (Most proteins contain sulfur, and can cause tarnishing and discoloration. Highly refined gelatin is free of sulfur.)

(c) nitrocellulose (Problems with early manufacturing processes resulted in a variable, often highly unstable product. Though the modern product is more consistent, it still cannot be recommended for use in conservation.)

(d) cellulose acetate (Some samples may be stable, but others have been known to release acetic acid. Test before use.)

(e) polyvinyl chloride (PVC) (This and other chlorinated hydrocarbons can release hydrochloric acid, and often contain volatile additives.)

(f) polyvinyl acetate (Some samples may be stable, but others, especially some emulsions, release acetic acid. Test before use.)

(g) polyvinyl alcohol (Prepared from polyvinyl acetate, and subject to the same provisions.)

(h) polyurethanes (These are inherently thermally and photolytically unstable, and always contain additives.)

(i) dyes (Many dyes contain sulfur or other reactive groups.)

These lists are based on long-term testing and/or extensive evaluation during use. Even so, these lists must be considered only as guidelines, as the use of the material must also be considered. For instance, many of the polymers listed are stable under recommended museum conditions but can be damaged by exposure to excessive amounts of ultraviolet light, which might be encountered outside the museum. Alkaline buffered paper materials are often used in contact with museum objects, but are not regarded as safe for use in direct contact with photographs with gelatin-based emulsions, which are naturally slightly acidic. The form of the material must also be considered. Acrylics can come in several forms: solids, solutions, and emulsions. Acrylics in solid form are often used in the museum, and solutions of pure acrylics dissolved in good quality solvents can be used as varnishes and coatings. Emulsions, though, contain additives to maintain the water-based suspension, and the suitability of the emulsion will be determined by the nature of the specific additives. Nonwoven polyester fabrics can be held together either by heating, which causes the fibers to soften and adhere to each other, or by adding a glue to hold the fibers together. Heat welded forms are generally acceptable. Some of the glues (which can be seen under the microscope as blobs at the points of intersection of the fibers) are not acceptable.

Some general tendencies can be seen in the above list. Most of the polymers in the "safe" category are those that generally do not require additives to modify their properties or to stabilize or preserve them. For instance, most polymers of acrylic esters are accept-

ably stable for use near or in contact with objects (use as a coating imposes stricter requirements which not all acrylics meet). Changes in the properties of acrylics can be achieved by modifying the polymer sidechains rather than by the use of additives, and without affecting the basic chemistry of the polymer, which is responsible for its stability.

On the other hand, many of the "unsafe" polymers are those that are inherently unstable and require the use of antioxidants, ultraviolet absorbers, or stabilizers, or whose properties can only be modified by additives, many of which are volatile. Pure polyvinyl chloride (PVC) is a hard polymer. Large amounts of plasticizers must be added to produce the flexible PVC which is used in a wide range of products that includes tubing and photo album pages. Polyurethanes are similar in that they invariably contain additives to modify their properties and to prevent photo- and oxidative degradation. The use of synthetic polymers with such additives is so widespread that the additives can be found throughout the environment.

The effects of unsuitable materials are not limited to the release of corrosive or oxidizing compounds. Solvents can soften organic materials, while other chemically unreactive compounds may simply contaminate objects. Two examples demonstrate the release of chemically unreactive compounds that can nevertheless affect or contaminate objects.

Figure 1 is the result of the gas chromatographic/mass spectroscopic analysis of volatile organic compounds collected in a new painted steel storage cabinet from which a strong odor emanated whenever it was opened. The odors were collected by leaving an open container of an absorbent inert polymer in the closed case. Each labeled peak represents a different chemical compound present in the air in the cabinet. All of the peaks are due to compounds typically present in paint solvents. This indicates that the problem is due to inadequate drying of the paint rather than to degradation or contamination, so that the cases should be usable after further drying and ventilation.

Figure 2 is the result of the gas chromatog-

raphic/mass spectroscopic analysis of volatile organic compounds collected in a new walk-in display case. Each of the identified peaks represents a different chemical compound present in the air of the display case. There are at least five different classes of compounds from at least three or four different sources. The source of the series of hydrocarbons probably is a petroleum oil. The most likely source is nearby escalator machinery, a pollutant source external to the case. Another series of compounds (naphthalenes) is from mothballs previously used to preserve the displayed objects, which happen to be textiles. The residue of mothballs persists long after their use was discontinued. Another compound, 1,1,3-trimethyl-3-phenylindane, is reported in the literature as both a photolytic decomposition product of a polystyrene derivative[6] and as a component of the oil of a carnivorous plant.[7] A cautious search of the case area failed to turn up any carnivorous plants, but did disclose the use of polystyrene foam. A peak labeled "alkylaromatic" was not positively identified but seems to be a dimeric derivative of styrene, as do several other small unlabeled peaks. These compounds most likely are byproducts formed during the production of polystyrene, which slowly escape from the polystyrene over time. The likely sources of several other compounds are also synthetic polymers. The phthalates are common plasticizers. The compound 2,5-diphenylquinone can be used to regulate the production of polyester resin and is also the oxidized (used-up) form of an antioxidant. The presence of these additives emphasizes the importance of using polymers that do not require the use of volatile additives to modify their properties or provide chemical stability.

The concentrations of pollutants must be above certain defined values for them to be considered hazardous (by most governments, anyway). The measurement of pollutant concentrations within a case, however, does not necessarily give an accurate indication of how much damage might be caused to objects. There will be some equilibrium between emission and absorption of pollutant by the source material, which, combined with

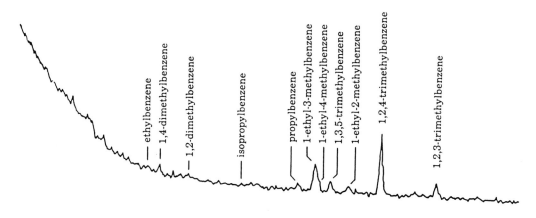

FIGURE 1
Gas chromatographic/mass spectroscopic separation and identification of volatile organic compounds present in the atmosphere in a new painted steel storage cabinet.

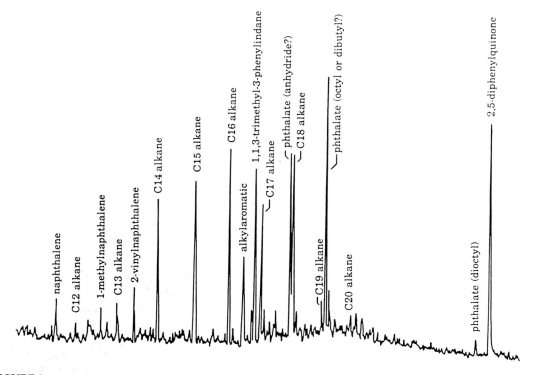

FIGURE 2
Gas chromatographic/mass spectroscopic separation and identification of volatile organic compounds present in the atmosphere in a new walk-in display case.

the natural ventilation rate of the case, keeps the concentration from rising too high. The presence of a "target" material that reacts with the pollutant will lower the concentration even more. For instance, in a case containing a silver object, the concentration of hydrogen sulfide will always be extremely low, possibly below measurable limits. Silver will react with any hydrogen sulfide that impinges upon it, so that the hydrogen sulfide is used up as quickly as it is emitted. The concentration of hydrogen sulfide in the air will have very little relationship to the amount of tarnish on the silver.

Many materials are not included on either the "safe" or "unsafe" list. These may or may not be suitable. For instance, the term "epoxy" refers to a chemically diverse class of materials whose common feature is an epoxy group at the site of polymerization. Their chemical stability varies widely, as does that of the many additives used in the available commercial formulations. For materials of variable, new, unknown, or untested composition, empirical testing is required to determine their suitability for use in case construction.

EVALUATING MATERIALS

There are many tests for the evaluation of materials for use in the museum.[8] They are generally one of two types. The material may be tested empirically in some form of accelerated aging test, or an analysis for a specific harmful chemical or property may be conducted.

Of the first type of test, most are some variant of a test first proposed by Oddy.[9] The material to be tested is bottled up for a time with polished metal coupons, and the results are compared with those for a control experiment which is identical except for the absence of the material being tested. Silver, lead, and copper coupons often are used in these tests. The release of acids or oxidizers by the material being tested will result in more corrosion or tarnish than in the control experiment. Such tests look for damage that may be caused by the material being tested. It is not necessary to determine the mechanism or cause of damage to rule out an unsafe material, although an analysis of corrosion products can be conducted if necessary. The conditions used for these tests are not meant to reproduce natural aging exactly, but are chosen to speed up reactions and exaggerate any problems which might occur. Since these tests are empirical, many modifications are possible. The conditions for the tests can include high humidity, increased temperatures, and/or exposure to intense visible or ultraviolet light or to pollutants. Detectors other than metal coupons, such as pH strips, can be used to detect acid gases. Carbon dioxide can be added to exaggerate the effect of acetic acid on lead. The detector can be separated from the tested material to check for volatile corrosives only, or the two can be placed in direct contact.

These tests necessarily must be long term (weeks or months) to predict accurately whether materials can be used safely over periods of years. This is especially true for many modern materials that have antioxidants or ultraviolet absorbers added. A material with such additives may appear stable for a period of time until a protective additive is used up, and then degrade relatively quickly. Even if a packing case is used for only one week each before and after a year-long exhibit, the second use may be after temporarily stable materials have started to degrade.

Other quicker tests are available to check for specific problems or to identify materials to determine if they belong to one of the classes which are generally safe or unsafe. Spot tests for the analysis of polymers[10] often are used when analytical instrumentation is not available. For example, the Beilstein test can be used to determine if a polymer is chlorinated and therefore unsuitable.[11] Other tests may be used to look for a specific type of reactivity. Daniels and Ward developed a test for fibers, which can be used to check for the presence of labile sulfur that can tarnish silver.[12] The test correlated well with the results of long-term testing. These quick tests can be used to determine if a material belongs to one of the safe or unsafe classes or if

it presents a specific problem. These tests can not, however, substitute for long-term testing in the evaluation of new or previously untested materials.

Other aspects of materials must also be considered. For instance, dyes and pigments in fabrics should be colorfast so that they do not rub off during shipping motions or leach out and migrate if water somehow gets into the container. The latter requirement can be tested by placing a sample of fabric in boiling water and watching for bleeding. This example of worst-case planning may seem minor, but could greatly reduce the scope of problems to be dealt with if an accident were to occur.

These empirical tests are especially important in the evaluation of commercial products that may contain or be formulated from a number of different materials. A paint may contain solvents, medium, pigments or dyes, fillers, levelers, driers, surfactants, and various other modifiers. A self-stick foam may consist of layers of foam, adhesive, solid backing, and more adhesive. It becomes impractical to identify or test each component separately. In some cases, enough information can be obtained from either a label or a call to the manufacturer to evaluate the product. If not, then empirical testing is required, and may have to be repeated on a regular basis as manufacturers usually reserve the right to change formulations without notice. These problems can be avoided either by custom preparation or ordering, or by buying only conservation grade products made specifically for use in the museum. Even these "museum quality" or "archival grade" products should be evaluated carefully on the basis of their descriptions to make sure that they are indeed appropriate for their intended use.

Ideally, the identification of any type of potential problem would disqualify a material from use in the museum. In practice, materials are tested that produce only minimal or slightly more damage than in the control. It has been suggested that such materials may be acceptable for short-term use.[13] In many cases, there will be no preferable alternative material. If so, then it is imperative that such use, indeed, be short term, and not

be extended indefinitely. In addition, the design of a case can be modified so that the exposure of objects to unsuitable materials is minimized and any noxious compounds are contained or diverted from contact with the object.

New cases or cases where a problem is suspected can also be tested. For reasons mentioned earlier (and also because it is not very easy) the measurement of pollution levels is usually not attempted. An empirical test, such as placing polished metal coupons within a new or suspect case, is probably the best way to evaluate the potential for problems. Such a method can also be used to monitor cases that are in use. Other simple devices for monitoring the effects of pollution in museums have been proposed.[14] Some of these techniques may help to detect problems when damage to objects might not be readily noticeable (as is true of many organic materials). In using such techniques, remember that these are real time, not accelerated, tests. By the time any change is noted in the monitors, damage to objects also may have occurred.

DEALING WITH UNSAFE MATERIALS

It is inevitable that unsafe materials will be packed and housed with objects. The use of a material such as wood continues despite all the evidence against it. There is no better alternative material that combines the insulation, relative humidity buffering, and strength of wood with its working properties and economic appeal. In addition, the materials of the objects themselves are often suspect. It is true that the quantities of emissions usually decline over the years, so that very old materials are generally safer than corresponding new samples. For example, the amount of corrosion caused by wood has been measured as being proportional to the square root of time.[15] Even very old objects, which might otherwise be considered safe, may have a new wooden frame or repair made with new materials. In the museum, hermetic sealing is usually only considered if the safety of the materials to be enclosed is absolutely assured. During shipping, though,

sealing of the enclosure is required.

The exterior of a packing case must be waterproof. This means that any noxious or corrosive compounds generated within the case will be trapped there. If possible, cases should be constructed well ahead of time. They can then be left open and ventilated as long as possible to allow as much as possible of the emissions from wood, glue, paint, and other materials to dissipate. It is also possible to test the completed case by placing polished metal coupons in it to check for volatile corrosives.

The use of sealants such as shellac or varnish will slow down, but not stop, the release of volatile compounds from materials such as wood.[16] Such coatings may reduce the concentrations of volatiles, but will not appreciably affect the total amount of volatiles eventually released. Damage to an object left in the case for an extended period of time can still be extensive. The case design should provide effective vapor barriers by using materials such as metal foils or foil laminates. Case design can also be used to direct toward the exterior of the case any volatiles that are produced. For instance, the transmission of volatiles through wood is fastest along the grain of the wood. Volatiles can be directed out of the case if the endgrain of any wood used in a case is exposed to outside ventilation.

If possible, materials that can absorb or react with acids and other volatiles should be incorporated into the design of the case. Activated carbon has been shown to be effective in absorbing the major pollutants.[17] It does not irreversibly react with pollutants, however, and can desorb them over time. It must be changed regularly to maintain its effectiveness. Alkaline materials can irreversibly react with volatile acids. A combination of activated carbon and alkaline absorbers should prevent most damage. These absorbers should, if possible, be placed in the path between objects and any suspect materials. Activated carbon is available in many forms, including impregnated in paper. Alkaline buffered paper and matboard is widely available from conservation supply sources.

The design of most packing cases includes a final vapor barrier placed immediately around the object. This minimizes the amount of air around the artifact, and reduces the buffering required for the interior space. It also means that the object can be isolated from most packing materials except, of course, for those required for contact and direct support. The final vapor barrier should have as low a permeability as possible. Metal foils and foil laminates provide the best protection, but they have the disadvantage of being opaque. Polyethylene sheeting provides both a reasonably good barrier and allows observation of the object without breaking the seal. A double layer of polyethylene inside a layer of an impermeable metal foil laminate, which could be opened for observation through the polyethylene, would perhaps provide the most effective protection.

If unsafe or suspect materials must be present with the object within the innermost envelope (usually because they are part of the object), then some form of absorber should also be present. Again, a combination of alkaline buffer and activated carbon is usually most effective. Both must be in a contained form or envelope that does not powder but does allow air access.

CONCLUSION

Packing cases used for the transport of art objects must provide complete and self-contained protection from the external environment, often for long periods of time. The demands placed on the physical properties of the materials used in the fabrication of packing cases are immense. Because of this, other considerations may be overlooked. One such factor is damage caused by the chemical instability of many of the materials that are used, which is a major problem in display and storage cases within the museum. The release of acids, oxidants, solvents, plasticizers, and other additives and degradation products by display and storage materials causes considerable damage which often is not readily apparent. These problems can be addressed by using materials known to be safe and by testing new or unknown materials. The use of unsuitable materials is, unfor-

tunately, often inevitable, however, the potential problems can be handled through a combination of absorbers and appropriate case design. □

NOTES

1. Agnes Kenyon, "Notes on the Effects of the Atmosphere on the Shells of Mollusca," *Papers and Proceedings of the Royal Society of Tasmania for 1896* (1897), 88; Loftus St. George Byne, "The Corrosion of Shells in Cabinets," *Journal of Conchology* 9 (1899), 172-178, 253-254; F. Taboury, "Des Modifications Chimiques de Certaines Substances Calcaires Conservées dans des Meubles en Bois," *Bulletin de la Société Chimique de France* 49 (1931), 1289-1293; John Ralph Nicholls, "Deterioration of Shells When Stored in Oak Cabinets," *Chemistry and Industry* 53 (1934), 1077-1078; Vera E. Rance and H. G. Cole, *Corrosion of Metals by Vapours from Organic Materials: A Survey*, Admiralty and Ministry of Supply, Inter-service Metallurgical Research Council, HMSO (London, 1958); S. G. Clark and E. E. Longhurst, "The Corrosion of Metals by Acid Vapors from Wood," *J. Appl. Chem.* 11 (November 1961), 435-443; P. D. Donovan and T. M. Moynehan, "The Corrosion of Metals by Vapours from Air-Drying Paints," *Corrosion Science* 5 (1965), 803-814; W. A. Oddy, "An Unsuspected Danger in Display," *Museums Journal* 73(1) (1973), 27-28; W. A. Oddy, "The Corrosion of Metals on Display," *Conservation in Archaeology and the Applied Arts*, Preprints of the IIC Conference, Stockholm (1975), 235-237; T. Padfield, D. Erhardt, and W. Hopwood, "Trouble in Store," *Science and Technology in the Service of Conservation*, Preprints of the IIC Conference, Washington (1981), 24-27; Kathryn Hnatiuk, "Effects of Display Materials on Metal Artifacts," *Gazette- Quarterly of the Canadian Museums Association* 14(3-4) (1981), 42-50; J. Carpenter and P. Hatchfield, *Formaldehyde: How Great is the Danger to Museum Collections?* (1987), monograph available through the Center for Conservation and Technical Studies, Harvard University Art Museums, 32 Quincy Street, Cambridge MA 02138.

2. Kenyon 1897; Byne 1899; Taboury 1931; Nicholls 1934; Oddy 1973 and 1975; Padfield, Erhardt, and Hopwood 1981; Hnatiuk 1981; Carpenter and Hatchfield 1987.

3. Margareta Nockert and Tommy Wadsten, Storage of Archaeological Textile Finds in Sealed Boxes, *Studies in Conservation* 23 (1978), 38-41.

4. D. F. Packman, "The Acidity of Wood," *Holzforschung* 14(6) (1960), 178-183; P. C. Arni, G. C. Cochrane, and J. D. Gray, "The Emission of Corrosive Vapors by Wood. I. Survey of the Acid-release Properties of Certain Freshly Felled Hardwoods and Softwoods," *J. Appl. Chem.* 5 (1965), 305-313; P. C. Arni, G. C. Cochrane, and J. D. Gray, "The Emission of Corrosive Vapors by Wood. II. The Analysis of the Vapours Emitted by Certain Freshly Felled Hardwoods and Softwoods by Gas Chromatography and Spectrophotometry," *J. Appl. Chem.* 5 (1965), 463-468.

5. Padfield, Erhardt, and Hopwood 1981.

6. Yukio Yamamoto, Miyaki Himei, and Koichiro Hayoshi, "Radiation-induced Pyrolysis of Poly(α-methylstyrene). Formation of 1,1,3-Trimethyl-3-phenylindane by an Ionic Chain Reaction," *Macromolecules* 9(5) (1976), 874-875.

7. D. Howard Miles, Udom Kokpol, Naresh V. Moody, and Paul A. Hedin, Volatiles in *Sarracenia Flava, Phytochemistry* 14 (1975), 845-846.

8. Edith Weyde A Simple Test to Identify Gases Which Destroy Silver Images, *Photographic Science and Engineering* 16 (July-August 1972), 283-286; Oddy 1973 and 1975; T. J. Collings and F. J. Young, Improvements in Some Tests and Techniques in Photograph Conservation," *Studies in Conservation* 21 (1976), 79-84; S. M. Blackshaw and V. D. Daniels, "Selecting Safe Materials for use in the Display and Storage of Antiquities," *ICOM Committee for Conservation, 5th Triennial Meeting,* Zagreb (1978), 78/23/2/1-9; S. M. Blackshaw and V. D. Daniels, "The Testing of Materials for Use in Storage and Display in Museums," *The Conservator* 3 (1979), 16-19; Walter Hopwood, "Choosing Materials for Prolonged Proximity to Museum Objects," *Preprints* of the seventh annual meeting of the American Institute for Conservation, Toronto (1979), 44-49; V. Daniels and S. Ward, "A Rapid Test for the Detection of Substances Which Will Tarnish Silver," *Studies in Conservation* 27(2) (1982), 58-60; R. Scott Williams, "The Beilstein Test: A Simple Test to Screen Organic and Polymeric Materials for the Presence of Chlorine," *IIC-CG Newsletter* 11(2) (December 1985), 15-17.

9. Oddy 1973 and 1975.

10. See, for example, A. Krause, A. Lange, and M. Ezrin, *Plastics Analysis Guide: Chemical and Instrumental Methods* (New York, 1983); T. R. Crompton, *Chemical Analysis of Additives in Plastics*, 2nd ed. (New York , 1989).

11. Williams 1985.

12. Daniels and Ward 1982.

13. Daniels and Ward 1982.

14. Toshiko Kenjo, "Certain Deterioration Factors for Works of Art and Simple Devices to Monitor Them," *The International Journal of Museum Management and Curatorship* 5 (1986), 295-300.

15. Harald Berndt, "Measuring the Rate of Atmospheric Corrosion in Microclimates," *Journal of the American Institute for Conservation* 29 (1990), 207-220.

16. Catherine E. Miles, "Wood Coatings for Storage and Display Cases," *Studies in Conservation* 31 (1986), 114-124.

17. Sucha S. Parmar and Daniel Grosjean, *Removal of Air Pollutants from Museum Display Cases*, final report to the

lutants from Museum Display Cases, final report to the Getty Conservation Institute, Marina del Rey, CA (August 1989).

A CUSHIONED TRANSIT FRAME FOR PAINTINGS

Timothy Green

ABSTRACT: *A wooden L-section transit frame with internal cushioning has been developed. The cushioned transit frame is designed to protect against most shocks experienced in handling and transit. A painting is attached to a wooden framework that slots into a recess cut into polyethylene foam blocks and is, in effect, floated; the floated framework and foam are housed inside an exterior wooden framework. Using this method, a standardized loading area on the foam is achieved. This avoids the difficulty associated with calculating static stress for highly varied display frame profiles. The cushioned transit frame can also be used as a handling unit, providing protection within the museum as well as while on loan. For national loan, the cushioned transit frame provides adequate protection during transport. For international loan, an exterior packing case can be added. This need only contain insulation. Results of shock and vibration tests are given and various practical considerations are discussed. A system for using standard sizes is outlined.*

INTRODUCTION

The Tate Gallery has recently begun a program of national touring exhibitions, the first of which included twenty-five landscape paintings by J.M.W. Turner. Handling throughout was performed by Tate Gallery staff and for the transport, the Gallery's own air-ride and temperature-controlled vehicle was used. Each transfer journey occurs within a day. For these reasons, the high level of protection afforded by packing cases was thought to be unnecessary. Based on previous experience gained when moving works between the Tate Gallery, Liverpool and London, it was proposed that simple L-section transit frames be used. Concern was expressed about the lack of cushioning in the rigid transit frame as evidence of minor display frame damage had begun to emerge. Transit frames are more typically provided for unframed modern paintings to aid both their safe handling and storage. Modern paintings are usually of low mass for their size. When subjected to shock, relatively moderate forces will act on their structures whereas traditional display frames are often

heavy and could impose damaging forces. These concerns prompted a cushioned transit frame to be designed, tested, and used.

CONSTRUCTION

A cross-sectional view is shown in Figure 1. The familiar L-section is retained (Figure 2A) but within this, a floated framework is held by foam in a centrally located slot (Figure 2B). Aluminum L-section is used to hold the foam in place (Figure 2C). The painting can then be attached in the normal way to the floated framework.

The arrangement provides cushioning in all directions yet produces a pack that can be handled in the same way as the traditional L-section transit frame.

Exterior L-Section

So that cushioned transit frames can be made more easily to any depth, the wood for the exterior L-section is cut from 121 x 264.3 x 1.9 cm (4 x 8 ft. x 0.75 in.) thirteen-ply birch plywood. The alternative would have been to

FLOATED FRAMEWORK

OUTER L-SECTION

PLASTAZOTE LD 45

ALUMINUM L-SECTION

FIGURE 1

join standard width planks together and cut them to the required size.

Chest handles are attached to the sides, 56 cm (22 in.) up (traveling format) measuring to the handle's center to aid lifting.

Foam Selection

Plastazote LD 45, a closed-cell, cross-linked polyethylene foam, manufactured by BXL Plastics Ltd. in England, was selected on the basis of its chemical stability and the imposed static stress. (Achieving optimum cushioning is described elsewhere in this publication by Mervin Richard.) The static stress in the cushioned transit frame is straightforward to calculate. The combined weight of the framed painting and the floated framework, in kilograms force (kgf), is divided by the area, in cm, of the floated framework's edge over which the weight is distributed. These values are shown in Figure 3 for the Turner loan.

According to the dynamic performance curves from the foam manufacturer, a 5 cm (2 in.) thickness beneath the floated framework should produce a peak shock on impact following a 45 cm (17.7 in.) drop of between 25 G's (first impact) and 31 G's (third impact). From the curves, a static stress of about 0.09 kgf/cm was indicated. Higher static stress values gain optimum cushioning for lower drop heights. The mid-range value for the Turner loan is close to 0.14 kgf/cm^2 (1.9 psi) which is recommended for a drop height of 30 cm (12 in.). However, protection in the unlikely event of a high drop accident would be less efficient. For example, with a static stress of 0.14 kgf/cm^2 (1.9 psi), following a first drop from 90 cm (35.4 in), a peak shock of 93 G's on impact is predicted by the curve, whereas 50 G is the minimum point. As all handling was to be performed by Tate Gallery staff, drop accidents from appreciable height were thought to be so unlikely that it was decided to optimize cushion performance against low drop height accidents. For a first impact 30 cm (12 in.) drop, static stress

FIGURE 2A

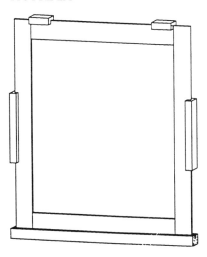

FIGURE 2B

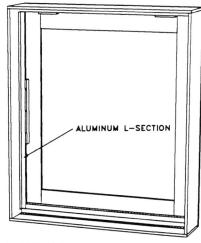

ALUMINUM L—SECTION

FIGURE 2C

from 0.09-0.22 kgf/cm^2 (1.2-3 psi) reduces impact shock to 20 G's or less.

A related factor to consider is *creep,* meaning a permanent loss of foam thickness due to constant applied static stress. This can develop when a weight rests on the foam for a long time. The foam manufacturer provides data to help anticipate the problem. Plastazote LD 45 will lose 7% thickness after about forty-two days if loaded to 0.21 kgf/cm^2 (2.9 psi) at 23°C (73F). By comparison, the more dense Plastazote LD 70 will only deform by 3% under 0.35 kgf/cm^2 (4.8 psi) over this same period and therefore offers better resistance to creep. Shock performance, according to the dynamic performance curves, is also slightly better. (For a first impact, 45 cm [17.7 in.] drop height onto a 5 cm foam thickness, the minimum point on the curve for LD 45 is 25 G's compared to 23 G's for LD 70.) The foam strips can be easily replaced, if required, by removing the securing aluminum L-section and withdrawing the board/foam unit. Thus far, creep has not proved to be a problem.

Topple Accident Protection

For protection in the event of topple, two measures are employed. First, a foam thickness equivalent to that currently specified for Tate Gallery packing cases is included in front of and behind the floated framework (see Figure 7, views A,B,and C). Surprisingly, drop tests indicated that short strips of the foam are required, see below. (In addition, a convoluted foam, illustrated in Figure 4, was found to be effective.) Second, a new fitting to hold paintings into transit frames has been designed which, in bending, absorbs significant energy. Because the second measure is only effective when the topple is on to the front, greater protection is provided against this type of accident. Increasing the thickness of foam behind the floated framework would help make protection more equal.

Defining the Topple Angle

Transit frames made for unframed modern paintings are inherently unstable and have to

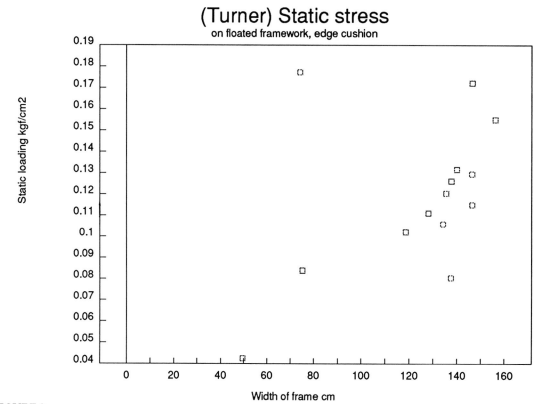

(Turner) Static stress
on floated framework, edge cushion

FIGURE 3

FIGURE 4
Convoluted Foam.

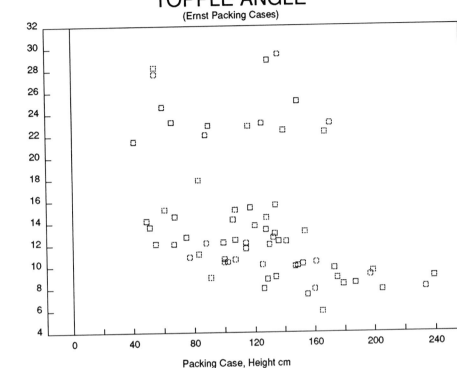

TOPPLE ANGLE
(Ernst Packing Cases)

Topple Angle

Packing Case, Height cm

FIGURE 5

be *parked* leaning against a wall. Traditional display frames usually have appreciable depth compared to unframed modern paintings. This fact, and the inclusion of foam, which adds 4.55 cm (1.78 in.) to the depth, results in a less readily toppled structure; indeed those handling the Turner loan were inclined to leave the cushioned transit frames free standing. Lightweight and/or thin cushioned transit frames are especially at risk to falling over if bumped. A measure with which resistance to toppling can be compared is the angle to the vertical at which the transit frame, when leaned over, can be balanced on an edge. It was established that, with the paintings fitted, the center of gravity was near the midpoint, i.e., each transit frame moved similar distances to the point of balance when leaned either forward or backward. From the external dimensions, it was therefore straightforward to calculate the angle of lean, or the *topple angle*. With all of the cushioned transit frames averaged, this angle

was 10.9° from vertical, with the worst example at 8.7°. For comparison, sixty-eight packing cases used for the recent Tate Gallery *Max Ernst Exhibition*, both single and multi-packed, were measured and their topple angle estimated, (assuming a midpoint center of gravity). These are shown in Figure 5 with the Turner topple angle data shown in Figure 6. For the fifty-eight single packed Max Ernst packing cases among these, the average topple angle was 11.36° with an average for all sixty-eight being 14.26°.

To incorporate a reduced risk of topple into the design, a simple ratio of width to height is now specified that achieves a point of balance at approximately 12° from vertical; the minimum frame depth=the height of the cushioned transit frame *x* 0.21. This assumes a midpoint center of gravity.

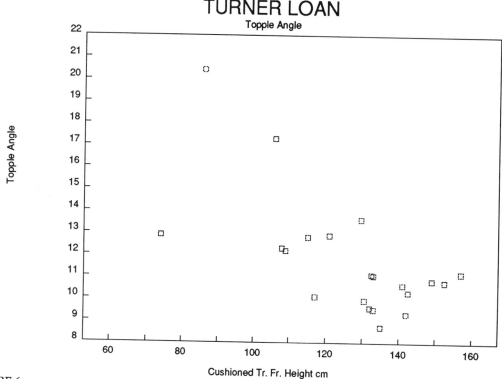

TURNER LOAN
Topple Angle

FIGURE 6

Foam Thickness-Side, Top and Bottom Pieces (Traveling Format)

A foam thickness of 2.5 cm (1 in.) was included both at each side (in the dimension that adds to the overall width) and above the floated framework. (The side pieces must be held in position, otherwise they may drop down.) Because most shocks from handling are thought to act on the bottom cushion, a double thickness of 5 cm (2 in.) was incorporated beneath the floated framework. A double foam thickness beneath the painting is also specified in the Tate Gallery's current packing case design.

Dimensions of the Foam Elements

Figure 7 A, B, and C show the distribution and thicknesses of foam with all the considerations outlined above.

TESTING

Tests were carried out at Pira Leatherhead on 14-15 February 1991 to assess the performance of the cushioned transit frame in terms of shock and vibration protection.

A traditional display frame, selected for its fragility and containing a test painting, was fitted to the transit frames during testing. The display frame measured (H) 90.5 x (W) 99 x 8.8 cm deep (35.63 x 38.98 x 3.5 in.). The static stress exerted on the cushion supporting the floated framework and test painting was 0.175 kgf/cm^2 (2.4 psi). Accelerometers were attached to the same top corner of both the display frame and cushioned transit frame at a matching height from the bottom edge.

Drop Tests

The following tests were performed:

(a) One end only of the upright cushioned transit frame was lifted, *rotating* it around the end remaining on the concrete floor, then dropped. Two drop heights were selected, see Table 1. This test was to simulate drops

which may occur when the cushioned transit frame is pivoted on one end to remove a two-wheeled trolley from beneath it.

(b) The upright cushioned transit frame was hoisted to a measured height and dropped so that the *flat base* impacted against a concrete floor. Three drop heights were selected to simulate drops that might occur when the cushioned transit frame is being hand carried.

Drop Test Results

The results for the drop tests are listed in Table 1. The cushioned transit frame performed well with the test display frame suffering only minor gesso loss during a series of drops.

When fitted to a rigid transit frame, severe damage occurred to the test display frame on impact following a 45.7 cm (18 in.) drop. A peak of only 48 G was recorded by the accelerometer attached to the display frame. This is a relatively low reading which indicates that shock measurements when damage occurs should be treated with caution. In this instance, energy would have been expended as the display frame split. Some structural weakening to the display frame may have been introduced in the preceding drops, but the rapid degradation that was witnessed during the sequence of drops with the rigid transit frame clearly demonstrated the risks of using an uncushioned system.

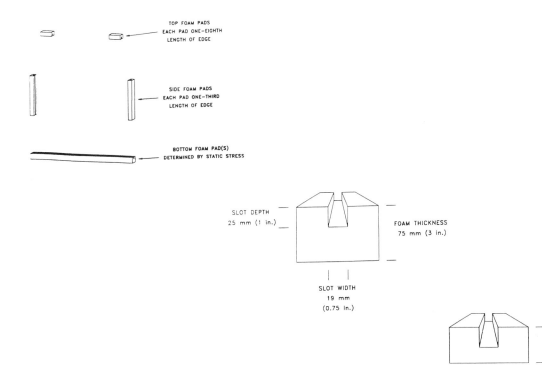

FIGURE 7 A,B,C

TABLE 1

DROP TEST	CUSHIONED T.F. DISPLAY FRAME pk G	FLOATED FRAMEWORK pk G	FIXED T.F. DISPLAY FRAME pk G	FIXED T.F. pk G
10 cm (4 in.) rotational	14	14	20	41
20 cm (8 in.) rotational	19	17	38	39
10 cm (4 in.) flat base	20	23	-	-
20 cm (18 in.) flat base	28	27	51	91
46 cm (18 in.) flat base	37	36	48*	71

*Severe damage occurred to the display frame in this test.

Topple Test

With the cushioned transit frame standing upright on a concrete floor, it was leaned over and balanced on an edge, then released.

Topple Test Results

When the painting was toppled face-down so that the new fittings were free to bend, the fittings gave some protection. Although only one result is reported, several tests were performed with two separate display frames. On each occasion, the fittings bent sufficiently to absorb significant energy without failing. This is demonstrated by the low-level peak shock of 42 G's shown in Table 2 compared with the 157 G peak. Both were recorded with the same amount of cushioning foam.

Three topple tests onto the back of the cushioned transit frame were performed. Initially, a severe peak shock was recorded which produced significant damage to the test painting; extensive cracking and loss of the brittle coating occurred. The amount of cushioning was decreased but it was not until the third test, when the amount of the convoluted foam had been drastically reduced, (two 9 cm [3.54 in.] pads) that an appreciably reduced peak shock level of 70 G's occurred. Consequently, the amount of convoluted foam eventually used in the Turner cushioned transit frames was also reduced.

Vibration Tests

Transmissibility traces were obtained using sinusoidal vibration with an input of 0.3 G's, sweeping between 3 and 100 Hz at a rate of one octave per minute.

Results

When measuring on the test display frame in the vertical direction and with the cushioned transit frame standing vertically on the vibration table, a maximum magnification of 5.5 times the input was recorded at 50 Hz. Vibration at this frequency is not considered to be serious (see Conference Handbook). In the crucial region, 4-20 Hz, little resonance occurred. With the cushioned transit frame lying flat, however, a magnification of four times the input occurred at 14 Hz. Less magnification of vibration would almost certainly have occurred if the floated framework were stiffened. This could be achieved, for example, by attaching an extruded aluminum T-section to the rear face. It should be noted that during the road trial carried out by Pira and reported by Peter Caldicott, the worst result was obtained, in terms of canvas vibration, with a conventional packing case lying flat.

On a truck, the inputs are most severe in the vertical axis, therefore the test with the cushioned transit frame standing upright is

TABLE 2

TOPPLE TEST, onto face "f" or back "b"	CUSHIONED T.F. DISPLAY FRAME pk G	FLOATED FRAQMEWORK pk G	FIXED T.F. DISPLAY FRAME pk G	FIXED TRANSIT FRAME pk G
f new fitting assessed	42	>100		
b	157	177	182	75
b some foam removed	137	133	205	74
b amount of foam greatly reduced	70	87		

more relevant.

RELATIVE HUMIDITY AND TEMPERATURE

The principle of wrapping and sealing the painting within a moisture barrier is applied. For the Turner loan, the cushioned transit frames were wrapped in polyethylene sheeting. An alternative would be to wrap the display frames themselves. Rigid covers, if fitted both to the front and back faces of the cushioned transit frame, could be covered with a suitable moisture barrier. When a glazed display frame has a backboard that is an effective moisture barrier, the painting is adequately sealed and providing further moisture barriers is probably unnecessary, (assuming all unloading operations take place under cover).

Temperature considerations are more involved but the cushioned transit frame was designed on the premise that the temperature would be controlled inside the vehicle within a narrow range around 20°C (68°F). The provision of thermal insulation is discussed below.

POTENTIAL FOR WIDER USE

Rigid transit frames are often fitted to protect projecting delicate molding on traditional display frames. As with unframed modern paintings, this use does provide the means to transport the painting within the museum to where it is to be hung. If generally used in this way, the commonplace minor damage that occurs to unprotected display frames would be mostly avoided. Considering this potential, possibilities for increasing the use of the cushioned transit frame are briefly discussed next.

PACKING FOR INTERNATIONAL LOAN

Many museums insist on a packing case being provided for all nonlocal transports. Handling packing cases inside a truck clearly poses real dangers for any soft-packed works and when the cushioned transit frame is used alongside packing cases, a front and back cover should be fitted. For a loan from the Tate Gallery to Germany, 1.2 cm (0.5 in.) plywood covers were attached with captive bolts. Other rigid but more lightweight covering materials are currently being investigated at the Tate Gallery.

Air-Ride and Temperature Controlled Truck Transport

Effective temperature control is always most efficiently provided by the vehicle. Cold tem-

peratures, as they have an embrittling effect on paint films, would be best avoided when the works are being handled as this is when the highest shock and vibration levels are likely to occur. Thermal insulation may or may not help depending on circumstance. For example, large amounts can have an adverse effect during handling operations at the receiving museum by maintaining the painting's low temperature following long journeys in cold conditions. In general, some thermal insulation probably has a useful effect in slowing the rate of temperature change.

The cushioned transit frame is not thermally insulated. To provide this feature, an exterior plywood packing case in which suitable material could be placed would be necessary. Mechanical handling at airports would then be viable making international loan use a possibility. Such use has yet to occur.

Reuse

On return from loan, the cushioned transit frame could be used for storing the painting, (as rigid transit frames are presently used) or reused as packing. For the latter it would be sensible to devise a series of sizes so that, as cushioned transit frames are made, it would be more likely they would be reusable. A scheme has been devised for the Tate Gallery's collections and is described in the Appendix.

CONCLUSION

The intention when devising the cushioned transit frame was to design a system that pro-

tected the painting and its display frame in transit and also where most damage presently occurs, that is, within the museum. Clearly to have cushioning present at all times is an improvement on rigid transit frames. This was dramatically shown in the drop tests. As a result of our experience with the Turner loan, a more dense foam may be used in the future, as is described above, but generally the loan transfer was problem-free.

An attempt has been made to identify and protect against other serious risks associated with transporting paintings. A systematic approach to topple resistance was examined. Compared to existing packing methods, the cushioned transit frames built for the Turner loan were found to be mostly adequate. To eliminate the risk of cushioned transit frames being made with too shallow a topple angle, a ratio of depth to height was defined.

The goal is to avoid wasting resources as occurs when used packing cases are routinely destroyed and a to produce a system of reusable cushioned transit frames to meet the requirements of a particular collection of paintings.

The possibility of using cushioned transit frames for storage of paintings has yet to be resolved. However, though they are mostly too wide for screens, it should be possible to devise a system for free-standing units.

The cushioned transit frame described can be readily modified to include greater thicknesses of cushioning foam if greater protection is required, and it is hoped that its introduction will provide framed paintings with improved overall protection. □

APPENDIX

Standard Sizes

A major consideration with all packing systems is the possibility of reuse either with the same painting or other similar sized paintings. For ease of reuse, it would be convenient to develop a range of sizes that relates to the dimensions of the paintings in the Tate Gallery's collections. Relatively few exterior frame dimensions were available to assist in identifying common sizes, but height and width measurements for all paintings are contained on the collection's database. Although the display frame often adds more to one dimension than the other, proportionately the difference is usually small.

The distribution of formats is concentrated between 1.18 and 1.6°, that is, the maximum dimension is between 1.18 and 1.6 times greater than the minimum dimension of the work. Slightly more than 73% of the paintings belonging to the Tate Gallery lie within these limits.

In the cushioned transit frame, to gain the necessary strength, the framework to which the painting is attached is made from battens that are at least 5 cm (2 in.) wider than necessary for a perfect fit. Therefore, any one cushioned transit frame could be used for paintings up to 5 cm (2 in.) smaller. Based on this, 227 cushioned transit frames would be required to cover the range of display frame size, minimum dimension between 50 cm-160 cm for the most common formats. Uncommon formats would mostly fit, but the cushioned transit frame would be at least 5 cm (2 in.) too large in one dimension. Extreme examples would require individual cushioned transit frames but these will only be a small minority.

When ordering a cushioned transit frame, it is necessary to round up the display frame dimensions so that a standard size is made. To assist with this, Table 3 has been written showing all the display frame sizes in the scheme and the Table will be used to record built sizes.

The depths of the cushioned transit frames allow a minimum 12° leaning to the point of balance. The maximum depths of display frame that can be accommodated within the standard sizes are listed in the right column in Table 3. As it is quite common for small paintings to have comparatively deep display frames, the minimum exterior depth for the cushioned transit frame is 23 cm (9 in.). This is why all the smaller cushioned transit frames can accommodate a display frame depth up to 10 cm (4 in.). In consequence, the smallest cushioned transit frame has the largest angle at the point of balance, 18°, which helps to reduce the risk of it being knocked over due to its slight weight.

NOTES

1. Timothy Green and Stephen Hackney, ICOM *7th Triennial Meeting,* Preprints, Copenhagen (1984), 585-596. This article discusses the test equipment used.

TABLE 3

Minimum Exterior Dimension cm (Display Frame)	CUSHIONED TRANSIT FRAME STANDARD SIZES — Maximum External Dimension cm (Display Frame)														Display Frame's Maximum Depth cm
160	190	195	200	205	210	215	220	225	230	235	240	245	250	255	24
155	180	185	190	195	200	205	210	215	220	225	230	235	240	250	23
150	175	180	185	190	195	200	205	210	215	220	225	230	235	240	22
145	170	175	180	185	190	195	200	205	210	215	220	225	230		21
140	165	170	175	180	185	190	195	200	205	210	215	220	225		20
135	160	165	170	175	180	185	190	195	200	205	210	215			19
130	155	160	165	170	175	180	185	190	195	200	295	210			18
125	150	155	160	165	170	175	180	185	190	195	200				17
120	140	145	150	155	160	165	170	175	180	185	190				16
115	135	140	145	150	155	160	165	170	175	180	185				15
110	130	135	140	145	150	155	160	165	170	175					14
105	125	130	135	140	145	150	155	160	165	170					13
100	120	125	130	135	140	145	150	155	160						12
95	110	115	120	125	130	135	140	145	150						11
90	105	110	115	120	125	130	135	140	145						11
85	100	105	110	115	120	125	130	135							10
80	95	100	105	110	115	120	125	130							10
75	90	95	100	105	110	115	120								10
70	85	90	95	100	105	110	115								10
65	75	80	85	90	95	100	105								10
60	70	75	80	85	90	95									10
55	65	70	75	80	85	90									10
50	55	60	65	70	75	80									10

PERFORMANCE CRITERIA FOR PACKING

Timothy Green

ABSTRACT: *There are many variables to consider when designing a packing case and preparing a painting for transport. This paper outlines specific conditions that could present potential hazards to the painting independent of the packing case, such as abrasion and stretcher bar impact. Additionally, the protection potential as well as the limitations of packing cases are presented. Recommendations are given for providing protection against most of the potential hazads.*

INTRODUCTION

In an ideal museum, a painting is protected from many harmful effects. On display or in storage the painting is kept in relatively stable conditions, secure from accidents or theft. When sent on loan, the painting is exposed to new risks and may be transported through potentially damaging environments. To protect the painting it must be isolated from environmental variation and any risks must be assessed and minimized.

Of course most museums, historic houses, or buildings for private collections are far from ideal, but the best museum conditions give us a standard by which to judge the need for protection in transit. For practical and economic reasons, protection in transit may also fall short of the ideal, but it is still important to have criteria with which packing can be compared.

PACKING CASES

It is common practice to use a packing case to protect against a variety of environmental and mechanical dangers, in particular, at airports where handling is carried out using forklift trucks and roller beds. Cargo may also be subject to storage and delay.

TEMPERATURE

For human comfort, spaces where paintings are exhibited are usually maintained at average room temperatures, though this may vary from cool conditions, for example, in a church to comparatively high levels in hot climates. More extreme temperatures frequently arise, particularly in unoccupied buildings. Annual and diurnal variations also occur within each building. When lending, a museum will often specify temperature to be controlled by the borrower to within a narrow range around 20°C (68°F). During transit this control can be impossible to achieve. Depending on the time of year and location, outside temperatures can be extreme. Absorbed solar radiation can raise the temperature within a container well above the external ambient level.

Controlling the temperature of the air surrounding packed works is most effective since providing thermal insulation in the packing case can only extend the period taken to equilibrate the external temperature change. Temperature control is not always available; for example, at airports, when palletized packing cases are on the tarmac waiting to be loaded. For this reason some thermal insulation is usually included to prevent the painting from experiencing sudden temperature changes and to reduce extremes.

A useful measure by which packing cases can be compared is temperature change half-time. For a packed painting at 20°C (68°F)

moved into a cold environment at 0°C (32°F), this would be the time taken for the painting to reach 10°C (50°F). Mervin Richard discusses how to estimate this for any packing case design in "Temperature and Relative Humidity" elsewhere in this publication. The degree of insulation has other implications as is discussed in the section on *Topple*.

Maintaining Stable Moisture Content

It might be assumed that to maintain museum conditions throughout a loan would be the ideal, but in some respects a painting is better protected once packed; most notably, a stable moisture content is maintained by its own moisture responsive *hygroscopic* materials once the painting is enclosed by a moisture barrier. Many thermal insulation materials have this property and are effective because full face pieces are used. To guarantee enclosure, however, it is straightforward to wrap the framed painting with polyethylene sheeting. This has the advantage of sealing in with the painting a minimum air volume thereby enhancing stability. The performance of this simple measure can exceed that of the most expensive air-conditioning system. However, the moisture content will have been determined by the relative humidity (RH) where the painting has been previously stored or exhibited. Undesirable levels will be maintained once the wrapping is applied. Indeed routinely, as monitoring confirms,[1] the most dramatic change that the painting sees is when the wrapping is removed at the receiving museum; the measure is so effective that any difference in relative humidity between the two institutions produces a greater change in moisture content than occurs otherwise in transit. Serious problems could occur if, for example, a painting stored in cool damp conditions were sealed and then transported at warm temperatures; mold could form. The cause lies with the environment and not the wrapping procedure.

Where the painting had been exposed to high humidity prior to transporting it by air, a moisture barrier will effectively isolate the painting from low in-flight relative humidity.

Inside a truck, the moisture barrier will make relative humidity control unnecessary though temperature control is still advisable.

SHOCK PROTECTION

Most packing cases for paintings include shock protection which is normally achieved with cushioning foam. Suitable materials are those manufactured to defined specifications from chemically stable polymers. Their performance is usually well defined. To appreciate the value of this data it is useful to consider precisely how a cushioning foam functions.

On impact, protection is achieved by extending the period of time during which a moving painting is finally brought to rest. Consider a man standing on weighing scales inside an elevator. If the elevator were to fall freely under gravity, ignoring air resistance, it will have traveled 490 cm (16.08 ft.) after one second. During this period of free fall, the scales will register zero weight. If then slowed at the same rate of acceleration, the elevator will travel a further 490 cm (16.08 ft.) for one more second. During this time, an unusually calm man could keep his legs straight and observe that the scales registered twice his static weight. Viewing these occurrences in acceleration terms, the man experienced 1 G when stationary, 0 G during the free fall and 2 G when the elevator was decelerating. To produce the low-level shock of 2 G required a stopping distance of 490 cm (16.08 ft), and a full second.

Cushion Thickness

A measure of an object's fragility is the minimum level of shock that produces damage. Testing[2] has indicated that an average painting can safely withstand an acceleration of 50 G. Were a packing case to fall 100 cm (39.4 in.), theoretically we could produce a shock of 50 G by bringing the painting to a stop in one fiftieth of 100 cm (39.4 in.), which is 2.0 cm (0.5 in.). (A slight addition would be necessary as gravity continues to act during the period of the deceleration.) This performance is not possible in reality because, as the foam

compresses, it increasingly resists further compression. In consequence, the rate of deceleration is not even, being most severe when the foam is at its most compressed. This produces a *peak* shock level. This effect is worst when the foam is compressed down to the absolute minimum thickness. It will be less if only 50% compression occurs. Therefore the foam thickness for a given level of shock protection will always be appreciably more than the theoretical minimum stopping distance.

It is obviously important to avoid full compression, or "bottoming out" as no further cushioning effect will occur and a substantial shock will subsequently result.

The foam is like a spring supporting a mass. On impact, it must be sufficiently stiff, however, too stiff a spring will not compress enough. A higher drop will require either a stiffer or longer spring. Manufacturers provide information about their foam that shows the weight that is best suited to a particular foam's stiffness. Other factors, such as foam thickness and drop height are also given. This is fully described by Paul Marcon, in "Shock, Vibration, and Protective Packaging Design" elsewhere in this publication. A spring is an individual item but foam is sold in sheets. Therefore, the information concerning weight is given for a unit area, as if each unit area were an individual spring. The weight on each "spring" is the total weight of the object divided by the number of unit areas of foam on which it is supported.

Damping

When dropped, an object supported on a spring will bounce up and down repeatedly following impact. This happens because little energy is absorbed by the spring, that is, little *damping* occurs. Cushioning foams absorb appreciable energy but some foam types absorb more than others. For example, work is done in forcing air in and out of the pores in an open cell foam. Closed cell foams tend to be less efficient, consequently, when comparing dynamic performance curves, it can be seen that to achieve a given level of shock protection, a greater thickness of a closed cell foam

is required. Performance of different foam types can be compared using a *cushion factor*. A low value indicates greater efficiency.

$$G\ Factor = Cushion\ Factor\ x\ \frac{DropHeight}{CushionThickness}$$

Cushion factor for examples of polyurethane polyester type foams vary from 2.1-2.5, whereas polyethylene foams have values of about 3.

Problems with Static Loading in Display Frames

Ideally the weight of the object is evenly distributed over the foam. It is then straightforward to calculate the mass per unit area, or static stress, for the anticipated drop height. Display frames for paintings usually have shaped edges so that only a portion of the face that is in contact with the cushion bears the weight. In some examples, high static stresses result. Figure 1 illustrates this effect for paintings in the recent *Max Ernst Exhibition* at the Tate Gallery. Each work is plotted twice:

□ shows the static loading as if the display frame's edge carrying the weight were in uniform contact with the supporting cushion;

+ shows what actually occurred. In the most extreme example, 0.26 kgf/cm^2 (3.8 psi) was exerted due to there being only 10% contact.

To provide a predictable contact area, one familiar solution is to use a double packing case. A close fitting inner case is provided so that the flat edges of the inner case evenly distribute the weight on the supporting cushion(s). (It is important that most of the cushion thickness lies between the inner and outer cases *not* inside the inner case otherwise *tandem cushioning* may occur.[3]) The same principle applies when a packed work has been fitted into an external L-section framework, sometimes called a travel or transit frame. This is commonly done to protect ornate molding that extends beyond the main

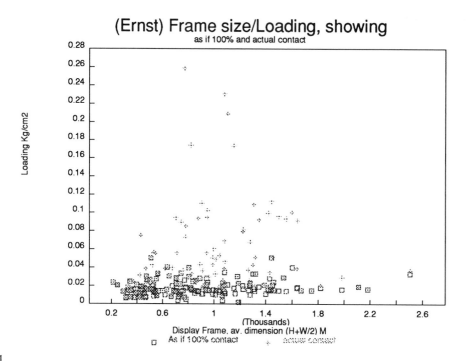

(Ernst) Frame size/Loading, showing

as if 100% and actual contact

Loading Kg/cm2

Display Frame, av. dimension (H+W/2) M
(Thousands)

☐ As if 100% contact ⊹ Actual contact

FIGURE 1

body of the display frame. If placed on a flat cushion, these delicate projections may be damaged because the total mass of the object would be resting on them.

It should be noted that the stiffness of the foam is affected by temperature. Polyester urethane foams become appreciably stiffer at low temperatures.[4] Further details are provided in the conference handbook.

Drop Height

Statistics derived from commercial packaging experience give an approximate indication of likely drop height for package weight. The general trend, that heavier packages are dropped from lower heights, may be applicable. However, the effect of specific aspects of fine art transport, in particular, arrangements to oversee handling at airports and the use of specialist fine art handlers on most other occasions, have not been assessed.

Certainly drops from appreciable heights are rare whereas lower drops are common, for example, when the packing case is put down heavily once the two- or four-wheel trolley used to move it around has been re-

moved. This raises a crucial question. Overall, are paintings and their display frames more damaged through being repeatedly exposed to low levels of shock or by the rare large shock?[5]

With any foam, a decision has to be made on what drop height is to be used to calculate optimum cushioning. The problem of protecting against a range of drop heights is illustrated by plotting static stress values for the minimum points on the dynamic performance curves for a 50 mm (2 in.) thickness of Plastazote LD 45 (see Figure 2). This shows how the minimum shock occurs at different static stress values depending on drop height. By extrapolating the curve, it can be seen that to achieve optimum cushioning for a 20 cm (8 in.) drop height it would require a static stress in the region of double that for a 30 cm (12 in.) drop. This emphasizes the importance of deciding what accident is being protected against.

Reference to dynamic cushioning curves shows that incorporating greater foam thicknesses improves performance overall. Therefore it is recommended that a greater foam thickness be included beneath the load-bear-

52

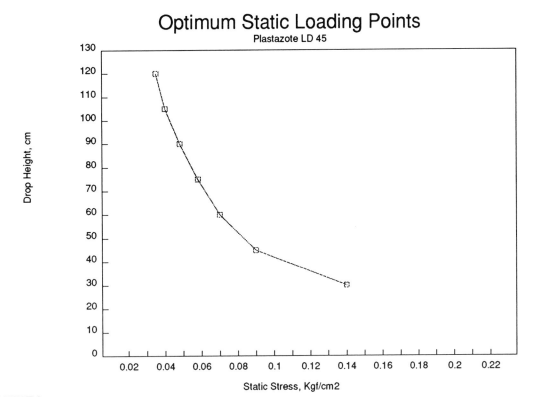

FIGURE 2

TABLE 1

Case Height	Case Depth	Case Weight	Topple Angle	Work Done Kg Meters
0.41	0.15	5	21.5	0.742
0.66	0.26	21	23.2	5.9
0.88	0.185	16	21.1	1.57
1.397	0.533	148	22.4	82.1
1.676	0.635	214	22.3	140.25
2.334	0.327	199	8.0	22.68

ing edge. Added protection is thereby gained against low level shocks in the vertical axis where it is most needed.

Topple

Paintings travel upright and packing cases designed for them usually have an unstable format. There is a real risk that a narrow packing case will fall over if bumped or placed on an uneven or unstable surface such as lorry (truck) floors or airline palettes on roller beds.[6] Tall or lightweight cases are most at risk. Thermal insulation in the large faces of the packing case adds stability by proportionately increasing the depth-to-height ratio. Packing more than one painting in a packing case has the same effect. Both measures have handling implications if the gross weight becomes excessive.

Topple accidents can be very serious for paintings and handling staff. The packing case exterior may be punctured by impacts with sharp projecting objects. Even if the packing case remains intact, the painting inside will be subjected to high levels of shock.

Cushioning against topple accidents is again a matter of establishing the correct static stress for the foam type and thickness as determined by the drop height. A topple drop is taken to be roughly equivalent to a flat drop onto the base equal to two-thirds the height of the container (based on impact velocity).

It would be useful to devise criteria by which individual packing cases could be assessed for their resistance to toppling. These might be:

(a) *The topple angle:* Within an average packing case for a painting, the distribution of mass is fairly even, therefore, the center of gravity is typically located at the midpoint. In practice, this means the packing case can be leaned over an equal distance, either forward or backward, to the point of balance. Calculating the topple angle is then a simple trigonometric problem and is dependent on the ratio of height to depth. Figure 3 shows the external case dimensions that achieve angles of balance equal to 10°,12°,14° and 16°.

(b) *The work done in raising the center of gravity* as the case is leaned over to the point of balance: This can be estimated by multiplying the static weight of the packing case by the distance h the center of gravity is raised. By assuming a mid-point center of gravity, the latter can be estimated using the following formulas:

$$a = r \cos \alpha$$

where a is the height, the center of gravity is above the bottom of the upright case, r is the radius of the circle, a segment of which is described by the center of gravity as the case is rotated to the point of balance (the radius is half the distance between opposite corners of a small vertical face, traveling format) and α is the topple angle. The height to which the center of gravity is raised is then:

$$h = r - a$$

and the work done, w is,

$$w = mgh$$

where m is the mass of the packed case and g is the acceleration due to gravity.

The table indicates that the largest case is likely to be at risk from toppling.

Vibration

Research has shown that of the various modes of transport, the most severe low frequency, 3-50 Hz vibration environment is found within trucks. Air-ride suspension gives a smoother ride overall compared to traditional leaf spring suspension probably because air bags absorb more energy. Very low-frequency vibration (4-5 Hz) is slightly enhanced in air-ride vehicles.[7] All trucks produce greatest inputs in the vertical axis. The principal response of a stretched canvas is transverse to the picture plane; this explains the common practice of transporting paintings on stretched canvas vertically and to minimize the response to breaking, parallel

to the direction of travel.

Shock and Vibration, Damage Mechanisms

In tests carried out to date at the Canadian Conservation Institute and the Tate Gallery, no immediate damage to paintings has been observed following exposure to vibration, even when severe inputs have been applied. A number of real paintings of various sizes with established crack patterns and also test paintings, some with uncracked brittle coatings, have been assessed. In a recent experiment, a stretched linen canvas measuring 68.7 x 77 cm (27 x 30.3 in.) was prepared at the Tate Gallery with two coats of plaster of Paris. The test canvas was fragile and of similar construction to an oil painting but not truly representative. A highly crimped condition was established in the canvas because the plaster set while the canvas was still damp. Although a slight reduction in tension was apparent after extensive vibration testing, the dramatic de-crimping evidenced by loss of tension during subsequent drop tests illustrated the damaging effect of shock. Extensive cracking and loss of plaster occurred. The barely discernable effect of vibration compared to the devastating effect of shock showed graphically that shock protection must be the overriding priority in terms of performance criteria.

Computer modeling carried out by Marion Mecklenburg and Charles Tumosa, discussed elsewhere in this publication, is consistent in failing to predict *primary* damage from vibration exposure at levels that occur during transit.

However, *secondary* damage is likely, for example when the vibrating canvas hits the cross-bars or glazing. Impasto may be damaged or possibly stretcher-bar cracks may form. Therefore it is advisable to reduce vibrational displacement. So many variables have an influence that predicting the canvas response is difficult. The resonant frequency of the display frame on the cushioning foam is more easily predicted to the extent that BXL Plastics Ltd. in England provide vibration data for their polyethylene foams.[8] Preferably resonance should occur outside the frequency range of peak input for trucks, which is 3-20 Hz. Testing[9] has shown resonant frequencies to occur within this range for the softer foams such as polyester urethane. According to BXL's data, their polyethylene foams, LD 33, LD 45, and LD 70 perform well in this respect with resonant frequencies generally above 20 Hz for appropriate static stress levels. This performance is likely to be true for polyethylene foams in general. In all events, shock protection must take priority as discussed above.

A well-recognized method of coping with vibration is to alter the response of the object, or part of the object, that is likely to be damaged through resonance by a forcing vibration. This approach is highly applicable to paintings on canvas supports and several readily applied techniques are described by the author in "Vibration Control" elsewhere in this publication.

If the criterion is to avoid visible damage, then the display frame is actually more fragile than the painting. Drop testing real frames supports this assertion as does the frequent discovery of detached frame molding when unpacking.

Other damage can result where there is foam contact, e.g. abrasion of gilding and gesso through rubbing caused by small movements from handling or vibration in transit.

Exterior Case

There are many practical considerations to take into account when making the exterior case. These include:

Stability. Is the case reasonably difficult to knock over?

Puncture resistance. Would the case adequately resist puncturing by the tines of a forklift truck?

Waterproofing. Is the exterior finish waterproof? Can water collect in any part? Is there an effective gasket seal around the lid? Would water enter the case if it were placed in a puddle?

Handling. Does the design aid the use of handling equipment, such as forklift trucks, piano trollies, etc.? Are the necessary lifting points, such as handles or battens, suitably positioned and sufficiently strong for the weight of the case?

Fire resistance. Often ignored as an impracticality, this factor should be considered when fire resistant options, such as aluminum exterior cases, are a possibility.

Rigidity. Is the case sufficiently rigid? Are the joins adequately strong?

Reflective properties. If left outdoors, would the external finish reflect solar radiation sufficiently enough to prevent the case interior from overheating?

General appearance. Does the external appearance engender respectful, therefore careful, handling?

Security. Does the lid closure method deter theft? Are there any markings that might indicate the case contains a work of art?

Access. Will gallery staff in the receiving museum(s) be able to remove the lid with readily available tools?

Markings. Are the necessary international markings present to indicate that the case contents are fragile and should be kept dry? Is it clear in what orientation the case should travel and which face forms the lid?

Weight and volume. Is the overall weight and size of the case excessive for the volume of the packed work(s) of art?

Information on many of these questions is provided in the Handbook and discussed in other papers in this publication.

CONCLUSION

The approach throughout the preparations for this conference has been to identify damage mechanisms for paintings and assess performance of packing by the effectiveness with which the damaging factors are limited to safe levels. Though this process is far from complete, the recommendations that are made should take some of the guesswork out of protecting paintings in transit and allow for more efficient use of the resources available for their protection. □

NOTES

1. Stephen Hackney, "The Dimensional Stability of Paintings in Transit," ICOM *Committee for Conservation 8th Triennial Meeting* Preprints, Sydney (1987), 597-600.

2. Timothy Green, "Shock and Vibration—Test Results for Framed Paintings on Canvas Supports," ICOM *Committee for Conservation 8th Triennial Meeting* Preprints, Sydney (1987), 585-596.

3. Christine Leback Sitwell, "Results from Shock Testing," *Preprint of UKIC One Day Meeting, London* (21 June 1985), 16.

4. Cyril M. Harris and Charles E. Crede, ed., *Shock and Vibration Handbook* (1976), 41-25.

5. Elsewhere in this publication, fatigue effects are discussed by Stefan Michalski, "Paintings—Their Response to Temperature, Relative Humidity, Shock, and Vibration," and figures are provided for stresses that cause failure in paint films by Marion Mecklenburg in, "An Introduction into the Mechanical Behavior of Paintings under Rapid Loading Conditions." These figures help to indicate the fragility of paintings.

6. For a period of eight years, the author has known of four topple accidents at airports with works involved in Tate Gallery exhibitions but of no other serious drop accidents. Taking into account number of works etc., this gives an approximate one in one thousand chance of a topple accident for a loan going and returning by air. Owing to the paucity of statistics relating to accidents involving paintings in transit, this is the best estimate of topple risks known to the author.

7. Harry Caruso and William Silver, II, "Advances in Shipping Damage Prevention" *The Shock and Vibration Bulletin* 46, Part 4 (August 1976), 42-43.

8. BXL Plastics Ltd. "Cushion Packaging Guide, Plastazote," (product literature), 14-15.

9. Timothy Green 1987, 591.

VIBRATION CONTROL: PAINTINGS ON CANVAS SUPPORTS

Timothy Green

ABSTRACT: *Several damage mechanisms that may be attributable to vibration exposure are discussed. Ways to prepare the painting that limit the response of the stretched canvas to vibrational inputs are outlined and test results are included that show one technique, the stretcher lining, to be particularly effective.*

INTRODUCTION

The high stresses required to form cracks in oil paint films on canvas make it unlikely that the low levels of stress that occur as the canvas freely vibrates will form cracks or extend existing cracks. Thus, short-term *primary* damage is unlikely. Considering the care with which paintings are examined before, during, and after loan, usually with reference to photographic and written records, any immediate effects should have become evident. However, the effects of damage may take some time to become visible.

Though cracking is disconcerting, viewers are adept at reading images despite their appearance. Structurally cracking is most significant as a first step in the cycle of degradation leading to delamination and eventually paint loss. However, there are other forms of degradation in which vibration may play a part. These include:

(a) Splitting of the canvas along the front fold-over edge, usually emanating from a corner. Consequentially, corner distortions often form and the condition requires treatment. If left, the splitting extends readily due to stresses concentrating at the end of the split where the fabric is still joined. Internal friction, which largely holds canvas fibers and yarns together, is overcome by vibration. This phenomenon is referred to by Peter Caldicott.[1]

(b) Abrasion of the varnish and paint film(s) may occur when a vibrating painting that is loose in the display frame rubs against the rebate. Inadequately fitted paintings are vulnerable as they may be loosened by vibration. During transportation in a truck, the maximum input is in the vertical axis. The stretcher has substantial mass and as it vibrates it may shake itself loose.

(c) Stretcher keys may be shaken free, fall down, and become trapped behind the canvas. Further vibration may help settle the key closer to the edge so that as most stretchers have a bevel, a worse distortion results. Trapped stretcher keys are a familiar problem and the associated sharp distortion can produce cracking and even paint loss.

(d) Delicate varnishes and impasto may be damaged through impacts against glazing. Although the velocity of a vibrating canvas is low (for example, at 20 Hz, with a 12 mm peak-to-peak displacement, the peak velocity is 2.7 km/hr.) impact can occur many times a second making damage more likely.

For those routinely examining and treating paintings, such damage is frequently seen following a loan.

Undoubtedly, shock could produce the problems outlined above. However, the probability of shock events for fine art ship-

ments has not been established whereas vibration during transport is known to occur.

Conservation procedures currently applied to museum collections dramatically affect the preservation of paintings, with measures including glazing and fitting backboards to produce stable microenvironments, air conditioning, and limiting exposure to light. Modern restoration treatments are now generally safer and more cautiously applied. With these current standards used, the sum of the minor damage that results from frequent transportation both within the museum and for loan is likely to become an increasingly significant factor in contributing to a painting's degradation.

EXAMPLE OF VIBRATION DAMAGE

Very fragile structures are the most likely to be damaged by vibration and, in terms of paint films, the most fragile structure is pastel. Only rarely and for exceptional reasons would the Tate Gallery agree to lend such works. A recent example was the loan of four pastels by Edgar Degas. An air-ride truck was used for all journeys and efforts were made to limit vibration further by placing thick felt beneath the works. All handling operations were supervised with the works being hand carried throughout. No accidents occurred, but despite these precautions, noticeable quantities of pigment were deposited on the inner faces of the glass fitted to three

FIGURE 1
View of the glass removed from N04710 *Woman at Her Toilet*, c. 1873 following loan. Photo courtesy Tate Gallery, London.

of the works. The construction of these works provides a useful illustration of vibration effects. Only the pastel applied to a 6 mm thick board was undamaged. This is consistent with the observation about wooden panel paintings made by Paul Marcon in "Shock, Vibration, and Protective Package Design" elsewhere in this publication, that panel supports have natural frequencies too high to be affected by the low frequencies that occur during transport. Two works on sugar paper attached to a Gatorfoam board (5 mm thick faced polyurethane foamboard) and paper attached to thin cotton canvas were affected. The latter example, which measured 95.6 x 109.9 cm (37.63 x 43.27 in.) is particularly demonstrative of this occurrence. As can be seen in Figure 1, pigment was deposited most heavily in areas where crossbars were present. Central areas were worst affected which is consistent with the first mode being excited. In this mode, the largest displacements occur in the middle area. Impact against the crossbars most likely caused the heaviest deposits, as can be seen by the distribution relating to the crossbar configuration. This was despite an adequate clearance of 0.8 cm (0.3 in.) and, if anything, too high a tension in the stretched canvas, which illustrates that what can be termed *secondary* effects, are even more likely to be damaging and appropriate measures should be taken to prevent them. (For aged oil paint films that are brittle, impacts against crossbars may generate cracking.)

VIBRATION CONTROL

Broadly speaking, there are three approaches to be considered:

(a) Procedures that are applied directly to the painting or the display frame.

(b) Materials that can be included in or around the packaging.

(c) Selecting transport on the basis of vibration performance. By far, the most successful are those procedures that are applied to the object.

Preparation of the Painting and Display Frame

Paul Marcon[2] has indicated that paintings on canvas can be considered to be membranes with minimal stiffness; therefore, they readily vibrate. Their stiffness can be increased in a number of direct and indirect ways. Lining, in the sense of the adherence of a second piece of fabric to the back of the original, certainly has an effect. When thick animal glue or paste is the adhesive used, a boardlike effect can result. Attachment to a board with an adhesive, referred to as *marouflage*, is sometimes carried out when severe distortions are treated. Less drastically, the canvas can be stretched around a board and attached using the canvas' tacking or if these are missing, a margin of fabric can be adhered to the edges of the original support, referred to as a *striplining*. Once a painting is attached to a board, the vibration characteristics become similar to those of a panel painting.

During a treatment when a painting has to be removed from its stretcher, an opportunity arises to introduce a supporting fabric. The fabric is stretched on the painting stretcher but no adhesive is used between it and the original canvas. This is called a *loose lining* or *dry backing*. When the fabric used has a high elastic modulus, such as polyester sailcloth, large displacements from low-frequency movements in the original canvas are likely to be reduced.

These solutions are only feasible when the painting requires restoration treatment. Many works are borrowed from private owners and procedures that involve minimal intervention are then especially useful. Adjusting the tension in the canvas by keying-out the stretcher is an obvious alternative, but it is advisable to measure the relative humidity to ensure that the slackness is not due to dampness. Sometimes the canvas lacks all tension and flaps back and forth. This is likely to be more damaging than any vibration as, at maximum displacement, there is a sudden stop, i.e., high deceleration. Large displacements are possible and impacts against any crossbars are likely. Keying-out sufficiently to produce some tension

FIGURE 2
Reverse view of a painting showing an attached stretcher lining.

is therefore advisable.

Backboards

Attaching a backboard can have a beneficial effect. For touring exhibitions organized by the Tate Gallery, permission is requested to fit backboards to all works for the purpose of limiting damage should an accident happen, for example, if an object falls against the painting. Although the backboard is positioned with some space from the back of the canvas, when a material is used that is more stiff than the painting, the canvas can be restrained to some extent from vibrating. At the primary natural frequency of the painting, the canvas will need to displace a significant quantity of air. Because the natural frequency of the backboard is higher, it will resist the pushing effect of the resonating canvas against the trapped air. Sealing the backboard is recommended to maximize this effect. Backboards of all sizes are usually made from thin materials. When large they lack stiffness and resonate at low frequencies, therefore, small paintings are more effectively protected. When a stretcher has crossbars, it may be possible to cut suitably sized pieces to attach to each open rectangle bordered by crossbars and outer stretcher members. An alternative method to achieve the same effect has been developed by Peter Booth at the Tate Gallery.[3] This is now referred to as a *stretcher lining*.

Method of Attaching the Stretcher Lining

A piece of fabric is cut to size and temporarily attached with a few staples to the back of the stretcher. Segments are cut out to allow space for the crossbar(s) and wedges. The staples are removed to free the material which is then folded and inserted between the canvas and crossbar(s). Once unfolded and correctly positioned, attachment is made through the edges into the back face of the stretcher (see Figure 2). The fabric is

stretched while being attached.

The process is easily reversed and the treatment is minimal as the attachment of the original canvas is left untouched.

With the fabric in position, there is less risk of crossbar-related cracks developing through impact, as a continuous surface rather than the crossbar's angles would be contacted. A further advantage has been demonstrated in vibration tests showing the elimination of displacements at low natural frequency. Large displacements, which are visually evident, do not occur following the fitting of the lining.

The effect can be explained by likening the canvas to a string instrument, with each string (the threads) stretched between fixed points. The natural frequency, its note, will depend on the length of the string, its mass, and tension. For the stretcher bar lining fabric, the crossbar is like a finger pressing down at the midpoint along the string. The string either side of the finger will now vibrate one octave higher. Canvases exhibit low natural frequencies, (commonly 4-10 Hz). It has been consistently observed during vibration testing of paintings on stretched canvas that larger displacements occur at low frequencies, increasing the risk of crossbar impacts. Doubling the natural frequency reduces displacement. This might be expected if displacements that occur at different frequencies at constant acceleration levels are compared, for example, 1 G causes 29 mm (1.2 in.) peak-to-peak displacement at 4 Hz, 1 G causes only 8 mm (0.3 in.) at 8 Hz.

It may seem surprising that the original canvas is greatly affected by the second material as they are not in direct contact. The effect comes about because the air between them links the two materials as the higher natural frequency of the stretcher lining impinges on the original canvas. A canvas vibrating at low frequency and with sufficient amplitude to risk crossbar impact requires appreciable displacement of air; with the lining in place, however, this cannot occur.

Vibration tests were performed on a one-

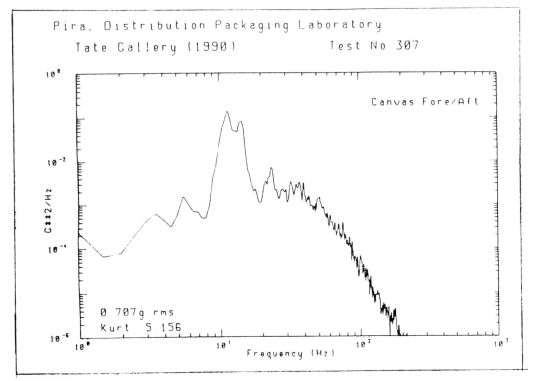

FIGURE 3
Power spectrum density (PSD) trace showing output from the unprotected student painting.

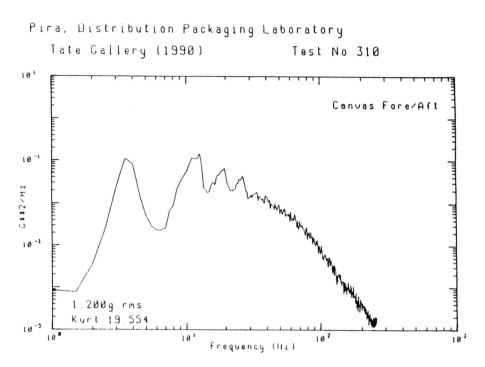

Canvas Fore/Aft

1.200g rms
Kurt 19.554

FIGURE 4
PSD trace showing output from the student painting to which a stretcher lining has been attached.

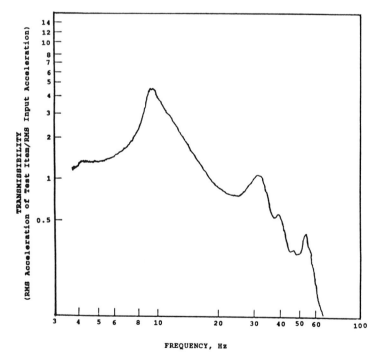

FIGURE 5
Transmissibility trace from a test frame inside a test packing case supported on all six sides by rubberized hair.

hundred-year-old painting by a student that measures 126.4 x 203.2 cm (49.75 x 80 in.) to assess the effect of the stretcher lining. The test painting had a full cross crossbar configuration and was fitted into an unglazed frame with no backboard. The painting and frame were secured, at a slight angle to the vertical, on a metal frame picture trolley clamped to a vibration table. A hydraulic ram produced random vibration at 90° to the plane of the canvas across a frequency range 3-100 Hz at a level indicated as realistic from the road trial reported by Peter Caldicott. (The g rms input was 0.062.) A centrally placed lightweight accelerometer used in previous studies[4] provided an output signal.

Without the crossbar lining, 1.2 G rms was measured, whereas, with the lining in place, this fell to 0.71 G rms. Therefore an improvement was gained overall for the frequency range used in the test, 3-100 Hz. The most dramatic improvement, though, occurred at low frequency, between 3-4 Hz. Most persuasive of the lining's beneficial effect was the visual appearance of the test which was recorded on video tape. In particular, when exposed to sinusoidal vibration at low frequencies, such violent displacements occurred that restraining webbing straps securing the painting to the test rig had to be held away from the painting's surface to avoid impacts. With the lining attached, these extreme displacements did not develop.

Stretcher linings are routinely applied at the Tate Gallery. Because the natural frequency of large paintings on stretched canvas are low and the vibration of the canvas can be seen, when the stretcher lining is in place the effect is readily assessed visually.

Several recommendations can be made to maximize the protective features of the stretcher lining:

(a) The greater the tension in the lining the higher its natural frequency, which will more effectively restrain low-frequency displacements of the original canvas. (The strength of the stretcher will often limit the tension that can be introduced. This might be improved by reinforcing the stretcher and crossbars with an aluminum L-section.)

(b) The elastic modulus of the fabric used should be high, i.e., appreciable pulling when stretching should produce minimal extension of the fabric. Such materials are more readily pulled to the required stiff state. Good results have been achieved with heat treated polyester sailcloth. The heat treatment welds the fibers together which also helps to reduce subsequent loss of tension through creep. A stretcher lining applied in September 1983 to the Tate Gallery's *La Table* by Pierre Bonnard still retains an adequate tension.

(c) The segments cut out of the lining to allow room for the crossbars and wedges should be kept to a minimum area. Larger gaps allow freer air movement thereby reducing the restraining effect discussed above; air will be pumped in and out of the gaps by the vibrating original canvas.

(d) Attaching a continuous backboard will also help restrict air movements.

Vibration Isolation

The low natural frequencies displayed by paintings make the successful application of vibration isolating materials difficult. A number of suitable materials have been assessed by the Tate Gallery including felt, rubberized hair, Sorbothane (a lightly crosslinked polyurethane) and Fabcell (a profiled rubber). Such materials display a high degree of internal damping. Even so, a resonant condition will exist at some frequency. As discussed by Paul Marcon elsewhere in this publication,[5] at frequencies below that at which resonance occurs, inputs will be transmitted at unity and increase at frequencies close to resonance. At some frequency above resonance, inputs will be reduced, or *attenuated*. The higher the degree of internal damping in the material, the lower the factor will be by which inputs are amplified at peak resonance. Because the resonant frequencies of paintings are low, an even lower resonant frequency needs to be displayed by the isolating material. The lowest achieved in the Tate's tests was 9 Hz using rubberized hair.

For all trucks engaged in fine art transportation, if there was a low frequency band of

negligible inputs, then the isolating material's resonance could be tailored to fit within this range. Results from road studies in which random vibration has been monitored have failed to identify such a range with any consistency.[6]

Packing Foams

A resonant condition will also exist for the cushioning foam supporting the framed painting. Vibration testing indicates that at static stress levels designed to achieve good cushion performance, peak resonant frequencies occur between 15-30 Hz.[7] An instance where the resonant frequency of the painting coincided with that of the display frame resting on foam has been described by Caldicott.[8] This will always be a possibility unless a specific packing case and painting have been tested. Generally, the observation by Caldicott that vibration was reduced overall by the packing foam is more likely to apply.

Transport Selection

Marcon and Caldicott have both described the vibration environments of the various modes of transportation.[9] Trucks are identified as providing the most severe environment in terms of the natural frequencies of canvas paintings. Even so, recorded levels are low and are unlikely to produce damage in the short term.

A study was carried out in England in 1965[10] in which extremely fragile objects, such as electric bulbs, were used to determine the most damaging locations within a conventionally sprung truck. The recorded damage was then correlated with that obtained through drop testing. The equivalent level of breakage resulted from drop heights of 15 cm (6 in.) or less. This is encouraging if the fragility of paintings lies in the region of 50 G, particularly as modern air-ride vehicles produce lower inputs. David Saunders[11] has confirmed the suspicion of many conservators, that the most serious inputs are seen during handling operations including those within the museum. This indicates that the greatest improvements would derive from changes in handling equipment and procedures.

CONCLUSION

It is possible to prepare a framed painting to eliminate the risk of damage from vibration during transport. Some methods that require only minimal intervention have been shown to be highly effective. Paintings that cannot be prepared in advance of their transportation are more at risk, particularly if they are poorly fitted into the display frame. The most energetic vibration is likely to occur during handling, and improvements in handling procedures are likely to provide the most overall benefit. ☐

NOTES

1. Peter Caldicott, "Vibration and Shock in Transit Situations—A Practical Evaluation Using Random Vibration," see Supplemental Entry, this publication.

2. Paul Marcon, "Shock, Vibration, and Protective Package Design" elsewhere in this publication.

3. Peter Booth, "Stretcher Design: Problems and Solutions," *The Conservator* 13, (1989), 31-40.

4. Timothy Green, "Shock and Vibration-Test Results for Framed Paintings on Canvas Supports" ICOM *Committee for Conservation 8th Triennial Meeting*, Preprints, Sydney (September 1987), 585-596.

5. Marcon, elsewhere in this publication.

6. F. E. Ostrem and W. D. Godshall "An Assessment of the Common Carrier Shipping Environment," *Forest Products Laboratory*, U.S. Department of Agriculture (1979).

7. Green 1987, 585-596; Sarah Staniforth, "The Testing of Packing Cases for Paintings" ICOM *Committee for Conservation 7th Triennial Meeting*, Preprints, Copenhagen (September 1984) 84.12.1-6; Timothy Green and Stephen Hackney, "The Evaluation of a Packing Case for Paintings" ICOM *Committee for Conservation 7th Triennial Meeting*, Preprints, Copenhagen (September 1987), 84.12.1-6.

8. Caldicott 1991.

9. Caldicott, see note 1 ; Paul Marcon, "Shock, Vibration and the Shipping Environment" elsewhere in this publication.

10. N. W. Lee "Glassware Breakage as a Measure of the Transport Environment" *3rd Symposium of the Society of Environmental Engineers, London* (April 1969), 15-18.

11. David Saunders, "Soft Pack—The Soft Option?" elsewhere in this publication.

PACKING CASE DESIGNS

Stephen Hackney and Timothy Green

ABSTRACT: *Fifty major museums and organizations involved in the loan of paintings throughout the world were sent questionnaires. The intention was to identify concerns that should be expressed during this conference and also to improve our knowledge of current practice in packing and transport. Responses have been interpreted in broad terms; and were compared with packing cases used for packing and transporting the paintings included in the* Max Ernst Exhibition *at the Tate Gallery. From these two sources and other research, the authors have attempted to identify and assess current packing case design practices and to suggest their opinions on how improvements can be made. It is hoped that this process will provide a starting point for discussions in the workshop and will be the first step towards standardizing the various specifications currently in use.*

QUESTIONNAIRE

A questionnaire was sent to the museums invited to the conference workshop to discover their attitudes, packing procedures, and concerns. Because the sample was small, no attempt was made to quantify the results of this questionnaire. The questionnaire was useful in identifying the issues on which respondents expressed similar views, but some replies were not easy to compile. For this reason, and as a comparison, it was decided to examine details of the design of packing cases used in the 1991 *Max Ernst Exhibition* at the Tate Gallery and to evaluate the conditions observed. The topics below include some replies to the questionnaire, followed by descriptions of the Ernst exhibition packing cases. Interpretation, suggestions and problem-solving observations follow each topic.

Like many other questionnaires, inevitably this one was structured around preconceived ideas and, in retrospect, contained some leading questions. Despite these reservations, respondents were generally helpful and positive, some offering extremely full replies and sending detailed packing case specifications.

Many of the specifications are based on simple but sound principles and appear to be the result of years of experience, incorporating sensible features and details. What is obvious, and recognizable by all who have written a case specification, is the room for error and misinterpretation in many of these specifications. It is clear that specifications assume previous experience and intelligent interpretation by the case manufacturer.

Considering first the response to questions eliciting overwhelming and consistent replies, some useful areas of agreement have emerged. All respondents prepare paintings for loan, carrying out typical procedures such as applying backboards or acrylic sheeting for protection. Jet aircraft and/or trucks are nearly always used and air-ride vehicles are usually specified, sometimes with heated or humidified cargo compartments. Trucks are used for shorter journeys, for delivery to an airport or to avoid transfers at airports. For truck transport alone, packing cases are not

always thought necessary and various soft wrap, padding, and travel frames are used to protect paintings and frames.

Need for Packing Cases

Reasons given for insisting on a packing case provide a useful compendium of views:

(a) Paintings to be transported by airfreight.

(b) All loans more than fifty miles.

(c) Separately shipped items.

(d) More than one venue.

(e) Extreme fragility or high value of paintings to be transported only short distances.

(f) Fragile frame.

(g) Isolation against perceived dangers such as extremes of temperature.

(h) Doubts about the competence of the transporters or handlers.

In addition, it is recognized that the large size of some paintings may restrict the choice of transport to a truck and that vehicle capacity and/or gallery access may preclude the provision of a packing case. Indeed, the principal concern raised by respondents is the difficulty of coping with the transport and handling of large works of art.

PACKING CASE CONSTRUCTION

The questionnaire revealed that, except for two designs of reusable rented cases, packing cases are frequently made of plywood strengthened with a framework of softwood battens. Joints are glued and screwed, rather than nailed, to form a rigid, relatively impact-resistant shell. Solid wood (planks) are also mentioned by respondents. From an examination of the Ernst exhibition cases, plywood strengthened with wood battens is confirmed to be by far the most popular type of construction for the outer shell of packing cases. The case survey confirms the use of solid wood as well as various other composites and laminates such as coreboards (lumber core, blockboard) and particle boards (wood

chipboard).

The plywood design is economic and can be constructed from widely available materials, requiring no special skills or tooling. Apart from the transporting vehicle, the outer shell of a packing case provides the main physical protection for a painting. The rigidity of the plywood box structure is probably adequate for normal requirements, but impact resistance of the two large faces may not be adequate. For instance, in an accident involving a forklift truck, impact damage will depend on the shape of the tine, the momentum of the vehicle and inertia of the packing case. Impact resistance for various thicknesses of plywood are given below. The median thickness from the Ernst exhibition was 1.25 cm (0.5 in.) but many were only 1 cm (0.4 in.). Better impact resistance could be achieved by attaching metal plates or grills to the two large faces. This is not current practice for custom-built cases. In this respect the two proprietary reusable cases with aluminum skins offer better protection.

Topple Stability

Packing cases always travel upright aligned in the direction of the vehicle. They stand on either feet or skids. The exhibition survey confirms the equal popularity of feet and skids.

Packing cases from the Ernst exhibition were examined for susceptibility to toppling. The average topple angle for all sixty-eight packing cases was 14.2°. For fifty-eight singly packed cases, the average topple angle was 11.4°. One case was not freestanding, therefore it had to be leaned against a wall. Twenty-eight cases had a topple angle less than 12°, and were consequently considered to be at risk of toppling.

The upright nature of painting cases is unusual in packing and transport experience, therefore designers must pay particular attention to stability, especially during mechanical handling. Of some concern are designs that incorporate narrow bases, relatively poor impact resistance, and incorrectly chosen cushioning characteristics in the event of a topple. Together these are a recipe for

disaster. Feet allow lateral handling by a forklift truck, as do discontinuous skids. Feet are more likely to be broken off. Skids allow easier lengthwise movement and maneuvering in a confined space. Worn skids could allow a topple accident. The design of bases requires original thinking. Designs that incorporate stability without sacrificing handling, maneuverability, and compact parking inside vehicles are needed.

For the exhibition sample, packing case height was compared with the smaller of the two framed painting dimensions. The differences in dimensions are shown in the Chart.

This difference for any particular painting and case is the result of a combination of the thickness of cushioning foam, the packing case walls, the base, and any thermal insulation or inner case present. To reduce the risk of toppling, the overall height must be kept to a minimum by optimizing this difference.

It may also be critical for large paintings traveling by aircraft or in other limited cargo holds.

In the exhibition sample, the ratios of painting volume to packing case volume were also compared. It was found that these ratios varied considerably, depending on the amounts of cushioning foam, thermal insulation, air space, and whether or not an inner case was used. A ratio of 1:13 was the average. A large relative volume may indicate a broad, more stable structure but it would also be heavier, less maneuverable, and more expensive in manufacturing and air freight charges. The minimum ratio was 1:3, but this was for a poorly designed case with little cushioning and a narrow base.

CHART
Differences in cm between height of packing case and smaller dimen;sion of painting and frame.

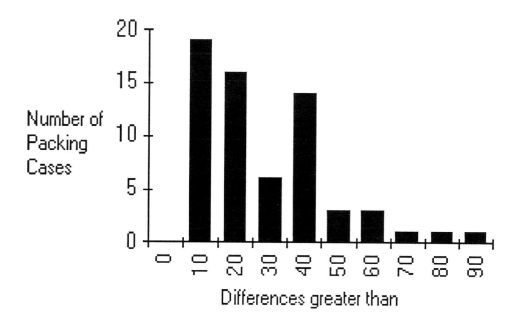

THERMAL INSULATION

Thermal insulation is not always used. Sometimes the thermal insulation properties of the cushioning foam is considered adequate. Not surprisingly, museums in areas of climatic extreme are more aware of the need for thermal insulation, and specify insulation of 5-10 cm (2-4 in.) of polystyrene. In contrast, some respondents rely on very thin layers of insulating material incorporated in proprietary moisture barriers or cite the insulation value of the wood of the packing case. Again the Ernst exhibition survey confirmed the questionnaire replies. The quantities of thermal insulation varied considerably from case to case.

Agreement is necessary on the extent of need for protection against temperature change.[1] This issue has been addressed within the conference in terms of the direct effect of temperature, its indirect effect on moisture content of a painting, and even its effect on cushioning materials.[2] Temperature can be controlled to some extent within vehicles, but not always during unloading and transfer. Vehicle heating and air conditioning will not be to museum standards and are more likely to fail. Thermal insulation is effective against rapid changes, but to protect over longer periods of time, the required thickness becomes excessive. Thermal half-times are a convenient measure and are used to compare the effectiveness of different insulation materials. Typically, half-times of about five hours can be expected for 10 cm (4 in.) of polystyrene. Insulation can add considerably to the overall size of a packing case, increasing both manufacturing and transport costs. To complicate the argument, in practice, thermal insulation, by increasing the depth of a packing case, adds to its topple stability.

MOISTURE CONTROL

According to the questionnaire replies, most wooden cases are painted or lacquered with a water-resistant material such as polyurethane or alkyd paint. To seal the enclosure, gaskets between the case and lid are normally specified. Moisture barriers in the form of polyethylene sheeting or proprietary foils are commonly used. Sometimes the inside of the case is caulked with silicone sealers. Reducing transfer of moisture between the case and its environment is considered a high priority. A few respondents add relative humidity buffers to their cases; silica gel, Artsorb, and Tentest are mentioned, but most do not use them.

Half the packing cases in the exhibition sample had no internal moisture barrier. A quarter of the painting frames were wrapped directly in a very good moisture barrier, such as polyethylene or bubble pack. The final quarter were wrapped in Glassine or kraft paper. These materials are hygroscopic with some moisture barrier properties.

The packing case and thermal insulation can be designed to reduce moisture transfer. The effectiveness of moisture barriers has been demonstrated.[3] A wrapped painting will retain the moisture content present when packed during the journey and for a long time afterwards. The painting will also be protected from possibly unconditioned packing case materials. The greatest change in moisture content likely to be experienced during the journey will be on unwrapping, reflecting the difference in ambient relative humidity between the lending and borrowing institutions.

Nearly all the respondents are aware of the concept of preconditioning of cases prior to packing, usually for a period of twenty-four hours.[4] Some make sure that cases are stored in air-conditioned areas at all times. Most also specify a twenty-four hour delay before unpacking a case to allow it to acclimatize. The latter procedure is sometimes carried out only when requested, suggesting that it is not normal practice in the museums reporting such procedures.

The demands of exhibition preparation, particularly when arrivals may be delayed, make current museum acclimatization procedures difficult to enforce. It has been noted that if a painting (and its frame) has been packed at less than 70% relative humidity, and remains within its moisture barrier, its immediate removal from the thermal insulation of the packing case will not cause con-

densation or serious changes in moisture content.[5] Arguably a new procedure should be defined for bringing the painting and exhibition galleries into moisture equilibrium at a controlled rate.

CUSHIONING

None of the respondents reports the use of mechanical shock absorbers, all rely on cushioning foams to provide shock protection. This is confirmed by the Ernst exhibition sample. The principle of a shell enclosing the cushioning,which in turn encloses the painting, is universal, but the use of single cases and of double (inner and outer) cases is fairly evenly divided. Five cm (2 in.) of cushioning foam is normal between inner and outer cases and a further 2.5 cm (1 in.) of foam surrounds the object.

Most respondents have little knowledge of the effectiveness of their cushioning foams. A variety of types and grades are named, mainly specifying the manufacturer and proprietary name and grade, which is usually related to density. Many do not give sufficient information on their use of cushioning foams. Aspects such as chemical type, density, thickness, and area of contact are rarely clearly stated. Respondents are, however, aware of the need for stable nondegradable materials, some specifically mentioning polyethylene or polyester types.

In the exhibition survey, there is considerable variation in the levels of shock protection. Some have no cushioning foam at all, whereas others, perhaps reused from previous loans, but for smaller paintings, incorporate up to 21 cm (8.4 in.) of foam. The average thickness is in the region of 3 cm (1.2 in.). In general, when polyethylene foam is used, attempts have been made to produce the correct range of static stress by using short pads or corners rather than continuous cushioning. In a few examples, the static loading is insufficient to make the most effective use of the foam. By examining a number of cases from the same manufacturer, it becomes evident that a general design has been used and that static stress has not been calculated for each painting.

Generally, respondents do not test or analyze their case designs to ensure optimum performance. Inevitably, packing case designs that cope with a variety of external conditions and a range of painting sizes and weights are not tailored to specific needs. In examples from the Ernst exhibition, performance could have been significantly improved by small adjustments to the design.

The best estimate is 50 G for the fragility factor of a painting frame, based on drop tests, modeling, and experience.[6] For a one meter drop, it is relatively easy to design a packing case to reduce the shock transmitted to a frame enclosed within to less than 50 G's. In practice this requires more than 7.5 cm (3 in.) of efficient cushioning foam used at its correct static loading. Similar calculations can be made for cushioning to protect against toppling.

The inner and outer case designs with 5 cm (2 in.) thick corner pads are probably in the correct static loading range. Corner pads, rather than continuous strips of foam, increase static loading, probably the range appropriate for typical polyethylene cushioning foams. The inner case provides a predictable surface area and the mass of the painting is less critical in this inherently reliable design. One drawback with this design is the increased height, volume, and weight of the packing case, which internally needs to be at least 17.5 cm (7 in.) larger than the enclosed painting. A second potential problem is the possibility of tandem cushioning.[7] In two examples, a similar foam thickness was present within the inner and outer cases. Tandem cushioning would have occurred if these packing cases had been dropped. Provided the danger is known, it can be guarded against by ensuring that most of the cushioning foam is in the outer case. The most commonly used design, with 5 cm (2 in.) outer and 2.5 cm (1 in.) inner cushioning foam is unlikely to be adversely affected.

VIBRATION AND REPEATED SHOCKS

None of the respondents incorporate any specific vibration protection in their case design, with the exception of one response that

mentions using Sorbothane pads as a stand for transit frames.

Until recently little was known about the occurrence and effects of vibration in transit. Recent research has revealed that resonances can occur in stretched canvases, and that their natural frequencies may be in the 4-20 Hz range typically experienced during transit.[8] A framed painting resting on cushioning foam will also have a natural frequency and this may be in the same range. In the worst case, these factors may combine to amplify the input vibration considerably. Although vibration specifically has not been shown to cause damage, the possibility of impacts on the stretcher crossbars caused by displacement of the canvas cannot be ignored.[9] A packing system cannot easily protect against such an event therefore preventative measures must be taken before a loan is required. Measures can be taken to increase the rigidity of the painting and frame structure, thereby raising its natural frequency above the 4-20 Hz input range. Stiff backboards, strengthened frame corners, and glazing can also help,[10] and stretcher crossbar linings can be used to lessen the vibrations of the canvas and stiffen the stretcher.[11] Further protection can be provided by the using an air-ride truck and by orienting the case in the recommended vertical mode.

Concern remains that long-term damage may occur, perhaps through fatigue processes leading to paint cracking or through repeated minor flaking of already cracked and poorly adhered paint. Evidence of long-term damage from vibration in transit may eventually be revealed to vigilant conservators, but in the meantime they can take comfort in its absence. The energy of vibration depends on the mass and velocity of the vibrating canvas. Because canvases are light, the energy that has to be dissipated is usually small, but a cracked and poorly adhered heavy paint film may be at greatest risk.

FASTENINGS

Security is important but may conflict with the requirement of ease of unpacking. If a small painting is transported unaccompanied, insurance statistics confirm that theft is a major danger therefore the case should be locked.[12] For security, a case should generally be readily identified by color or code but not specifically labeled as containing a work of art or as belonging to a known collection of paintings.

For most large paintings accompanied by a courier or agent, theft from a case is unlikely. The survey revealed that most cases are not locked. Lid fastenings are many and varied, they can be captive bolts, latches, or closure plates. Two important aspects are relocation of fastenings on repacking and resistance to impact-damage. A fastening that protrudes may be accidentally broken off. It should not require special tools that may not be readily available. Screws and nails are unacceptable since they require drilling or hammering on each packing operation.

Handles are not usually provided on heavy packing cases, instead the wooden battens on each end are frequently modified to allow sufficient grip when lifting the case onto a trolley. When handles are provided, they are often at the wrong height or inappropriate for a heavy case. Some thought about the safety of the packer and handler is necessary. Obviously sharp edges or rough wood should be avoided and cases should be designed to be suitable for manhandling as well as mechanical handling.

Unpacking

Most packing cases for paintings open by complete removal of one of the large faces. This is usually carried out with the case in the horizontal position raised on a suitable support such as trestles. For very large cases however unpacking may be more conveniently performed in the vertical mode. Safe and easy access for packing and unpacking is essential. The correct procedure should also be self-evident or at least explained clearly in the appropriate language by instructions placed inside the case lid. There is a strong argument for standardization of packing and unpacking procedures to protect packers from making errors caused by inexperience in using a particular system. As many im-

provements in aspects of case design neglect to anticipate the consequences for those packing or unpacking the works of art. Being confronted by new case design may confuse those accustomed to other systems, causing difficulties in the unpacking procedure. Thought must be given to how the painting should be repacked for return. Packing materials should be reusable, easily identified, and their position in the case obvious and unique, otherwise mistakes will occur. International symbols for fragility, direction, and water susceptibility should be used.

Slotted Cases

Slotted packing cases are also mentioned by respondents. These are particularly useful for small works of art, such as panels and works on paper. Several examples of slotted cases were noted in the Ernst exhibition, some of which were very large and heavy, each including three or four paintings. In many of the examples in the exhibition, the amount of cushioning foam was extremely small or non-existent, constituting a major risk. Use of thermal insulation was also minimal.

The slotted case design is economic to build and quick and easy to unpack. Several paintings can be packed in one case. Access is by removing the end and sliding the paintings out, preferably protected from abrasion by runners, wrapping, or an inner structure. Abrasion risks still occur during unpacking, and the dropping of one end when the painting emerges from the slot is a common error. The design is adequate if cushioning foam has been used in the case, and mechanical handling is available in the museum, with unrestricted access. Toppling is rarely a problem in cases of this type.

Paintings on Wood Panels

Although many respondents indicate that they do not lend wood panels, it is unfortunate that the questionnaire did not request information on case designs specific to wooden panel paintings.

Many wood panels are particularly vulnerable to humidity change and to shock and require that a case design contain a moisture barrier and more cushioning material than is currently used for canvas paintings. Paintings on panel compare in fragility to gilt frames. As the damage most observed during loan is in the form of small losses of gesso from gilt frames, this would seem to indicate that some current case designs are not sufficient in compensating for the fragility of frames. Wooden panels enclosed by frames would be better protected than the frames, but are perhaps more fragile. To be safe, increased shock protection (more than the existing 5 cm currently used) is required.

Glazed Paintings

Most paintings are lent with protective transparent acrylic sheeting (Perspex or Plexiglas), except for large or unframed paintings which cannot usually be protected in this way. Many galleries are increasingly using glass with an anti-reflecting coating to protect their paintings on display. There are enormous advantages both in terms of display and conservation in retaining this glass in place during loan. The problem is to transport it safely. Any breakage could cause serious damage to a painting. In theory, a packing case designed to protect to 50 G maximum acceleration should be safe for both the painting and glass. However, since the consequences of breakage are potentially so severe, some further precautions are necessary. Taping the glass with an easily removable self-adhesive tape can help hold the glass together in the event of a break.[13] Recently, laminated low-reflecting glass has become available. With lamination it has now become feasible to transport glazed paintings with some safety. The glass must be fitted in the frame carefully, avoiding imposing any flexural tensions and allowing space for thermal expansion, and the frame must be kept at constant moisture content.

Large Paintings

Since large paintings are universally agreed to be a major problem, it is worth looking at some of their special needs. Obviously height

restrictions present difficulties and these must be identified before a loan is agreed. Access problems for these paintings during loan can cause the courier enormous difficulties. What is evident is that a courier is essential on such occasions, and should not be someone inexperienced. Handling heavy and tall cases require extra care, patience and confidence.

The normal packing criteria may not apply. Weight and rigidity become critical. Air-ride truck transport and soft wrapping with handling carried out by skilled and strong handlers may be preferable to full packing cases.[14] Cushioning, moisture barrier and thermal insulation requirements are unchanged, but to reduce weight the last may be dispensed with, provided the truck is reliably heated.

CONCLUSION

There appears to be some degree of consensus among respondents and lenders for the Ernst exhibition in packing case design. Cost is a factor, particularly for larger cases, but in general, museums and private owners do not skimp on materials and specifications. This may be because the borrower pays these expenses. The main weakness is a failure to make the most of existing knowledge. Significantly, the greatest errors occur in those aspects where painting requirements differ from those of other types of cargo. Statistics, where they are available, confirm that damage in transit is rare, but this may be because, fortunately, on most occasions packing cases are seldom required to perform to their theoretical limit.

Enough is known about most aspects of packing to define performance criteria for packing cases. Various designs can be compared by calculation or by physical testing. Borrowers and lenders can then make more informed decisions on their packing needs. More uniformity in case design, materials used, and packing and handling procedures would lead to better understanding, fewer mistakes, and manufacturing economies.

The long-term effects of loan remain a source of concern. Further research and analysis is required to assess the extent of damage caused by repeated exposure to the transport environment. Changes may be subtle, and cause and effect difficult to establish, but cumulative damage is unacceptable.

It would be a mistake to expect a packing case to solve all problems arising in transit, but a good design can reduce systematic damage. Protecting against human error or major catastrophe is less predictable; some risk will remain, not least in the packing process. □

NOTES

1. Stefan Michalski, elsewhere in this publication.

2. Timothy Green, Mervin Richard, elsewhere in this publication.

3. Nathan Stolow, *Controlled Environments for Works of Art in Transit*, (1966); Stephen Hackney, "The Dimensional Stability of Paintings in Transit," ICOM *Committee for Conservation 7th Triennial Meeting*, Preprints, Sydney, Vol. 2, (1987), 597-600.

4. Nathan Stolow, *Conservation and exhibitions: packing and storage considerations (1985).*

5. Mervin Richard, elsewhere in this publication.

6. Timothy Green and Stephen Hackney "The Evaluation of a Packing Case for Paintings," ICOM *Committee for Conservation 7th Triennial Meeting*, Preprints, Copenhagen, (1984), 84/12/1-6; Marion Mecklenburg, elsewhere in this publication; Paul Marcon, elsewhere in this publication.

7. T. Green, "Shock and Vibration—Test Results for Framed Paintings on Canvas Supports," ICOM *Committee for Conservation 8th Triennial Meeting*, Preprints, Sydney, Vol. 2, (1987), 585-596.

8. Sarah Staniforth, "The Testing of Packing Cases for the Transport of Paintings," ICOM *Committee for Conservation 8th Triennial Meeting*, Preprints, Copenhagen, (1984), 84/12/7-16; Green and Hackney 1984, 1-6.

9. Green 1987, 585-596.

10. Green 1987, 585-596.

11. Peter Booth, "Stretcher Design: Problems and Solutions," *The Conservator* 13 (1989), 31-40.

12. Robert Hiscox, "Insuring Works of Art in Transit," elsewhere in this publication.

13. Stephen Hackney, "Framing for Conservation at the Tate Gallery," *The Conservator* 14 (1990), 44-52.

14. Christopher Holden, "Notes on the Protection of Modern Art Works during Handling, Packing and Storage," *The Conservator* 3 (1979), 20-24.

INSURING WORKS OF ART IN TRANSIT

Robert Hiscox

ABSTRACT: *Setting the cost of insuring works of art is a subjective process that attempts to balance the value of the object against the nature of the risks that the object is likely to encounter. The risks are not limited to when the object is in transit but also those periods when the painting is hanging on the walls of its permanent installation. This paper examines broad differences in catastrophic and particular risks. Risk assessment for objects in transit is discussed, including the transportation aspects such as the nature of the move, the level of care provided the object during the move , and possibility of incidents such as theft, fire, and accident. Premium costs are presented and explained in terms of the type of possible risk and the client.*

CONTEXT

In the summer of 1990, the Chairman of Lloyd's hosted a lunch for a group of curators from museums throughout the United States, to which leading Lloyds underwriters of fine art insurance were invited. The underwriters came away from that lunch with a clear message: the cost of insurance was such a large item in the budget for an exhibition that this factor alone could determine the viability of staging exhibitions in the future. One curator even suggested that insurance represented up to one-third of the total cost. He had been staging exhibitions for a number of years, and clearly did not think he was getting value for money. If we, the insurers, did not cut premiums, then there would be no exhibitions to insure. Not only would we suffer a fall in business, but the public at large would be deprived of the opportunity to see our cultural heritage.

Insurance is, of course, a necessary ingredient of all exhibitions. Some loans from national museums will be covered by government indemnities, but to make any exhibition comprehensive, the hosting institution will wish to draw upon works of art from private collections and museums, which will not be prepared to lend unless they are protected against financial loss. We must, then, find ways in which the risks of loss and insurance premiums can be reduced to a minimum.

COSTS AND RISKS OF EXHIBITION INSURANCE

It is useful to begin by analyzing the way in which insurance premiums are set. Insurance premiums vary greatly according to the risk to which a work of art is exposed. At one extreme is a ten-ton bronze sculpture permanently on display in a museum that is temperature controlled and patrolled regularly by guards; at the other extreme is a fragile item such as a glass goblet that a dealer carries in the back of the car from one trade fair to another. In assessing a risk, underwriters look first at the nature of the work of art; then at the degree of movement to which it is exposed; then at the level of care and protection it is given; and finally, having weighed these factors, they assess the likelihood of varying perils, such as fire, theft or accidental damage.

Perils

It is worth just looking at the perils first. These may be broadly divided as either *cata-*

strophic or particular. Catastrophic perils are those that will have a large-scale effect, and include fire, lightning, aircraft collision, smoke, earthquake, and war. Fortunately, such perils occur rarely, but their effect can be devastating. Particular perils are those that tend to affect individual works, such as theft, vandalism, water damage, and breakage (also known as accidental damage). These perils occur frequently, but the loss is limited.

Movement

It is clear that a painting hanging on a wall is far less exposed to risk than a glass goblet traveling around the country. But what precisely are the increased risks in transit? Mostly they are accidental damage and theft. To a small degree, there is an increased war risk (the article may be in an airplane that is bombed) and an increased chance of water damage. But, conversely, a painting on display is more vulnerable to a deranged person who might slash it with a knife than when it is in transit and out of the public gaze.

Medium

In examining the potential perils to which a work of art may be exposed, we must also consider the medium in which it is created.

Our glass goblet is unaffected by water damage, and may survive a minor fire; but it can easily be broken. A book suffers conversely; fire and water damage is devastating, but it can be mishandled without great risk. These are obvious examples, but where insurers fail to distinguish sufficiently is within the broad categories themselves. Consider, for example, an Old Master by Titian, thick with paint and probably restored a number of times, and contrast it with an acrylic by Rauschenberg with its large surfaces of monochrome. Both can suffer water damage. The Titian is easily restored, with little loss of artistic value and, consequently, financial depreciation. But the Rauschenberg is destroyed, the pigments cannot be matched, and even the most expert restorer is unable to cover the damage without it being

visible to the naked eye.

So here we have added a fifth and significant element in the insurer's calculations—financial depreciation. It is not a risk in itself, but can and usually does have a significant impact on the size of a claim, and must be considered when setting the premium.

Setting Insurance Premiums

Now let us quantify these various elements in setting premiums for exhibitions and works of art in transit as a whole.

In the table below, I have illustrated a possible breakdown of premium between various exposures on a valuable Old Master. There are four categories: thirty days on display (1) in a museum and (2) in an art gallery; and a transatlantic transit of up to thirty days under (3) museum, and (4) commercial conditions. For simplicity, the risks are assumed to be of only four types: catastrophic (fire, earthquake, etc.), vandalism, theft, and accidental damage.

o/oo	DISPLAY		IN TRANSIT	
	Museum	Gallery	Museum	Commercial
Catastrophic	.03	.075	.05	.075
Vandalism	.02	.005	.00	.00
Theft	.04	.10	.25	.525
Accidental damage	.01	.02	.10	.60
Total	.10	.20	.40	1.2

Figures are expressed per thousand (one-tenth of percent) and are, of course, illustrative—don't rush off to your broker and demand these terms. They are, however, somewhere near reality.

What can we deduce from these figures?

First, for museum risk, the premium for one transatlantic crossing that may only last twenty-four hours is approximately equal to four months on display on a museum wall. The reduced risk of vandalism is massively outweighed by the risk of theft.

Notice, though, that the risk of accidental

damage while in transit is not disproportionate to the risk while on display. As insurers, we recognize that packing techniques are now extremely sophisticated, and the increased risk of accidental damage while in transit originates almost exclusively from taking the work of art in and out of its container.

Second, the risk of accidental damage in a commercial transit is significant especially when compared with museum transits. It is a sad fact that shippers vary widely in their expertise and handling. To a large extent, museums are shielded from the worst disasters, as they exercise rigorous controls over shipping techniques and, to their credit, use those shippers, who by their record, demonstrate expertise. Unfortunately, insurers are not always so discerning.

It is our experience that the greatest risks for works in transit are those of theft and accidental damage. In discussing these two aspects let us explore ways in which premiums might be reduced.

PRINCIPLES OF INSURANCE

What are the basic assumptions underlying all forms of insurance?

Insurance operates by protecting the individual against financial loss that in the normal course of events results from an unforeseen event. The underlying assumption is one of due care. It is not possible to insure our glass goblet in transit if it is sent unwrapped in a brown envelope through the regular mail service. However, even where due care is exercised there are differing degrees of care, and the more a work of art is protected, the lower the premium will be.

Suppose a magazine-size painting is to be transported across the Atlantic. By accompanying the painting personally, and buying it a seat on the airplane, a curator will give that painting more protection than if it was sent by air freight, and the transit will enjoy a lower premium. Conversely, a shipper who subcontracts packing, delivery, or customs clearance increases the risks of theft and accidental damage, and so the transit should merit a higher premium. It is not unusual for

transits to be subcontracted to many different companies.

Our syndicate recently experienced a loss following a transit from a New York dealer to a London dealer that was routed as follows: shipper "A" packed and delivered a marble table to Kennedy airport; it was flown to Madrid; deposited overnight with freight forwarder "B"; flown to London Heathrow where it was cleared by customs agents "C"; and delivered by subcontractor "D"; not surprisingly, it was shattered by the time it was unpacked. The problem for insurers is that shippers are generally protected from the consequences of their actions by trading agreements such as the British International Freight Association rules, which limits the shipper's liability to 75,000 SDRs, equivalent to about £10,000 per transaction. Without the risk of financial penalties, there is considerably less inducement for shippers to exercise maximum control over the work of art while it is in their care, and to reduce the risks of damage and theft to a minimum. In this environment, it is harder for insurers to reward the diligent and penalize the negligent, and the trend is for premiums to stabilize at a level that accommodates the careless, rather than falling in line with the improving techniques and expertise of the responsible shippers.

INSURING INDIVIDUAL LOANS

Let us explore how this general hypothesis affects works in transit in a museum environment.

In the table discussed earlier—the one that allotted premiums to various risks while in transit—we observed that the risk of accidental damage in transit was significantly greater in the commercial environment than it was in the museum environment. One explanation was that museums exercised rigorous control over shipping standards.

To encourage museums to exercise these controls, it is now common practice for insurers to reward museums by returning a portion of the premium at the end of the year in the event of a good claims record. The Tate Gallery benefits from such a system, which is

not dissimilar from the *No Claims Bonus* that exists in motor insurance. However, this is an unsatisfactory way of alleviating a basic injustice that only works when there are no claims. If losses do arise, then in the long term a museum will be labeled with a bad record when the responsibility more often than not lies more properly with the shipper, whose own claims record will be untainted. Using the analogy of car insurance, it is like penalizing the careful driver who has done no wrong, but has had the misfortune to be driven into by a reckless teenager, and the insurer turning around and saying the careful driver must suffer the penalty while letting the teenager get off scot free. We all expect the insurer to recover damages from the teenager. Why, then, should the art insurer be prevented from recovering from the shipper when the shipper is in the wrong?

To add insult to injury, we must not forget that the museum is a funded body with limited resources, whereas the shipper is paid for its services; paid and yet not responsible for its actions.

Shippers must be more willing to accept the responsibility that is theirs. Then the good shippers would benefit from receiving more business, the bad would wither and, as day follows night, premiums would fall.

INSURING LARGE EXHIBITIONS

Contrast the situation where a museum is making a series of individual loans throughout the year to the "blockbuster" exhibition such as the recent Van Gogh or the forthcoming Rembrandt shows. For the series of loans, the museum will use two or three different shippers from a list; and the transits will be a small part of the shipper's annual turnover, each one being of minor importance on its own. Large exhibitions, on the other hand, generally have one organizer and one shipper per venue.

This is an ideal situation from an insurer's perspective. The shipper will have full control over all exhibits, and its reputation will be on the line.

This ideal situation is reflected in the premiums, which are heavily discounted: the risks of theft and accidental damage are reduced, because the shipper will exercise utmost care to ensure its continued good reputation and record. In many cases part of the premium is only payable in the event that losses are above a given level. All parties benefit from this arrangement. The insurers can quote lower premiums with confidence and therefore encourage further exhibitions; the shipper enhances its reputation by good management and so increases its opportunities for further orders; and the museum has both the convenience of one shipper and the benefit of lower insurance costs. When the spotlight is on them, we can expect the shippers to exercise the maximum possible care to protect the property in their care.

RISK MANAGEMENT

We have seen that insurance premiums are set by drawing on experience of past exhibitions, and by the insurer's perception of different risks for each exhibition as it arises. Considerable attention is given to the security of exhibition sites and the measures taken to protect works of art from thieves and vandals at such venues. Much less care is taken to investigate the circumstances of transits between venues, and this is precisely where insurers fear the worst, as can be seen from the breakdown of premiums.

To a large extent, the different perception of the risks at exhibition sites and in transit is a result of ignorance. A greater knowledge of transit methods could do much to reduce premiums, where the greatest risks are perceived as accidental damage and theft. Insurers recognize that packing techniques in a museum environment are first class, although few insurers could describe those in detail; whereas in a commercial environment packing is frequently inadequate, unsuitable, or just plain careless. Even so, we, as insurers, could still learn more. For example, which mediums are the most liable to damage? Or, what is the optimum way in which to pack a terra cotta horse? When it comes to the handling of works of art, insurers' knowledge is even more sketchy. Who are the best shippers, that is, the shippers used most fre-

quently by museums and approved by national security advisers? Which shippers use which counterparts abroad, and which forwarding agents and customs agents at ports and airports? To what extent are transits accompanied, be it throughout the journey, to the point of loading onto an aircraft, or just to the next subagent? How are works of art cleared through customs? How soon will works of art be collected after they are taken off an aircraft, and when will they be deposited in bonded warehouses to await collection? Which shippers have their own high-security facilities which they use as collection points? In essence, which shippers are professional throughout from the highest manager to the humblest handler?

CONCLUSION

Greater awareness of the hazards of transit and of the measures taken to reduce such risks can do much to reduce premiums for works of art in transit. Lower premiums mean lower costs, more exhibitions will be staged, and more art can be displayed to an increasingly hungry public. This conference, I hope, will do much to disseminate knowledge of techniques, and increase the expertise of shippers and insurers alike.

To museum curators I say this: Share your knowledge of good techniques, educate your insurance brokers, and throw open the doors to your back rooms where the packing is done; tell your brokers which shippers you use, why you use them, and let us hear your horror stories.

To shippers I say: Don't hide behind trading agreements and shipping conventions; take financial responsibility for your actions; stand up proud of your service, proud of your expertise, and shout your record from the rooftops. If you are truly professional, you will command admiration from museums and insurers alike, you will attract lower insurance premiums, and you will prosper while your less careful competitors flounder.

And to insurers, the message is this: Listen and learn; learn about techniques, learn who the true professionals are; and once you have learned, discriminate and price your premiums accordingly; encourage the good and promote truly competitive pricing levels.

If insurance costs can be cut, then exhibition costs will be reduced significantly. All of those involved in planning exhibitions will gain as more and more exhibitions are staged, and the works of art entrusted to our care will be seen by a wider public throughout the world. □

THE ROLE OF THE BRITISH COUNCIL IN THE TRANSPORT OF PAINTINGS

Henry Meyric Hughes

The visual arts department of the British Council arranges some fifteen to twenty major exhibitions overseas each year. These are mainly in collaboration with foreign museums, art galleries, and private foundations. These exhibitions, mostly devoted to contemporary British art, present unique conservation and handling problems. Other highly publicized events such as the 1986 *Treasure Houses of Britain* exhibition in Washington and the 1988 exhibition *Masterpieces of British Painting* at the Prado, Madrid comprise work from earlier periods with the usual associated difficulties.

Our loan exhibitions are shown in Europe, Japan, Australia, and other areas of the world where there is sophisticated, well-established museum infrastructure, high security standards, environmental control, and a reliable level of curatorial and technical expertise.

Prior to agreeing on a project as part of our program, we carefully consider any request and its context. Like most other countries, Britain makes numerous cultural exchange agreements with foreign countries, and in practice relies heavily on direct negotiation at a professional level with our overseas partners. This is provided by our specialist visual arts advisory committee, comprised of many directors of leading national institutions, including the Tate and National Gallery. The Council is aware that lenders will not support a frivolous or politically expedient exhibition. Proposals require confirmation concerning historical validity and how they will enhance the reputation of British art internationally.

At times our work is often parallel to that of curators at individual museums in North America and western Europe who closely monitor their projects and earn recognition for their specialized judgment and flair. Often, the Council is asked to assist with projects involving numerous artists or many lenders and has a coordinating role. Two examples are the recent exhibition of work by sixteen contemporary artists, *British Art Now*, which toured six cities and Japan earlier this year, and the forthcoming exhibition of Victorian paintings at Munich's Neu Pinakothek and the Prado in Madrid.

We depend on the continued goodwill of lenders. We seek loans from national, public, and private collections, artists, and their dealers. We must demonstrate and maintain our record of impeccable care and responsibility from each potential source of loans; a single error or disaster could irreparably damage our reputation. In addition to requests for loans from heavily used national collections such as those of the Tate Gallery or Arts Council, the Council's own collection must also be readily available for exhibition.

Our exhibitions staff comprises six specialist exhibition officers and three assistants, together with full research facilities and administrative and technical support. Exhibition officers, reporting to the deputy head of the department or the director, act as project leader and work closely with the staff of the receiving institution, lenders, artists, and the experts appointed to collaborate on the catalogue for the exhibition. Some operations are vastly complicated and expensive and it is

not possible to describe the responsibilities in a generalized manner. Because some countries where we have exhibitions lack appropriate materials and equipment, we aim to be entirely self-sufficient.

The visual arts department has a high-security paintings storage facility and a well-equipped, modern workshop. Our technical staff is accustomed to handling diverse materials, ranging from paintings and sculpture, to ceramics, furniture, and jewelry. The type of packing materials used depends largely on the particular method of transport and the number of venues to which an exhibition is sent, but the aim is to match or exceed standards set by leading national and international institutions. The Council's light blue, wooden crates with black stencilled lettering on the sides are instantly recognizable to professionals around the world.

Everything possible is done to comply with the wishes of lenders but at times the Council receives conflicting advice on the merits of using wooden cases packed with wood wool or conversely, using aluminum Dri-Style. A confident relationship with freight agents is essential and the Council carefully considers using the most suitable agent for a particular exhibition shipment. One of the problems of working outside western Europe, including the United States, is depending on a second party as forwarding agent. There are only a few agents, even within western Europe, who have sufficient resources and expertise to satisfy our rigorous criteria for overland transport.

Negotiations on transport, specifications for handling by agents and indemnity management, are handled by the Council's administrative officer who performs functions similar to a museum registrar. Indemnity provides a guarantee, endorsed by Her Majesty's Government, to the British Council giving comprehensive insurance for the value declared by the owner and accepted by Her Majesty's Treasury, provided all conditions for the safe handling of work are guaranteed by the Council. The British Council's overseas network offers inestimable advantages; this includes assistance from colleagues in ninety different countries, most of whom enjoy either full diplomatic privileges or the support of the local embassy or high commission. The benefits of working for an official government agency include the ability to maintain working relations with customs and minimize the risk of delays in handling consignments, which is particularly important in unnecessarily exposing art work to the hazards of a damp warehouse or a sun-baked runway.

Choosing the appropriate route and method of transport is one of the most difficult aspects involved in preparing an overseas exhibition and has important budget implications. For this reason, it is important to obtain information early in the planning process about lenders' requirements. Currently, freight costs represent about sixty percent of an exhibition budget, principally because of high security needs and technical requirements for moving large and valuable items. Air freight provides shorter transit times and usually a relatively smooth journey, but may be subject to disruption by unexpected changes of schedule, flight cancellation through strikes, weather problems, or general disorganization. Conversely, road transport, though subject to the hazards of unreliable traffic conditions, weather, and potential breakdown, allows Council escorts to retain total control and supervision of the freight. Comparatively, airports represent probably the most hazardous point of the journey, with the risks focused on the handling and loading of pallets.

In the case of the Old Masters exhibition in the Prado in 1988, the Council pioneered the method of driving air-ride environmentally controlled trucks directly onto a couple of Heavilift turboprop airplanes. The Tate Gallery monitored this operation, which gave a favorable preliminary report on the low level of vibration inside the packing cases. A final assessment of the success of this procedure is still pending. This new technique for handling artwork proved expensive. The Prado exhibition return was estimated at £20,000 by conventional surface route as opposed to £100,000, the cost using the Heavilift aircraft.

It is vital to be able to assess accurately the packing requirements for each project, e.g. the Council's recent participation in the Kunst Europa project in Germany, which required the Council to pack artwork by thirty-seven contemporary British artists for a single showing in nine venues. Wherever possible, the staff uses simple traveling frames. Conversely, we constructed sturdy, lined, and slotted cases to use for over thirty circulating exhibitions of work from the Council's permanent collection that toured worldwide over a period of years. With their captive bolts and heavily reinforced sides, these cases are heavy duty and have been designed to be virtually immune to the broad spectrum of weather and handling.

The Council's readiness to give curators and conservators an opportunity for overseas travel while couriering their loans to an exhibition generates goodwill and serves to foster direct links between institutions at a professional level. Their assistance however, incurs expenditures such as courier airfares and expenses which represent an increasing portion of the budget. They can impede efficient transport, however, if they have not received adequate training for the task, are not briefed by their own institution on the requirements of the specific assignment, show a selfish or inflexible preoccupation with guarding the artwork under their care, or make numerous and claimant demands on others. A competent courier should know the technical requirements of the task, including working practices of airlines, transport agents, and customs officials; demonstrating flexibility in dealing with unanticipated problems; exercising an appropriate degree of authority in a difficult situation; and displaying sensitivity in dealing with host institutions. The role of a courier should be taken seriously, and it is hoped that this conference provides an opportunity for principles and techniques to be revised for standard practice for couriers.

Documents that provide clear divisions of administrative and financial responsibilities are being emphasized. While these documents may not be strictly enforceable, they serve to emphasize each partner's responsibilities in their respective areas. Heightened concern should be initiated during the packing phase and subsequent transport at the conclusion of the show. The host institutions frequently lose interest at this stage since their attention is diverted to the next project; it is useful to remind them that their contractual obligation does not end until the moment when the consignment leaves their premises.

As with other related organizations, the Council has been pressured to seek commercial sponsorship as a means of supplementing strained financial resources. It may seem that airlines are an obvious source of sponsorship however negotiations must ensure that the organization will not be offered terms that are already available through a reliable transport agent. Conditions imposed by airlines in relation to the choice of route, timing of travel, movement of couriers, and the shipment of material in a single consignment may sometimes negate the value of the agreement.

The Council, through its overseas offices, monitors and assesses circumstances of local situations that might jeopardize a project—these may include political instability or organizational events such as the sudden dismissal of a museum director. In this way, the Council is able to exercise as complete control as possible for the valuable items under its care.

While transport measures have improved, more is needed. The future will no doubt bring more stringent conservation measures, and more sophisticated packing and handling within growing constraints imposed by rising prices and an increasing demand for services.

Those hoping to compete and survive will need to invest in the appropriate equipment, develop new technology, and learn to properly apply them. This will most likely cause lenders to rely on the service of highly specialized art shippers.

The political changes within the European Economic Community will have a profound impact on customs, taxes, regulations, heritage guidelines, and movement of art work within continental Europe.

The most successful strategy in dealing with these new considerations remains essentially unchanged: know your partners; keep abreast of all details and arrangements; plan meticulously in advance; retain full control over every stage of the operation; and be willing to pay for required expertise. ☐

THE BORROWER—RISK ASSESSMENT AND RESPONSIBILITIES

William R. Leisher

ABSTRACT: *Two of the most important elements of the agreement between lender and borrower are the risk assessment and loan agreement. They formally articulate specific considerations that are essential in ensuring the safe transport of works of art.*

The conservator's goal of preservation is put at risk the moment a picture is hung on the wall. Handling, moving, and exhibiting pictures involves a series of complex decisions balancing the responsibilities of preservation against the risks of damage. Each decision can have grave consequences. The conservator's reaction to such responsibilities is to envelop the work of art with protective measures. It is a desire, however, that must be tempered by respect for the artist's intention and the visual integrity of the work. Allowing for appropriate environmental conditions, conservators would generally agree that most paintings would be better served if they were left on the wall and not disturbed. It is no wonder that conservators endorse Polonius' advice to Hamlet to "neither a borrower nor a lender be." The importance and difficulty of evaluating and minimizing risks are greatest in the transaction between lender and borrower of a work of art.

The borrower's responsibility is to ensure that the painting is shipped to the museum or exhibition site and returned to the lender in exactly the same condition as it was when it departed. The document that shapes the course of events during the painting's journey is the loan agreement. It is a document signed by the lender that states the conditions under which the loan is to take place. Among other things that it should address are the issues of packing, transport, the ne-

cessity of couriers, special handling, condition reports, environmental requirements, glazing, framing, hanging devices, installation, supervision, and crate storage. The borrower must abide by this agreement.

Requests to the lender to make exceptions to the agreement should not present increased risks to the painting. Issues such as variations from appropriate and prescribed environmental standards, or the removal of glazing, the modification of frames and hanging devices, and reframing must be settled before—not after—the painting arrives at the exhibition site. Occasionally lenders specify only the dates of the loan, assign the responsibility of the costs and insurance to the borrower, and leave the remaining conditions unstated. It is not a license for the registrar, curator, or exhibition designer to ignore acceptable standards of care and preservation. It is expected that the borrowers exercise the same care and precautions as they would with their own collection.

Occasionally paintings arrive for exhibition that, in the conservator's opinion, are badly packed, or because of the nature of the painting's construction and materials or fragility, should not have been lent. The borrowing institution has an obligation to make responsible loan requests and to see that the transaction is safely carried out. An example of a violation of this trust is an institution that is unwilling to lend certain materials or

has a general ban on lending works such as panel paintings, pastels, or certain twentieth-century paintings from their own collection, yet, they are willing to ask another institution or collector to loan theirs. This happens when there is little communication or cooperation between conservator, registrar, curator, and director. The conservator, then, must make the best of a bad situation to protect the condition of the artwork.

Much of the damage and high risk that paintings endure in transit and exhibition can be eliminated or minimized when the curator invites the registrar and conservator to participate in forming the initial exhibition checklist. Unfortunately, it is an invitation that rarely occurs. Early involvement in the selection of paintings for exhibition allows the conservator to assess the appropriateness of a request concerning condition and the institution's ability to safely transport the work.

The conservator and/or the registrar may need to examine the painting or communicate with their counterparts to determine the painting's condition or the need for special handling or specially designed packing cases. Valid environmental requirements can be determined by joint assessment of borrower and lender. Too often the lender requires the standard 50% ± 5% RH with a demand to review hygrothermograph tapes for the previous year without documenting the necessity or accuracy of their request by supplying the borrower with their own hygrothermograph tapes relating to the painting's home environment.

The registrar also has the opportunity to explore the limitations of types of transport, possible schedules, access routes, and door dimensions, all of which become important when considering moving large-scale paintings, especially twentieth-century art. It is fervently hoped that the decision to eliminate important but problematic paintings through the above process is the result of mutual agreement and goals, and not the result of adversarial dynamics.

Institutions organizing traveling exhibitions become lenders as well as borrowers. The borrower must negotiate loan agreements with individual lenders as well as represent all of the lenders in establishing the conditions of the exhibition for the participating museums and galleries. Condition reports, crating, shipping, environmental control, etc. are developed by the staff of the organizing institution.

At the first exhibition site, modifications to packing crates and hanging devices (with the lender's consent) may be required. While the packing is satisfactory for a single to/from shipment, it may not be worthy of withstanding the wear and tear of four to six exhibition stops. The first site is also an opportunity to fine-tune environmental requirements and control and to work out handling techniques that may be used for special works by the succeeding museums/galleries in the exhibition circuit.

It is the pre-loan agreement assessment between lender and borrower that, perhaps more than any packing technique or material, minimizes or eliminates damage and reduces risks. Damage occurs when paintings that are too fragile for loan are included in traveling exhibitions. Risks increase with the addition of each exhibition site. Paintings are damaged by over-designed, complex packing schemes where the painting is threatened by the very act of packing and unpacking. At the other extreme are paintings shipped wrapped only in corrugated paperboard. The best packing methods are typified by well-thought-out simplicity. Large-scale twentieth-century paintings are often damaged because the weight and mass of traditional double crating make them impossible to handle. Lack of substantial hardware for secure hand holds is another serious problem. By far, the most serious threat to paintings in transit reflects lack of supervision and poor handling. All the time and effort in research and development of material and crate design to protect a painting can become meaningless in five minutes of unsupervised handling of a large-scale twentieth-century painting by too few workers in an air cargo warehouse. No high-tech packing method will guarantee the absence of damage. Obviously, a painting must be adequately pro-

tected by the best materials and techniques available, but the loan agreement is the most important factor in reducing risk of damage. Many paintings are shipped every day without damage but that fact does not eliminate the risks, which is what both the borrower and the lender must assess before an agreement to lend is reached. □

A CIRCULAR SLIDE RULE FOR PROTECTIVE PACKAGE DESIGN

Paul J. Marcon

ABSTRACT: *One of the greatest hazards an item will face during shipment is potentially damaging levels of shock. Some of the most severe shocks that are likely to occur during shipment are usually the result of accidental drops or mishandling. Routine handling operations such as stacking, loading, and unloading can also produce significant and potentially harmful levels of shock. In order to protect items from damage, design procedures and performance data for cushioning materials are available for use. The design procedures involve using tables, interpreting graphs, and performing repetitive calculations. The circular slide rule described in this paper is based on common design methods and procedures, and frees an art packer from the tasks mentioned above. With the help of the slide rule, a packer can quickly select a cushioning material that will provide a quantifiable level of shock isolation by dialing the weight of a package, the weight of the object to be packed, and the objects' surface area. This paper provides a description of the slide rule and sample applications for its use.*

PROTECTIVE PACKAGING

The design of protective packaging for artifacts is a topic of common interest to museums and art galleries. Many institutions in North America, Europe, and elsewhere participate in lending programs that involve national and international art shipments. The high value and often fragile nature of artifacts make effective cushioning an important consideration in protective package designs.

Designing cushions for shock isolation according to common design procedures requires the following information:

(a) the environmental hazards that are likely to be encountered during shipment;

(b) the sensitivity of an item to shock, otherwise known as the fragility rating; and,

(c) the performance characteristics of cushioning materials.

The packing literature already provides information on shipping hazards and detailed information on the properties of cushioning materials is available from cushion material manufacturers and other sources.[1] The major limitation in the design of protective packages for artifacts is the lack of accurate information on shock fragility levels. This situation is further complicated because common fragility test procedures are destructive and, therefore, unsuitable for fragility assessments of actual artifacts.

Experimental research on artifact fragility is presently in progress at the Canadian Conservation Institute and elsewhere. As this research progresses, a stronger basis for the performance requirements of protective cushioning will become available. Meanwhile, three conservative approaches to cushion design are possible despite the limitations imposed by a lack of fragility data.

Optimized Designs

Modern cushioning materials are capable of providing extremely high levels of protection. Many institutions pay premium prices for these materials but do not obtain the best performance possible. An optimized design involves selecting the most appropriate mate-

rial for an application and loading the material in a way that provides the best possible degree of shock isolation. Interestingly, this approach can often yield significant material savings plus improved shock abatement.

Fragility Estimates

The fragility levels of a variety of items have been measured.[2] When the fragility of an object is unknown, it can be cautiously estimated by inference to other fragile items. While there is always a certain degree of risk associated with inferred estimates, they are usually conservative and often lead to an overdesigned cushioning system.

Experience

The experience of institutions and individuals shipping many collections can be useful sources of information if fragility data is unavailable. By studying packing methods that provide satisfactory performance and by working out the isolation levels of these packages in relation to their total weight, an approximate fragility guideline can be obtained for a given class of artifacts.

SLIDE RULE

The slide rule is illustrated in Figure 1. It measures 19 cm (7.5 in.) in diameter and is comprised of three disks. The three disks are illustrated in Figures 2–4 with labels that identify the features of each disk. The slide rule is based on standard cushion design procedures that involve using cushioning curves. Calculations are performed using logarithmic scales.

The Lower Disk of the slide rule is removable and provides cushioning data for seven different resilient materials. The information contained in one lower disk is roughly equivalent to the information contained in 168 dynamic cushioning curves.

When designing a cushioning system with the slide rule, the performance of seven different materials can be simultaneously compared without referring to numerous graphs or performing repetitive calculations. The

slide rule is based on cushioning curves obtained from *MIL-HDBK-304B*.[3]

Cushioning Curves

Cushioning curves are used by commercial and military package designers to quantify the degree of shock isolation that a material will provide from a specified drop height as a function of the load on the cushion. This load is the force per unit area on the cushion and is often referred to as the *static load* or *static stress*. Applying the correct static load to a cushion is an important design consideration.

If the static load is excessive, it may cause an item to bottom-out on impact and to strike the inside of a container. Excessive static loads can also cause a considerable loss of cushion thickness over a relatively short time.[4] If this loss is great enough, the resulting looseness inside a package will then lead to reduced cushioning efficiency.

At the other extreme, if the static load is insufficient, a cushion may not compress adequately on impact. If this happens, enough shock can be transmitted through the cushion to damage a highly fragile item. The correct working load ranges for different cushioning materials are built into the slide rule. An art packer can avoid extreme load conditions by working within the colored load ranges that appear for each material on the slide rule. Within these load ranges, quantifiable levels of shock isolation can be obtained.

SLIDE RULE DESCRIPTION

A description of the slide rule follows with two sample applications for its use.

TOP DISK (See Appendix for Figures 2–6)

Package Weight Table

The Package Weight Table allows a packer to predict the severity of handling shocks based on package weight. The anticipated shock severity is expressed as a free fall drop from a probable drop height, and each drop height is assigned a shock level code from A to F.

Explanations for this code are in the sections that follow.

The drop heights listed in the Package Weight Table are based on comprehensive studies that have verified that shock levels can be predicted on the basis of package weight.[5] Typical handling methods for the weight ranges in the Package Weight Table are listed in Table 1.

Isolation Level Table

The levels of protection that can be built into a package are listed in the Isolation Level Table. The six isolation ranges in the table correspond to six fragility categories that are frequently used in commercial and military packing literature. The isolation levels are expressed in G units where one G equals the acceleration due to gravity. The best level of protection is 1 with a shock isolation range of 15 to 25 G's. This degree of protection is usually provided for items considered extremely fragile, such as aircraft altimeters and precision instrumentation. A typical level of protection for commercial glassware is level 3, and level 4 is considered adequate for an av-erage glass bottle. Rugged items such as machinery and castings can usually receive adequate protection in packages designed to an isolation level of 6.

Object Weight Scale

The Object Weight Scale (W) represents the weight of the object to be packed. If braces or supports are attached to the object, their weight should be added to the object weight. There are two weight scales printed on the Top Disk. The white scale units are in kilograms (kg) and the units on the shaded scale are in pounds (lb.). This convention is consistent for all of the slide rule scales i.e., metric units on the clear scales and English units on the shaded scales.

Runner

A clear plastic Runner is attached to the upper disk by means of a metal eyelet. An indicator line on the Runner intersects the object weight and surface area scales. When the Runner is set to the object weight, the Top Disk can be rotated without changing this

TABLE 1

PACKAGE WEIGHT RANGE	HANDLING METHOD	DROP HEIGHT
0-5 kg 0-10 lb.	1 person throwing	120 cm 48 in.
5-10 kg 10-29 lb.	1 person throwing	105 cm 42 in.
10-20 kg 20-50 lb.	1 person carrying	90 cm 36 in.
20- 45 kg 50-100 lb.	1 person carrying	75 cm 30 in.
45-115 kg 100-250 lb.	2 people carrying	60 cm 24 in.
115+ kg 250+ lb.	light to heavy equipment handling	45 cm 18 in.

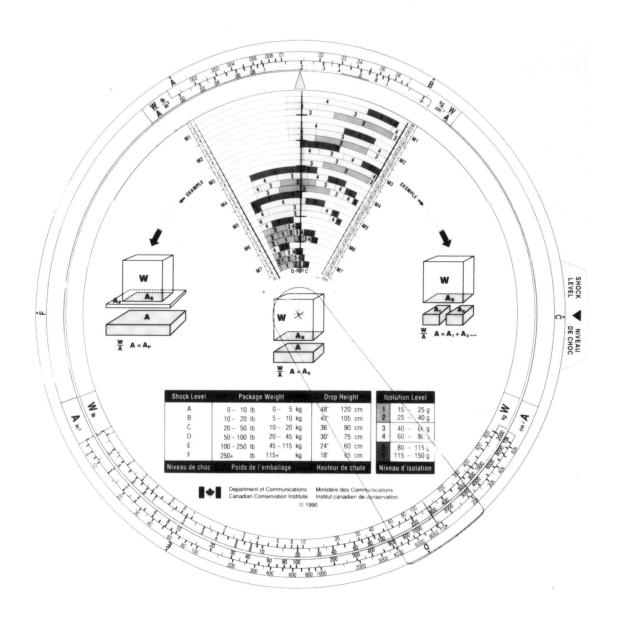

FIGURE 1

weight setting. The significance of this feature will be apparent in the application examples that follow.

Isolation Range Indicator

The Isolation Range Indicator is the vertical line printed on the clear 120° plastic window of the Top Disk. This indicator simultaneously shows all of the material types and thicknesses that can be used to solve a packing problem. The arrow at the top of the Isolation Range Indicator points to the current value of the static load on a Static Load Scale that is printed on the Middle Disk. When the Top Disk is rotated, the Isolation Range Indicator will cross numbered Isolation Level Segments on the Lower Disk. These segments are visible through the 60° Window in the Middle Disk. For easy reference, small lines perpendicular to the Isolation Range Indicator help emphasize the Lower Disk divisions according to material type.

Figures

Three figures are printed on the Top Disk. The Figures illustrate the effect on the output solutions of rotating the Top Disk. The center Figure illustrates that if the area (A) dialed into the slide rule corresponds to the surface area (As) available on a given side of an object (A=As), then the solutions provided by the slide rule are for total area coverage or encapsulation.

If the Top Disk is rotated clockwise from this point, as indicated by the arrow near the right-hand figure, the cushion area (A) will be reduced and will be less than the surface area (As).

If an object is heavy in relation to its surface area, the load may not be sufficiently distributed and may apply excessive pressure on the cushion. When this is the case, the available surface area can be projected onto a larger surface (Ap). This type of solution is obtained by rotating the Top Disk counterclockwise from the encapsulation position described above. The area of cushioning material (A) for encapsulations, pads, or projections is indicated where the indicator line on the Runner intersects the Area Scale on the Middle Disk.

MIDDLE DISK (Figure 3)

Shock Level Codes

The Shock Level Code is determined by weighing (or estimating) the total package weight (including contents), and referring to the Package Weight Table on the Top Disk. Codes A to F correspond to the various package weight ranges printed along the outer circumference of the Middle Disk. By aligning the Shock Level Tab of the Lower Disk with a Shock Level Code, the appropriate Shock Level Sector will be revealed through the 60° Window in the Middle Disk.

Area Scale

The Area Scale corresponds to the surface area on one side of an object. The Area Scale also represents cushion area. At the beginning of a problem, the Runner is aligned with the object weight, then the Top Disk is rotated until the indicator line on the Runner intersects the object surface area on the Area Scale. The solutions that appear along the Isolation Range Indicator are for cushions that are the same size as the surface area. If this is the desired solution, a suitable material and thickness can be identified where an appropriate Isolation Level Segment (see description for the Lower Disk) intersects the Isolation Range Indicator. Otherwise, the Top Disk can be rotated either clockwise or counterclockwise, and the cushion area will be either decreased or increased accordingly.

When the Top Disk is rotated and the Isolation Range Indicator identifies a suitable material type and thickness, the cushion area can be read where the indicator line on the Runner intersects the Area Scale. The units on the white Area Scale are in square centimeters, and the area units on the shaded Area Scale are in square inches.

Static Load Scale

The Static Load Scale shows the result of di-

viding the object weight (W) by the cushion contact area (A).

The static load, W/A is indicated by the arrowhead above the Isolation Range Indicator on the Top Disk. The units for static load are in kilograms per square centimeter on the white scale, and in pounds per square inch on the shaded scale.

60° Window

A 60° Window displays the Shock Level Sector for the current Shock Level Code setting. Seven cushioning materials are represented by codes M1 to M7 on either side of the window. Material codes have been used because the Lower Disk is removable. This allows the slide rule to be used for an unlimited number of cushioning materials. The materials corresponding to codes M1 to M7 are identified on the back of the Lower Disk. The thickness of each material is indicated by the column of numbers printed next to the material codes on the Middle Disk. Metric thickness measurements (i.e., 25 mm, 50 mm, 75 mm, 100 mm) appear on the left-hand side of the 60° Window, and English thickness measurements (i.e., 1 in., 2 in., 3 in., 4 in.) are printed on the right-hand side of the 60° Window.[6]

Sample Problem

On the lower portion of the Middle Disk are two examples. One is printed in English, the other in French. During normal operation of the slide rule, the examples are covered by the Top Disk. The examples can be revealed by rotating the Top Disk in the direction of the arrow next to the Example label of the desired language. In the examples, the input data for the sample problem is printed above the gray arc, and three possible solutions using one material (M6 of disk D-001) are printed below the arc. This sample problem can also be solved on the actual scales of the slide rule.

LOWER DISK (Figure 4)

Shock Level Sectors

The Lower Disk is divided into six 60° Shock Level Sectors. Each sector contains shock isolation data for a specific drop height for seven different materials. There is presently one Lower Disk available for the slide rule. This disk is identified as disk D-001, and it contains data for seven resilient materials frequently used in museums and art galleries.

Material Thickness Bands

Each cushioning material is represented by a group of four bands in a given Shock Level Sector. A band corresponds to one thickness of a specific material. Materials and thicknesses are identified by the material codes (M1 to M7) and numbers that appear along the borders of the 60° window of the Middle Disk.

Isolation Level Segments

Each Material Thickness Band is subdivided into Isolation Level Segments. The segments are numbered according to the ranges listed on the Isolation Level Table of the Top Disk. Moving along a Material Thickness Band shows the shock isolation that a given type and thickness of cushioning material will provide over a range of static load values. The Isolation Level Segments are numbered where space permits. Unnumbered segments are separated by vertical divisions and are understood to contain the next number in the increasing or decreasing numerical sequence. On the actual slide rule, the Isolation Level Segments are colored. Level 1 and 2 segments are green, segments for levels 3 and 4 are yellow, and segments for levels 5 and 6 are orange. White sections on the Material Thickness Bands identify load conditions that should not be used because they are outside the normal working load range for the cushioning material.

Shock Level Tab

The tab on the Lower Disk is used to set the slide rule to the correct Shock Level Code for a particular problem. The correct shock level can be determined by referring to the Package Weight Table on the Top Disk. When the Shock Level Tab is aligned with a Shock

Level Code on the Middle Disk, the appropriate Shock Level Sector will be displayed in the 60° Window of the Middle Disk.

Material Identification Table

A Material Identification Table is printed on the reverse side of the Lower Disk (see Figure 5). The table lists material types and, whenever possible, examples of commercially available materials.

SAMPLE APPLICATIONS

Example 1—Foam Encapsulation for an Object of Known Fragility

The square object in Figure x weighs 9 kg (20 lb.), has a fragility rating of 40 G's and will be shipped in a crate that weighs 23 kg (50 lb.). A 50 mm (2 in.) space is available for packing material between the object and the inner surface of the crate. The surface area on all sides of the object is 3,000 cm^2 (480 in.2). Find a foam material that is capable of supporting the entire surface area of the object while providing a required shock isolation.

(a) The total package weight is 32 kg (70 lb.). According to the Package Weight Table on the Top Disk of the slide rule, the probable drop height for the package is 75 cm (30 in.). This corresponds to a shock level of D. By rotating the Shock Level Tab on the Lower Disk to shock level D on the Middle Disk, the Shock Level Sector for a probable drop height of 75 cm (30 in.) will be displayed in the 60° Window of the Middle Disk.

(b) The object weight is 9 kg (20 lb.). Set the clear Runner to 9 kg on the white Object Weight Scale (or 20 lb. on the gray Object Weight Scale).

(c) The surface area on all sides of the object is 3,000 cm^2 (480 in.2). Rotate the Top Disk until the indicator line on the Runner intersects the Area Scale at 3,000 cm^2 (480 in.2).

(d) A suitable material can now be identified where the Isolation Range Indicator crosses an Isolation Level Segment that is numbered 2 or lower. Because there is only a 50 mm (2 in.) clearance between the painting and the container, the Isolation Level Segment that is chosen must lie on a Material Thickness Band that corresponds to a 50 mm (2 in.) material thickness.

(e) The slide rule solutions for this problem are illustrated in Figure 6. From this diagram, observe that a 50 mm (2 in.) thickness of either material M6 or M7 will provide the required support and shock isolation. Note also that the load conditions for this problem lie outside of the normal working ranges for materials M1, M2, and M3. The final solution is illustrated in Figure 7.

The preceding example shows that the initial solution provided by the slide rule is for a foam pad that is the same size as the surface area available on a given side of an object. It also shows the importance of appropriate material selection for effective cushioning performance. If materials M1, M2, or M3 had been selected, they would have been insufficiently loaded, and drops from the design drop height of 75 cm (30 in.) would have transmitted shocks well in excess of 150 G's to the packed item.

Example 2—Corner Pads for a Canvas Painting

A square canvas painting weighs 7 kg (15 lb.), and has the dimensions shown in Figure 9. A crate has not yet been constructed, but the weight of the complete package (including the painting) has been estimated at 18 kg (40 lb.). The fragility of the canvas painting is not known, but major lending institutions have observed that packages designed for a shock isolation level of 3 for normal design drop heights are performing well for this type of painting. It is best then to design corner pads that provide a protection level of 3 using the minimum possible thickness of cushioning material.

(a) For good support, the pads will be designed to cover 50% of the surface area on all sides of the frame. The total foam contact area on each side of the painting will then be 200 cm^2 (32 in.2).

(b) The total package weight is estimated at 18 kg (40 lb.) this corresponds to a Shock Level Code of C.

(c) Set the Runner to 7 kg (15 lb.) on the Object Weight Scale.

(d) Rotate the Top Disk until the indicator on the Runner intersects the desired pad area of 200 cm^2 (32 in.2) on the Area Scale.

(e) Since the objective is to find a material that provides an isolation level of 3 using the minimum possible material thickness, the thinnest material that provides an isolation level of 3 will be chosen. The slide rule solution for this problem is illustrated in Figure 6.

When referring to this diagram, observe that a 50 mm (2 in.) thickness of material M3 provides the desired solution. The final corner pad solution for this problem is illustrated in Figure 9. By referring to the slide rule settings in Figure 8, note that if material M7 was used for the corner pads, the load on the cushions would not be within the working range of this material, and the painting could bottom-out and strike the inside of the container if the package was dropped from the design drop height of 90 cm (36 in.).

Note: When designing individual pads, check to ensure that the minimum pad dimension is at least 1.33 times wider than the material thickness. This will avoid pad designs that may be prone to uneven compression or buckling on impact.

CONCLUSION

The circular slide rule for protective package design is based on cushioning curves and on commonly used design principles. It has been developed to allow an art packer to apply these principles without having to interpret tables and graphs or having to perform repetitive calculations. Please note that the slide rule and the cushioning curves it is based on are only able to *predict* the performance of cushion designs. The actual performance of the cushions may vary due to differences between the experimental conditions under which the cushioning data is ob-

tained and the actual conditions existing inside a package. With this limitation in mind, the slide rule can help an art packer to achieve approximate quantifiable levels of shock isolation, and it can serve as a guide to the optimum selection and use of cushioning materials for protecting fragile collections during shipment. ☐

AVAILABILITY

The graphic design and layout of the slide rule is now complete, with production planned for 1991, For further information on the slide rule, contact the author or:

CANADIAN CONSERVATION INSTITUTE
DEPARTMENT OF COMMUNICATIONS
INFORMATION AND EXTENSION SERVICES DIVISION
1030 INNES ROAD, OTTAWA, ONTARIO
CANADA K1A 0C8
TELEPHONE (613) 998-3721
FAX (613) 998-4721

APPENDIX — FIGURES 2–6

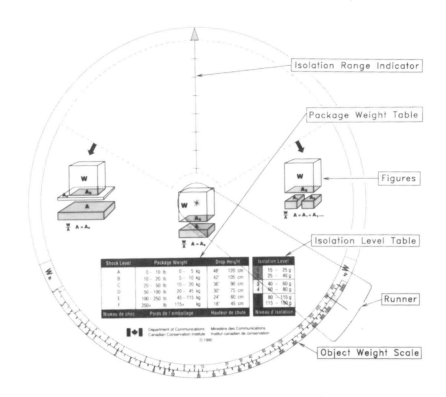

Isolation Range Indicator

Package Weight Table

Figures

Isolation Level Table

Runner

Object Weight Scale

FIGURE 2

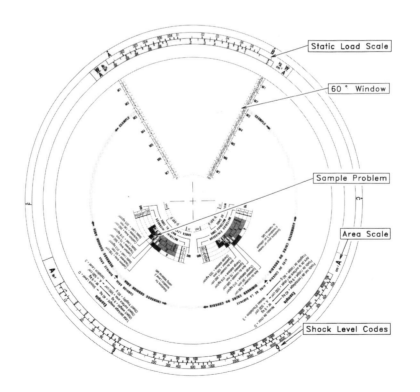

Static Load Scale

60 ° Window

Sample Problem

Area Scale

Shock Level Codes

FIGURE 3

102

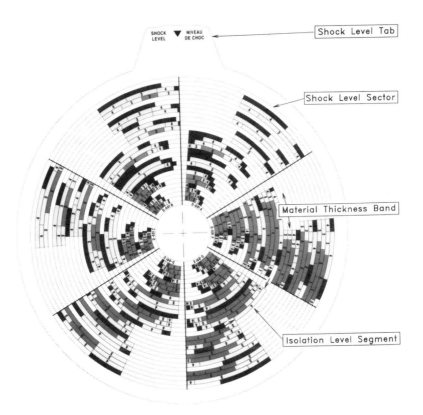

FIGURE 4

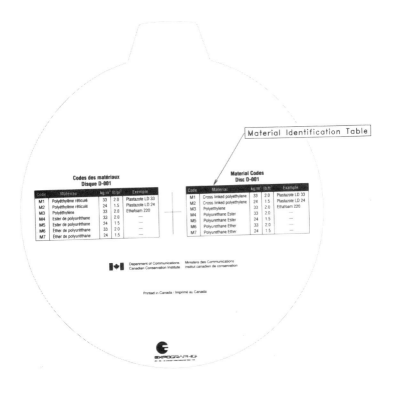

FIGURE 5

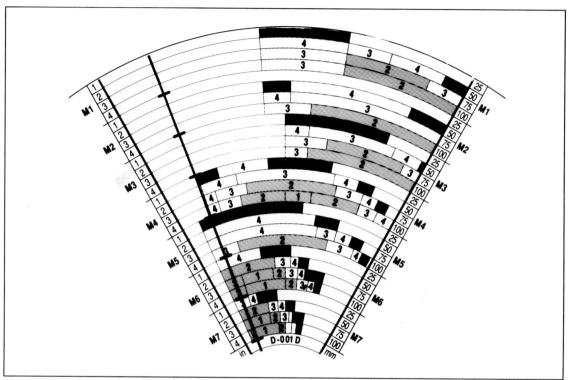

FIGURE 6

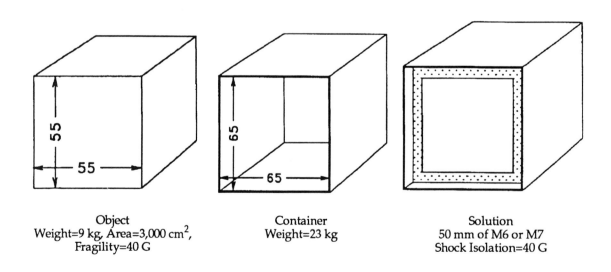

Object
Weight=9 kg, Area=3,000 cm^2,
Fragility=40 G

Container
Weight=23 kg

Solution
50 mm of M6 or M7
Shock Isolation=40 G

FIGURE 7

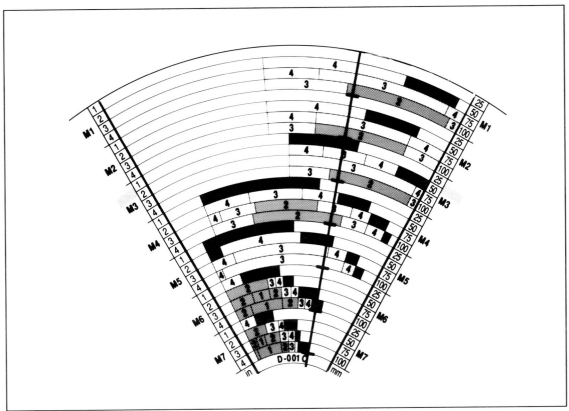

FIGURE 8

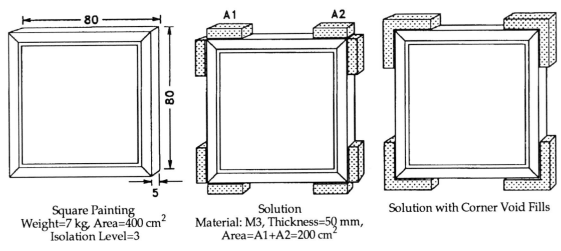

Square Painting
Weight=7 kg, Area=400 cm²
Isolation Level=3

Solution
Material: M3, Thickness=50 mm,
Area=A1+A2=200 cm²

Solution with Corner Void Fills

FIGURE 9

NOTES

1. *Military Standardization Handbook, Package Cushioning Design* MIL-HDBK-304B, U. S. Department of Defense, Washington, DC (1978).

2. *Packaging and Packing: Detailed Procedures for Bases/Stations/Units,* CFP 187(3), DND, Canada Department of National Defence (1977), 6A-2.

3. *MIL-HDBK-304B* 1978, section 2.

4. For normal design loads, a 10% to 15% loss in cushion thickness can be expected. This is usually accounted for in package designs. If excessive loads are applied on a cushion, a loss in thickness of up to 40% can occur in as little as thirty days.

5. F. E. Ostrem and W. D. Godshall, *An Assessment of the Common Carrier Shipping Environment* General Technical Report, Forest Products Laboratory, FPL 22, USDA, (Madison, 1979), 4-10.

6. Millimeters have been used on the slide rule for metric cushion thickness measurements. This is consistent with the metric units used by cushion material manufacturers in product descriptions and for cushion performance data.

SHOCK, VIBRATION, AND PROTECTIVE PACKAGE DESIGN

Paul J. Marcon

ABSTRACT: *This paper provides an overview of the basic concepts, quantities, and definitions associated with protective package design for shock and vibration isolation. Package design considerations for canvas and panel paintings are also provided.*

INTRODUCTION

The design of protective packaging involves three considerations:

(a) the sensitivity of an object to the conditions that occur during a shipment,

(b) the severity of the conditions that are expected during a shipment, and;

(c) the performance characteristics of packaging materials.

When the conditions that occur during a shipment exceed the ability of an object to withstand these conditions without damage, protective packaging can be designed to provide the required degree of protection.

The conditions of shock and vibration are of particular interest when designing a protective package because they are generally considered to have the greatest damage potential. The following provides an introduction to the basic theory of shock and vibration isolation for packages. The cushion design procedures and shipping environment descriptions that can be applied to package design for paintings are reviewed. Basic cushion design guidelines based on the structural characteristics and sensitivities of canvas and panel paintings are provided along with methods of reducing the vibration inputs to paintings during shipment.

SHOCK

Mechanical Shock Fragility

The maximum shock level that an object can withstand before damage or some unacceptable alteration of the object occurs is called a shock fragility rating.[1] This is a basic physical characteristic of the object, which determines the performance requirements of a protective package. Object fragility is measured in G's which are multiples of the acceleration due to earth's gravity. For example, the fragility rating for a glass bottle is approximately 60 G's.

When an object is subjected to shock, the impact force is equal to the object's mass times the peak or maximum acceleration level of the applied shock.[2] It is, therefore, apparent that high shocks having high acceleration levels can impart large and potentially destructive forces on objects. If an item is subjected to a shock of 500 G's, then the peak impact force applied to the object can reach a level that is equal to five hundred times the force of gravity.

For package design purposes, the highest shocks that are expected to occur are the result of accidental drops of mishandling. The shock level experienced by an object in the event of an accidental drop depends on the hardness of the object, the hardness of the impact surface, and the height of the drop (which determines speed of the object at the time of impact). If the glass bottle mentioned

above is dropped onto a concrete floor, shocks in excess of the bottle's 60 G fragility rating can be expected for drop heights above three inches.[3]

Shock Fragility Assessment

Experimental fragility estimates for objects can be obtained by different methods. Experimental fragility assessments based on damage boundary theories require the use of programmable shock machines.[4] These tests account for the elasticity within objects or their fragile components that can provide protection against shock within a certain drop hazard range. If this drop hazard range is likely to be exceeded in practice, a critical acceleration level is determined using a shock pulse configuration that provides an upper bound of component response. This is to help ensure that an experimentally determined critical acceleration value will be applicable for any type cushioning material.[5] Fragility tests can also be performed using equipment such as package drop testers but internal component characteristics such as damping and elasticity are not accounted for. If the natural frequencies (see *Vibration*) of critical components are greater than the natural frequency of the package cushioning, damage will tend to be proportional to maximum acceleration and the maximum acceleration values obtained by this method can be used as an index of fragility.[6] Other methods of fragility assessment include analytical modeling procedures and acquired experience in the handling and shipping of collections. Further information of this nature can be found elsewhere in this publication.

Shock Hazards

The environmental factors that result in shocks to packaged items are common to all modes of shipment. For package design purposes, shock hazard severity is normally expressed in terms of a *probable drop height*. Package designers frequently use package weight to estimate drop heights because weight tends to determine the manner in which packages are handled. Typical handling methods and probable drop heights for a range of package weights are provided in Table 1 (see *Appendix*). These values are reasonable estimates if specific information on the handling operations that will be encountered during a shipment are not accurately known. When packages contain extremely valuable or fragile objects, higher than anticipated drop heights can always be used for the design of protective cushions to provide additional protection.

Protective Packaging and Shock Isolation

When a package is dropped onto a floor or strikes a hard immovable surface, the abrupt deceleration of the outer container on impact will result in a short shock pulse of several thousand G's. The elastic deformation of the container and the compression of the cushioning material will reduce the severity of this initial shock by spreading it out over a longer period of time, typically in the order of 10 to 40 milliseconds for drop heights of 50-100 cm (18-36 in.).[7] Packages are usually designed so that the level of shock that is transmitted to a packed item is near the item's fragility level.

In commercial packing, the degree of shock isolation built into a package is usually a trade off between the cost of packing materials and a measure of damage in distribution. For art shipments, there must be a virtual guarantee that damage will not occur. This suggests a more conservative design approach for packages containing works of art and a reasonable degree of over-design in relation to the shock fragility of artifacts.

Cushion Design For Shock Isolation

Quantitative Aspects of Cushion Design

If the shock fragility of an object is known or if a suitable design range can be established, cushions can be designed to provide a roughly quantifiable degree of protection.[8] Dynamic cushioning curves (or cushioning curves) are a common design tool for this purpose. A cushioning curve illustrates the

108

shock isolation provided by a cushioning material under various load conditions from a particular drop height.

Cushioning curves are derived experimentally by dropping a weighted platen onto a sample of cushioning material from a fixed drop height. When the platen strikes the cushion sample, the peak acceleration of the platen is recorded.[9] This procedure is repeated with different loads on the platen in order to cover the entire working range of the cushioning material. When the test results are plotted on a graph of peak acceleration versus platen load, a curve is produced that summarizes the shock isolation performance of a foam material under various load conditions from a given drop height.

The load on a cushion is an important design parameter when designing a cushioning system. Cushioning materials under excessive loads may permit an item to bottom-out and to strike the inside of the container on impact. Excessive cushion loads can also cause an excessive loss in cushion thickness over a relatively short time. This can lead to looseness inside the package and reduced shock isolation efficiency. If cushions are not sufficiently loaded, they can present a hard impact surface due to insufficient deformation. If this occurs, enough shock may be transmitted to a sensitive object through an insufficiently compressed cushion to cause damage.

A description of the cushion design procedure using cushioning curves is described elsewhere in this publication.[10] Cushioning curves for various materials are available from manufacturers' literature and *MIL-HDBK-304B*.[11] A circular slide rule and a computer program (padcad) for cushion design have been developed at the Canadian Conservation Institute.[12] Both of these items are based on standard design procedures but do not require the cushion designer to interpret graphs or to perform numerous repetitive calculations. The slide rule and computer program contain data for seven different materials (equivalent to 168 dynamic cushioning curves) and are relatively easy to use. While these items are not intended to replace packing experience, they can provide guidelines to appropriate material selection and use.

Qualitative Aspects of Cushion Design

When cushioning curves are used to solve packing problems, there may be several different materials or different quantities of a single material that will provide the required shock isolation level. The best solution among several alternatives is usually apparent when criteria such as support, object characteristics, and efficient cushion performance are considered. For example, if the weight of an object is evenly distributed and the item is relatively insensitive to bending, then the use of pads that are less than the total surface area on a given side of the object can be considered. The minimum pad dimension should then be at least 1.33 times wider than the material thickness to avoid uneven compression and buckling on impact (see Figure 1 Note: *All figures are in Appendix*). If an item is considered highly sensitive to bending, then a cushion that supports the entire surface area of the object may be the best alternative.

The qualitative aspects of protective cushion design are a matter of experience and judgment. The actual cushion design requirements for different items will vary and several different solutions for a given problem may be equally effective. When designing cushions for paintings, the following basic structural characteristics and sensitivities of canvas and panel paintings should be considered.

(a) Canvas Paintings

Corner impacts have been identified as one of the most severe hazards for canvas paintings.[13] The damage mechanism in the case of a corner drop is stress-induced in the canvas by distortion of the stretcher bars. The photograph in the Appendix shows the result of a 76 cm (30 in.) corner drop on a 60 x 60 cm (20 in. x 20 in.) test painting.[14] The shock level experienced by the canvas on impact with the floor from this drop height was approximately 200 G's.[15] Vertical cracking (relative to the impact plane, see Figure 2) is the result of

tensile forces in the canvas due to stretcher bar distortion. The vertical compressive forces have caused buckling of the canvas, paint loss, and flaking.

If a canvas is loose and in contact with the stretcher bars, damage to the paint layer can be expected at low shock levels (30 G's and above).[16] For paintings under normal tension, it can be shown that a canvas can be self-protecting in the event of a flat drop if there is no possibility of stretcher bar impact. This is due to the long period of oscillation of the canvas compared to the duration of the applied shock pulse.[17]

(b) Panel Paintings

A major weakness of certain panel paintings is to bending forces along the wood grain. This weakness is augmented if there are cracks or similar defects in the panel that provide concentration points for any applied bending forces.

Based on these structural considerations, cushion designs for canvas paintings should emphasize corner drop protection due to the extreme damage potential of this kind of hazard. Corner drop protection for packages usually increases in importance with decreasing package size and weight. As package size and weight increase, the likelihood of corner drops decreases. Corner drop protection can be improved by the inclusion of corner void fills in pad designs.[18] Traveling frames and backing boards will also provide additional reinforcement and protection against corner drops. Cushions for panel paintings should avoid applying any bending forces to a vulnerable panel on impact (see Figure 3).

VIBRATION[19]

Vibration Fragility

The dynamic vehicle environment consists of low-level vibrations that are below the critical acceleration values of most objects. These vibration levels are not generally considered to be directly damaging to items during transportation. The condition of interest during transportation is *resonance*, which can re-

sult in the magnification of low-level vehicle vibration to component failure levels. An assessment of vibration fragility of an item, therefore, involves identifying critical vibration frequencies at which resonance may occur.

A simple mechanical system that is capable of resonance appears in Figure 4 and consists of a mass suspended by a spring. If the mass is displaced below its equilibrium position and is released, it will oscillate at the system's *natural frequency* of vibration. This is the critical frequency at which resonance of the system will occur.

If the support of the spring-mass system in Figure 4 is subjected to a source of periodic vibration, the system will vibrate at the frequency of the externally applied vibration.[20] The response of the system to the applied vibration is determined by three system parameters; the spring force, damping forces, and inertia force of the mass. The extent to which these three quantities controls the response of the system depends on the frequency of the externally applied vibration and three types of system response are possible (see Figure 5).

Transmission

If the frequency of forced vibration is lower than the natural frequency of the spring-mass system, the inertia force and damping forces will be small compared to the spring force. The response of the system will then be controlled by the spring, which exerts a force that is equal and opposite in direction to the force of the input vibration. In this case, there is a one-to-one relationship between the input quantities of displacement, velocity, and acceleration, and the response of the system in terms of these quantities.

Resonance

When the frequency of forced vibration is near the natural frequency of the spring-mass system, the relatively large spring and inertia forces within the system balance each other. This leads to a condition known as resonance, where the vibration of the system will

110

exceed the input vibration level and dangerously large oscillations may occur. When a system is resonating, the only force that limits the amplitude of oscillation is the energy losses due to damping forces. The lower the damping in a system, the greater the intensity of the resonant state and the greater the magnification of the input vibration.

Attenuation

At frequencies above the natural frequency of the spring-mass system, the inertia force of the mass will control the system response. In this case, the external vibration is almost entirely expended in overcoming the large inertia force of the mass and the vibration of the system will only be a fraction of the input vibration magnitude.

The spring-mass system in Figure 4 is classified as a discrete system. It has a single mass, one elastic element, and the position of the mass at any given time can be fully described in terms of one independent coordinate vertical displacement. Most real objects have distributed mass and elasticity and are described as continuous systems. To specify the motion of every single point on a continuous system, an infinite number of coordinates is necessary. As a result, a continuous system has a theoretically infinite number of resonant frequencies.

The resonant frequencies of continuous systems are characterized by specific vibration patterns. These vibration patterns are called *mode shapes* and are generated when every particle of a continuous system undergoes simple harmonic motion at the same frequency. The mode shape consists of areas where no motion occurs, called *nodal lines*, and areas of oscillation, called *antinodes*. The mode shapes of a vibrating canvas can be easily revealed by sprinkling a fine- grained sand mixture on the canvas as it vibrates at a resonant frequency. The sand will tend to accumulate along the nodal lines where there is no canvas movement and will produce a "Chladni Figure," named after Ernst F.F. Chladni (1756-1824) who first described the use of this technique. The first four mode shapes of a vibrating rectangular canvas are illustrated in Figure 6.

The vehicle vibration environment is random in nature and can have a number of vibration frequencies present at once.[21] If a continuous system is subjected to a random vibration input, several resonant frequencies will be excited simultaneously. Despite the complex response of paintings to a random vibration input, it is possible to consider the natural frequency or lowest mode of vibration and consider the magnitude of vehicle vibration component that will be applied to a painting at this frequency.[22] The painting can then be considered as a discrete system exposed to a periodic vibration input at its resonant frequency. The objective in this case is not to reproduce the vehicle environment, but rather to isolate and assess its damage-producing properties.

Vibration Fragility of Paintings

Canvas Paintings

The natural frequency of a canvas is determined by the parameters of length, width, weight per unit area, and tension. For canvas paintings under normal tension, the natural frequency range will be on the order of 1-50 Hz.

If an externally applied vibration is near the natural frequency of the canvas, the resonant response near the center of the canvas will be approximately twenty times the input vibration level.[23] Although the strain levels resulting from canvas displacement are not sufficiently high to cause damage during shipment, secondary effects of canvas vibration such as impact of the canvas against stretcher bars may be potentially damaging.[24] Another potentially damaging secondary effect of vibration is damage to painting surfaces and frames due to abrasion against cushioning materials. Methods for controlling the resonant response of a canvas painting are provided below. There is a need for further research into the abrasive effects of cushioning materials on painting materials under normal cushion loads and at vehicle vibration levels.

111

Panel Paintings

The resonant frequencies of panel paintings are high compared to canvas paintings. As a result, they will normally be above the resonant frequency of most cushioning systems. One of the main vibration hazards for panels is abrasion.

VIBRATION CONTROL METHODS

Minimizing the effects of vibration is a prudent measure in the shipment of valuable items. There are three methods of controlling vibration for shipping paintings; they are source reduction, altering the painting's sensitivity to vibration, and vibration isolation. Source reduction can be applied to both canvas and panel paintings and simply involves minimizing the vibration input to a package. Altering a painting's sensitivity to vibration and vibration isolation can be applied to canvas paintings. In many cases, vibration isolation is automatically built into protective packages containing panel paintings, in most cases due to the high resonant frequencies of the panels compared to the natural frequencies of the cushioning systems. Abrasive effects, however, must still be considered.

Source Reduction

Vehicle Selection

Trucks form an integral part of virtually all transportation cycles. Trucks also impose the greatest vibration loads on cargo compared to other modes of travel. While there may be littlechoice in the aircraft, railcars, or ships that are used during intermodal shipments, there may occasionally be opportunities to select the type of truck that is used for transporting a collection. If the choice is available, trucks with air-ride suspensions have considerably lower vibration levels than trucks with conventional suspension systems.

Vehicle Maintenance

Considerable vibration levels can be gener-

ated by poorly maintained vehicles. The main suspension system, wheels, and axles of a truck will vibrate at frequencies ranging from 2.5-20 Hz. Strong vibration frequencies above 100 Hz can be caused by a suspension system in need of repair. Canvas paintings can have natural frequencies within a range of 2.5-20 Hz. Although the vibration levels may still not be directly damaging, increased vibration levels at these frequencies may intensify the secondary effects mentioned above. In well-maintained vehicles, vibration levels in the 2.5-100 Hz range will be of relatively low magnitude.

Mode of Shipment

Trucks generally impose the most severe loads on cargo, followed by railcars, ships, and aircraft.[26] The damage potential of each vehicle environment ultimately depends on the sensitivity of the item being shipped. Although truck environments are considered most severe, the advantages of source-to-destination shipments by truck without intermediate handling operations (where most shipping damage occurs) should be considered.

Alteration of Vibration Sensitivity

Backing Boards

A stiff backing board will increase the natural frequency of a canvas painting. The natural frequency, or the first mode of vibration, will undergo the greatest increase in frequency because the movement of the canvas in the first mode of vibration attempts to change the net volume of air trapped between the canvas and the backing board. Higher modes of vibration are characterized by symmetrical vibration patterns, and there will be a minimal net volume change of air in the enclosed space. As a result, the higher modes of vibration are not as greatly affected. This effect is illustrated in Figure 7.

Increasing the vibration frequency of a canvas will result in lower displacements of the canvas for a given input vibration level. Increasing the natural frequency of a canvas

can also reduce the amount of vibration transmitted to the canvas due to the increasing vibration attenuation effect of packaging materials with increasing frequency.

False Linings

The use of a false lining alters the vibration characteristics of a canvas painting. The reduction of the response of a canvas to vibration when equipped with a false lining is achieved by energy dissipation. This can help control the intensity of resonance effects and will limit the canvas impact and bending against stretcher bars. An example of such a lining procedure is the camilining described by Booth.[27]

Vibration Isolation in Package Design

The vibration attenuation condition described above can be created inside a package for the control of external vibration. The "spring" in this case is the foam cushioning material, and the "mass" is the packaged object as illustrated in Figure 8. If the resonant frequency of the system consisting of a painting resting on the cushioning material is lower than the natural frequency of a painting, the cushioning material can attenuate vibration frequencies at and above the natural frequency of the painting. Tables and graphs that list the resonant frequencies and frequency attenuation of various cushioning materials under different loads (transmissibility curves) are available.[28]

If it is not possible to design an isolation system with a resonant frequency that is lower than the natural frequency of an object. The package can occasionally be designed so that the critical frequency of an item lies in the transmission frequency range of the cushioning system.

When using transmissibility curves, it helps to remember that there may be significant differences between the experimental conditions that the curves are generated under and the conditions created inside a closed package. The best method of assessing the performance of cushioning materials for vibration is by package testing. For canvas paintings, a more practical alternative may be to design protective cushions for shock isolation and to control vibration by method such as source reduction and altering the vibration sensitivity of canvas painting.

CONCLUSION

The information contained in the packing literature can be highly useful for art shipments. Shipping environment descriptions for shock and vibration can help an art packer assess the risks posed by shipment and can help the art packer anticipate when and where these hazards will occur. The performance characteristics of most cushioning materials are documented and techniques for the proper use of cushioning materials are relatively easy to apply.

The ultimate damage potential of the shock and vibration inputs that occur during shipment depend on the fragility levels of the items that are shipped. While further research into painting fragility continues, art shippers can use these shipping environment descriptions, cushion design procedures, and vibration control methods to minimize the shock and vibration inputs to fragile items during shipment. □

APPENDIX — F IGURES

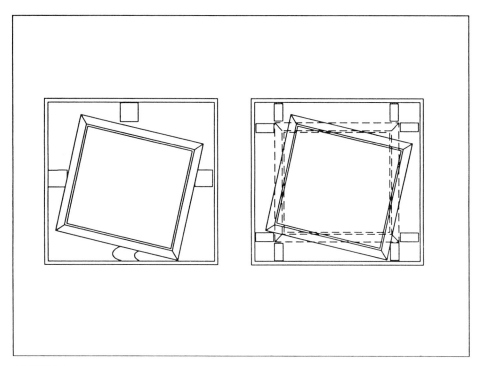

FIGURE 1
Cushion buckling. Left: cushion buckling and painting impact on case interior. Right: dislodged painting due to buckling and excessive compression of cushions on impact.

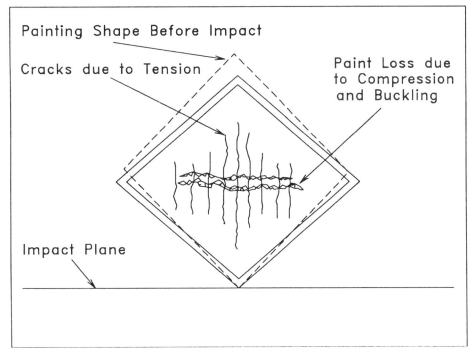

FIGURE 2
Canvas painting damage due to stretcher bar deformation on impact.

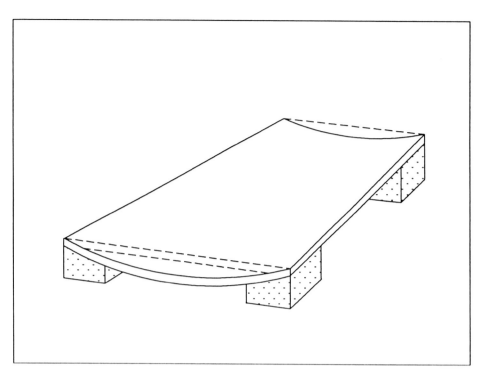

FIGURE 3
Bending of a panel on impact due to insufficient support.

FIGURE 4
A simple mechanical system consisting of a mass suspended by a spring.

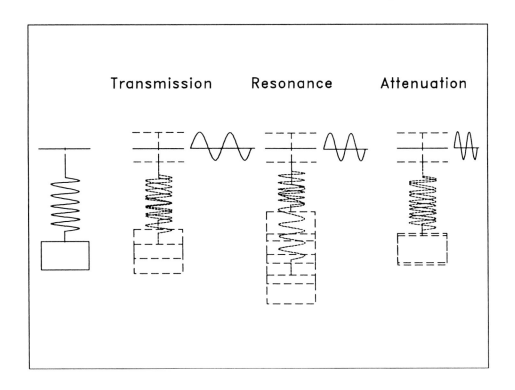

FIGURE 5
The response of a spring mass system to a vibration input of constant amplitude at different frequencies.

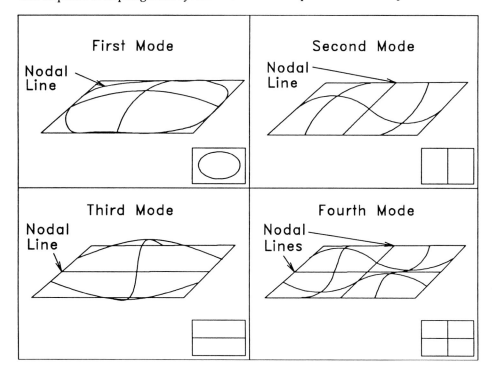

FIGURE 6
The first four modes of vibration for a rectangular canvas.

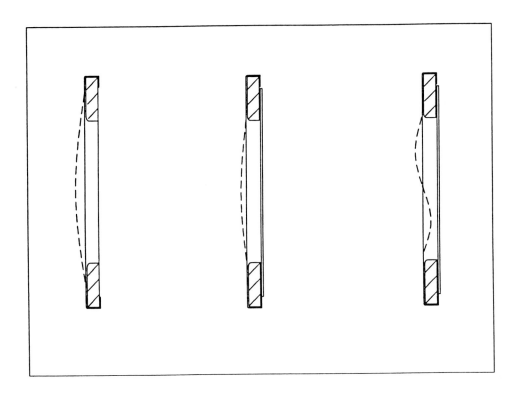

FIGURE 7
The effect of a rigid backing board on a canvas painting. Left: painting without backing board. Center: reduced first mode response to vibration due to increase in natural frequency. Right: symmetrical pattern of higher mode response.

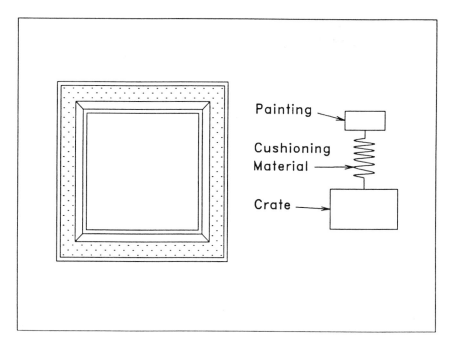

FIGURE 8
The respresentation of an object supported on cushioning matrial as a simple spring mass system.

118

The effect of a 76 cm (30 in.) corner drop on a 60 x 60 cm (20 x 20 in.) model canvas painting.

TABLE 1
Typical drop heights based on total package weight.

PACKAGE WEIGHT RANGE	HANDLING METHOD	DROP HEIGHT
0-5 kg 0-10 lb.	1 person throwing	120 cm 48 in.
5-10 kg 10-29 lb.	1 person throwing	105 cm 42 in.
10-20 kg 20-50 lb.	1 person carrying	90 cm 36 in.
20- 45 kg 50-100 lb.	1 person carrying	75 cm 30 in.
45-115 kg 100-250 lb.	2 people carrying	60 cm 24 in.
115+ kg 250+ lb.	light to heavy equipment handling	45 cm 18 in.

NOTES

1. Mechanical shock is a sudden, severe, non periodic disturbance of a mechanical system. A shock pulse is characterized by its shape, magnitude, and duration. The most useful quantity when dealing with practical packaging problems is the shock magnitude. This quantity is expressed in units of G's, which are multiples of the earth's gravity. Since force is equal to the product of mass times acceleration (i.e., F=ma, Newtons Second Law of Motion).

2. The acceleration level of a shock pulse is also referred to as deceleration when the acceleration acts against the direction of the object's movement. In general, the most important quantity when dealing with shock is the acceleration (or deceleration) magnitude because magnitude is a measure of the shock severity.

3. C. M. Harris 1988, *Shock and Vibration Handbook,* 41-45.

4. American Society for Testing and Materials, *Annual Book of ASTM Standards,* ASTM D3332 (1988), 461-466.

5. M. Bakker, *The Wiley Encyclopedia of Packaging Technology* 1986, 655-660.

6. Harris 1988, 41-43.

7. U. S. Department of Defense, *Military Standardization Handbook* (1978), 168.

8. The conditions created in a package may differ from the test conditions used to obtain the dynamic cushioning curves. Accurate quantification of the shock isolation performance of a protective package is best determined by testing.

9. American Society for Testing and Materials, ASTM D1596 (1988), 287-292.

10. M. Richard, "Foam Cushioning Materials—Techniques for Their Proper Use," elsewhere in this publication.

11. U. S. Department of Defense 1978.

12. P. J. Marcon, "A Circular Slide Rule for Protective Package Design," elsewhere in this publication.

13. P. J. Marcon, "An Assessment of the Mechanical Shock Fragility of Canvas Paintings," Canadian Conservation Institute, work in progress.

14. Prepared canvas coated with 93% PVC gesso recipe from M. F. Mecklenburg, "Some Mechanical and Physical Properties of Gilding Gesso," Conservation Analytical Laboratory, Smithsonian Institution, Washington (1988).

15. Harris 1988, 41-45.

16. S. Michalski, elsewhere in this publication.

17. Based on a fragility model proposed by W. J. Kipp, "Product Fragility Assessment" Lansmont Corporation, Monterey, CA (1972). Assuming a canvas natural frequency range of 1-50 Hz and shock pulse duration range of 0.012-0.040 s.

18. See P. J. Marcon, "A Circular Slide Rule for Protective Package Design," Figure 9, elsewhere in this publication.

19. Vibration describes the oscillation of a body in relation to a fixed reference position. The two basic quantities that are used to quantify vibration are frequency and amplitude. Frequency refers to the number of times a complete motion cycle occurs during a period of one second and is measured in Hertz (Hz). Amplitude is a measure of vibration severity and can describe the displacement, velocity, or acceleration of the vibrating body. Peak values of vibration amplitude are useful for quantifying the level of short duration shocks, but do not account for the time history of vibration. The root mean square (rms) value of vibration amplitude takes both the vibration time history and vibration magnitude into account and thus provides a measure of the energy content and the destructive ability of the vibration.

20. Periodic vibration is a repetition of a specific wave form at regular time intervals. The constant, repetitive nature of periodic vibration allows it to be predicted on the basis of past vibration history. The time history of periodic vibration is often described as being simple harmonic motion or sinusoidal in form. Simple harmonic motion provides a theoretical representation of vibration, but in practice vibration does not normally have a regular pattern.

21. Vibration that does not have a regular pattern is called random vibration. The magnitude of random vibration varies in a way that does not allow its magnitude to be specified for any given instant of time. The instantaneous magnitude of random vibration is specified by a probability function that predicts the fraction of the total time during which the vibration magnitude lies within a specific range. The vibrations generated by moving vehicles are random in nature.

22. This is adequate because the displacements and strains will be greater for the fundamental mode than for higher modes. If the package is designed to attenuate frequencies near the natural frequency, higher mode frequencies will be attenuated.

23. P. J. Marcon, "An Assessment of the Structural Response of Canvas Paintings to Vibration," Canadian Conservation Institute, work in progress.

24. See articles by Mecklenburg and Michalski, elsewhere in this publication.

25. P. J. Marcon, "Shock, Vibration and the Shipping Environment,"

26. F. E. Ostrem and W. D. Godshall, "An Assessment of the Common Carrier Shipping Environment", General Technical Report, Forest Products Laboratory, FPL 22, (1979).

27. P. Booth, "Stretcher Design: Problems and Solutions," *The Conservator* 13 (1989), 31-40.

28. U. S. Department of Defense 1979, 321-494.

SHOCK, VIBRATION, AND THE SHIPPING ENVIRONMENT

Paul J. Marcon

ABSTRACT:*The shipping environment has been studied by the packaging field, military, and resource organizations. As a result, substantial information on shipping hazards is available that can be applied to art shipments and artifact fragility test procedures. The following provides an overview of the shock and vibration inputs to packages during shipment, the sources of these inputs, and their magnitude. Aspects of the shipping environment that are well defined are identified as well as areas where further research is required.*

INTRODUCTION

The conditions of interest to art packers during the shipment of artifacts are shock, vibration, compression, temperature, and humidity. While all of these factors affect packed items to varying degrees, commercial package designers generally consider the shock and vibration inputs as having the greatest damage potential. When planning an art shipment, there is often concern over the nature and intensity of the shock and vibration inputs to packages and whether or not these conditions are damaging to artifacts.

Substantial information on the shipping environment is available in the packing literature. In reviewing the literature, it is apparent that shock and vibration environments for vehicles (or dynamic vehicle environments) have received a great deal of attention compared to handling hazards. One reason for this is that while risks due to handling can be estimated by observations and experience (e.g. drops of the rear tailgate of a truck, drops based on handling methods, etc.), the only way to quantify the shock and vibration loads on a package in a moving vehicle is by measurement. Another reason for studying the dynamic environments in vehicles is that there is often little control over the inputs received by a package once it is loaded onto a vehicle compared to handling operations which can occasionally be controlled in varying degrees.

Shipping environment research has been carried out by a number of organizations for different reasons. Commercial interest in the shipping environment is motivated by economic factors such as achieving a balance between potential losses, damage due to shipment, and minimizing packaging costs. Military interest is based on life safety and maintaining operational readiness, which require a virtual guarantee that the material will be serviceable when needed for use. Resource and agricultural-based institutions have initiated studies on shipping environments because of their concern over the enormous quantities of materials and resources that are being used for packaging applications.

The ultimate goal of any shipping environment description is to translate shipping hazards into meaningful laboratory tests. These tests can be used to evaluate the sensitivity of items to shipment hazards and to obtain representative laboratory-based performance evaluations of protective package designs. Many environment descriptions for these applications are technical and are mainly of interest to product and package design engineers. Although this information will be

useful for artifact fragility research and package testing, the main objective is to provide an overview of the information that is available in the packing literature and to present some information that may be of practical interest to an art shipper. Technical descriptions and quantities are occasionally provided for information purposes when applicable.

In the following sections, a shipment will broken down into its component parts to illustrate where and why shipping hazards occur and how they are quantified. Areas where adequate information on the shipping environment is available are identified as well as areas where further research is required. Basic definitions of some of the quantities used in this paper are described elsewhere in this publication.[1] For further information on these topics, the reader may wish to consult an introductory text on vibration theory or physics.

SHIPPING ENVIRONMENT

Accurately assessing the shock and vibration hazards during a shipment involves anticipating the handling operations and transportation methods that are likely to be used during the course of a journey. This task can be simplified by breaking the journey into parts.

When cargo is shipped from a source to a destination by truck, for example, the typical shipment sequence involves loading the truck at the source, transporting the cargo to a given destination, then unloading the cargo followed by storage. This sequence of events can be defined as a *transportation cycle* that begins and ends with handling and storage operations and involves cargo movement by one mode of transportation. It is therefore possible to consider any journey as being comprised of one or more transportation cycles. The places where handling and storage

TABLE 1
Typical drop heights based on total package weight.

PACKAGE WEIGHT RANGE	HANDLING METHOD	DROP HEIGHT
0-5 kg 0-10 lb.	1 person throwing	120 cm 48 in.
5-10 kg 10-29 lb.	1 person throwing	105 cm 42 in.
10-20 kg 20-50 lb.	1 person carrying	90 cm 36 in.
20- 45 kg 50-100 lb.	1 person carrying	75 cm 30 in.
45-115 kg 100-250 lb.	2 people carrying	60 cm 24 in.
115+ kg 250+ lb.	light to heavy equipment handling	45 cm 18 in.

The vibration environments for vehicles have been studied in greater detail than have any other shipment hazard. Statistical vibration data is available for trucks, aircraft, and railcars. The present information on ships is regarded as adequate on an interim basis. Statistical data is considered an optimum environment description and provides the basis for a risk-oriented approach to package design and testing.

The shock and vibration environment descriptions for the four modes of travel provide a comparison of the dynamic loads that each mode of travel imposes on cargo. The research findings of several sources indicate that the damage potential for aircraft is significantly lower than for surface modes of travel. There is general agreement in the literature that trucks usually impose the greatest vibration loads on cargo, followed by railcars, ships, and aircraft.

The knowledge that truck vibration environments are considered the most severe provides a good basis for fragility assessment procedures. Trucks have been studied in greater detail than any other mode of travel and an extensive database exists on their dynamic environments, which make representative laboratory-based tests possible. Trucks also form an integral part of almost all transportation cycles.

The damage potential of the shocks and vibration that occur during handling and transportation ultimately depends on the sensitivity of the items that are shipped. Current shipping environment descriptions provide a basis for meaningful shock and vibration fragility assessments. The handling environment hazard descriptions can provide a basis for standard shock fragility assessment procedures. The dynamic environment descriptions provide a statistical basis for modeling vehicle environments or for reproducing the damage producing properties of the vehicle environment. □

NOTES

1. Paul J. Marcon, "Shock, Vibration and Protective Package Design," elsewhere in this publication.

2. *Military Standardization Handbook, Package Cushioning Design, MIL-HDBK-304B* U. S. Department of Defense (1978), 9.

3. F. E. Ostrem and W. D. Godshall, *An Assessment of the Common Carrier Shipping Environment* General Technical Report, Forest Products Laboratory, FPL 22, USDA (Madison, 1979), 4-10.

4. Ostrem and Godshall 1979, 9.

5. Ministry of Defence, Glasgow, Defence Standard, *Packaging of Defence Material*, 81-41(Part 1)/Issue 2, Section D, 13.

6. Ostrem and Godshall 1979, 35.

7. N. W. Lee, "Glassware Breakage as a Measure of the Transport Environment," 3rd Symposium of Society of Environmental Engineers London, England, 15-18 April 1969, cited in Ostrem and Godshall (1979), 34.

8. Ostrem and Godshall 1979, 34.

9. F. E. Ostrem and B. Libovicz, *A Survey of Environmental Conditions Incident to the Transportation of Materials*, General American Research Division GARD Report No. 1512-1 (1971), 88.

10. Ostrem and Libovicz 1971, 88.

11. Ostrem and Libovicz 1971, 163-164.

12. M. B. Gens, "The Dynamic Environment on Four Industrial Forklift Trucks," *The Shock and Vibration Bulletin No. 45*, Part 4 (June 1975), 59, cited in Ostrem and Godshall 1979.

13. Ostrem and Libovicz 1971, 96.

14. *Wood Crate Design Manual, Agriculture Handbook No. 252*, USDA Forest Service (February 1964).

15. *Agriculture Handbook No. 252*, 1964, 74

16. J. T. Foley, M. B. Gens, and C. G. Magnuson,"Current Predictive Models of the Dynamic Environment of Transportation," *Proceedings of the Institute for Environmental Sciences* (1972), 36.

17. E. W. Clements, "Measurement and Analysis of Acceleration Environments Generated by NRL Rough Road Simulator" *Naval Research Laboratory, NRL Report 2097* (February 1970) cited in Ostrem and Libovicz 1971, 13.

18. Foley et al. 1971, 38.

19. Ostrem and Godshall 1979, 16.

20. Ostrem and Libovicz 1971, 27-34.

21. Foley Gens Magnuson 1971, 39.

22. Ostrem and Godshall 1979, 23.

23. Ostrem and Godshall 1979, 18-23.

24. F. C. Bailey, D. J. Fritch, N. S. Wise,"Acquisition and Analysis of Acceleration Data," *Report SSC 159, Ship Structure Committee*, cited in Ostrem and Libovicz 1971, 88.

25. Ostrem and Godshall 1979, 27.

26. Ostrem and Godshall 1979, 28.

27. J. T. Foley, "Transportation Shock and Vibration descriptions for Package Designers," Sandia Laboratories, Albuquerque, New Mexico (July 1972), 29-30.

28. Ostrem and Godshall 1978, 26.

29. *MIL-HDBK-304B* 1978, 11.

30. Foley et al. 1971, 38.

31. D. E. Goldman, *USNMRI Report 1*, NM 004 001 (March 1948) cited in C. M. Harris, *Shock and Vibration Handbook*, 3rd ed. (1988), Chapter 44, 23.

32. P. J. Marcon, "Shock Vibration and Protective Package Design," elswhere in this publication.

33. *MIL-HDBK 304B* 1978, 30.

34. *The Wiley Encyclopedia of Packaging Technology*, M. Bakker, ed. (1986), 655.

35. See P. J. Marcon,"Shock Vibration and the Shipping Environment," and articles by S. Michalski, M. F. Mecklinburg and C. Tumosa elsewhere in this publication.

36. Ostrem and Godshall 1979, 29.

37. Foley et al. 1971, 38.

38. Foley 1972, 30.

39. P. J. Marcon, "Shock, Vibration and Protective Package Design" elswhere in this publication.

THE RELATIONSHIP BETWEEN ART MUSEUMS, PACKERS, AND SHIPPERS

Nancy McGary

ABSTRACT: *With the increase in exhibitions requiring the transport of paintings, there has been an evolution in the relationship between museums, packers, and shippers. This paper examines some of the factors such as the professional development of registrars in the United States and their role on promoting advances in packing and shipping. Also discussed are some of the differences between large and small American museums and how their shipping services differ from those of other countries.*

Some art museums in the United States are equipped with art specialists around every corner. In-house expertise includes small villages of conservators, teams of riggers, installers, designers, registrars, matters, framers, and others in addition to multitudes of curators representing as many as twenty or more curatorial areas. Curatorial and registrar departments are equipped with specially trained technicians to manage departmental storerooms and move art internally. The packing of collection loans is likely to be the responsibility of a full-time staff packing team. The museum may even have its own van for shipping art within a certain radius of its location.

Art in large encyclopedic museum collections is often categorized by loan class in addition to other internal and art historical classifications. Objects deemed most important to the collection, highest valued, or most fragile, ordinarily involve the gathering of the longest string of loan request approvals, starting with the head of a curatorial department, proceeding to a chief curator, director, and finally, having passed those hurdles, the board of trustees. The least important, least valuable, most sturdy objects, perhaps one of many similar object examples in a collection, may require fewer steps for approval. However, a conservator's inspection of every object is integrated into the loan approval process to assure careful consideration of an object's ability to withstand travel, pre-loan treatment or other special object preparation, and advice on packing and handling requirements.

Museums full of specialists have staff conservators, registrars, curators, and packers working together to develop and implement the best packing and shipping solutions. An object is released for loan, perhaps with a courier to assure proper care and security, after careful consideration of the object's condition, mode of transportation, the routes it will travel, and the recipient's facility. All loan preparation and decision making has been accomplished by a team of people working under one roof. The convenience is enviable.

In more humbly staffed museums, which comprise the majority of museums in the United States, the goals for proper collection loan care are, of course, the same. The procedures for loan approval and preparation follow a similar routine. However, larger roles must be played by fewer staff members obliged to wear more hats. For example, the participation of the registrar is more common during the loan approval process rather than beginning after the loan is approved. Some

roles, such as conservation, framing, packing, and shipping must always be filled by temporarily hired participants with their expense absorbed by the borrower. Packing case construction most often takes place outside the museum and ideally these cases are delivered to the museum for fitting and packing. Occasionally objects must travel to where these packing cases are made.

The contemporary art museum sometimes has an added collection loan player, and that is the artist anxious to have his or her work included in an exhibition. While artist pressure to approve a loan may be unwelcome, the participation of the artist, who is intimately familiar with the construction of an object, can be helpful in determining packing and shipping solutions. Involvement in the preparation of an object for travel has been known to encourage artists to change present and future object construction for easier, less expensive packing and shipping. Few artists want to be left out of an exhibition because their work is unnecessarily fragile or inflexible, making it too vulnerable or too costly to include.

While some museums may be self-sufficient collection loan packers, and may even own vans used for shipments within certain distances, museums everywhere rely on packing and shipping companies for collecting temporary exhibition loans from others. Inevitably, the first communication with packing and shipping companies involves estimates based on sketchy information. Once loan agreement forms begin arriving, the sketches darken, questions are answered, estimates are firmed, and final plans are made. The hunt for packers and shippers in remote areas starts with a conversation with the closest art museum. Sometimes no museum or company is nearby and packing cases must be shipped to object locations along with the appropriate museum staff or packing company representative to do the packing. The borrowing museum hopes that incoming packing cases will not have to be replaced for the return of objects, and that they will last through a traveling exhibition tour in order that budgets stay under control. Museum staff note innovative incoming packing cases

for future packing sources and design applications.

For most of this century, American art museums have relied upon so-called registrars and registrar departments to handle packing and shipping arrangements for outgoing and incoming loans. The evolution of the role of the registrar in American art museums has been one of continuous growth. The most dramatic professional advancement occurred in 1977 when registrars formed a standing professional committee in the American Association of Museums, the largest professional museum organization in the United States. As a result of the formation of the National Registrars Committee, currently numbering over six hundred members, and the subsequent formation of six regional registrar committees, under the auspices of six regional museum organizations, stronger communication links have been established between registrars and others with whom they work in museums and in the world of commercial art specialists. The committees encourage commercial and foreign memberships; the national committee now includes fifty-nine commercial members and forty registrars from other countries.

The emergence of these professional committees has provided annual opportunities to share expertise on a regional, national, and international basis. Panel discussions at annual meetings often cover topics of interest to both museum and commercial members, drawing upon the experience and expertise of each group. For example, recent meeting topics overlapping the interests of both sectors have included subjects such as the possible effects of the European Economic Community on shipping art within Europe. A session titled *And the Walls Came Tumbling Down* shared advice on preparing for loans and exhibitions with Eastern Europe and the Soviet Union. Another session shared three case studies on setting up and operating museum collection storage facilities located outside museum buildings, and there have been many more useful subjects covered.

Another advantage of the national and regional meetings is that companies are invited to display their products and services in an

exhibition hall provided for vendors offering products related to museum needs. While this benefits vendors, who can reach a large cross section of the museum world, it is a useful vehicle for museum staff who have the opportunity to discover companies, ask questions, and compare products and services.

In 1974, a meeting of registrars and commercial art packing and shipping companies took place at the Museum of Fine Arts in Boston. Afterwards, an owner of a company located in New York City, who had handled local and long-distance van shipments for The Metropolitan Museum of Art for years, exclaimed that he had never realized how much responsibility registrars had above and beyond hiring shippers. He was newly impressed after twenty years of working closely with a major museum and grateful to have gained a better understanding of the museum side of exhibition planning. His reaction was repeated by representatives of other companies.

There is another side to this realization, and that is that museum people often cannot visualize things from the packing and shipping company's perspective. We make them keenly aware of our loan commitments and publicly announced exhibition schedules, but are kindly allowed to be oblivious to their workloads. Being on the commercial side requires diplomacy and flexibility in coping with the idiosyncrasies of varied museum projects and personnel.

Companies become frustrated at losing a job to a lower bidder especially when they are certain that the lower bid is based on a lower quality product or service. Understandably companies want to be on equal footing and have an equal chance when competing for business. This situation probably occurs more often with packing bids than for transportation. Sometimes museums supply each bidder with exact packing descriptions, including diagrams of the type of crating and materials they wish to use,. This is coordinated with the price lists offered by supplies for various types of packing. Often there is vague communication resulting in one company's bidding for a job based on one pack-

ing standard and their competitor bidding on another standard. Many companies have packing standards below which they are reluctant to work and appreciate being given a chance to explain the difference between their product and a less expensive one.

Museums are constantly asking for assistance from packing and shipping companies to develop exhibition budgets for fundraising purposes. Often the budgets are developed two or more years before a show will actually take place. As a courtesy to the companies that have contributed their time and expertise to a budget's development, museums should, of course, offer them an opportunity to bid on the packing and transportation on these exhibitions.

During the past twenty years specialized companies have developed that provide services that art museums have indicated as being important. Companies have invested in climate-controlled vans, climate-controlled warehouses, and have made it a point to become adept at some of the special handling services museums require such as rigging and rolling, folding, and stretching paintings. One of the dangers in the present American museum economy is that those protecting the budgetary "bottom line" in museums will be in conflict with those responsible for maintaining appropriate standards for art care. If this budget rationale prevails, the companies with high standards and specialized services may be unable to weather the economic climate and may cease operation, and when the economy improves, these companies may no longer be available. Ours is a symbiotic relationship—we need each other.

Museums look for packers and shippers to supply reliable, ethical service, accurate estimates, and conscientious well-trained staff. We hope for companies to be located close to our facilities or near objects to be packed. We want a company to be experienced and to have a record of proven success in handling, packing, and moving every conceivable kind of art object. All they require of us is accurate information and adequate lead time.

Prior to the evolution of the large number of companies specializing in art packing and moving services, museums were likely to

have carefully cultivated a local household moving company to pack and move collection loans. Substantial effort went into forming the relationship and building up the required trust and training. In some areas of the United States, outside active art centers, this type of relationship is still common. However, in many cities, including Los Angeles, San Francisco, Dallas, Miami, Washington, Chicago, Boston, New York, and others, many companies exist that specialize in art transportation, packing, storage, and installation services.

The evolution of art packing and shipping specialists has been different in Europe. Whereas in the United States or Canada objects can move thirty-five hundred miles (forty-two hundred kilometers) without crossing a political boundary, obviously the situation is different in Europe. Consequently, European art transportation companies also function as import and export specialists, a function handled by separate companies in the United States. European art museums without full-time art handling crews, or that have a temporary need of additional crew members, can have them sup-plied by a packing and shipping agent. This "umbrella" type of art operation has also developed in Japan, a highly service-oriented country. However, while many companies in the United States can offer special services, the pattern has not been that of the convenient umbrella operation, making the role of the museum registrar more difficult by making external art activity arrangements more complex.

Regardless of their differences, commercial art operations everywhere have evolved in response to museum needs and will continue to be part of the museum world. It is the responsibility of all involved in art care professions to maintain and share professional advancements. Those working for museums and facilities without conservators especially rely on the practical applications of conservation research shared in professional publications and meetings. Ongoing communication efforts from the conservation field are essential, because the more collectively skilled we become in safeguarding art in transit, will result in less expensive insurance, the more efficient our lending process will be, all resulting in a greater potential for comprehensive international exhibitions. □

AN INTRODUCTION INTO THE MECHANICAL BEHAVIOR OF PAINTINGS UNDER RAPID LOADING CONDITIONS

Marion F. Mecklenburg and Charles S. Tumosa

ABSTRACT: *Paintings exposed to vibration or impact due to handling and transportation are often considered to be at risk for damage. This study examines some of the mechanical properties of typical artist materials under different environmental conditions and using that information, conducts a computer based analysis of representative paintings subjected to impact and vibration. The findings of the study indicate that paintings have a substantial intrinsic dynamic strength and that within reasonable limits the objects are generally able to withstand considerable sustained vibration as well as rather serious impact. Some conditions that merit special attention are examined.*

INTRODUCTION

If a painting is subjected to vibration, or dropped such that it will suffer a sudden impact, there will likely be a displacement of the painting out of the plane defined by the stretcher. In addition, paintings dropped on their edge can experience an in-plane distortion of the paint, ground, glue, and fabric composite layer. The severity of the distortion encountered during vibration results from the orientation of the painting to the vibration source and the closeness of match to the source vibration frequency of one of the natural or resonant frequencies of the painting. Any displacement or distortion of the painting, whether accidental or intentional, such as hammering out corner keys, necessarily distorts the materials that make up the painting, and as a consequence, induces stresses. If the stresses are high enough the materials fail, usually in the form of cracked and flaked paint. Relating the severity of the dynamic environment to the painting displacements, material distortions and ultimately the magnitude of the stresses developed in the layers of a painting is a study in engineering mechanics. In order to accomplish this, it is necessary to either

measure or calculate the stresses in a vibrating painting and compare those stresses to the maximum the materials can sustain.

Clearly, it is not feasible to test paintings in the various collections around the world to determine the severity of shock and vibration that will cause design layer cracking. Other methods are necessary. A systematic engineering approach to solving the problem is available and requires specific steps. First, an analytical procedure must be found that determines the deformations and stresses in any of the layers of a painting subjected to vibration and impact. In this case computer modeling in the form of *Finite Element Analyses* (FEA) will be used. Second, the general dynamic mechanical properties of the artists' materials must be determined under different temperatures and relative humidities expected to be encountered under normal transport conditions. Third, a correlation between vibration and impact stimulus must be developed and the failure levels of the painting materials such that a *risk assessment* may be conducted that allows for the safe packing and transport of the work of art. While there is considerable literature on the mechanical

properties of commercial paints used as protective coatings,[1] there is not an abundance of information regarding the strength or stiffness of artists' materials under dynamic conditions. Some of this information has been determined at the Conservation Analytical Laboratory (CAL) by direct materials testing and yet more still needs to be done. The following is a summary of some of the information currently available.

MECHANICAL PROPERTIES OF MATERIALS

There are often misconceptions regarding the properties of solid materials. The mechanical properties of materials are frequently confused with their physical properties. The physical properties of materials refer to those such as density, color, luster, and atomic or molecular structure. Moisture-related swelling properties and the thermal coefficient of expansion also fall under this heading. The mechanical properties of a material refer to the strength, stiffness or flexibility, and elastic or plastic properties of materials.

The mechanical properties of materials can be quite specifically defined, and in fact, these properties can be quantified. For example, the stiffness of a material directly relates the amount of deformation, δ , (the stretched length, L_s, minus the unstretched length, L_o), a material undergoes when subjected to a force, F. If the applied force is large enough, then the material will break, and thus the strength of the material is determined. The difficulty with using the terms force and deformation arises when comparing one material to another. All of the specimens must be the exact same size and this is not always possible to accomplish. For example, comparing the mechanical properties of a thin paint film to a sample of hide glue means casting the materials so they both dry to the same dimensions which is nearly impossible. To get around this problem, the mechanical properties are "normalized." This is done by dividing the specimen deformation, δ, by the unstretched length of the specimen, L_o. This is the definition of engineering strain, ε, or mathematically:

$$\varepsilon = \frac{L_s - L_o}{L_o} = \frac{\delta}{L_o}$$

If the applied force, F, is divided by the cross-sectional area, A, of the test specimen, the term stress, σ, is thus defined:

$$\sigma = \frac{F}{A}$$

The ratio of stress to strain is the measure of the stiffness of the material, and for elastic material behavior, the modulus of elasticity, E, is how material stiffness is defined. Elastic behavior, simply stated, means a previously loaded material will return to its original length when the force is removed. Mathematically the modulus is:

$$E = \frac{\sigma}{\varepsilon}$$

A material is said to exhibit plastic properties when a permanent deformation occurs after the force is removed. The mechanical properties of a solid material are typically described using stress-strain diagrams, which are the result of direct specimen testing. One such plot is illustrated in Figure 1 (See *Appendix A* for all Figures). This figure shows the results of a tensile stress-strain test of a typical steel, which is one of the few materials that serve to demonstrate several points of interest on the same stress-strain test. This diagram shows the modulus of elasticity, E, as the slope of the linear (elastic) part of the plot, the yield point, δ, where plastic behavior begins, and the ultimate strength, δ_{ult} , the maximum stress the material can withstand.

Nearly all polymers such as paints and hide glue do not have clearly defined yield points, nor do they have such extended plastic regions.[2] More importantly, all of their mechanical properties are altered by temperature, relative humidity (RH), and the speed with which the force is applied to the specimen. Polymers often exhibit a "stress relaxation" once loaded and the strain fixed, this is in contrast to continued straining, or "creep," if loaded and the load is fixed. This time-dependent behavior of polymers is often referred to as visco-elastic effects.[3] At low temperatures and/or low relative humidity, these materials can behave in an ex-

tremely brittle, or "glassy," manner and conversely, at high temperature and relative humidity, they can be quite ductile or rubbery. At very high rates of loading they can also exhibit glassy and elastic behavior, demonstrating no yield point prior to failure. On the other hand when loaded slowly, the materials exhibit rubbery characteristics, with moderately large deformations.

MATERIALS TESTING

At CAL, a materials testing program has been underway for the last several years. This program was established to develop a data base of the mechanical properties of artists' materials. The information needed included long-term effects of temperature and relative humidity as well as the effects of loading rates and how they are affected by the same environmental factors. Additionally, some important information on the physical properties was determined. These included the dimensional response of the materials to temperature and relative humidity and the time required to achieve equilibrium to new environments. The materials tested to date include various pigmented artists' oil paints cast in 1978 and 1979, rabbit skin glues of different concentrations, various gesso mixtures, and linen textiles. Some wood testing was done, but as there is considerable literature on the mechanical properties of wood,[4] this discussion will only briefly include this aspect.

Sample Preparation

The oil paints were provided by the major manufacturers of artists' paints and were cast directly from the tube containers without the addition of any dryers, varnishes, or solvents. After thorough mixing, the paint was spread in 2.54 cm (1 in.) wide strips on .0127 cm (.005 in.) polyester film using strips of black vinyl electricians' tape as thickness guides. The tape was .0127 cm (.005 in.) thick and the paints were cast using both two and three layers resulting in paints of approximately .025 cm (.01 in.) and .038 cm (.015 in.) thicknesses. The thickness of the specimen af-

fected the tensile test results while the paint was still less than four years old. There were no effects on the mechanical properties of the paints resulting from the two different thicknesses of paint for specimens over thirteen years old. This was a strong indication that the paints had dried uniformly throughout the thickness of the paints. The oils were typically linseed and safflower. Alkyds and acrylics were cast at the same time; however, testing on these materials is at present incomplete. The vinyl tape was removed after one month of drying time and the polyester was easily peeled away from the paint at the time of testing. The dry paint was then cut into strips .508 cm (.2 in.) wide and about 15.24 cm (6 in.) long for testing.

The rabbit skin glue samples were prepared by pouring 10% and 20% solutions (by weight) on the same type of polyester sheets as described above. These sheets were stretched tight onto flat, level surfaces. Once dry, usually after ninety-six hours at 23°C (73°F) and 50% RH, the glue specimens were cut to the similar dimensions as the paint. However, it was possible to obtain different thickness samples by simply cutting them from different areas of the casting. The different glue samples varied from .00381 cm (.0015 in.) to .0305 cm (.012 in.) in thickness. Gesso mixtures having different chalk- (ground calcium carbonate)-to-glue ratios were prepared from a single stock, 10% solution of rabbit skin glue. The gesso mixtures were cast and test samples were prepared in a manner similar to the glue.

Testing Equipment

The equipment used for conducting the tensile stress-strain tests of the materials was designed and constructed at CAL and can be generally described as miniature *screw-driven tensile machines*. The machines were small since the specimens to be tested were relatively small. The general layout of the equipment is illustrated in Mecklenburg (1984).[5]

As many as twenty-one of these devices were operating at any given time. It was necessary to have this many units because they often needed to be dedicated to a single

specimen for long periods of time. It took up to several months to generate some of the data if the specimens were to reach equilibrium with the test environment. All tests were conducted in chambers that provided controlled temperature and relative humidity. Conditioned silica gel was the primary technique for maintaining buffered environments.

Oil Paint Test Results

When it came to the actual testing, at least three specimens were initially tested to determine if the results would be consistent. Later testing showed that two specimens were sufficient, since the scatter was remarkably small, considering that the test materials were cast by hand. When variation did exist in the test results, it was usually the strain at failure. Specimens were tested at 3, 3.75, and 13 years after casting.

The tests undertaken were directed at specific questions: How are the mechanical properties of artists' materials influenced by temperature and relative humidity under very long term conditions? How are those mechanical properties affected by rapid loading events or dynamic conditions? and How does temperature and relative humidity influence the mechanical properties of materials subjected to dynamic conditions? The environments chosen emphasized low temperature and low relative humidity, because these conditions are where brittle behavior is most likely to be encountered.

While this paper will concentrate on dynamic systems, it is worth using the information on long-term material behavior as a baseline. This is best accomplished by examining the long-term or the "equilibrium" stress-strain test as illustrated in Figure 2.

In this test the paint specimen is rapidly strained a small amount, approximately .0007 (the units of strain are length per length or unitless), and the strain is fixed. The initial stress is recorded and the specimen then proceeds to stress "relax." This stress relaxation is a time-dependent phenomenon and takes about seven to ten days for the stress relaxation to cease or "equilibrium" is reached. The

specimen is strained a subsequent increment and again allowed to fully stress relax. This process is continued until the specimen breaks, which in this case, took several months while the environment was maintained at 23°C and around 50% RH. Figure 3 shows the results of three specimens tested to failure. They are extremely consistent in terms of the modulus, but show a broad range of the failure strains which were .02, .026, and at least .034. This was the largest amount of scatter demonstrated by the test materials, and all of these strains are much larger than the calculated strains resulting from vibrations of a painting.

The locus of "relaxed" points (Figure 4) generated by the tests described above results in a stress-strain plot that is in equilibrium with the test environment and represents the mechanical properties of the material under extremely long-term conditions. The paint samples for all of the tests were prepared from a Naples yellow paint, which was, in fact, a lead carbonate tinted with cadmium sulfide and iron oxide ground in linseed oil. This paint was cast in March 1978.

Figure 4 clearly indicates there is no sharply defined yield point, but it appears to occur at approximately .414 Mega-Pascals (MPa) (60 pounds per square inch [psi]). The ultimate strength attained by this paint was 1.52 MPa (220 psi). The equilibrium modulus of this paint was about 68.94 MPa (10 ksi, 1 ksi=1,000 psi). This paint sample was able to "stretch" over 3.6% (strain x 100=percent elongation) of its original length. More on the equilibrium behavior of materials is discussed in the paper "The Mechanical Behavior of Paintings Subjected to Changes in Temperature and Relative Humidity."[6]

Also in Figure 4 are the results of rapidly run stress-strain tests of the same paint in the same environment. One of the tests was conducted with a separate test specimen, not previously tested and the other rapid test was conducted after the paint sample had been subjected to the very long-term tensile test. The most obvious observation is that in both rapid tests, the paint exhibits considerably more strength and is considerably stiffer

than in the equilibrium test. In this case, the paint attained strengths between 6.894 MPa and 7.58 MPa (1,000 psi and 1,100 psi). The previously untested paint had an elastic modulus of 689 MPa (100 ksi) and the previously tested paint was even stiffer with a modulus of 1,172 MPa (170 ksi). Apparently the long-term testing has "strain hardened" the paint. This behavior was exhibited on all of the paints tested except burnt sienna, which became less stiff. What is important is that these materials, even though subjected to long-term environmental testing, still have a dynamic reserve strength. They still develop considerable strength under rapid loading no matter what previous testing conditions were encountered.

Rapid Testing

After looking at the differences in behavior between the equilibrium and rapid mechanical properties, it is clear that the rate of loading has a pronounced influence. There does seem to be an upper limit on this influence. Loading the specimens faster than about .0005 cm/cm/sec at 50% RH and 23°C did not seem to appreciably affect either the modulus or the strength of the paint. The maximum modulus attained for the previously untested Naples yellow was 689 MPa (100 ksi) at several strain rates as shown in Figure 5. The testing procedure was to approximately double the strain rate for each subsequent test.

Additional results of the rapid loading tests conducted at 50% RH and 23°C are presented in Table 1 (See *Appendix B* for Tables). The first three paints listed in this table can be considered "fast driers" and the fourth and fifth, burnt sienna and burnt umber are "slow driers." Of the more than fifty paints (oils, whether linseed or safflower) cast in 1978 and 1979, only about 15% of the paints dried similar to the "fast dryers" and most of these contained lead. The "vermilion" tested was actually filled with a synthetically dyed calcium carbonate and presumably contained some dryer.[7] While not yet completely tested, titanium dioxide actually dried and remained quite flexible compared to the lead white.

The balance of the paints are "slow dryers" and are still flexible at this time.

These testing results serve to demonstrate the considerable differences in mechanical behavior between the slow and fast driers. Another interesting aspect was the difference between the safflower and linseed oils. The linseed oils were able, at least in these tests, to elongate considerably more than the safflower oils. The safflower oil was found primarily in the white paints, presumably because it tends to discolor (yellow) less than the linseed upon drying. As the Naples yellow primarily contains lead carbonate, this paint offered a good comparison with the flake white ground in safflower. Finally, it is worth commenting that while a large proportion of paints used by artists are slow driers, and are quite flexible, a considerable number of paintings grounded with oil paints use white lead paint. This means that in many cases there is a fairly stiff paint layer between the glue size and the upper paint layers. If this paint substrate fails, then any layer above it will most likely fail also.

It is of some interest to know how these paints dry over time. In Table 2, test results are presented for the same paints as shown in Table 1, with the exception that the paints are considerably younger. The modulus of the younger paints are significantly lower than the thirteen-year-test paint in all cases.

The Effects of Temperature and Relative Humidity

Both cooling and desiccation increase the stiffness and strength of the materials tested. Tables 3a and b tabulate the influence of different relative humidity levels on the mechanical properties of two of the thirteen-year-old paints tested at 23°C. In both paints, desiccation at 5% RH shows the stiffest and strongest properties. Equally important is the reduction of the strain to failure. Clearly, the paints are losing their ability to deform without breaking. Under both environmental and dynamic conditions, the artists' material's ability to deform without

failure is our primary concern.

Cooling has an equally dramatic effect on the mechanical properties of these paints, (Tables 4a and b). At approximately -3°C, the materials are extremely brittle and relative humidity still affects these materials. Maintaining a relative humidity higher than the 51% reported was not possible with the equipment in use at the time of testing. The fast dryer, Naples yellow, showed relatively less response to relative humidity when compared to the slow dryer, burnt umber. Normally when testing a material, failure of the test specimen occurs as a single break. However, when testing at 5% RH and -3°C, the paints and hide glues shattered into multiple pieces. The hide glue disintegrated into over thirty separate pieces. These materials are acting in a truly "glassy" manner at this environment. On the other hand, the strengths of the materials measured at the cold environments were remarkably high.

Rabbit Skin Glue Test Results

At room temperature, relative humidity dramatically affects the mechanical properties of rabbit skin glue (Table 5). The *rapid-loading strength* of this material is remarkable in that it exceeds even the strongest epoxies at relative humidity levels above 60%.[8] Raising the relative humidity above this level causes a rapid decrease in the stiffness of the materials and at about 85% RH there is effectively no strength or stiffness in this material. The maximum strength and modulus attained was at 23°C and 5% RH, decreasing the temperature to -3°C at the same relative humidity effectively had little influence on the modulus but lowered the strength and strain to failure considerably. Hide glue specimens shattered in this environment and this was the first real evidence of a serious reduction of fracture resistance of these materials. Clearly this is an environment to avoid.

Gesso Test Results

Gesso is another material typically used as a ground on both panel and some fabric sup-ported paintings.[9] The mechanical properties of this mixture of rabbit skin glue and whiting, in this case ground calcium carbonate, is affected by the ratio of pigment to glue. Some of the results of gesso testing are shown in Table 6. In this table the gesso mixture is expressed as the chalk-to-glue ratio, by weight, and the percent *pigment volume concentration*, (PVC). These mixtures can be compared to the modulus and strength of the glue alone (Table 5), where it is seen that the addition of the whiting increases the modulus, but decreases the strength considerably. At chalk-to-glue ratios greater than fifteen, both the strength and stiffness fall off severely. In comparison to the paints, the gesso is generally stiffer, but not quite as strong. In other words, it is more brittle. Since rabbit skin glue is the binder holding it together, gesso response to relative humidity will be also quite pronounced.

Support Materials

The mechanical properties of wood are well described in the literature since it is an important commercial material and used extensively as a structural material.[10] The one aspect of wood that is most important is that it is orthotropic, that is, it has considerably different mechanical properties in the mutually perpendicular directions, longitudinal, tangential, and radial. For example, oak, which along with poplar, was used as painting supports.[11] Oak can easily have a modulus of 6,894 MPa (1,000 ksi) in the longitudinal direction and approximately 551.5 MPa (80 ksi) in the other two directions. The strength of oak is equally different in the three different directions, about 96.5 MPa (14 ksi) in the longitudinal and only about 4.2 MPa (.6 ksi) in the other two. Hence, when it breaks it splits with the grain. The mechanical properties of wood vary, but in general they correlate somewhat with the density of the wood.[12] The most serious difficulties with wood is that it is so hygroscopic. Serious deviations in relative humidity can cause high stress levels in restrained panels, particularly when there is an existing crack.

In order to round out the materials, it is necessary to look at some of the properties of

textiles. Fabric painting supports are not homogeneous materials; they are a structure constructed of twisted bundles of fibers, yarns, woven together to form a mattlike structure. The difficulty presented by textiles arises when one is trying to numerically model them on a computer. Because of the type of woven structure, textiles tend to be considerably stiffer and stronger in the direction of the yarns, but are very flexible when subjected to bending. By using a volumetric analysis, it was possible to establish a mean fiber cross-section area per yarn. Using a large sample from the test fabric, the warp yarns were separated from the weft yarns and their separate volumes were measured using a nonpolar solvent. This volume was divided by the yarn length resulting in a total fiber bundle cross-section area. In turn, this total area was divided by the number of yarns resulting in a mean fiber cross-sectional area per yarn. By counting the yarns in a tensile test specimen, a mean fiber area could be obtained and enabling calculation of the mean fiber stress and modulus. This gave a better understanding of the fiber stresses than other types of measurements. Using three different linen textiles, #248 from Gernay-Delbec, #444 and #8800 from Ulster, the test results were remarkably close (Table 7).

It was found that the average yarn cross-sectional area was only about 22% of the nominal textile area if the area was taken to be the linen "thickness" times the specimen width. Typical linen thicknesses were .063 cm (.025 in.) for #248 and #444, and .048 cm (.019 in.) for #8800. For computer modeling purposes, the effective thickness of the fabric should only be about 22% of the measured nominal thickness. The effective modulus used in modeling should be those presented in Table 8.

The mechanical testing results of the #248 linen are shown in Table 8. This data is representative of all of the textiles tested. The strengths are not included because they are so high (considerably higher than the glue) that they are rarely a consideration except when the textile is extremely degraded. What is important is that the modulus of this material is considerably lower in the warp direction than the weft direction and the modulus tends to increase with relative humidity. This is the direct opposite of all of the other materials, which increase in stiffness with desiccation. Both of these properties are related to the fact that yarns are woven in the manufacture of a textile. The values of the warp yarns are so low because most of the early stretching is a result of straightening out the crimp. The weft direction, which has little crimp, is stiffer since the yarns are being stretched without additional straightening.

It must be noted that when a linen is stretched on a stretcher, the crimp is considerably reduced in the warp direction and slightly increased in the weft, so the mechanical properties tend to even out in the two orthogonal directions. Additionally, once stretched and subjected to high relative humidity, the initial fiber tension in the linen is considerably reduced due to interfiber slippage. This puts additional demands on the glue and the paints to support themselves.

COMPUTER MODELING

If a material is loaded, it will deform and the modulus describes the amount of deformation that will occur. If a structure is loaded, it also will deform and the amount of deformation is again a direct result of the modulus of the materials used in constructing the structure. Unfortunately, when many materials are involved or the geometry of the actual structure is complex, analysis of the structure is nearly impossible when using classical techniques of elastic theory. One method that provides remarkably good analytical results is the *Finite Element Analysis* (FEA) method.[13] This method mathematically approximates the structure on the digital computer by assembling the "structure" from smaller, geometrically simple "elements" whose mechanical properties can be determined. The elements are normally but not solely connected at the corners of the elements. These connections are called nodes. From elastic theory, force-displacement relationships can be established for individual elements. For example, it can be determined how much

stretching, bending, and twisting occurs when forces are applied to the nodes of the elements. If the element properties are formulated correctly, they can be assembled into a fairly complex structure using algebraic operations, which are easily handled by the computer. Further, convergence to the correct stresses and deflections will depend largely on the number of elements used in the model. For example, Figure 6 illustrates a simple cantilevered beam made of thick sheet acrylic plastic. The beam is supported at one end and a force of 1,334 Newtons (300 lbs.) is applied vertically at the other end. The dimensions of the beam are length, 45.7 cm (18 in.), height, 7.63 cm (3 in.), width, 2.42 cm (.95 in.). The modulus of this material used in the solutions was 3,102 MPa (450 ksi). From *beam theory*[14], which is one of the most thoroughly developed theories reflecting real-world accuracy, this beam will deflect 1.567 cm (.617 in.) downward at the free end and the maximum bending stresses will be plus or minus 26.2 MPa (3.79 ksi) at the fixed end. The maximum shear stresses will be 1.09 MPa (158 psi) occurring along the neutral axis (see Figure 6). The beam was modeled using FEA, but using different numbers of elements each time. The results of the analyses are shown in Tables 9a and b.

The final results of the solution using 360 elements agrees closely with theory and it is noteworthy that the solution for the deflection is converging to the correct answer from below, that is, the computed deflection will always be less than theoretical. On the other hand, the bending stresses will be higher, and this is the conservative solution. The measured failure stress of sheet acrylic is approximately 68.9 MPa (10 ksi) so it is possible to say that the force applied to this beam is only 39% of that needed to break it, according to this analysis. A risk analysis has now been conducted for the beam, which estimates that any force over 3,425 N (770 lbs.) will break the beam.

Sources of Forces under Dynamic Conditions

In the beam problem, it is easily seen that a weight hanging on the end of it can be the source of the applied force. For paintings subjected to vibration and impact, the forces are "inertial" and are not so readily envisioned. Isaac Newton, for whom the "Newton," the SI unit of force is named, determined that the force on a body is equal to its mass times the acceleration it experienced, or mathematically;

$$F = M \; x \; a$$

On earth, the weight of an object is its mass times earth's gravitational field, g, or W=m x g. The mass of an object is defined as m=w/g. For a body experiencing vibration or shock, the forces it experiences are a result of its mass times the accelerations experienced. It is possible to say then, the force experienced, F_G, is:

$$F_G = \frac{W}{g} \; x \; a \quad \text{and}$$

$$F_G = W \; x \; \frac{a}{g} \quad \text{and defining}$$

$$G = \frac{a}{g}$$

where G is the ratio of experienced acceleration to earth's gravity.

This G is the value to which is often referred when calculating inertial forces. For example to comment that an impact resulted in several G's, is to say that the impacted object is experiencing forces equivalent to G times the weight of the object. A dropped painting feeling 40 G's, then is said to act as if the painting is 40 times heavier than it actually is. For computer modeling purposes, a painting dropped on its edge experiencing 40 G's can have an applied force, totaling 40 times its weight, distributed over the entire area of the painting and in the direction parallel to the impact. It is necessary then to know how much the artist's materials weigh. See Table 10 for the nominal weight densities of some of the materials examined for mechanical properties.

144

The weight of any given painting per unit area will be the sum of the layer densities times the thickness of the respective layer. Expressed mathematically:

$$W_A = \Sigma\ (D_L\ x\ t_L\)$$

Where:

W_A = the total weight of the painting per unit area.

D_L = the density of the layer.

t_L = the thickness of the layer

The dynamic loading on the painting per unit area will then be W_A times G. Its now possible to run an analysis of a model painting at room temperature, 23°C and 50% RH. The dimensions of the first painting are 76 x 102 cm (30 x 40 in.). The fabric is #248 with a nominal thickness of .0635 cm (.025 in.) therefore it weighs .0004 N/cm^2 (.0058 lbs./in.2). The glue layer is .0076 cm (.002 in.) thick and weighs .0000508 N/cm^2 (.0000736 lbs./in.2) and assume that the paint layer and ground is a total of .0178 cm (.003 in.) thick and is all white lead since it is the most brittle. The weight of the paint layer is .000213 N/cm^2 (.000309 lbs./in.2). The total weight of the painting per unit area is .000664 N/cm^2 (.00618 lbs./in.2) which is not very much, but this might be considered moderately thick for a paint film. At a 30 G impact, the painting will feel as if it weighs .012 N/cm^2 (.1855 lbs./in.2).

All of the information needed for a FEA on the computer is now available. The model was assembled using 300 elements and 484 nodes and the three different layers are as described above with the exception that the model thickness of the linen is .01524 cm (.006 in.) and a mean modulus of 690 MPa (100 ksi) was used. All other material properties are described in the preceding tables for 23°C and 50% RH. The computer program is ANSYS, Version 4.4, leased by CAL and is run on a Gateway 2000 desktop PC. The computer uses 80386 technology at 33 MHz. It has a math coprocessor, an expanded RAM of 4 megabytes and a hard disk of 150 megabytes. The following modeling results are intended to examine the effects edge impact and out-of-plane vibration on the various layers of the painting.

Edge and Corner Impacts, the 76 x 102 cm Model Painting

A 76 x 102 cm (30 x 40 in.) painting was modeled first to examine the effects of a 30 G impact when dropped squarely on the long edge. ANSYS has a feature that allows programming in of the *mass* densities of the materials and then subjecting the model to any desired acceleration. Further, the painting was modeled such that the stretcher was firmly fixed and extremely rigid so that only the painting itself would respond to the impact without external influences such as stretcher distortion. In this way it is possible to look at the response of the painting alone. As with most real paintings, only the fabric was attached at the edges. This model and all subsequent model analysis performed assume that there are no pre-existing cracks in the paint film and all of the painting models have no auxiliary supports such as linings. The distorted painting is shown in Figure 7 along with the first layer element arrangement (the paint layer).

The maximum deflection is quite small, only .019 cm (.0075 in.). The maximum displacement of the paint layer is downward, only about .019 cm (.0075 in.) at the center of the painting. It actually deflected forward also, .0127 cm (.005 in.). The maximum stress the paint layer experienced is only .11 MPa (.016 ksi), which is less than 3% of the measured rapid loading breaking strength of the white lead paint, which is the lowest strength measured of the brittle paints. The distribution of the stresses is presented in Figure 8, and if the impact was ever large enough to actually break the paint, well over a 1,015 G impact, the theoretical crack pattern is shown in Figure 9 superimposed over the maximum principal stress vectors. In reality, this would most probably never occur, since buckling of

145

the painting out of the plane of the stretcher would be a more likely result of a high G impact. However unlikely that this crack pattern is, it is conceivable that very heavy traditional linings on very large paintings, could over a long period, cause this type of failure.

The same 30 G drop was modeled on the same painting except the orientation of the painting is with the diagonal vertical, Figure 10. Again the stretcher was rigid and fixed. The results were that the stresses again did not exceed .11 MPa (.016 ksi). The distribution of stresses from the 30 G corner impact and extremely high impact theoretical crack pattern are presented in Figures 11 and 12, respectively. These models suggest that factors other than the mass of the painting alone must intervene before impact can damage the paint layer.

Corner Impact of a 61 x 61 cm Painting with a Traditional Wood Stretcher and Fixed at the Corners

A smaller painting (61 x 61 cm [24 x 24 in.]), and therefore a lighter one, was modeled as if it were also subjected to a 30 G impact on its corner. In this case, a wood stretcher was included in the model with 2.54 x 7.62 cm (1 x 3 in.) stretcher bars. The corners of the stretcher were fixed as if they had been secured with screws, and in reality this describes a strainer. The post-impact distortion of the model painting is shown in Figure 13, and as can be seen, the painting reconfigured from a square to a diamond shape.

The maximum principal stresses in the paint film reached nearly 1.38 MPa (.2 ksi) or 37% of the measured breaking strength of the white lead paint. The complete stress distribution is shown in Figure 14 and the theoretical crack pattern is shown in Figure 15 if the impact exceeded 82 G's, which is quite possible.

The results of this test model has been compared to the test results provided by Paul Marcon, who made a model test drop of a painting at the Canadian Conservation Institute (CCI).[15] The computer model crack pattern is nearly identical to the experimental

results. The indication here is that the stretcher, even if it is fixed at the corners, is sufficient to present a hazard to the painting if it is dropped on its corner. The wood stretcher bars are simply too flexible to prevent the type of distortion seen in Figure 13. Any weight attached to the painting, such as the frame, will only serve to aggravate the situation if a stiff backing board is not attached to the reverse of the stretcher.

Out-of-plane Vibration

For a painting to sustain a continuous out-of-plane vibration during transport, certain conditions must exist. The source of the vibration, i.e. trains, trucks, and airplanes, must provide a continuous vibration and it must be at a frequency near one of the natural or harmonic frequencies of the painting. Paul Marcon [16] has examined the types of vibrations most likely to occur in the various transportation modes, which makes it somewhat unlikely that sustained vibration will occur in a painting. He does point out those circumstances where it is possible that the right conditions exist to be of some concern. Therefore, it is worth examining what might happen if sustained vibration were to occur. The worst case is when the primary frequency is matched and the entire painting is deflected either to one side of the plane of the stretcher bars or the other. Additionally, some bending stresses are encountered, and the paint layer is under greater tension when the painting is deflected towards the side of the design layer. First, a 61 x 61 cm (24 x 24 in.) model with the same layers as described previously was used to examine the effect of initial uniform tension on the out-of-plane vibration of the painting.

Some preliminary remarks are necessary before showing the results of the computer modeling. When any object vibrates out of its original plane, a phenomena called *stress stiffening* occurs. This means the displacement is considerably reduced due to the conversion of bending stresses to purely axial stresses as the object no longer lays in the initial starting plane. For example, a stretched wire may experience bending stresses as it is initially dis-

placed from a straight line, but the further it is displaced, the more the stresses become uniform through the axial direction of the wire. In a painting, the initial displacement may have the paint film in tension, the glue layer with no stresses, and the fabric in compression. At full displacement all layers are in tension. This occurs because the ends of the wire, or in our case the edges of the painting, are restrained from moving. The computer program cannot handle stress stiffening directly, but must increment the applied load gradually mathematically correcting the orientation (rotation) of the elements. The problem, therefore, takes considerably longer to solve; in this case, between thirty-five and sixty minutes, depending on the number of iterations required. Ten iterations usually solved the problem correctly.

The next factor to consider is the actual inertial force applied to the model. Uniform accelerations were used in these models; in actual conditions the accelerations are maximum at the center of the paintings and reduce when approaching the edges. This means that the results shown are more severe than would occur to an actual painting. Finally, it has been thought that a vibrating painting is damped by its effort to move air adjacent to the painting out of the way. This may not be significant. If a painting is vibrating at 20 Hz (cycles per second) and has a displacement of 1.27 cm (.5 in.), the maximum velocity the painting experiences is only about 5.7 KPH (3.5 MPH). This velocity is not sufficient to cause serious pressure development at the surface of the painting unless the painting is enormous, in which case the frequency will be considerably lower, or it is tightly sealed by a very rigid backing board at the reverse. In the latter case, the painting must be vibrating in its primary mode. The 10 G acceleration level used in the following models was chosen on the assumption that the amplification factor of the paintings was around 20, which was measured by Paul Marcon at CCI, and the maximum peak acceleration from sustained vibration delivered by a transportation mode was .5 G. Additional useful information regarding sustained vibration in transportation vehicles can be found in the literature.[17]

Out-of-plane Accelerations on a 61 x 61 cm Model Painting

A 10 G acceleration was applied to the 61 x 61 cm (24 x 24 in.) model painting which had different uniform tensions applied. This model painting was "stretched" with different tensions and subjected to 10 G vibrations. The construction of the model painting is the same as described in the section on edge drops. The 10 G acceleration occurs at the same time that the painting is fully displaced from the plane of the stretcher. The typical out-of-plane displacement of the entire painting is illustrated in Figure 16, where the painted surface is upwards. The typical stress distribution shown in Figure 17 and a theoretical crack pattern is shown in Figure 18. The illustrations presented are for the least initial tension in Table 11.

It is noteworthy that the stresses are fairly uniform over the entire surface with a variation between a minimum stress of .43 MPa (.062 ksi) to a maximum of .58 MPa (.085 ksi). The maximum stresses occurred at the edges a bit away from the corners and the minimum at the center of the painting. This uniformity was found throughout each of the model painting layers. The maximum stress results for each of the pre-stress levels is shown in Table 11. The deflections included in this table are the center of the painting, moving from the plane of the stretcher to the maximum displacement of the painted surface outward.

The most important observation to be made here is the differences in the paint layer stresses before and after the application of a 10 G acceleration, which ranges from .24 MPa to .34 MPa (.040 ksi. to .049 ksi.). This is less than the initial pre-stresses placed in the paintings before a vibration at 10 G's. Even then, the total paint film stresses never exceed 25% of the measured breaking strength of the white lead paint. It appears easier to damage the painting by stretching it than by vibrating it. Recall also that these stresses are greater than would actually occur in a real painting. Another point is the relatively high

glue stresses due to the high modulus, and the low fabric stresses, due to the low modulus. This demonstrates the major influence the modulus has on the stress development in a material.

Out-of-plane Accelerations on a 67 x 102 cm Painting

A much larger painting was modeled to examine the effects of a larger surface area and different G levels. The 67 x 102 cm (30 x 40 in.) painting described in the section of the edge and corner impact was subjected to 1, 5, and 10 G accelerations at a fixed initial tension. The initial uniform pre-tension was induced by uniformly expanding the model painting .057 cm (.0225 in.) in the short direction and .07 cm (.03 in.) in the long direction. This resulted in initial pre-stresses in the layers of .517 MPa (.075 ksi) in the fabric, 3.09 MPa (.488 ksi) in the glue layer and .517 MPa (.075 ksi) in the paint layer. The calculated maximum stresses resulting from applying different G levels to this model are shown in Table 12. The net stress increases for the paint layer at the different accelerations are .28 MPa (.040 ksi), .29 MPa (.043 ksi), and .37 MPa (.053 ksi), which are not significant when considering the breaking strength of the paints. The application of a 1 G acceleration is the same as the painting would experience by simply resting face down on a table. The stresses in the paint film that developed under these circumstances is not much different than the 5 and 10 G accelerations and can be viewed as a result of the initial bending stresses that occur when the painting just begins to deflect from the in-plane position.

Even the deflections are not considerably different from the smaller painting modeled previously. The out-of-plane displacement computed is illustrated in Figure 19. The overall stress distribution resulting from the 10 G acceleration (Figure 20) is remarkably uniform as noted earlier in the smaller model and the theoretical crack pattern is shown in Figure 21.

Effects of Desiccation and Cooling

If the larger painting modeled above is subjected to desiccation and chilling while being subjected to a 10 G out-of-plane acceleration, the effects are considerable, and the results are primarily a consequence of the changes in the modulus of each material. The paint layer used in this model is the Naples yellow as the mechanical properties data is available and the properties of this paint is similar to the white lead previously used. The new stiffness values for the materials are now: the fabric 861 MPa (125 ksi), the glue 5,515 MPa (800 ksi), and the paint 4,019 MPa (583 ksi), which correspond to a 5% RH and -3°C environment. Also, because of the increase in the E values, the pre-stresses are significantly increased. The final analysis stress values are shown in Table 13. Of particular interest is the final stress of the paint film, which is 4.75 MPa (.690 ksi), which is considerably less than the strength of the Naples yellow and considerably less than the strength of this paint at this cold, dry climate (16.5 MPa [2.4 ksi]). Because of this large difference in the stresses, there is still a considerable safety factor from the vibration. It would be prudent to avoid this and any other environment that tends to stiffen the materials since there is a marked decrease in the strains to failure and inadvertent, though slight, blows directly to the painting surface will most likely cause damage.

Analysis of a 61 x 61 cm Painting with a Gesso Layer Replacing the Paint Film

If the paint film is replaced with gesso (PVC=93) at 23°C and 50% RH and subjected to a 10 G acceleration, the results reflect two major influences. The first is that the gesso only weighs about 36% of the white lead paint, so the forces resulting from the acceleration are less. The second and the most influential, is the modulus of the gesso is about 2.5 times greater than the paint and this appears to be the major consideration since the net stress increase (total minus initial) is .77 MPa (.112 ksi), which is over twice that experienced by the same size painting with a

paint layer. The results of this analysis are summarized in Table 14. The total calculated stress of the gesso (1.45 MPa [.211 ksi]) exceeds the breaking strength of the tested gesso (1.17 MPa [.170 ksi]) and suggest that this layer will start cracking. About half of this stress was a result of "stretching" the painting. The fact that we don't see crack patterns calculated by the computer analysis, suggests that the vibrations paintings encounter are not so severe.

SUMMARY

Artists' materials have rapid loading mechanical properties that vary with changes in temperature and relative humidity, becoming stiffer and stronger with drying and cooling. The paint is the weakest material in comparison to the glue and fabric, though depending on the mixture of chalk and glue, can be stronger than the gesso. The slow driers, burnt umber and burnt sienna, are so flexible that their ability to withstand deformation far exceeds the fast driers that contain lead carbonate or other driers. The primary concern are the lead-based paints, which are relatively stiff, having the higher modulus. The glue strengths are quite high and its failure will be extremely rare at ambient room temperature and at relative humidity level above 75%. This material has a strength of over twenty times the weaker lead paint at room temperature and 50% RH. If it does fail, it is almost a guarantee that the paint layer will also be destroyed.

At the coldest (-3°C) and driest (5% RH) environments, the materials tested shattered into multiple pieces even though the breaking strengths are quite high. At this environment, it is likely that the presence of pre-existing cracks in a painting composed of these materials might be a real concern, and further crack growth might be possible.

These initial results indicate that paintings constructed with even the stiffest and weakest thirteen-year-old lead paint can withstand fairly severe impacts if the stretcher is extremely rigid, otherwise the distortion of the stretcher will contribute to damaging the painting. Avoid any drop that allows a painting to hit corner first without any protection. The crack patterns predicted by the corner impact study where the stretcher is free to distort are easily reproducible on actual test paintings. Those crack patterns predicted by the stiffened stretcher model are not encountered in actual paintings.

The primary reason that the stress levels in paintings subjected to vibration are low, is the low total weight of the painted surface. This means a low mass, and inertial forces are in direct proportion to both the mass and the acceleration encountered. On the other hand, the added weight of the stretcher and frame, combined with the stretchers ability to deform are the reasons that damage is possible from a corner impact.

The modeling showed that the paintings were at very little risk from 10 G vibration should it occur. This was true even for the cold, dry environment, though this environment should be avoided at all costs. Even if paints become much stiffer and lose a considerable amount of their strength over the years due to slow evaporation of volatile components,[18] leeching of solubles from cleaning solvents, or other reasons, the stresses modeled by the computer are still insufficient to put the painting at serious risk. The stress due to vibration in any of the layers of the painting is remarkably uniform, but the analysis suggested that the highest stresses will occur at the edges and not in the middle. What theoretical crack patterns were developed by vibration modeling, have not been seen by the authors on any actual paintings. □

APPENDIX A — FIGURES

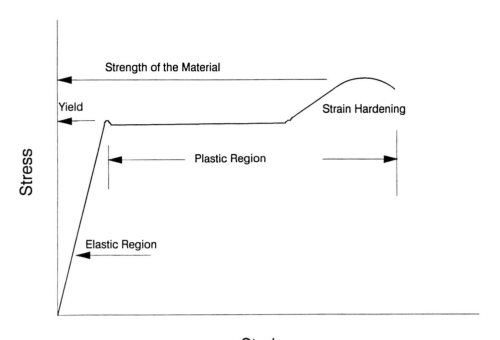

FIGURE 1
A typical stress-strain curve for a mild steel showing the major features of the mechanical properties of the material. Typical modulus for steel is 199,926 MPa (29,000 ksi) and the yield strength is 248 MPa (36 ksi). These are considerably higher than the polymers tested.

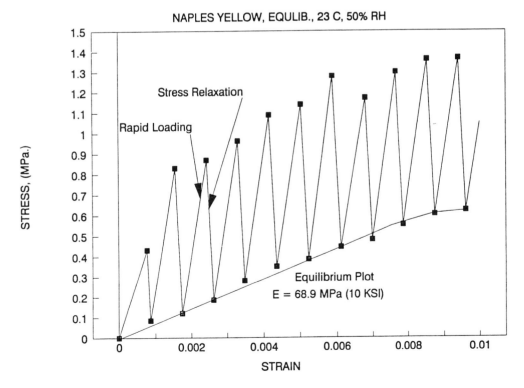

FIGURE 2
The typical test plot for establishing the "equilibrium" stress-strain data for artists' materials. Stress relaxation occurs after a rapid loading increment and the fully stress relaxed points establish the equilibrium stress-strain plot.

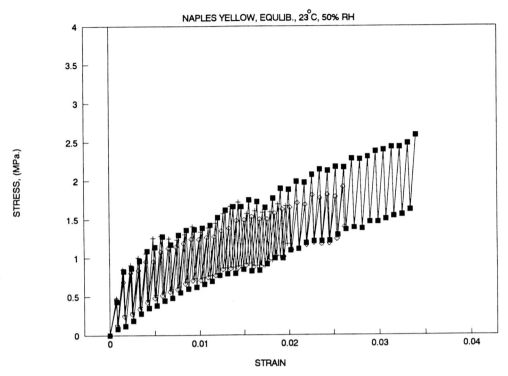

FIGURE 3
Equilibrium stress-strain tests results for three different samples of Naples yellow oil paint. This data represents the largest scatter observed in the materials testing. The slopes of the plots are quite consistent while the strain to failure is spread widely.

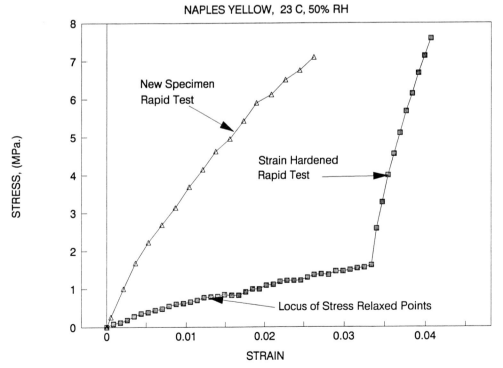

FIGURE 4
A comparison of the equilibrium stress-strain data to the rapid loading data. Rapid loading tests were conducted using both new specimens and specimens previously tested under equilibrium conditions. The differences in the stiffness and strength of the paint under these different loading conditions is considerable. There is still substantial rapid loading strength even after long-term testing.

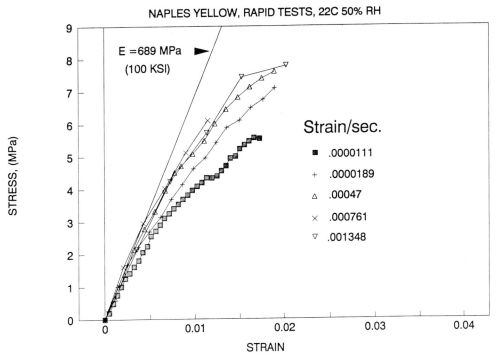

FIGURE 5
Rapid loading stress-strain results for Naples yellow paint loaded at different strain rates. There appeared to be an upper limit to the stiffness of this material since higher strain rates showed no increase in the modulus.

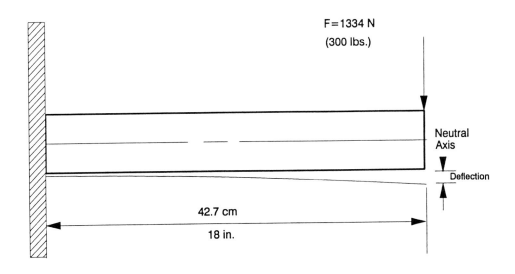

FIGURE 6
Fixed end, cantilevered beam problem run on the computer using Finite Elements. The load at the end of the beam causes a downward deflection of 1.567 cm (.617 in.) which the program computed with a difference of less than 2%.

FIGURE 7
In-plane deflection of the model 76 x 102 cm painting after a 30 G impact on a flat edge. The stretcher in this model was assumed to be infinitely rigid to determine the results of the impact on the painting itself.

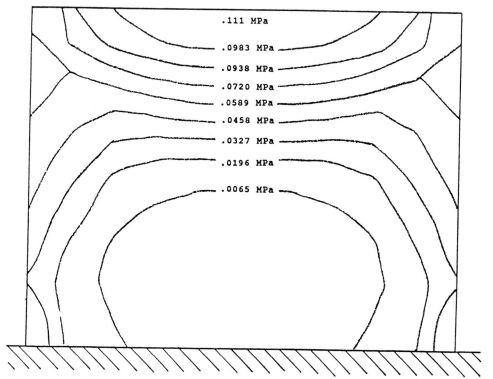

FIGURE 8
The in-plane principal stress distribution as shown on stress contours resulting from a 30 G edge impact on the 76 x 102 cm model painting. The maximum stresses are extremely low, only .11 MPa, less than 3% of the breaking strength of the white lead paint at 50% RH, 23°.

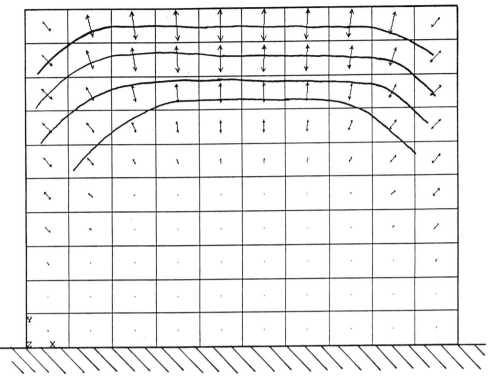

FIGURE 9
The principal stress vectors resulting from a 30 G edge impact of a 76 x 102 cm model painting. The theoretical crack pattern is superimposed over the vectors which intersect the cracks at 90 degrees.

FIGURE 10
In-plane deflection of the model 76 x 102 cm painting after a 30 G impact on its corner. The stretcher in this model was assumed to be infinitely rigid to determine the results of the impact on the painting itself. The maximum deflection is quite small, only .019 cm (.0075 in.).

155

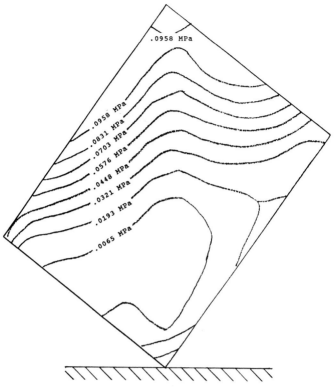

FIGURE 11

The in-plane principal stress distribution as shown on stress contours resulting from a 30 G corner impact on the 76 x 102 cm model painting. The maximum stresses are extremely low, only .11 MPa, less than 3% of the breaking strength of the white lead paint at 50% RH, 23°C.

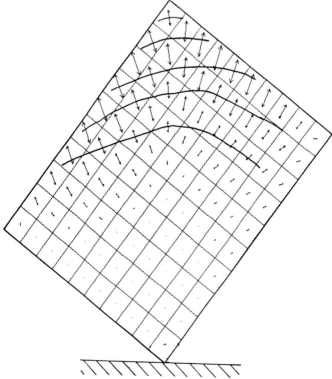

FIGURE 12

The principal stress vectors resulting from a 30 G corner impact of a 76 x 102 cm model painting. The theoretical crack pattern is superimposed over the vectors which intersect the cracks at 90 degrees.

156

FIGURE 13
The before and after shape and displacement of a 61 x 61 cm model painting attached to a traditional wood stretcher. The corners of the stretcher were fixed. Model was subjected to a 30 G corner impact.

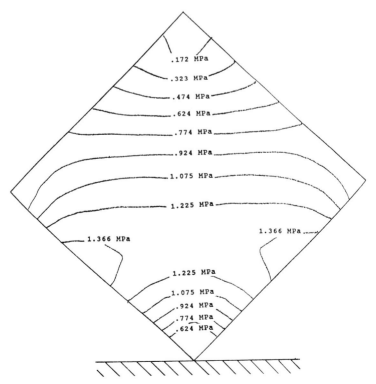

FIGURE 14
The in-plane principal stress distribution as shown on stress contours resulting from a 30 G corner impact on the 61 x 61 cm model painting. This model had a traditional wooden stretcher with fixed corners. The wood is still flexible enough to cause stresses of 1.38 MPa (.2 ksi) or 37% of the breaking strength of the white lead paint at 50% RH, 23°C.

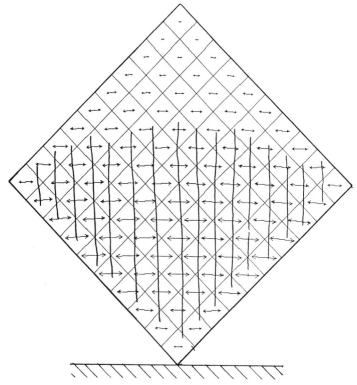

FIGURE 15
The principal stress vectors resulting from a 30 G corner impact of a 61 x 61 cm model painting with fixed corners on a wooden stretcher. The theoretical crack pattern is superimposed over the vectors which intersect the cracks at 90 degrees.

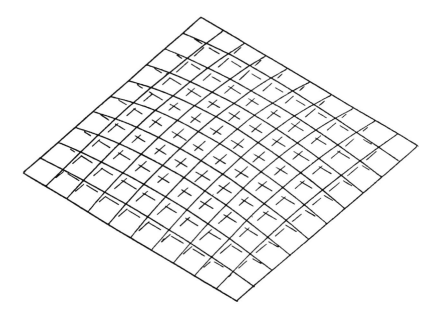

FIGURE 16
Computer generated out-of-plane displacement for a 61 x 61 cm model painting subjected to a 10 G out-of-plane acceleration.

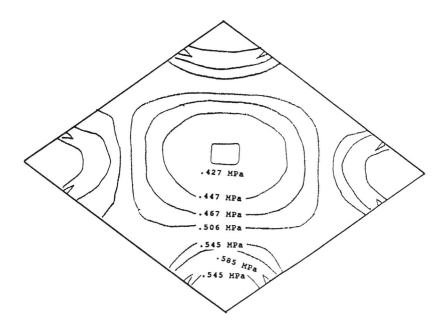

FIGURE 17
The in-plane principal stress distribution of the white lead paint layer as shown on stress contours resulting from a 10 G out-of-plane acceleration on the 61 x 61 cm model painting. The Stress is fairly uniform over the surface of the painting. The maximum stresses occur at the edges, away from the corners, and not at the center as might occur from pure bending.

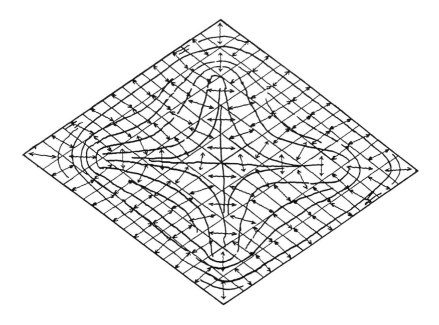

FIGURE 18
The principal stress vectors resulting from a 10 G out-of-plane acceleration of a 61 cm x 61 cm model painting. The theoretical crack pattern is superimposed over the vectors which intersect the cracks at 90 degrees.

159

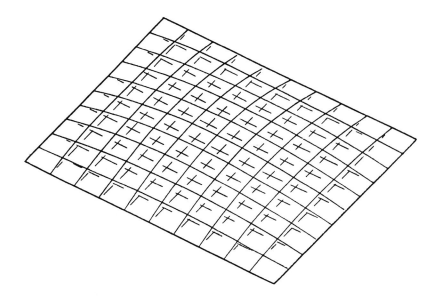

FIGURE 19
Computer generated out-of-plane displacement for a 67 x 102 cm model painting subjected to a 10 G out-of-plane acceleration.

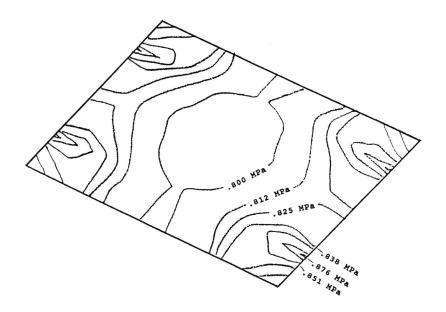

FIGURE 20
The in-plane principal stress distribution of the white lead paint layer as shown on stress contours resulting from a 10 G out-of-plane acceleration on the 67 x 102 cm model painting. The Stress is fairly uniform over the surface of the painting. The maximum stresses occur at the edges, away from the corners.

160

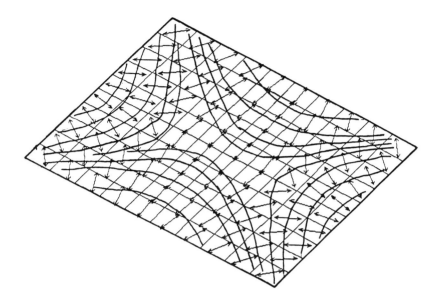

FIGURE 21

The principal stress vectors resulting from a 10 G out-of-plane acceleration of a 67 cm x 107 cm model painting. The theoretical crack pattern is superimposed over the vectors which intersect the cracks at 90 degrees. This pattern and the one in Figure 18 are not readily recognized.

APPENDIX B — TABLES

TABLE 1
Rapid test results of various 13-year-old paints at 23°C, 50% RH.

TEST MATERIAL 23°C, 50% RH	Previously Untested			Strain Hardened	
	E MPa* (KSI)**	Max σ MPa (KSI)	Max ϵ	E MPa (KSI)	Max σ MPa (KSI)
Naples Yellow Linseed Oil	689 (100)	7.58 (1.1)	.020	1172 (170)	7.58 (1.1)
Flake White Safflower Oil	689 (100)	3.72 (.54)	.0051	–	–
Vermilion Safflower Oil	737 (107)	3.86 (.56)	.0062	1241 (180)	6.06 (.88)
Burnt Sienna Linseed Oil	137.9 (20.0)	4.48 (.65)	.075	173.7 (25.2)	5.38 (.78)
Burnt Umber Linseed Oil	34.5 (5.0)	.62 (.09)	.056	–	–

* 1 KSI = 6.894 MPa ** KSI = PSI x 1000

TABLE 2
Rapid test results of various paints at 23°C.

TEST MATERIAL 23°C, 50% RH	Previously Untested		
	Age Years	RH	E MPa (KSI)
Naples Yellow Linseed Oil .043 cm thick	3.75	47	304.7 (44.2)
Naples Yellow Linseed Oil .0038 cm thick	3.75	47	327.4 (47.5)
Flake White Safflower Oil	3.75	45	413.6 (60.0)
Vermilion Safflower Oil	3.0	55	462 (67.0)
Burnt Sienna * Linseed Oil	3.75	50	0
Burnt Umber * Linseed Oil	3.75	50	0

* These paints were not dry enough to test.

163

TABLE 3a
The effect of RH at 23°C on the mechanical properties of 13-year-old Naples yellow.

	Previously Untested			Strain Hardened	
Naples yellow 23°C	E MPa (KSI)	Max σ MPa (KSI)	Max ϵ	E MPa (KSI)	Max σ MPa (KSI)
5% RH	1310 (190)	10.3 (1.5)	.01	1440 (209)	8.27 (1.2)
50% RH	689 (100)	7.58 (1.1)	.02	1172 (170)	7.58 (1.1)
91% RH	110 (16.0)	3.86 (.56)	.054	–	–

TABLE 3b
The effect of RH at 23°C on the mechanical properties of 13-year-old burnt sienna.

	Previously Untested			Strain Hardened	
Burnt Sienna 23°C	E MPa (KSI)	Max σ MPa (KSI)	Max ϵ	E MPa (KSI)	Max σ MPa (KSI)
5% RH	641 (93)	7.92 (1.15)	.023	561 (81.4)	6.27 (.91)
50% RH	138 (20)	4.48 (.65)	.075	174 (25.2)	5.38 (.78)
91% RH	4.48 (.65)	.31 (.045)	.064	–	–

TABLE 4a
The effect of RH at -3°C on the mechanical properties of 13-year-old Naples yellow.

Previously Untested

Naples Yellow -3° C	E MPa (KSI)	Max σ MPa (KSI)	Max ϵ
5% RH	4019 (583)	16.5 (2.4)	.0051
42% RH	2627 (381)	12.4 (1.8)	.0058
51% RH	2600 (377)	10.7 (1.55)	.0056

TABLE 4b
The effect of RH at -3°C on the mechanical proerties of 13-year-old burnt sienna.

Previously Untested

Burnt Sienna -3°C	E MPa (KSI)	Max σ MPa (KSI)	Max ϵ
5% RH	2757 (400)	16.5 (2.4)	.006
42% RH	868 (126)	11.7 (1.7)	.050
51% RH	241 (35)	5.5 (.8)	.085

TABLE 5
Rapid test of rabbit skin glue at different environments.

Rabbit Skin Glue Test Environment	E MPa (KSI)	Max σ MPa (KSI)	Max ϵ
50% RH, 23°C	4481 (650)	82.0 (11.9)	.023
5% RH, 23°C	5515 (800)	124 (18.0)	.029
5% RH, -3°C	5343 (775)	92.4 (13.4)	.019

TABLE 6
Rapid testing of gesso mixtures at 22°C and 63% RH.

Gesso to Glue Ratio by Weight	Pigment Volume Concentration	E MPa (KSI)	Max σ MPa (KSI)	Max ϵ
3.15	58.3	3200 (464)	6.51 (.945)	.0027
10.0	81.6	3757 (545)	5.75 (.835)	.0021
13.3	85.5	4136 (600)	4.66 (.676)	.0012
15.0	86.9	4101 (595)	4.66 (.677)	.0013
20.0	89.9	2088 (303)	2.54 (.368)	.0012
30.0	93.0	1709 (248)	1.17 (.170)	.00061

TABLE 7
Measured average fiber cross sections per yarn for the test linens.

	Warp	Weft		Warp	Weft
Fabric	Area of Yarns cm^2 $in.^2$	Area of Yarns cm^2 $in.^2$	Fabric Weight N/cm^2 $oz./in.^2$	Yarn Count no./cm no./in.	Yarn Count no./cm no./in.
#248	.00057 .000088	.00048 .000074	.000398 .00924	24.6 62.5	20.2 51.5
#444	.00052 .000080	.00043 .000066	.000347 .00897	24.4 62.0	19.3 49.0
#8800	.00050 .000078	.00052 .000080	.000268 .00622	16.7 42.5	15.4 39.1

TABLE 8
Mean fiber modulus versus relative humidity for a typical linen textile.

Relative Humidity %	Warp Direction, E MPa (KSI)	Weft Direction, E MPa (KSI)
18	24.1 (3.5)	289 (42)
40	-	675 (98)
48	24.1 (3.5)	-
59	-	758 (110)
70	68.9 (10)	-
75	-	2275 (330)
91	213 (30.9)	-
93	-	1585 (230)
95	606 (88)	-
Saturated	510 (74)	-

TABLE 9a
Comparison of the FEA analysis results wity the theoretical free-end deflection for the cantilevered beam problem.

Number of Elements	Theoretical Solution/cm	Finite Element Solution/cm	% Difference
1	1.567	.104	93
4	1.567	.348	77
72	1.567	1.33	15
180	1.567	1.45	4
360	1.567	1.557	1.2

TABLE 9b
Comparison of the FEA analysis results with the theoretical stresses when 360 elements were used.

Maximum Stresses	Theoretical MPa (KSI)	FEA Results MPa (KSI)	% Difference
Bending	26.1 (3.79)	26.8 (3.89)	-2.6
Shear	1.09 (.158)	1.07 (.155)	1.9

TABLE 10
Nominal weight densities for typical artists' materials.

Material	Nominal Density N/cm^3	Nominal Density $Lbs./in.^3$
White Lead Paint	.0279	.1029
Naples Yellow Paint	.0254	.0936
Burnt Sienna Paint	.0206	.0757
Rabbit Skin Glue	.01	.0368
Gesso, PVC = 58.3	.0128	.0473
Gesso, PVC = 89.9	.0101	.0374
Linen #248	.00628	.0231
Linen #444	.00546	.0201
Linen #8800	.00555	.0201
Oak, average	.00979	.03605

TABLE 11
Maximum stresses from a 10 G acceleration at different initial tensions for the 61 x 61 cm painting.

Initial Fabric Stress MPa (KSI)	Initial Glue Stress MPa (KSI)	Initial Paint Stress MPa (KSI)	10G Fabric Stress MPa (KSI)	10G Glue Stress MPa (KSI)	10G Paint Stress MPa (KSI)	10G Max. Def. cm (in.)
.316 (.458)	2.05 (.298)	.317 (.046)	.593 (.086)	3.81 (.552)	.586 (.085)	.703 (.277)
.345 (.050)	2.24 (.325)	.345 (.050)	.634 (.092)	4.10 (.595)	.627 (.091)	.592 (.233)
.434 (.063)	2.80 (.406)	.434 (.063)	.730 (.106)	4.71 (.683)	.724 (.105)	.475 (.187)
.572 (.083)	3.73 (.541)	.572 (.083)	.916 (.133)	5.92 (.859)	.910 (.132)	.358 (.141)

TABLE 12
The effects of increasing out-of-plane acceleration on the 67 x 102 cm painting at a fixed initial tension.

Acceleration	Fabric Stress MPa (KSI)	Glue Stress MPa (KSI)	Paint Stress MPa (KSI)	Deflection cm (in.)
1G	.799 (.116)	5.14 (.745)	.79 (.115)	.066 (.026)
5G	.813 (.118)	5.26 (.763)	.813 (.118)	.39 (.156)
10G	.89 (.129)	5.73 (.831)	.88 (.128)	.81 (.317)

TABLE 13
The effects of desiccation and chilling while applyhing a 10 G acceleration to the 67 (30) x 102 cm (40 in.) painting.

Initial Stresses Total Stresses @ 10 G

Fabric Stress MPa (ksi)	Glue Stress MPa (KSI)	Paint Stress MPa (KSI)	Fabric Stress MPa (ksi)	Glue Stress MPa (KSI)	Paint Stress MPa (KSI)	Def. cm in.
.648 (.094)	4.13 (.600)	2.98 (.432)	1.03 (.149)	6.55 (.95)	4.76 (.690)	.424 (.167)

TABLE 14
Maximum computed stresses for a painting with gesso replacing the white lead paint at a 10 G acceleration.

Initial Stresses Total Stresses @ 10 G

Fabric Stress MPa (ksi)	Glue Stress MPa (KSI)	Gesso Stress MPa (KSI)	Fabric Stress MPa (ksi)	Glue Stress MPa (KSI)	Gesso Stress MPa (KSI)	Def. cm (in.)
.276 (.040)	1.79 (.260)	.684 (.099)	.593 (.086)	3.82 (.554)	1.45 (.211)	.973 (.383)

ACKNOWLEDGMENTS

We wish to thank the Scholarly Studies Program of the Smithsonian Institution for its generous support of this research project.

NOTES

1. A. Elm, "Some Mechanical Properties of Paint Films," *Official Digest*, 25 (1953), 750-774; A. C. Elm, "The Stress-Strain Properties of Clear and Pigmented Films of Pure Drying Oil Compounds," *Official Digest*, (1951), 701-723; M. G. Shiker, "Deformation Properties of Linseed Oil Films," *Journal of Applied Chemistry*, (USSR), 12 (1932), 1884-1891; A. V. Damfilov and Ye. G. Ivancheva, "Mechanical Properties of Pigmented Oil Films," *Journal of Applied Chemistry* (USSR) 20 (1947), 676-683; A. Toussaint and L. D'Hont, "Ultimate Strength of Paint Films," *J. Oil Col. Chem. Assoc.* 64 (1981), 302-307; A. Zosel, "Mechanical Behavior of Coating Films," *Progress in Organic Coatings* 8 (1980), 47-79; Kozo Sato, "The Mechanical Properties of Filled Polymers," *Progress in Organic Coatings* 4 (1976), 271-302; M. F. Mecklenburg, "Some Aspects of the Mechanical Behavior of Fabric Supported Paintings," Report to the Smithsonian Institution (1982), 7-12; G. Hedley, M. Odlyha, A. Burnstock, J. Tillinghast, and C. Husband, "A Study of the Mechanical and Surface Properties of Oil Paint Films Treated with Organic Solvents and Water," IIC *Preprints* of the contributions to the Brussels Congress (1990), 98-105.

2. J. M. Ward, *Mechanical Properties of Solid Polymers* (1983); P. Mears, Polymers, *Structure and Bulk Properties* (1967); M. F. Mecklenburg, Ph.D. Dissertation, University of Maryland (1984), 15-20.

3. H. D. Ferry, *Viscoelastic Properties of Polymers* (1961).

4. *Wood Handbook, Wood as an Engineering Material,* USDA Agricultural Handbook No. 72 (1974); R. B. Hoadley, *Understanding Wood, A Craftsman's Guide to Wood Technology* (1981); P. Koch, *Utilization of Southern Pine, Volumes I and II,* USDA Agricultural Handbook No. 420 (1977), F.F.P. Kollmann and W. A. Côte, Jr., *Principles of Wood Science and Technology, Volume I, Solid Wood* (1986), 321-405.

5. Mecklenburg 1984, 10.

6. M. F. Mecklenburg and C. S. Tumosa, "Mechanical Properties of Paintings Subjected to Changes in Temperature and Relative Humidity," elsewhere in this publication; M. F. Mecklenburg, "The Effects of Atmospheric Moisture on the Mechanical Properties of Collagen Under Equilibrium Conditions," AIC *Preprints of Papers Presented at the 16th Annual Meeting* (1988), 231-244.

7. Analysis of this paint was conducted at CAL by W. D. Erhardt and W. Hopwood, unpublished research, (1990).

8. H. Lee and K. Neville, *Handbook of Epoxy Resins* (1967); Mecklenburg 1984, 15-20.

9. K. Wehlte, *The Materials and Techniques of Painting with a Supplement on Color Theory* (1975), 348-354; R. Mayer, *The Artist's Handbook of Materials and Techniques* (1980), 256; A. P. Laurie, *The Painter's Methods and Materials* (1967), 66.

10. See note 4.

11. Wehlte 1975, 326-331.

12. A. J. Panshin and C. de Zeeuw, *Textbook of Wood Technology* (1980), 223-225.

13. R. D. Cook, *Concepts and Applications of Finite Element Analysis* (1974), 173-188; J. S. Przemieniecki, *Theory of Matrix Structural Analysis* (1968), 102-122.

14. S. P. Timoshenko and J. N. Goodier, *Theory of Elasticity* (1970) 361-366; E. J. Hearn, *Mechanics of Materials* (1977), 57-72.

15. P. J. Marcon, "Shock, Vibration and Protective Package Design," elsewhere in this publication (1991).

16. P. J. Marcon, "Shock, Vibration and the Shipping Environment," elsewhere in this publication (1991).

17. P. J. Marcon, Canadian Conservation Institute, private communication; C. M. Harris, *Shock & Vibration Handbook* (1988); F. E. Ostrem and B. Liboviez, "A Survey of Environmental Conditions Incident to the Transportation of Materials," Final Report, PB 204 442, prepared for USDOT (1971); "An Assessment of the Common Carrier Shipping Environment," General Technical Report FPL 22, USDA Forest Products Laboratory (1979).

18. Hedley 1990.

MECHANICAL BEHAVIOR OF PAINTINGS SUBJECTED TO CHANGES IN TEMPERATURE AND RELATIVE HUMIDITY

Marion F. Mecklenburg and Charles S. Tumosa

ABSTRACT: *The effect of changes in temperature and relative humidity on the mechanical behavior of paintings is examined with regard to assessing the potential for damage. While forces, such as those applied by vibration and impact, occur over brief time intervals, those caused by environmental change tend to be considerably longer. This study examines the effects of temperature and relative humidity on the mechanical properties of artists' materials. In addition, the physical response, such as swelling, of some of the materials is described. Using both the mechanical properties and the dimensional response of the materials, computer models of typical paintings correlate the magnitude of developed stresses to the environmental changes. Comparing these calculated stresses with the measured strength of the materials in the painting allows for the development of a risk assessment for damage caused by environmental change.*

INTRODUCTION

Considerable experimental evidence exists indicating that changes in the environment induce internal forces (stresses) in the different layers of paintings.[1] In fact, it was observed that moving the collection of the National Gallery of London to a quarry for protection against bomb damage during World War II reduced the active flaking previously found to occur while the collection was on exhibition at the Gallery.[2] This observation prompted the idea that a stable climate offered long-term stability for the paintings. Since then, it has become almost standard policy for institutions to attempt to maintain environments with constant temperature and relative humidity, (usually around 50% RH and 24 °C [75 °F]) for the collections. This policy is sound, but unfortunately not always possible. Retrofitting many old historic sites with air-conditioning systems tends to dramatically alter the architectural quality of the spaces. In the winter, many old buildings suffer severe exterior wall damage caused by freezing water that permeated through the walls and crevices. In many of these cases, the installation of the proper vapor barriers is not possible or too costly. There are other circumstances where maintaining a constant environment may be problematic. One of these is the transportation of objects to and from exhibitions.

Curators, conservators, registrars, and collectors are continually attempting to assess the risk of lending a painting to an exhibition given the potential for the object being exposed to environmental changes and possibly suffer damage. This risk assessment is difficult since there is no real correlation between environmental deviations and damage to objects. Additionally, there is a seemingly infinite variation in the construction of paintings. Does this enormous variation, therefore, have an equally large influence on the painting's response to relative humidity and temperature? The problem, while large, can be systematically addressed using engineering mechanics and examining the mechanical responses of artists' materials and paintings to environmental factors such as temperature and relative humidity. These are the sources of stresses and stress-related cracking and flaking and will be encountered wherever

there are changes in the ambient environment of the painting.

There are two fundamental properties that must be examined. The first is the dimensional response of the painting materials to both temperature and relative humidity. If these materials are restrained, as they are in a stretched painting, and are subjected to desiccation, they have a propensity to shrink. This produces a stress rise. The second mechanical properties are those that relate force and deformation (stress and strain). These properties are used to determine the magnitude of the stresses resulting from the restrained materials attempting to contract.

Using this information, a "structural" analysis of the typical paintings can be performed to determine how the objects as entities respond to the changes in environment. Specifically, the sources, magnitudes, and locations of stresses can be identified and compared with the measured strengths of the materials to correlate environmental change to damage of paintings. One of the most powerful analytical tools for structural analysis is the digital computer. For handling structures with complex shapes in three dimensions and constructed of a wide variety of materials, the technique of *Finite Element Analysis* (FEA) is most appropriate.

DIMENSIONAL RESPONSE OF ARTISTS' MATERIALS TO RELATIVE HUMIDITY

Oil Paints

Most artists' materials will expand with an increase in moisture content and conversely shrink upon its loss. The major mechanism for changes in the materials' moisture content is the ambient relative humidity. If a shipping case is not buffered, temperature will influence the internal relative humidity, causing a rise with cooling and a decrease with heating.

Various artists' materials respond differently to moisture content. Oil paints, for example, experience considerable variation in their dimensional response to relative humidity. Figures 1 and 2 (see *Appendix B* for

all Figures) illustrate two paints that differ considerably in this respect. In Figure 1, flake white, ground in safflower oil, swells a maximum of .18%, with the largest increase, about .6%, occurring between 70% and 95% RH. Burnt umber, in linseed oil, swells a total of 2.6% at 95% RH and, like flake white, the greatest increase occurs between 70% and 95% RH (Figure 2). These specimens, which were between .025 cm (.010 in.) and .038 cm (.015 in) thick, took at least forty-eight hours to reach equilibrium with the environment at which the data was recorded.

There are two basic regions of swelling for most of these paints, from 0% to 70% RH where the swelling rate is low, and from 70% to 95% RH, where there is a marked increase in swelling. Twelve paints were tested and their two swelling regions are listed in Table 1 (see *Appendix A* for all Tables). The paints listed in Table 1 were cast in March 1978 and tested in December 1982. Details of the paint sample casting, preparation, and testing are presented elsewhere in this publication.[3] It was noted that the stiffer paints, the "fast driers" such as the white lead paints, showed considerably less dimensional response to moisture than the slow driers such as the earth colors. This suggests that with time, as paints become dryer, their swelling response to relative humidity diminishes. Both safflower and linseed oils seemed to respond similarly.

Using Table 1, it is now possible to calculate two different "moisture" coefficients of expansion that linearly approximate the effect of moisture on the dimensional properties of the paint. These coefficients include the ranges from 0% to 70% RH and from 70% to 95% RH and can be calculated by using the percent length changes in each of the listed relative humidity ranges. For example, the low relative humidity range, moisture coefficient, α_a, for the flake white is:

$$\alpha_a = \frac{.18}{70} \times \frac{1}{100} = .0000257,$$

which is the change in strain per percent relative humidity. For the high relative humidity range:

the change in strain per percent relative humidity. For the high relative humidity range:

$$\alpha_b = \frac{.62}{25} \times \frac{1}{100} = .000248$$

which is nearly ten times the low range coefficient. These coefficients will be used to calculate the stresses resulting from the desiccation of restrained paint.

Rabbit Skin Glue and Gesso

One material, traditionally used in paintings, that is dimensionally responsive to relative humidity is rabbit skin glue. This material is used as a fabric size and a binder to gesso, when such grounds are used. The glue can absorb considerable water and in doing so, swells to over 3.5% of its dry length between 0% and 85% RH. Glue shrinkage during desiccation has been identified as one of the most important sources of relative humidity-related stress development in paintings.[4] Figure 3 shows the loss of length of two rabbit skin glue specimens when desiccated from 85% to near 0% RH. Similar to paint, there are two distinct regions of dimensional change, 0% to 70% RH and 70% to 85% RH, with the latter region having a considerably higher shrinkage rate than the former for the time that it takes glue to reach equilibrium (see *Restrained Stress Development*).

Gesso's response to relative humidity is similar to that of rabbit skin glue. The difference is that the total length change with comparable ranges of relative humidity is considerably less, and that 80% RH, not 70% RH, seems to mark the point of demarkation between the different swelling rates. Gesso swelling is influenced by the chalk-to-glue ratio. The higher this ratio, the smaller the total dimensional response to relative humidity. Table 2 gives the dimensional response for two different gesso mixtures when the filler was calcium carbonate.

Support Fabrics

Support fabrics' dimensional response to relative humidity is somewhat complicated because they respond differently at their in-

itial relative humidity cycle from all subsequent cycles. At between 80% and 85% RH they shrink with desiccation, as well as shrink when the relative humidity increases. This behavior is illustrated in Figure 4, which shows the percent length changes of both the warp and weft directions of samples of Ulster Linen #8800[5], with changes in relative humidity. At approximately 80% to 85% RH, shrinkage occurs irregardless of whether the relative humidity increases or decreases.

The high relative humidity shrinkage is a result of the textile weave. The transverse swelling of the yarns forces the mutually perpendicular yarns to increase in crimp, shortening the textile dimensions. The low relative humidity shrinkage (below 80% RH) is primarily a result of fiber shortening with desiccation, again with the weave again influencing behavior. The larger dimensional response in the warp direction, which has greater crimp in this textile, than in the weft substantiates this. The dimensional response occurring after the initial cycle is the most important.

The dimensional response of the fabric (Figure 4) is generally typical of woven linen textiles. The high relative humidity shrinkage results in high tension in a wetted, stretched linen, which is commonly observed by conservators preparing lining linens in painting conservation. This same stretched linen becomes completely slack upon drying and this has implications in the painting's response to environmental changes. Once a painting canvas is stretched and sized with glue, the resulting tautness upon drying is from the dried glue, not the canvas. At this stage the glue, not the canvas, is the primary support of the paint layers in the painting.

Wood

Wood is used as support panels in painting construction and as stretchers that support the canvas in fabric-supported easel paintings. The variety of woods used in making paintings is large, Wehlte lists at least nine hardwoods and nine softwoods.[6] Additionally, there is a proliferation of literature on the dimensional response of paintings to rela-

tive humidity.[7] Therefore, only a few pertinent features on the response of wood to relative humidity warrant discussion. Wood is orthotropic, that is, its physical (as well as mechanical) properties are different in the three mutually perpendicular directions. These directions are normally the longitudinal, tangential, and radial. Generally, the dimensional response of wood is considerably greater in the radial and tangential directions than it is in the longitudinal. Panshin and de Zeeuw[8] have shown that on the average, and over a broad spectrum of moisture contents, wood can dimensionally change approximately .3% in the longitudinal direction, 3.6% in the radial direction, and 5.9% in the tangential direction. Old woods still respond to changes in relative humidity and within the normal ranges encountered, the changes are still significant. Figure 5 shows the dimensional response to changes in relative humidity of three samples of oak that are at least one-hundred years old[9] with approximate testing of two specimens in the radial direction and the third in the tangential direction. The total length changes in the specimens subjected to a change in relative humidity from 12% to 76% were .9%, .98%, and 1.64%, at 23°C (73°F).

These specimens were small; the end grain dimensions were between .099 cm (.039 in.) and .284 cm (.112 in.) and the widths of the test specimens were between .76 cm (.3 in.) and .89 cm (.35 in.). It took at least ninety-six hours for these specimens to reach equilibrium with the environment at which measurements were recorded. Estimating the total dimensional response of wood found in a panel painting requires not only the identification of the wood but its grain orientation relative to the dimensions of the panel.

It is significant that there is little response of the wood in the longitudinal direction. Materials applied to wood, such as glue, gesso, and paints will still attempt to shrink upon desiccation regardless of the substrate. If the wood responds little to relative humidity in the longitudinal direction, it must be considered a *restraint* to the different material layers applied to it. Upon desiccation, that restraint will cause stresses in the upper layers,

and if failure (cracks) occurs, they will generally appear perpendicular to the grain of the wood.

DIMENSIONAL RESPONSE OF ARTISTS' MATERIALS TO TEMPERATURE

Relative humidity is not the only factor that affects the dimensional stability of artists' materials. Temperature, independent of relative humidity, can also have an effect. The material dimensional response to temperature is less dramatic than that of relative humidity when considering the temperature ranges encountered. Nevertheless, these effects, too, are significant.

For insight into the dimensional response of artists' materials to temperature without a serious influence from relative humidity, the thermal coefficients of expansion for Naples yellow paint and rabbit skin glue were determined while the ambient relative humidity was held at approximately 5%. The yellow paint was chosen because it is one of the stiffest paints examined. Figure 6 shows where the percent length change of the materials is plotted against temperature. Two tests of the Naples yellow were conducted to check for consistency of results. The results are remarkably linear in the temperature range from 23°C to -6°C as is shown by the fitted lines.

The total change in the length of the materials is small over the tested temperature range and the slope of these lines divided by one hundred will give the thermal coefficients (γ) of expansion for these materials. This is the change in strain per degree Celsius. For the paint, the thermal coefficient, γ, is equal to .000052 per degree Celsius; the rabbit skin glue has a thermal coefficient of about half that or .000025 per degree Celsius. Wood has thermal coefficients that differ in the three directions. For both hardwoods and softwoods, the thermal coefficient of expansion ranges from .0000027 to .0000045 per degree Celsius in the parallel-to-grain direction.[10] This is about one-tenth that of the hide glue. Perpendicular to the grain, both radial and tangential, the coefficients are pro-

portional to the density of the wood and can range between five to over ten times greater than the parallel-to-grain direction.

For comparison purposes, it is known that three common metals, copper, steel, and aluminum have coefficients of .000017, .000011, and .000024 per degree Celsius, respectively.[11] A material having a coefficient of expansion of .000025 per degree Celsius and cooled from 20° to 0°C will shrink only .05%, which is small compared to the changes that occur with even modest changes in relative humidity.

MECHANICAL PROPERTIES OF ARTISTS' MATERIALS UNDER LONG-TERM CONDITIONS

Because the time required for artists' materials to equilibrate with new environments is relatively long, it is necessary to examine the mechanical properties of artists' materials under long-term conditions. Paintings can hang on a gallery wall for years before being moved in preparation for transport to an exhibition in another institution. Under these circumstances it is probable that a painting will have equilibrated to the mean ambient environment of its location. This means that any dimensional changes are at a minimum if the environment is stable. It also means that any stresses in the different layers of the painting have fully relaxed, or diminished to a minimum. The mechanical properties of painting materials are very different under these long-term circumstances than they are under dynamic conditions. Artists' materials are able to deform considerably when stresses are applied slowly. The maximum strengths attained are also low under these conditions when compared to rapid loading conditions.

In defining some terms, stress, σ, is the applied force, F, divided by the cross-sectional area, A, of the test specimen. Stated mathematically:

$$(\text{Equation 1}) \ \sigma = \frac{F}{A}$$

Engineering strain, ε, is the change in specimen length, δ, divided by the original length of the specimen, L_o, where:

$$(\text{Equation 2}) \ \varepsilon = \frac{\delta}{L_o} = \frac{L_s - L_o}{L_o} \ \text{and}$$

L_s is the "stretched" length of the specimen, L_o is the original length of the specimen.

The ultimate strength of a material, σ_{ult}, is the maximum stress the material can sustain, and in artists' materials, it is usually the time at which the material breaks. The modulus, E, is the measure of a material's ability to deform when subjected to stress, and is:

$$(\text{Equation 3}) \ E = \frac{\sigma}{\varepsilon}$$

The modulus is defined normally for the elastic region of a stress–strain plot where the material returns to its original dimensions when the stress is removed. A material is said to exhibit *plastic behavior* if it remains permanently deformed after the removal of the stress. The yield point, σ_{yld}, is the stress where the material goes through a transition from elastic to plastic behavior.

Oil Paints

Several paints were mechanically tested under long-term loading conditions. Sample preparation and test procedures are outlined elsewhere in this publication.[12] The tests were conducted by applying a small strain to the test sample, about .007, and allowing it to fully stress relax. Once full stress relaxation was attained, a subsequent increment of strain was applied and the stress was allowed to fully relax (Figure 7).

The time to relax fully the paints was typically between five and ten days, depending on the paint. This process was repeated until the specimen broke. The entire test took several months for each equilibrium test to be completed. Typically, three samples were tested to check for consistency of results. Figures 8 and 9 show the fully developed *equilibrium* stress-strain tests for Naples yellow and burnt sienna, both in linseed oil. Three samples were tested of these paints and the modulus, the initial slopes of the specimens, is consistent.

Of all the tested materials, Naples yellow showed the most scatter in the strain attained at breaking. All of the paints tested were cast

in March 1978 and tested as free, unsupported films in 1989 and 1990. The modulus was determined by taking the slope of the locus of relaxed points from the equilibrium test (see Figure 7). In this case, for Naples yellow at 23°C 50% RH, the modulus was 68.9 Mega-Pascals (MPa), (10,000 pounds per square inch [10 ksi]). This is only about one-tenth of the modulus of the same material when tested rapidly in the same environment[13] (see Figure 10). The mechanical properties of the some of the paints tested in different environments are listed in Table 3.

Rabbit Skin Glue

Rabbit skin glue will not sustain a stress indefinitely. If a long enough period elapses, the glue will fully relax. The time for this complete relaxation to occur is at least 160 days for thin, .00059 cm (.0015 in.), specimens. If the glue is thicker, the relaxation time is considerably longer, at least 200 days for a .0043 cm (.011 in.) specimen. Its response time to environmental changes is considerably shorter and its mechanical properties can be measured in context of the time required to adjust to new environments. For the thickest glue measured, .0043 cm (.015 in.), it took about one-hundred hours to reach equilibrium with the new moisture content as measured by both stress development and swelling measurements. The thinnest glue sample, .00059 cm (.0015 in.), took only one hour to equilibrate. If ten days was used as the baseline to reach environmental equilibrium, then quasi-equilibrium mechanical properties can be determined for ten-day relaxation times for each loading increment. In Table 4, the ten-day equilibrium mechanical properties are shown for four different environments. The strengths reported in Table 4 are the approximate yield and not the maximum strengths. These values are used because the maximum glue stresses reached in a painting are based on their yield stresses. These strengths are much higher than those of the paints. These tests reveal that it is the glue layer in a sized painting that is responsible for most of the humidity-re-

lated damage.

STRESS DEVELOPMENT IN RESTRAINED MATERIALS RESULTING FROM CHANGES IN TEMPERATURE AND RELATIVE HUMIDITY

If any of the artists' materials are restrained and subjected to decreases in either temperature or relative humidity, they will experience an increase in tension. This results from the material's inability to contract while undergoing a loss of heat or moisture. The *magnitude* of the tensile stress the material experiences is a result of both the attempted shrinking and the modulus of the material. The modulus in any of the materials is a function of both the temperature and relative humidity which must be considered in any calculation that attempts to predict the level of stress increase resulting from environmental changes.

Temperature Effects

Generally, if the thermal coefficient of expansion and the equilibrium modulus of a material is known, the stress levels resulting in cooling a restrained material can be predicted. The method of calculating this stress increase can be derived from the basic Equation 3, repeated here:

(Equation 3) $E = \dfrac{\sigma}{\varepsilon}$

which can be rewritten as:

(Equation 4) $\sigma = E \ x \ \varepsilon$

To include the temperature effects, it must be recognized that both the modulus, E, and the strain, ε, are functions of temperature and therefore:

(Equation 5) $\sigma(T) = E(T) \ x \ \varepsilon(T)$

where

T represents temperature.

The equilibrium modulus for Naples yellow was measured at 23°C, 5% RH to be 327 MPa (47.5 ksi) and at -3°C, 5% RH it was found to be 1,034 MPa (150 ksi). If it is assumed that E varies linearly with temperature (see Figure 11) then a linear function for E(T) can be fitted and stated as:

(Equation 6) $E(T) = 955 - 26(T)$

where the units are MPa for the modulus and temperature is in degrees Celsius. That the function is linear is not unreasonable, since it was shown that the thermal coefficient is linear over the temperature ranges considered here.

The strain, (T), as a function of temperature is derived by considering the shrinkage of the specimen as if it were free to do so. The specimen would contract upon cooling and it is effectively being "stretched" backed to its original restrained length. The "unstretched" length would be the free shrinkage length and the deformation would be the amount needed to stretch the contracted specimen to the restrained length. Using the thermal coefficient of expansion, $\gamma = .000052$, for the paint, the freely contracted length for the paint for any temperature is:

(Equation 7) $L_T = L_R + \gamma \times \Delta T \times L_R$ or:
$L_T = L_R \times (1 + \gamma \times \Delta T)$ where:
L_T is the free shrinkage length,
L_R is the restrained length,
ΔT is the change in temperature the material experiences,
γ is the thermal coefficient of the material.

The strain at any temperature is now calculated as:

(Equation 8) $\varepsilon(T) = \dfrac{(L_R - L_T)}{L_T}$

Equation 8 can also be written in terms of the thermal coefficient of expansion, temperature change, and the stretched length as:

(Equation 9) $\varepsilon(T) = \dfrac{L_R - L_R \times (1 + \gamma \times \Delta T)}{L_R \times (1 + \gamma \times \Delta T)}$

or as:

(Equation 10) $\varepsilon(T) = -\dfrac{\gamma \times \Delta T}{1 + \gamma \times \Delta T}$

The negative sign indicates that positive tensile strains are resulting from negative temperature changes, i.e. cooling. The stresses for a fully restrained specimen are now the product of Equations 6 and 10. From an experimental point-of-view, it is not possible to measure easily the stress of a *fully* restrained specimen as the *load cell*, the device

that measures the stresses, is *compliant*. This means it *gives* a little as force is applied to it. This load cell compliance effectively relieves some of the restraint on the specimen and the stresses measured are actually less than if fully restrained. This compliance can, however, be included in the calculations that allow us to predict the behavior of the specimen subjected to restrained temperature changes. The compliance of the test device is a function of the total force and is measured during the test of the specimen. The value of the compliance, measured in units of length, is the raw data output, AO, times a compliance constant, KD. It is now possible to correct for the compliance of the load cell and calculate the expected stresses in the experimental restrained test where:

(Equation 11) $\sigma(T) = E(T) \times [E(T) - \dfrac{AO \times KD}{L(T)}]$

This calculation was conducted for the Naples yellow using the measured modulus and the thermal coefficient of expansion of the material. The results of this calculation are presented in Figure 12 as the lower continuous line.

Also on Figure 12 is the actual test data (squares) for the Naples yellow. There is a substantial correlation between the predicted and the actual measured stress levels at the different temperatures while the relative humidity is held at 5%, and additionally, the nonlinear increase of the stresses with temperature in both the predicted and actual measurements. This experiment was conducted with the temperature both increasing and decreasing. Figure 12 also shows the data (crosses) for restrained rabbit skin glue. Since the thermal coefficient was measured, it is possible to derive the equilibrium modulus from the restrained test. At -3 °C, the extrapolated value of the hide glue modulus is 4,860 MPa (705 ksi), which is only twelve percent less than the rapid loading modulus of 5,515 MPa (800 ksi).[14] This is the expected value since the difference between the rapid loading modulus and the equilibrium modulus for the artists' materials diminishes with a reduction in temperature and relative humidity. If, as before, the modulus is assumed to vary linearly with temperature, then a pre-

diction for all of the temperature-related stresses is possible. This is shown on Figure 12 as the solid line overlaying the rabbit skin test data.

Using Equation 5, it is now possible to calculate the stress development in Naples yellow and rabbit skin glue if they were *fully restrained*. Figure 13 shows the expected stresses of these materials when fully restrained and chilled from 23°C to -6°C at 5% RH. The load cell compliance has a significant stress reduction effect since the fully restrained stresses are nearly double for the glue and about fifteen percent higher for the paint.

The immediate conclusion drawn from Figures 12 and 13 is that, while the coefficient of thermal expansion for hide glue is only one-half that of the Naples yellow paint, the hide glue still has a larger stress increase, not because of changes in dimension but because of a substantially higher modulus. It is important to recognize that both the modulus and the coefficient of expansion influence the magnitude of the resulting stresses in materials restrained and cooled.

The ambient temperature is not the only way in which paintings can be subjected to changes in temperature. Figure 14 shows a plot of the stress in a restrained specimen of Naples yellow that has been subjected to an acetone "cleaning treatment." The stress is plotted against the time of the solvent application. Within a short period of time, the stress in the paint film increases. There is a corresponding decrease in the paint film temperature from the evaporation of the acetone solvent and as the temperature returns to ambient, the stresses in the paint film slowly return to lower levels and eventually nearly to the original value. This cooling phenomenon also shows how rapidly temperature effects can influence the mechanical properties of a paint film. Other chemical and physical effects may be taking place as well. The removal of low molecular weight materials, which serve as plasticizers, may make the paint more brittle. Erhardt and Tsang have measured the loss of over one percent of the weight of a paint film as free palmitic acid after treatment with solvents. The loss of other

free fatty acids, glycerides, and oligomers may total up to four to five percent of the weight of the film, which might be approximately fifteen percent of the weight of the medium.[15]

Relative Humidity Effects

The effects of relative humidity on the artists' materials are analogous to those of temperature. Changes in relative humidity induce both dimensional and mechanical properties changes. In effect then, stress development in restrained materials subjected to desiccation can be treated in a manner similar to restrained materials subjected to decreases in temperature. The mathematics for relative humidity behavior would be:

(Equation 12) $\sigma(RH) = E(RH) \times \varepsilon(RH)$
where:

(Equation 13) $\varepsilon(RH) = -\dfrac{\alpha x \, \Delta RH}{1 + \alpha x \, \Delta RH}$ and Δ RH is the change in relative humidity,

with α the *moisture* coefficient of expansion. This is an approximation as the change in dimensions with relative humidity is not linear. The simplest approximation would be to have two values of α: one, α_a from 0% RH to 70% RH and another, α_b, from 70% RH to 90% RH. The values are shown as the slopes of the two straight lines in Figures 1 and 2. The change in the modulus, to a first approximation, could be handled as a linear function of relative humidity. Therefore, generally:

(Equation 14) $E(RH) = M(RH) + N$
where:
M is the slope of a linear E versus RH approximation and,
N is an offset constant which locates the Y intercept.

Oil Paints

Two paints, Naples yellow and flake white were restrained at 66% RH and 23°C, and desiccated to 58% RH where the stresses in the paints were .014 MPa (.002 ksi) and .028 MPa (.004 ksi), respectively. The paints were further desiccated to 5% RH and the stresses now reached were as high as .455 MPa (.066 ksi) and .634 MPa (.092 ksi), respectively (see

Figure 15). The time for equilibration was forty-eight hours for .0059 cm (.015 in.) thick films.

Using Equation 12 (corrected for load cell compliance), it was possible to calculate the expected stresses. The value, $\alpha_{a=.0000257}$ was used for both the Naples yellow and the flake white. The equations (Eq. 14) for the modulus of the materials were:

for Naples yellow, $E(RH) = 357.1 - 5.8(RH)$ and, for flake white, $E(RH) = 440.0 - 5.8(RH)$ where the units are in MPa and percent relative humidity. These two equations have the same slope and differ only in the intercepts. The difference in the intercept values is the difference in the modulus of each material at 50% RH. The results of the calculations are shown in Figure 15 as the solid lines passing through the data points. The test data stresses are only about 15% less than that expected if the specimens were fully restrained.

One interesting aspect of these calculations is the remarkable accuracy using linear approximations of the actual material behavior. Equally interesting, for the Naples yellow, is the magnitude of stress reached, (.455 MPa [.066 ksi]), at a desiccation from 66% RH to 5% RH, considerably less than that reached (1.0 MPa [.145 ksi]), when cooled from 23 °C to -3 °C.

Rabbit Skin Glue

Until now, all of the discussions about the mechanical properties of the artists' materials and stress development in either cooled or desiccated materials have assumed that all behavior was elastic. This assumption seems to be valid because all of the elastic modulus equations result in successful stress predictions. For the rabbit skin glue, the behavior is almost never in the elastic range but exhibits a *quasi*-plastic behavior. The reason for this behavior is that the material wants to shrink extensively with desiccation. This results in strains, when the specimen is restrained and desiccated, that exceed the yield stress for any given relative humidity environment. Once these yield stresses are reached, the glue can have no further rise in stress no mater what strain level is attained. This presents

the complication that the elastic modulus is no longer valid, since any calculation using these values will result in stresses well in excess of the yield stresses.

What can be done is to determine an effective modulus, $E_e(RH)$, for all of the different relative humidity values. The effective modulus is:

(Equation 15)

$$E_e(RH) = 1{,}378.8 + 15.17 \text{ x } (75\text{-}RH_i) + (15.17 \text{ x } RH)$$

where:
RH_i is the value of the starting or initial relative humidity,
RH is the relative humidity at any time.

If a moisture coefficient of $\alpha_a = .000264$ is used, which was determined from the data presented in Figure 3 including Equation 15 in Equation 12, the resulting restrained specimen desiccation stresses can be calculated for the rabbit skin glue. They are as presented in Figure 16, which is extremely close to the actual experimental data seen in Figure 17.

It is irrelevant that the load cell compliance is influencing the results, the stresses will become no higher for most of the testing since no additional stress is possible. Results that might be affected are the stresses resulting from the restrained desiccation starting at 30% RH, where it is possible that they are a result of elastic behavior.

The time for rabbit skin glue to reach equilibrium with the environment depends on the thickness of the sample. Three specimens, .028 cm (.011 in.), .013 cm (.005 in.), and .0038 cm (.0015 in.) thick were restrained at 60% RH, 23 °C and the environment was rapidly desiccated to 5% RH. The increases in stress levels were measured against time as the relative humidity was quickly lowered to 5%. Figure 18 plots the results of the test for the first ten hours.

The thinnest specimen took only about sixty minutes to reach equilibrium at 27.9 MPa (4 ksi). The .013 cm (.005 in.) specimen took ten hours and the thickest specimen took about one-hundred hours to reach the maximum. All specimens achieved stress levels of nearly 27.9 MPa (4 ksi). After the specimens had reached their peak stress value, the hide glue films started to stress relax; Figure

19 shows the rate of relaxation of these films over several months. The thinnest hide glue film took over 150 days to relax to near zero stress. The thicker films took even longer but this may be a result of the longer time it took for it to reach its maximum stress. The data suggests that the actual relaxation rate is thickness independent.

An important point is that the whole process of stress increase caused by desiccation is much shorter than the time required to achieve stress relaxation. Stress resulting from restrained desiccation can linger for months. What was important was the glue's ability to reactivate itself if subjected to a high relative humidity level. On the 158th day, the relative humidity was raised to 90%, and maintained for forty-eight hours. The humidity was then lowered to 60% and the specimens that were sagging at 90% became tight. Finally, the relative humidity was again rapidly lowered to 5% and the dramatic stress rise reoccurred to nearly the same levels as before. The thinnest specimen glued itself to the test equipment at the very high relative humidity, and broke upon desiccation. For the two thicker specimens, stress relaxation proceeded at the same rates noted earlier.

In North America, extremely high relative humidity frequently occurs in the summertime and extremely low relative humidity occurs in heated, nonhumidified spaces in the wintertime. The magnitude of environmental changes discussed above can certainly occur as an annual event. It is difficult to envision such changes occurring on a daily basis, but the changes that occur might be sufficient to damage a painting. The stress levels reached in the hide glue tests are more than sufficient to damage a painting. At some time, however, the relative humidity must reach sufficiently high levels for the glue to reactivate. Otherwise it will stress relax to extremely low stress levels.

Fabric Canvas Supports

The mechanical properties of fabrics used as painting supports are effectively nonexistent. While it is possible to measure the modulus of a textile at different relative humidities, permanent creep caused by interfiber slippage at high humidity releases any ability to sustain a stress. In addition, when measured, the modulus of the textiles drops precipitously with desiccation.[16] This is exactly the time when a stiff support is needed to prevent the in-plane displacements developed in a stretched painting at low relative humidities.

The only time a fabric develops a significant modulus is at an extremely high humidity, when all of the other materials of a painting become gellike as with the glue layer or extremely flexible as with the paints. The lack of fabric stiffness plays a significant role in the paintings' response to low relative humidities (see *Computer Analysis*).

COMPUTER ANALYSIS OF PAINTINGS SUBJECTED TO CHANGES IN TEMPERATURE AND RELATIVE HUMIDITY

The experimental determination of the effects of cooling and desiccation on the mechanical behavior of an actual test painting is very limited. Normally, when a complex structure is experimentally evaluated during the application of forces, stress levels are determined by using strain gauges attached to the structure.[17] These gauges measure the strains applied to the structure while loaded and the stresses are calculated using the strain measurements and the modulus of the materials used in making the structure. A restrained structure, subjected to cooling or desiccation will develop either extremely small, or no strains, at the same time experiencing very high stresses. Here, strain gauges are of little value, as is any system that attempts to extrapolate an accurate assessment of the stress distribution of a painting by measuring the strains. Other researchers[18], have succeeded in showing that changes in temperature and relative humidity change the magnitude of the *average* forces as measured at the edges of a biaxially restrained painting. This is not, however, the same as determining the distribution of stresses occurring throughout the painting. What stresses develop at the edges

of a painting are not necessarily the same as those found in the center, or even a slight distance from the edges. Stresses can even vary along the edges. It is these variations in stresses that determine if a painting will crack at all during desiccation or cooling, and if it does, these variations determine the crack patterns that result.

It is not possible to use actual paintings for experiments, since this is a destructive test method. The evaluation of the overall behavior of painting is best approached by a thorough understanding of the mechanical properties of the artists' materials and a determinate analytical procedure. One of the best procedures to use is *Finite Element Analysis* (FEA) and the digital computer.[19] This method mathematically approximates the structure by assembling the structure from smaller, geometrically simple "elements" whose mechanical properties can be determined easily. (Consult Mecklenburg and Tumosa[20] for further information on this method and an example of its accuracy.) The program used in all of the computer modeling in this paper was ANSYS®, Version 4.4, run on a 386, 33 megahertz desktop computer with an expanded RAM of 4 megabytes.

Trial Test of Computer Modeling

To assess the accuracy of the computer using the equations that relate the stress of a material to changes in temperature and relative humidity, the coefficients of expansion, and the modulus, a simple trial was conducted. In this test, a model of a sample of the Naples yellow paint specimen was numerically constructed and fully restrained. Equations 6 and 10 were programmed into the computer using .000052 per degrees Celsius as the thermal coefficient of expansion for the Naples yellow. The model was then mathematically subjected to changes in temperature from 23 °C to: 18°, 10°, 5°, 0°, and -5 °C. The results, which compare favorably, are shown in Figure 20, where stress versus temperature is plotted for the computer model results and the stress values calculated from the actual paint test data using Equation 5. This test verified that the equations were being pro-grammed correctly as well as the computer model's ability to accurately analyze a material subjected to temperature changes that influence the modulus as well as the strains.

Modeling the Effects of Cooling a 76 x 102 cm Painting

A 76 x 102 cm (30 x 40 in.) painting was modeled and subjected to changes in temperature while the ambient relative humidity was held at 5%. The layer of the painting consisted of a linen .064 cm (.025 in.) thick, modeled as a .0152 cm (.006 in.) layer[21], a glue layer .00508 cm (.002 in.) thick and a Naples yellow (lead) oil paint layer .0076 cm (.003 in.) thick. The stretcher was not expanded. Each of the layers of the model painting were programmed with their respective material properties taken from the data tables presented earlier. For example, the paint layer was programmed as described in the computer trial section above. The glue layer was characterized using Equation 10 with a thermal coefficient of .000025 per degrees Celsius and a changing modulus that varied linearly from 4,860 MPa (705 ksi) at -3 °C to 3,791 MPa (550 ksi) at 23 °C. This data was used to develop the equation:
(Equation 16) $E(T) = 4,756 - 51 \ x \ T$ where:
T is any temperature.

Equation 16 was the equation that allowed programming of the change of the rabbit skin glue's modulus with changing temperature at 5% RH. The fabric was programmed with an average constant modulus of 38.6 MPa (5 ksi) and a thermal coefficient of .00001 per degrees Celsius. The distribution of the principal stresses in the paint layer, calculated by the computer is shown in Figure 21. This stress distribution is uniform, ranging from 2.09 MPa to 2.11 MPa (.303 ksi to .307 ksi) and just reaches the measured breaking strength of Naples yellow paint at 5% RH and -2 °C (see Table 3). This suggests that cracking of the paint layer will occur throughout the entire surface of the model painting when the temperature is decreased from 23 °C to -3 °C at 5% RH. It most certainly would have occurred if the starting environment was 23 °C and 50% RH. This would be the consequence

of the combined adverse effects of both desiccation and cooling.

The stresses have a directional bias as shown in Figure 22. In this figure, the principal stresses are indicated by the calculated directional vectors (arrows), and cracking that occurs will do so perpendicular to the vectors as shown by the continuous lines. This is a crack pattern that appears frequently in paintings in North America, particularly those that are on strainers, which are stretchers with fixed, nonexpandable corners. If the paint modeled was the flake white tested and reported in this paper, it would have also failed, but at a higher temperature, since this paint has a higher modulus but consistently less strength than the Naples yellow. The glue layer principal stresses reached levels ranging from 4.72 MPa to 5.13 MPa (.685 ksi to .745 ksi).

The model painting was again analyzed but with a much stiffer fabric (689.4 MPa [100 ksi]) such as a synthetic lining attached to the reverse of this model painting; the results show little difference. The calculated principal stresses for the paint film still reach 2.11 MPa (.306 ksi). This means that the individual layers of a painting are independently responding to the temperature change without any interlayer interference. As will be seen later, this is in marked contrast to the influences of linings on paintings subjected to deep desiccation. This temperature analysis has even greater implications. Paint, attached to any material that has little dimensional response to temperature, such as the parallel-to-grain direction of wood, is capable of developing stresses sufficiently high enough to cause cracking when the temperature drops sufficiently. In the case of panel paintings, cracks will tend to form perpendicular to the grain of the wood. Conversely, if the painting is attached to a continuous support that has a thermal coefficient similar to the paint film, the problem of cooling is diminished significantly since the entire system is allowed to contract with cooling.

The question of why the stresses in the computer modeled paint layer achieve considerably higher levels than the fully restrained simple paint sample must be addressed. The paint layer in a painting is restrained in two mutually perpendicular directions, each developing considerable strains when cooled. The single paint specimen is restrained only in the test direction. It is readily shown that the stresses in one direction are influenced by the strains occurring in all directions.[22] For example, if the strains in three dimensions are nonzero, as with a painting, the stress in one dimension, say, x-direction is computed using:
(Equation 17)
$$\sigma_x = \frac{E}{(1+\upsilon) \, x \, (1-2\upsilon)} \, x \, [(1-2\upsilon) \, x \, \varepsilon_x + \upsilon \, x \, (\varepsilon_x + \varepsilon_y + \varepsilon_z)]$$
where υ is Poisson's ratio.

As with the simple paint samples, the stress in the painting does not increase linearly with decreasing temperature. If the painting is heated above the 23 °C starting point and *the relative humidity is held constant*, the painting will go slack and sag. The specific temperature depression that represents a danger to actual old paintings is unknown to date since the modulus and strength of the older materials is yet undetermined. It might be prudent to avoid temperatures below 10 °C if the relative humidity becomes low simultaneously.

Modeling the Effects of Desiccating a 76 x 102 cm Painting

While seemingly similar to the effects of cooling, reductions in ambient relative humidity have somewhat different effects and they seem to be more readily controlled than the temperature effects. In starting the computer simulation of the effects of desiccation, the same 76 x 102 cm (30 x 40 in.) painting described in *Effects of Cooling* was used. In this case, the computer was programmed to alter the relative humidity instead of the temperature. Additionally, to obtain greater analytical detail, it was possible to take advantage of the painting's double symmetry and to model only the upper right-hand quadrant. This was done by programming the appropriate material properties—RH equations for each of the individual layers of the model painting as well as the proper boundary conditions. Again, in this case the paint layer

again was Naples yellow. For the changes in relative humidity, $E(RH)=357.1 - 5.8(RH)$ was the equation used. For the strain calculations, Equation 13 was used with a moisture coefficient of .0000257 per percent relative humidity. For the glue layer, the modulus was computed using Equation 15 and for the strains, using Equation 13 with a moisture coefficient of .000264 per percent relative humidity. The fabric was assumed to be a minimally contributing material since glue sizing a stretched linen removes any residual stress in the fabric. In this case, the modulus was assigned a nominal constant 35 MPa (5 ksi) and the moisture coefficient was an average .0001 per percent relative humidity.

The model painting was desiccated from 70% to 10% RH at 23 °C. The maximum calculated principal stress in the paint film was only .806 MPa (.117 ksi). This is insufficient stress to break the Naples yellow, which has a breaking strength of 2.5 MPa (.36 ksi) at 5% RH and 23 °C, or perhaps even the flake white which is weaker. If changes in relative humidity are going to crack an unbroken paint film, other factors must be considered. As a paint dries longer, it get stiffer (a higher modulus), but in all probability it will also get stronger as all of the testing to date shows that the factors that stiffen a paint also increase its strength. Additionally, moisture coefficients of the paints seem to decrease with an increase in the modulus, making them less dimensionally responsive to changes in relative humidity. In this initial computer analysis it was noted that the calculated glue layer stresses exceeded 34.5 MPa (5.0 ksi). Perhaps the thickness of the glue layer is a factor to consider. In many poorly prepared, commercially available canvases, the linen is of poor, lightweight quality, and the glue size is applied freely to give the canvas body. Additionally, a painting lined by using traditional linen canvas and a hide glue adhesive increases the total glue thickness without significantly increasing the support from the canvas. Both of these cases can be simulated on the computer by increasing the thickness of the glue layer and without changing any other parameters. The model painting was modified to increase the glue thickness from .0051 cm to .01 cm (.002 in. to .004 in.). The results of the new analysis are dramatic. The stresses in the paint layer increases to a new range of .698 MPa to 1.93 MPa (.1 ksi to .28 ksi). Doubling the glue layer more than doubled the stresses in the paint layer. The distribution of the stresses is shown in Figure 23. This distribution is not nearly as uniform as demonstrated from the cooling analysis. Cracking, if it occurs, will initiate mainly in the corner regions of the painting (Figure 24). In this figure, both the direction vectors of the principal stresses and the possible crack pattern are shown. If the equilibrium breaking strength of the paint at 5% RH and 23 °C was low, e.g. only 1.38 MPa (.2 ksi), the cracks would go no farther than about 7.6 cm (3 in.) from the corner. It seems, therefore, that low temperature rather than low relative humidity has the greater potential for cracking an *undamaged* painting.

Changing the thickness of the glue layer influenced the stresses in the paint layer when desiccating the painting. This indicates that the very high glue stresses cause an interlayer interaction. If this is true, then a stiff fabric material should reduce this effect of layer interaction. The model painting with the thick glue was again analyzed using a modulus of 689 MPa (100 ksi) for the fabric. The maximum principal stress in the paint layer was reduced to 1.44 MPa (.209 ksi) when the relative humidity was reduced from 70% to 10%. This shows that high glue stresses, (in all cases examined so far, it exceeded 34.5 MPa [5 ksi]), are capable of causing in-plane deformations in the painting and stiff supports are capable of reducing them. Whether these cracks will continue to grow once started is unknown, but in other brittle materials there is substantial evidence that stresses needed to cause further crack growth are considerably less than those needed to start the initial cracks.[23] In ductile materials, the stresses needed to increase crack length are no different from starting a new crack. As the paints get older and more brittle, perhaps this alteration of the mechanical properties is most manifest in crack extension and not new crack formation.

To date, it has been shown that traditional

glue linings can reduce the extremes in environments in which paintings might survive and stiff linings can expand that environment. See Figure 25 for a summary of these effects.

Effects of Stretcher Expansion on a Painting Subjected to Changes in Relative Humidity

There are other factors that influence the paintings' response to relative humidity. *Tightening* the painting by expanding the stretcher is one of them. Traditionally, stretchers have been expanded when the paintings they are supporting have gone slack because of considerations such as increased relative humidity. Expansion has either been accomplished by driving in corner keys (wedges), or turning expansion bolts at the corners. In some situations, springs attached at the corners have been compressed to increase the tension in the painting. In all cases, the stretcher bars are displaced outward from the plane of the painting (Figure 26). In this figure, the dashed lines represent the original configuration of the painting and the solid lines show the newly displaced geometry. If the stretcher bars are each displaced outward by .1 cm (.04 in.) on the same 76 x 102 cm (30 x 40 in.) painting used in the cooling analysis, and the painting is desiccated from 70% to 10% RH, the results are dramatic. This bar expansion is the same as expanding the corner gap at the key location only .142 cm (.056 in.). The result of the computer analysis (Figure 27) shows where the principal stresses reach a magnitude of 10.4 MPa (1.508 ksi). The paint film will fail as the strength of the Naples yellow is only 2.5 MPa (.36 ksi). Figure 28 shows the directions of the principal stresses and the expected crack pattern, which is different from the previous computer analysis, but nevertheless recognizable on actual paintings. Interestingly, any expansion of the stretcher so modifies the principal stress distribution due to desiccation that an entirely different set of cracks appear. A summary of the results of computer analysis at different degrees of stretcher expansion and different levels of desiccation

appears in Figure 29. This figure suggests that even minimal stretching reduces the environmental changes that the painting can safely tolerate.

Relative Humidity Effects on a Previously Cracked Painting

Until now, this study has concentrated on the environmental factors that contribute to the creation of new cracks in a painting. It is, however, important to examine the effects of changes in relative humidity on a painting with preexisting cracks. The model assumes that the crack runs from the surface of the paint layer to the interface of glue size and the fabric. The distance from crack to crack is .508 cm (.20 in.). The ground and paint layer are both lead-based oil paint (Naples yellow) .0076 cm (.003 in.) thick; the glue layer is .00508 cm (.002 in.) thick, and again, the fabric is .0635 cm (.025 in.) thick, modeled as .015 cm (.006 in.) thick. The strain and modulus equations used in programming the computer are the same as described in *Modeling the Effects of Desiccation on a Painting*. The section of the painting modeled is illustrated in Figure 30. The model was subjected to changes in relative humidity, starting from 70% and desiccating to 50%, 30%, and 10%. For a test basis, it is assumed that the glue layer responds as if it had been recently exposed to a very high relative humidity. Figure 31 shows the deformation (*cupping*) that occurs with desiccation from 70% to 10% RH. This is a result of the partial contraction occurring in the paint and glue layers. The principal stresses resulting from this desiccation are still substantial as shown in Figure 32, an enlarged view of the cracked part of the painting with stresses concentrating at the glue fabric interface. Figure 32 also shows the stresses as the paint glue interface reach levels of between 9.65 and 13.8 MPa (1.4 and 2.0 ksi). These calculated stresses in the paint film are over four times the breaking strength of the Naples yellow at this environment, indicating the onset of severe active flaking of the painting. The presence of a crack represents the source of stress concentrations and this model illustrates the effect of a crack. The

186

stresses in the paint layer of the uncracked models never reached the levels observed here. Even if this model of the cracked painting was desiccated to only 50% RH, the stresses in the paint would reach 2.96 MPa (.43 ksi), which is still sufficient to cause flaking. Paintings don't always flake with variations in relative humidity of only 20% (70% to 50%, or 50% to 30%). If the fabric is thin or flexible, this can reduce restraint on the paint chip and thereby reduce stress development. Once a glue layer has been subjected to severe desiccation and stress relaxed, it goes slack upon returning to its starting environment. This residual slackness potentially reduces the total stress resulting from daily oscillations in relative humidity. Additionally, there appears to be a long-range stress reducing effect, still undetermined, that diminishes the glue's response to relative humidity. Hedley showed that high relative humidity reactivation of the stress-relaxed glue will at least triple its stress response to relative humidity when restrained in a painting over one-hundred years old.[24] However, for the safety of the painting, it should be assumed that it has been recently subjected to high relative humidity due either to weather, a recent glue lining treatment, or as an attempt to reduce the cupping distortion in the painting's design layer. Depressions in relative humidity of 20% or more will probably cause incipient flaking in a substantial number of paintings.

PAINTINGS ON WOOD PANEL SUPPORTS

The present discussion is limited to introducing some of the important considerations that relate relative humidity to wood response. There are two primary considerations when evaluating a wood panel's ability to withstand changes in relative humidity. The first is to determine the degree of a panel's constraint from dimensional response to relative humidity. If a panel is free to contract upon desiccation, stresses resulting from changes in relative humidity are at a minimum, if they exist at all. If a panel is fully restrained from motion, then relative humidity-related

stresses are maximized and can be destructive. A panel painting rigidly fixed in a frame, must be considered restrained. If there is a cradle attached to the reverse of the panel, even though this device was intended to allow in-plane motion, it is almost certain that panel warpage has locked up the cradle and motion is no longer possible. Battens, glued cross-grain to the panel, also act as a restraint to dimensional response. The second consideration, and possibly the more problematic, is the presence of cracks in the panel. There is difficulty because both the location and the length of the crack influence the panel's ability to safely accommodate changes in relative humidity and it is not always easy to determine either the existence or the true length of a crack.[25]

An analysis of a computer model of an oak panel, 76 x 102 x 1.27 cm (30 x 40 x .5 in.) was conducted to examine the potential for damage resulting from reductions in relative humidity. In this case, the panel was restrained at the upper and lower edges and the initial relative humidity of 50% as well as 70% was used in as in previous models. The parallel-to-grain modulus was assumed to be a constant 6,204 MPa (900 ksi), the radial and tangential moduli were both assumed to be 689 MPa (100 ksi). The moisture coefficients used were .00002 parallel to the grain, .000219 in the tangential direction, and .000133 in the radial direction, which in this case is the restrained direction. The breaking strength of the oak was assumed to be 4.14 MPa (.6 ksi) in the radial direction though the actual strength of the wood can vary somewhat according to its density. The computer model and wood grain orientation with the representative panel painting are shown in Figure 33. Taking advantage of double symmetry, it was necessary to model only the upper right-hand quadrant of the panel.

Uncracked, Restrained 76 x 102 x 1.27 cm Oak Panel

The first series of analyses were conducted on a restrained panel where the changes in relative humidity were induced with the initial values at 50% and 70% RH. Figure 34

shows these results where the stresses rise in tension with desiccation from the starting points and rise in compression with increases in relative humidity. These analyses indicate that an average uncracked or flaw-free oak panel might withstand desiccation of 50% to 10% RH, but not from 70% to 10% RH if the breaking strength of the wood is 4.14 MPa (.6 ksi). If the panel had been restrained initially at 70%, a change to approximately 25% RH would have broken the panel. At higher levels of relative humidity, the wood actually becomes softer and crushing or *compression set* will occur. At the higher humidities, it is even possible to buckle thin panels.

Wood properties are not uniform even from trees of the same species, or even consistent throughout a single piece of wood, therefore, this analysis must be considered an average baseline from which other considerations such as the presence of a crack can be compared.

Cracked, Restrained 76 x 102 x 1.27 cm Oak Panel

Cracks can form anywhere in a panel, but it is probable that they will occur at defects in the wood or at the edges. Computer analyses were conducted on model oak panels with cracks occurring along the center line of the panel and originating at either the center or the edges of the panel. Figures 35 and 36 show the computer-generated principal stress distributions of cracked panels desiccated from 50% to 40% RH and the severe stress concentrations resulting from these cracks. Figure 35 also shows the results with a 20.3 cm (8 in.) center crack and Figure 36 shows the results with a 10.16 cm (4 in.) edge crack. For the desiccation from 50% to 40% RH, the edge crack has a maximum principal stress of 2.45 MPa (.358 ksi), or .7 MPa (.102 ksi) greater than the center crack, which is twice as long. This information, along with the summary results shown in Figure 37, indicate the substantial increase in potential hazard an edge crack presents over a center crack. More importantly, this figure shows the sharp increase in crack zone stresses resulting from the increasing crack length. This

explains why a crack, once started, can run unchecked through the entire panel with no additional change in the environment. Further analysis showed that for desiccation from 50% to 30% RH, a 7.62 cm (3 in.) edge crack would grow, since stresses reached 5.25 MPa (.76 ksi). A desiccation from 50% to 20% RH would cause a 5.08 cm (2 in.) edge crack to grow as there was a stress rise to 5.03 MPa (.73 ksi), and for a change from 50% to 10% RH, a 2.54 cm (1 in.) crack would grow with a stress rise of 6.27 MPa (.91 ksi). None of the stresses discussed would have developed if the panel had been left unrestrained.

SUMMARY

To assess the risks to paintings associated with changes in temperature, relative humidity, shock, and vibration, an accurate determination of the stresses in the different layers of a painting is necessary. In turn, those stresses must be compared to the strengths of the artists' materials at the specific environments in question and rates of loading encountered by the painting. Computer modeling in the form of finite element analysis readily lends itself to performing the needed analysis. However, the ability to numerically model multiple-layered structures such as paintings largely depends on accurately determining the mechanical properties of the painting's constitutive materials. This includes assessing alterations to the mechanical properties brought about by time. This study has examined some of the materials typically found in a large proportion of canvas and panel paintings and concentrated on paints such as the lead-based oils that demonstrate brittleness. Additionally, the study confines the analysis to effects of temperature and relative humidity brought about over moderately long periods of time. In all of the analytical modeling, it was assumed that all of the materials were at equilibrium with the environment.

All of the materials respond dimensionally to the changes in temperature and relative humidity. The thermal coefficients of expansion for hide glue and lead paint were small, while their moisture coefficients were consid-

erably higher. Restraining these materials caused stress development with desiccation and cooling, but the magnitude of the stress was a result of both the material's attempt to contract and its related modulus or stiffness.

Computer modeling of a typical canvas painting with glue size and lead-based oil paint layers showed that substantial drops in temperature at low relative humidity (from 23° to -3°C, at 5% RH) resulted in both uniform and high stresses in the paint layer. These stresses equalled or exceeded the measured breaking strengths of thirteen year-old paint. It could be inferred that an actual painting, constructed with the materials modeled, would exhibit severe and extensive cracking over the entire surface of the painting. The same computer analysis also showed that the glue layer reaches stresses slightly more than twice those of the paint layer. Additionally, subsequent modeling revealed that attaching a stiff lining material to reinforce the canvas support would do little to prevent the formation of new cracks in the design layer. It can be concluded that severe cooling results in the independent response of the various layers of the painting with little interlayer interaction. Paint and glue tested at -3°C and 5% RH, showed extremely brittle behavior as they shattered into multiple pieces when broken.

The same painting, when subjected to depressions in relative humidity (from 70% to 10% RH), showed on the computer model similar crack patterns as those formed during cooling; these patterns, however, were not as extensive. In fact, it was not until an additional layer of glue was added to the model that stresses in the paint layer were high enough to prompt cracking. Even then, the analysis suggested that it would cause considerably less damage than it incurred during cooling. Further analysis showed that the traditional lining technique of using linen and hide glue dramatically increased the potential for damage to paintings subjected to desiccation. Conversely, stiff lining supports considerably increased the painting's ability to withstand desiccation. This occurs because of the remarkable stress levels achieved by the glue during periods of low relative humidity and the almost total lack of canvas stiffness in the same environment. Unlike the cooling analysis, there appears to be considerable interlayer interaction in a painting during desiccation. Some glue layer contraction reduces the stresses in the paint layer in the central region of the painting while increasing the paint film stresses in the corner regions. Hence, almost no cracking occurs in the central region of the painting, most of the cracking is evident at the corners. This indicates that stiff lining supports attached with adhesives that are not responsive to relative humidity will reduce the formation of new cracks caused by severe fluctuations in relative humidity.

The expansion of paintings by any corner device, even seemingly small amounts, renders a painting more susceptible to damage due to either cooling or desiccation. This type of deformation of the painting expands its layers, including the grounds and paint layers. The stress distribution can result in cracks radiating from the corners in a pattern that is entirely different from those caused by cooling and desiccation alone. The advantage of a stiff lining material is to allow the painting to develop tension with the minimum of expansion, though this type of support does nothing to stop expansion-related stresses in the paint layers. It only minimizes them.

Paintings with existing cracks appear to be the governing case regarding restricting the allowable fluctuation in relative humidity. Computer modeling of a section of a painting containing preexisting cracks revealed intense stress concentrations in the crack tip region. With changes in relative humidity from 70% to 50% at 23°C, the resulting stresses in the paint–glue interface easily exceeded the paint's ultimate strength. This would be also true of drops from 50% to 30% RH. This analysis suggests that for paintings with an active glue layer (recently exposed to high relative humidity), 20% depressions in relative humidity can conceivably initiate active flaking of the paint layer. The analysis also suggests that the region of stress concentration is so localized and confined to the area of the crack, that nearly all lining techniques and materials will do little to retard this ef-

fect with the exception of those adhesives that actually retard moisture penetration to the area of the crack. For transportation risk assessment, traditional canvas paintings, with preexisting cracks should be protected against temperature and relative humidity fluctuations.

Relative humidity fluctuations present a very real hazard for paintings on wood panels with preexisting cracks if the panel is restrained in any way. While the computer analysis was confined to a model oak panel, it may be inferred that the presence of cracks in restrained panels of any wood presents a potential for relative humidity damage. Restraint can take the form of improper attachment in the frame, cradling, or cross-grain battens attached to the reverse of the panel. Panels free to dimensionally respond to changes in relative humidity will experience virtually no stress rise at cracks. Nevertheless, the lack of material uniformity of wood strongly suggests that dimensional response in a wood panel will vary in different areas of the same panel, resulting in localized stress development with desiccation. All panel paintings should be maintained in a very narrow relative humidity environment. □

APPENDIX A — TABLES

TABLE 1
Relative humidity-related swelling of different 4.5 year-old paints, 20°-22°C (68°-72°F).

Paint Oil	% Length Change 0%-70% RH	% Length Change 70%-95% RH	% Length Change 0%-95% RH
Flake White Safflower	.18	.62	.80
White Lead Linseed	.23	.38	.61
Burnt Umber Linseed	.72	1.83	2.55
Burnt Umber Safflower	1.20	2.80	4.0
Alizerin Crimson Linseed	.59	.99	1.58
Cadmium Yellow Linseed	.65	2.75	3.4
Cerulean Linseed	.32	.4	.72
Prussian Blue Linseed	.53	1.07	1.6
Raw Sienna Linseed	.7	1.16	1.86
Titanium White Linseed	.2	.32	.52
Ultramarine Linseed	.65	2.50	3.15
Vermilion Safflower	.46	.56	1.02

TABLE 2
Dimensional response of gesso to relative humidity, 23°C (73°F).

Gesso Chalk-to-Glue Ratio by Weight	% Length Change 10% to 80% RH	% Length Change 80% to 95% RH	% Length Change 10% to 95% RH
3.15	.75	1.0	1.75
10.0	.25	.65	.90

TABLE 3
The mean "equilibrium" mechanical properties of oil paints tested at different environments.

Paint Oil	E MPa (KSI)	Max σ MPa (KSI)	Max ϵ	Test Temp,°C % RH
Naples Yellow Linseed Oil	1034 (150)	2.1 (.3)	*	-3 5
Naples Yellow Linseed Oil	327 (47.5)	2.5 (.36)	.018	23 5
Naples Yellow Linseed Oil	68.9 (10)	1.2 (.17)	.025	23 50
Vermilion Safflower Oil	51.7 (7.5)	.8 (.115)	.025	23 50
Flake White Safflower Oil	155.8 (22.6)	.8 (.115)	.008	23 50
Burnt Sienna Linseed Oil	110 (16.0)	.65 (.095)	.03	23 5
Burnt Sienna Linseed Oil	25 (3.6)	.6 (.087)	.05	23 50
Burnt Umber Linseed Oil	10 (1.45)	.5 (.073)	.005	23 5
Burnt Umber Linseed Oil	0	**	0	23 50

* Test not completed
** Stress relaxed to zero

TABLE 4
Quasi-equilibrium mechanical properties of rabbit skin glue.

Relative Humidity 27°C	E MPa (KSI)	Yield Strength MPa (KSI)
5%	3792 (550)	27.6 (4.0)
30%	3192 (463)	19.3 (2.8)
50%	1551 (225)	12.4 (1.8)
75%	0 * (0)	0 (0)

* Fully stress relaxed

APPENDIX B — F IGURES

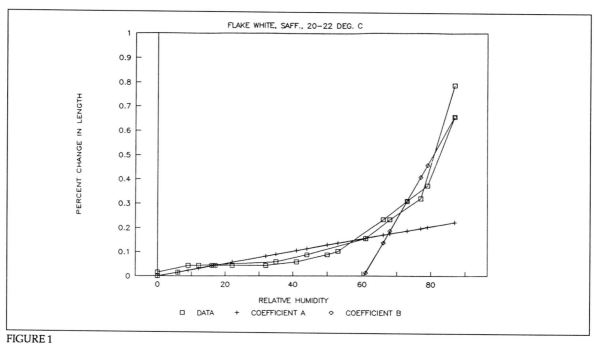

FIGURE 1

Percent length change of flake white (lead carbonate) ground in safflower oil versus the percent relative humidity. This paint shows relatively low dimensional response to relative humidity compared to burnt umber in linseed oil. The straight lines are the approximations used to determine the moisture coefficients of expansion α_a and α_b.

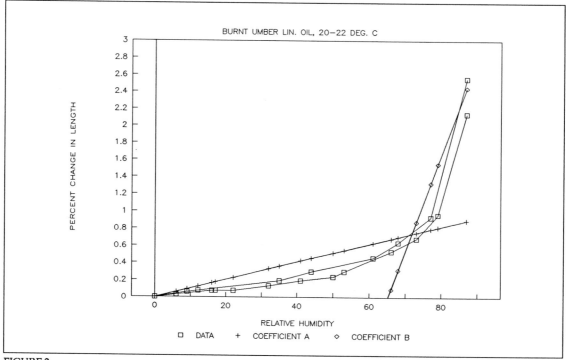

FIGURE 2

Percent length change of burnt umber ground in linseed oil versus the percent relative humidity. This paint shows relatively high dimensional response to relative humidity compared to flake white in safflower oil. The straight lines are the approximations used to determine the moisture coefficients of expansion, α_a and α_b.

196

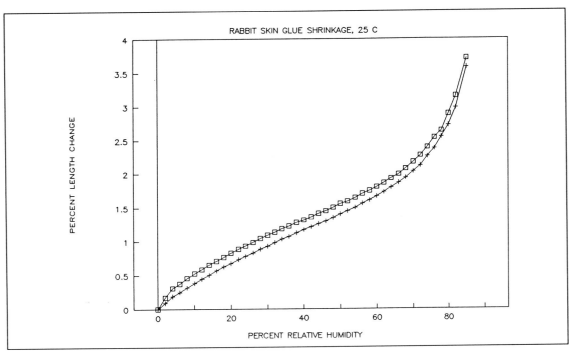

FIGURE 3
Percent length change of two samples of rabbit skin glue versus percent relative humidity during desiccation. Glue's dimensional response to relative humidity is greater than any of the other artists' materials.

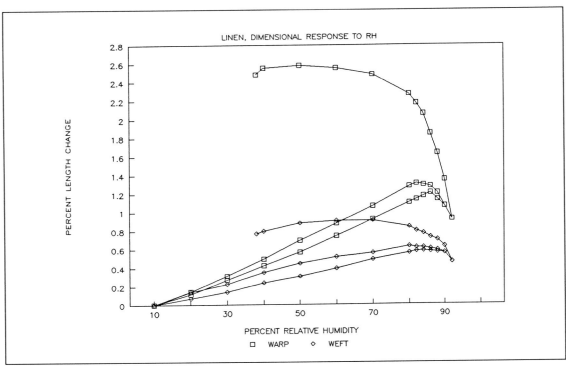

FIGURE 4
Percent length change of samples of a linen textile in the warp and weft directions. After an initial contraction from about 50% RH, the samples settle into a repeatable cycle as shown in the lower portions of the plots. Starting from approximately 80% RH, shrinkage occurs from either decreasing or increasing the relative humidity.

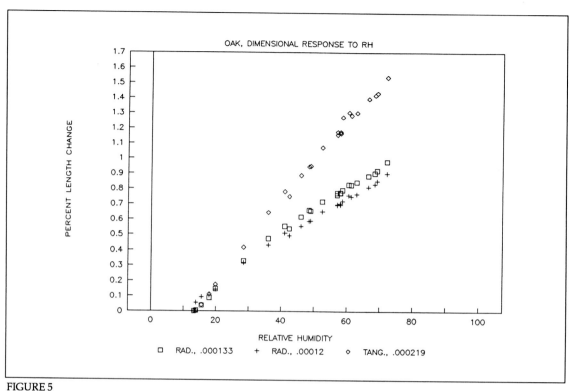

FIGURE 5

The dimensional response of three oak samples to increasing relative humidity. The samples are over one-hundred years old. The two lower plots are samples measured in the radial direction, the upper plot is in the tangential. The numbers next to the legends are the moisture coefficients of expansion for these samples, in strain per percent relative humidity.

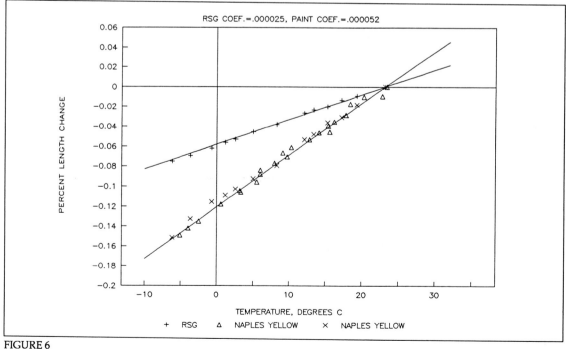

FIGURE 6

The dimensional response of rabbit skin glue and Naples yellow oil paint to changes in temperature. The thermal coefficients of expansion listed at the top of the figure are in strain per degree Celsius.

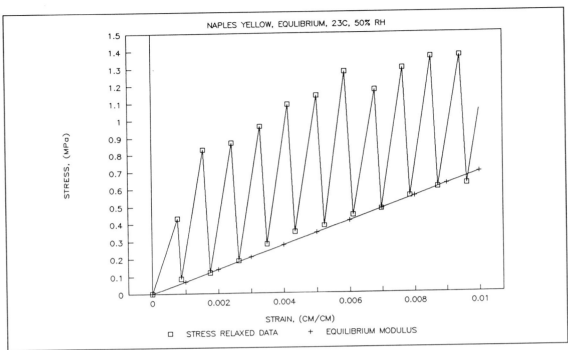

FIGURE 7
The initial portion of the equilibrium stress-strain plot for Naples yellow at 50% RH and 23° C showing the line used to determine the equilibrium modulus, E. This line is the locus of stress relaxed points measured from the long-term test.

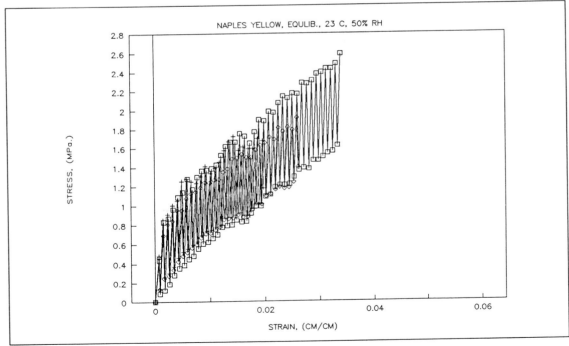

FIGURE 8
The equilibrium stress-strain plots for three separate samples of Naples yellow paint at 50% RH and 23°C. The slopes of the specimens were nearly identical while the breaking strengths were scattered. This paint showed the largest amount of scatter in the materials test program.

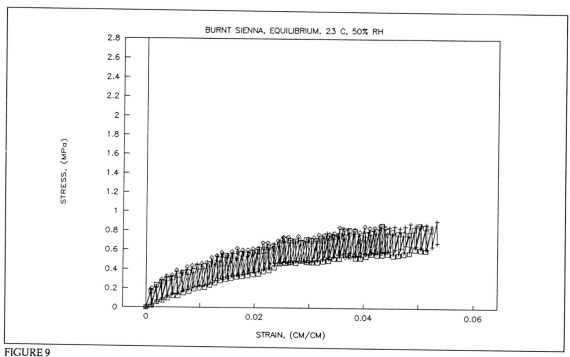

FIGURE 9

The equilibrium stress-strain plots for three separate samples of burnt sienna paint at 50% RH and 23°C. The slopes and breaking strengths of the specimens showed considerable consistency. This paint, while reaching a lower strength than the lead-based paints, showed considerable elongation to failure.

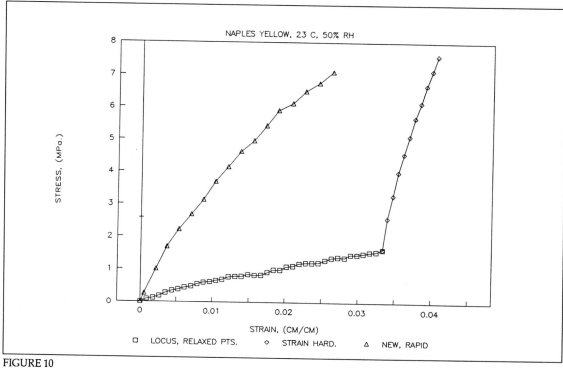

FIGURE 10

The stress-strain plots for Naples yellow paint tested at different rates of straining. The steep plots had strain rates of .001348 per second, while the lower plot reflects months of testing. The difference between the rapid loading tests reflects the strain hardening that long-term testing imparts to the material.

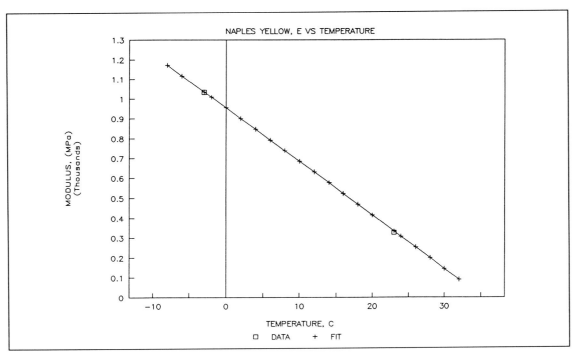

FIGURE 11
The change in the equilibrium modulus, E, of Naples yellow paint with change in temperature. The line labeled fit was used to determine Equation 6 in the text.

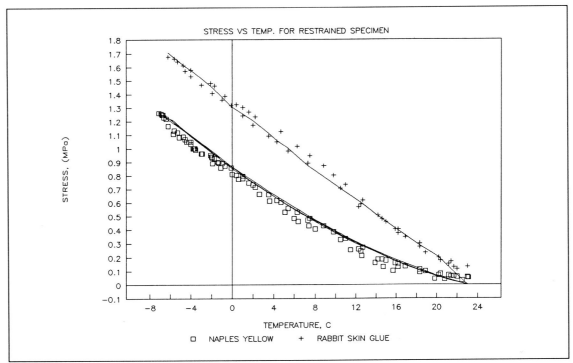

FIGURE 12
Stress versus temperature for restrained samples of Naples yellow paint and rabbit skin glue. This figure shows the data (symbols) and the predicted stress developed (lines) for these materials using Equation 11 which includes the partial stress release due to the load cell compliance.

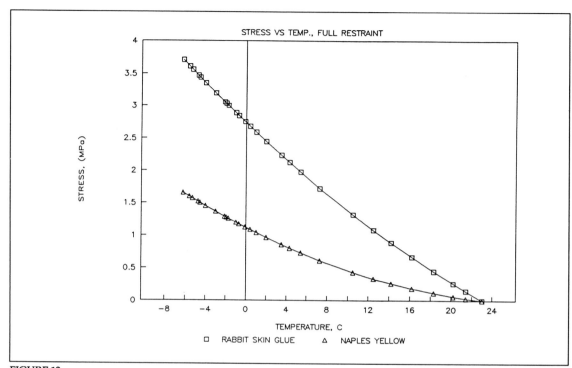

FIGURE 13
The stress versus temperature plots for fully restrained Naples yellow and rabbit skin glue using Equation 5.

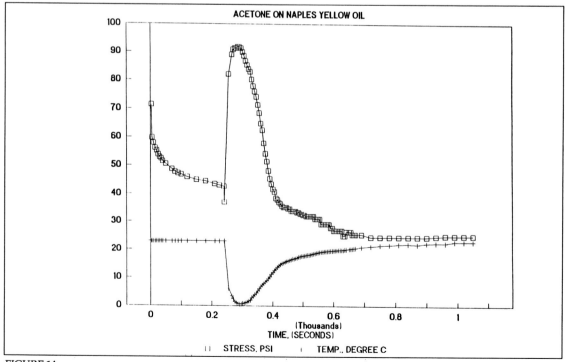

FIGURE 14
The effect of solvent evaporative cooling on a restrained samples of Naples yellow paint. The units of stress, plotted in pounds per square inch (psi) were used to simplify the graphics. For conversion, 1 ksi (1,000 x psi)=6.894 MPa. The time for the paint to respond to the temperature change is short.

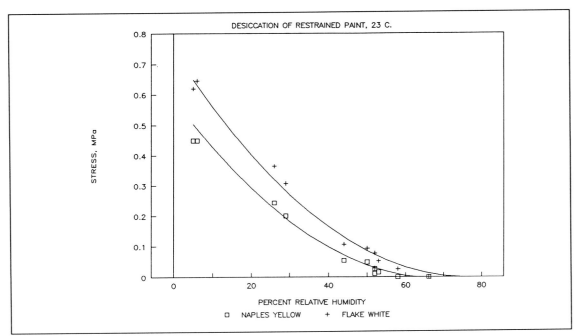

FIGURE 15
Stress versus percent relative humidity for restrained samples of Naples yellow and flake white paint. This figure shows the data (symbols) and predicted stress developed (lines) for these materials using Equation 12 with a correction for the stress release due to the load cell compliance. The primary difference in these two paints is the higher modulus in the flake white.

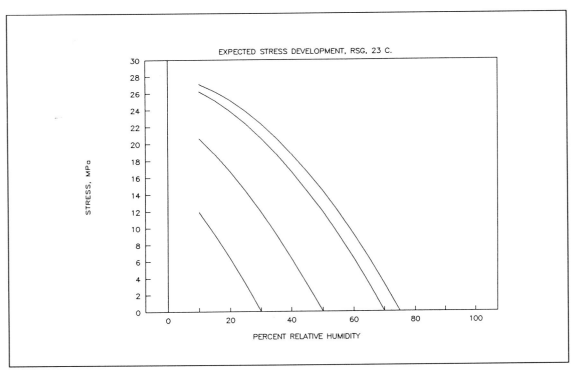

FIGURE 16
The computed predicted stress versus relative humidity for restrained rabbit skin glue with the length fixed at: 75%, 70%, 50%, and 30% RH and desiccated. Equation 12 was used for this calculation where the modulus was calculated using Equation 15.

203

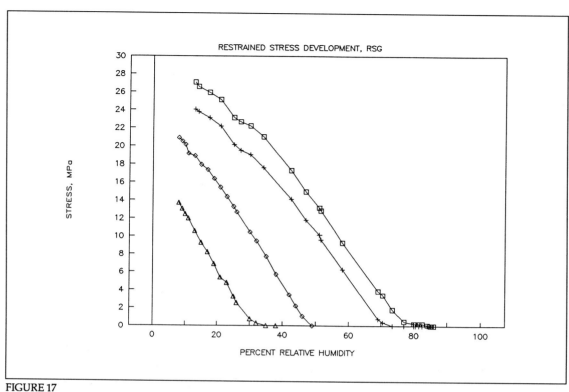

FIGURE 17
Measured stress versus relative humidity for samples of rabbit skin glue restrained at different values of relative humidity and then desiccated. This test data can be compared with the calculated values shown in Figure 16.

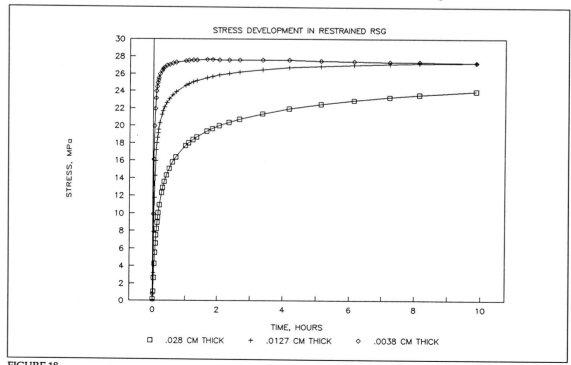

FIGURE 18
Stress versus time data for three different thicknesses of rabbit skin glue subjected to rapid desiccation to 5% RH after being restrained and equilibrated at 66% RH. All samples ultimately reached a maximum stress level of 27.6 MPa (4 ksi), though it took the thickest sample 100 times longer than the thinnest.

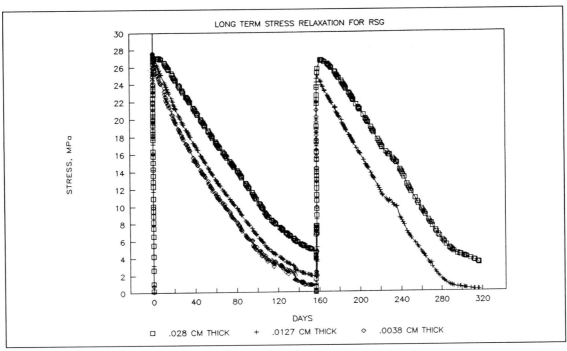

FIGURE 19
The stress relaxation versus time for the three samples of rabbit skin glue shown in Figure 18. All of the glue samples show the stress "reactivation" after raising the relative humidity to 90% and then rapidly desiccating to 5% for a second time. The time required for full stress-relaxation is considerably longer than the time needed for even the thickest specimen to fully react to a change in relative humidity.

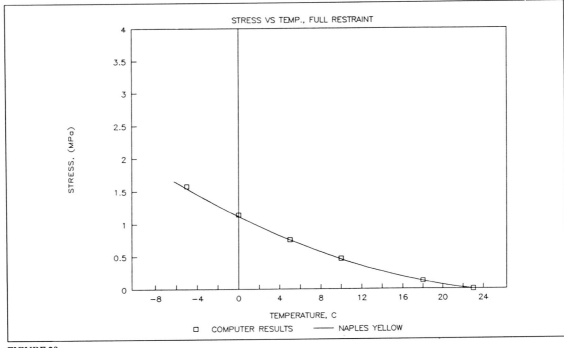

FIGURE 20
The stress versus temperature plots for a computer model results of a simple restrained Naples yellow paint sample and the results of Equation 5, using the Naples yellow paint test data. This was a programming check to verify both the modeling accuracy and the correct computer input equations for the dimensional and mechanical properties of the material. The computer model correlates well with the experimental test results.

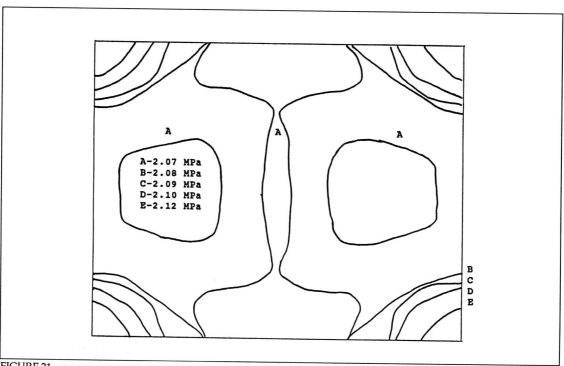

FIGURE 21

The computer calculated principal stress contours for a numerical model of a typical canvas supported oil painting 76 x 102 cm (30 x 40 in.), cooled from 23°C to -3°C at 5% RH. The stress distribution is uniform, varying only by 2% and reaches a magnitude that exceeds the tested breaking strength of the paint used in the model. This model suggests extensive cracking over the entire painted surface.

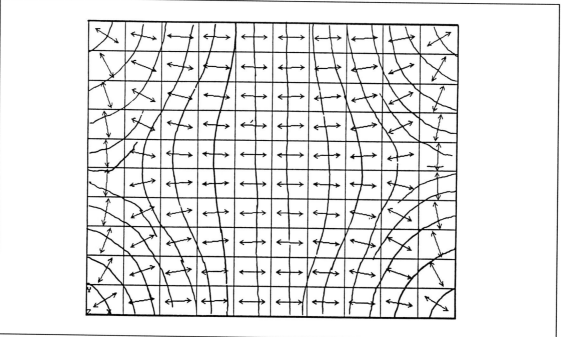

FIGURE 22

The directions vectors (arrows) of the computer calculated principal stresses in the model painting described in the text and Figure 21. Cracks that form will do so perpendicular to the direction vectors. Superimposed over the vectors is the expected crack pattern from this computer analysis. This crack pattern occurs frequently in North America.

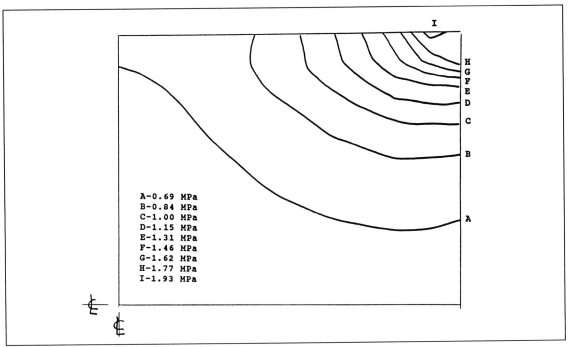

FIGURE 23
The computer calculated principal stress contours for a numerical model of a typical canvas supported oil painting 76 x 102 cm (30 x 40 in.), desiccated from 70% to 10% RH at 23°C. The stress distribution is not as uniform as found in the cooling anaysis, varying by 64%. The stresses don't reach the magnitude of the tested breaking strength of the paint used in the model. This model suggests minor cracking occurring at the corners only if the strength of the paint was less than 1.7 MPa (.28 ksi).

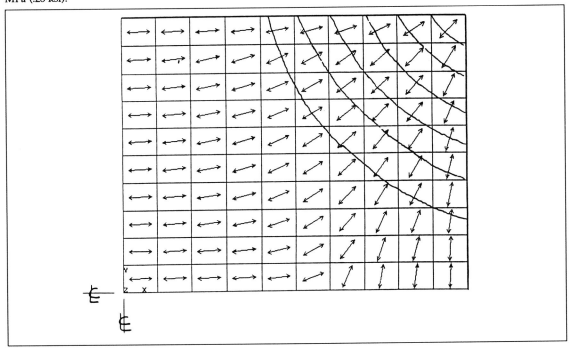

FIGURE 24
The direction vectors (arrows) of the computer calculated principal stresses in the model painting described in the text and Figure 23. Cracks that form will do so perpendicular to the direction vectors. Superimposed over the vectors is the expected crack pattern from this computer analysis only if the strength of the paint is less than 1.7 MPa (.28 ksi). This pattern occurs in paintings throughout the world.

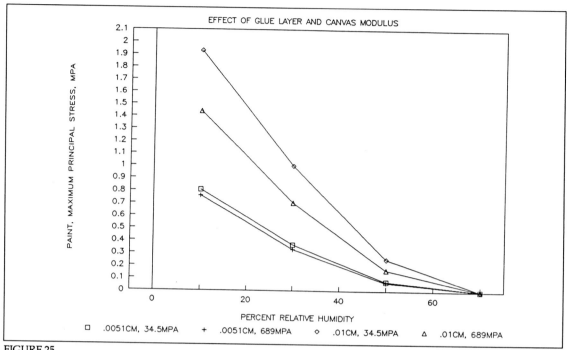

FIGURE 25

This figure shows the computer generated results reflecting the effects of the glue thickness and the support canvas stiffness on the stresses in the paint layer when the painting is desiccated from 70% to 10% RH. The two numbers given in each legend are the glue thickness and the modulus of the support. This analysis shows that moisture responsive lining adhesives such as hide glue, reduce the allowable relative humidity range a painting might safely sustain. Stiff lining materials increase the range.

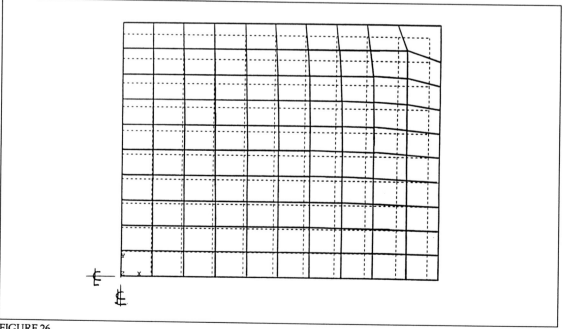

FIGURE 26

The computer calculated distortion for a numerical model of a typical canvas supported oil painting 76 x 102 cm (30 x 40 in.), keyed out at all corners .14 cm (.056 in.) and desiccated from 70% to 10% RH at 23°C. The solid lines display the distorted shape and the dashed lines represent the original configuration of the painting. The corner of the painting is highly distorted.

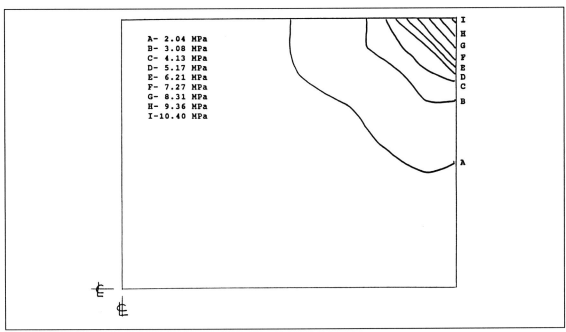

FIGURE 27

The computer calculated principal stress contours for a numerical model of a typical canvas supported oil painting, 76 x 102 cm (30 x 40 in.), keyed out at all corners .14 cm (.056 in.) and desiccated from 70% to 10% RH at 23°C. The stress distribution varies as much as 500% and reaching magnitudes five times greater than the measured breaking strength of the paint used in this model. Expanding a stretcher considerably reduces the range of relative humidity the painting is able to withstand.

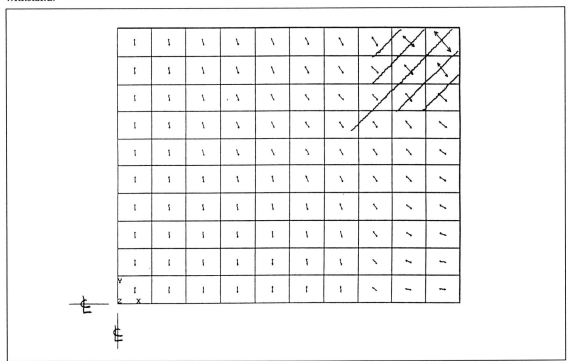

FIGURE 28

The direction vectors (arrows) of the computer calculated principal stresses in the model painting described in the text and Figure 27. Cracks that form will do so perpendicular to the direction vectors. Superimposed over the vectors is the expected crack pattern from this computer analysis. The cracks radiate approximately 8 in. from the corners. This pattern occurs in paintings throughout the world.

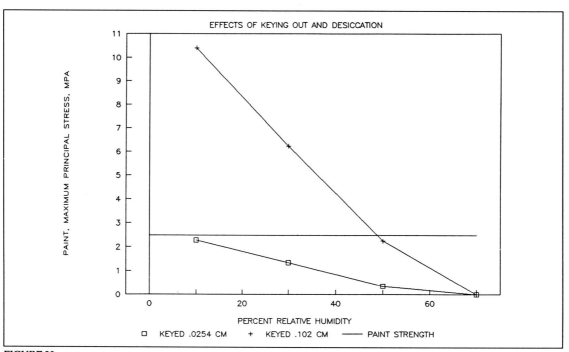

FIGURE 29
This figure shows the computer generated results reflecting the effects of different magnitudes of corner expansion on principal stresses in the paint layer when the painting is desiccated from 70% to 10% RH. The paint strength is included as a reference.

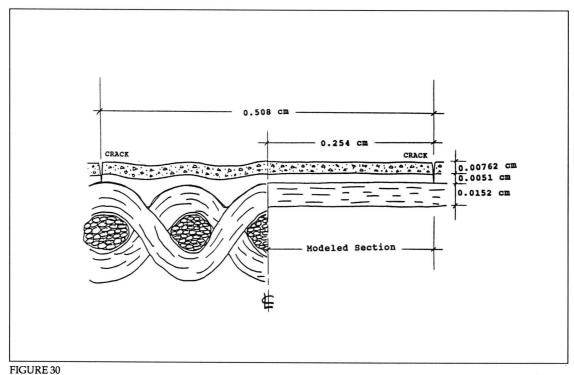

FIGURE 30
Detail section view of a painting from crack to crack, illustrating the difference between the actual structure and the computer model of the same structure. The reduction in thickness of the fabric is necessary to account for the voids in fabric and hence correct for the fact that the in-plain stiffness of a canvas is considerably higher than the bending striffness, though both are low. Details of the correction factors are in reference 3.

210

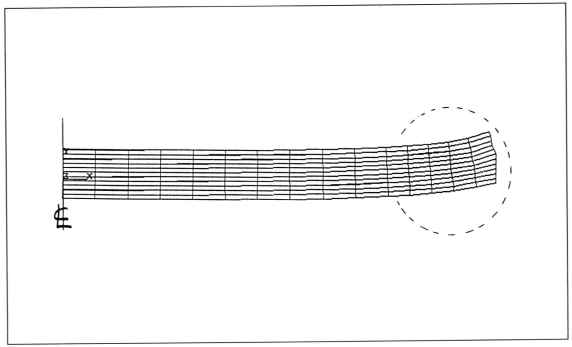

FIGURE 31
The computer calculated distortion of "cupping" for a numerical model of a typical canvas supported oil painting with existing cracks as illustrated in Figure 30. The model section was numerically desiccated from 70% to 10% RH at 23°C. The left-hand edge of the model is the center of the painting section detail and the right-hand edge is the crack location. The circle encloses the area shown in greater detail of Figure 32.

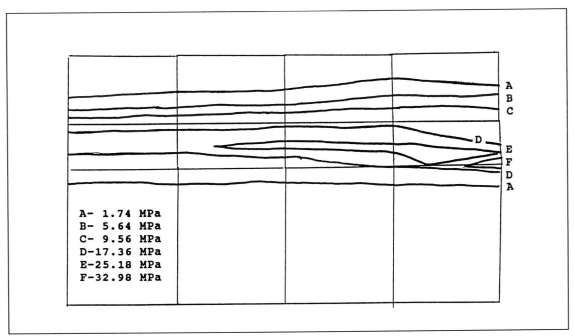

FIGURE 32
The computer calculated principal stress contours for a numerical model of a typical canvas supported oil painting with existing cracks as illustrated in Figure 30. The model was numerically desiccated from 70% to 10% RH at 23°C. The stress distribution shows intense concentrations at the glue fabric interface with stresses in the paint layer well in excess of the measured breaking strength of the modeled paint. This model suggests major flaking of the design layer will be a consequence of this magnitude reduction in relative humidity.

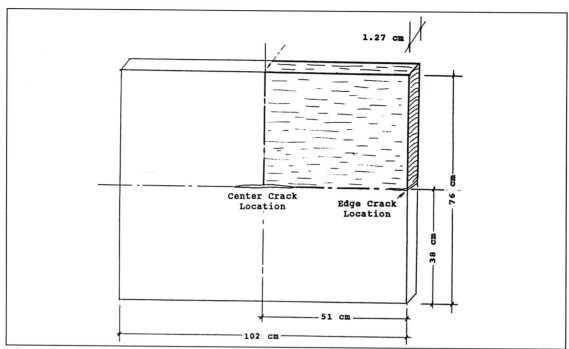

FIGURE 33

This figure illustrates a typical oak panel, showing the location of the modeled cracks, grain orientation, and panel restraints. Due to the double symmetry of the panel, only the upper right-hand section needed to be modeled.

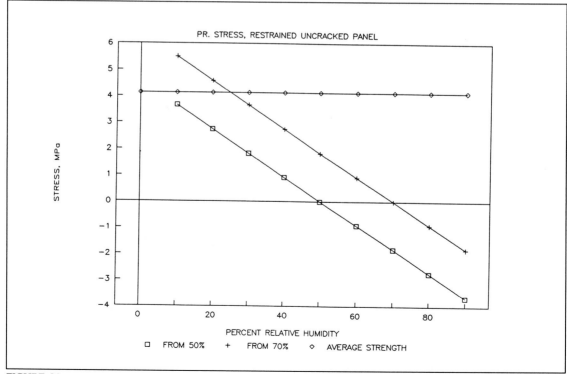

FIGURE 34

This figure shows the computer generated maximum principal stresses in the uncracked wood panel, resulting from changes in relative humidity when the panel is restrained at 50% and 70% RH. The average strength of the wood is included as a reference. Cracking of the panel might occur at 25% RH if the panel had been restrained at 70% RH.

212

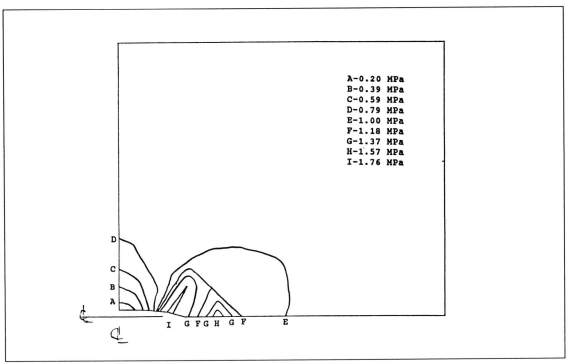

FIGURE 35

The computer calculated principal stress contours for a numerical model of a restrained oak panel with an 8 in. center crack and desiccated from 50% to 40% RH. The stress distribution shows intense concentrations in the regions of the crack tip. The maximum stress calculated in the presence of a center crack is about four times greater than without the crack.

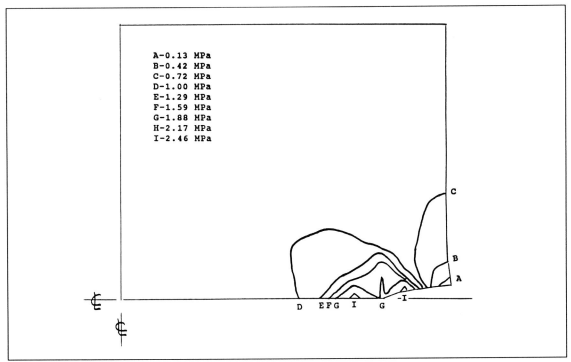

FIGURE 36

The computer calculated principal stress contours for a numerical model of a restrained oak panel with a 4 in. edge crack and desiccated from 50% to 40% RH. The stress distribution shows intense concentrations in the regions of the crack tip. The maximum stress calculated in the presence of a center crack is about six times greater than without the crack.

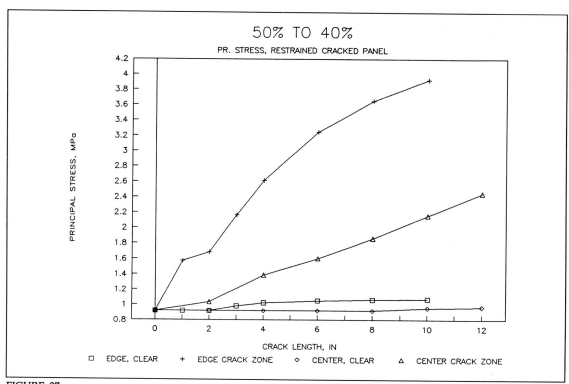

FIGURE 37

This figure shows the computer generated results reflecting the effects of different crack lengths on the maximum principal stress in the restrained oak panel when desiccated from 50% to 40% RH. Large edge cracks can potentially exhibit unstable growth with relatively modest depressions in relative humidity. The word clear in the **legend** means areas far removed from the region of the crack.

ACKNOWLEDGMENT

We wish to thank the Scholarly Studies Program of the Smithsonian Institution for its generous support of this research project.

NOTES

1. M. F. Mecklenburg, "Some Aspects of the Mechanical Behavior of Fabric Supported Paintings," Report to the Smithsonian Institution (1982), 12-15.; M. F. Mecklenburg, "The Effects of Atmospheric Moisture on the Mechanical Properties of Collagen Under Equilibrium Conditions," AIC *Preprints of Papers Presented at the Sixteenth Annual Meeting* (1988), 231-244; G. A. Berger and W. H. Russell, "An Evaluation of the Preparation of Canvas Paintings Using Stress Measurements," *Studies In Conservation* 33, No. 4 (1988), 187-204; G. A. Berger and W. H. Russell, "The Mechanics of Deteriorating Surfaces," *Materials Issues in Art and Archaeology II*, Materials Research Society Symposium Proceedings, Vol. 185, P. B. Vandiver, J. Druzik, and G. S. Wheeler, eds. (1991), 85-92; M. F. Mecklenburg, "Applied Mechanics of Materials in Conservation Research," *Materials Issues in Art and Archaeology II* Materials Research Society Symposium Proceedings, Vol. 185, P. B. Vandiver, J. Druzik, and G. S. Wheeler, eds. (1991), 105-124; G. Hedley, "Relative Humidity and the Stress/Strain Response of Canvas Paintings: Uniaxial Measurements of Naturally Aged Samples," *Studies In Conservation* 33, No. 3 (1988), 133-148; A. Karpowicz, "In-Plane Deformations of Films of Size on Paintings in the Glass Transition Region," *Studies In Conservation* 34, No. 2 (1989), 67-74; A. Karpowicz, "A Study on Development of Cracks on Paintings," *Journal of the American Institute for Conservation* 29, No. 2 (1990), 169-180.

2. T. R. Keeley and F.I.G. Rawlins, "Air Conditioning at the National Gallery of London, Its Influence Upon the Preservation and Presentation of Pictures," *Museum* 4 (1951), 194-197.

3. M. F. Mecklenburg and C. S. Tumosa, "An Introduction into the Mechanical Behavior of Paintings Under Rapid Loading Conditions," elsewhere in this publication.

4. Mecklenburg 1982, 12-13; Hedley 1988, 143-144.

5. Mecklenburg 1982, 6.

6. K. Wehlte, *The Materials and Techniques of Painting With a Supplement on Color Theory* (1975), 330.

7. F. duP. Cornelius, "Movement of Wood and Canvas for Paintings in Response to High and Low Humidity," *Studies in Conservation* 12 (1967), 76-79; R. D. Buck, *The Behavior of Wood and the Treatment of Panel Paintings*, The Upper Midwest Conservation Association, compiled by J. S. Horns, on the occasion of the IIC Oxford Conference (1978). (Author's note: This is an excellent summary of the issues of wood panel paintings and suggested wood panel treatments.)

8. A. J. Panshin and C. de Zeeuw, *Textbook of Wood Technology* (1980), 209.

9. Test specimens were provided by Mervin Richard, National Gallery of Art, Washington.

10. *Wood Handbook, Wood as an Engineering Material*, USDA Agricultural Handbook No. 72 (1974), 3-21.

11. G. S. Brady and H. R. Clauser, *Materials Handbook, An Encyclopedia for Managers, Technical Professionals, Purchasing and Production Managers, Technicians, Supervisors, and Foremen*, 11th ed. (1977), 932.

12. Mecklenburg and Tumosa 1991.

13. Mecklenburg and Tumosa 1991.

14. Mecklenburg and Tumosa 1991.

15. G. Hedley, M. Odlyha, A. Burnstock, J. Tillinghast, and C. Husband, "A Study of the Mechanical and Surface Properties of Oil Paint Films Treated with Organic Solvents and Water," IIC *Contributions to the Brussels Congress* Preprints (1990), 98-105; D. Erhardt and J. S. Tsang, "The Extractable Components of Oil Paint Films," IIC *Contributions to the Brussels Congress* Preprints (1990), 93-97.

16. Mecklenburg 1982, 8-11.

17. A. Higdon, E. H. Ohlsen, W. B. Stiles, and J. A. Weese, *Mechanics of Materials* (1967), 58-59.

18. Berger and Russell 1991, 85-91.

19. R. D. Cook, *Concepts and Applications of Finite Element Analysis* (1974), 173-188; J. S. Przemienicki, *Theory of Matrix Structural Analysis* (1968).

20. Mecklenburg and Tumosa 1991.

21. Mecklenburg and Tumosa 1991.

22. A. P. Boresi, O. M. Sidebottom, F. B. Seely, and J. O. Smith, *Advanced Mechanics of Materials* (1952), 77.

23. D. Broek, *Elementary Engineering Fracture Mechanics* (1982), 3-22; M. F. Mecklenburg, J. A. Joyce, and P. Albrecht, "Separation of Energies in Elastic-Plastic Fracture," *Non-Linear Fracture Mechanics: Vol.*

II—Elastic-Plastic Fracture, ASTM SPT 995, J. D. Landes, A. Saxena, and J. Merkle, eds. (1989), 594-612.

24. Hedley 1988, 143-144.

25. A. Murray, R. E. Green, M. F. Mecklenburg, and C. M. Fortunko, "Nondestructive Evaluation of Works of Art," elsewhere in this publication.

THE PROBLEMS OF PACKING AND SHIPPING

The Rationale for Scientific Studies

Ross M. Merrill

ABSTRACT: *The "blockbuster" exhibition is not a new phenomena, as often thought. With the event of large exhibitions, increased movement of works of art have imposed risks that must be addressed for the safety of any collection. These problems and ways of addressing them serve as the rationale for this conference.*

INTRODUCTION

Large exhibitions are often mistakenly thought to be a modern phenomena of the twentieth century. Some curators and conservators supplement this perception by concluding that most paintings are in perfect condition prior to being shipped for exhibition, but they will be wrought with damage as a result of the experience. This mystique insists that the stress of travel lies dormant within the object for some period before precipitating its destruction upon the work of art and the unsuspecting curator. The *blockbuster*, the term given these enormous exhibitions, has been common since at least 1851 as an integral part of nineteenth-century international expositions and world fairs. Encouraged by international diplomacy, there is little doubt that these early extravaganzas introduced a pattern of risks to the assembled works. Such exhibits removed paintings from the relatively stable environment maintained within museums. To reduce potential dangers within the museum, modern institutions have developed systems using air conditioning and sophisticated environmental control to assure a stable climate for the collection, therefore extending the life of the art it houses. Enforced guide-lines and specialized workers with narrowly focused responsibilities for handling and installation further reduce the risks to the paintings. Despite these efforts, today's museums are not entirely risk-free; it is during handling within the museum that most artwork is damaged rather than during transit. Still, when the work of art departs the museum for exhibition, collection managers become uneasy, as they feel they lose control of the painting during the critical handling period and movement within the borrowing institution.

Shipments for special exhibitions need not increase the risks to the painting. National Gallery of Art monitored shipments have shown that, when properly packed, the transit environment can considerably surpass even the best museum standard.

HISTORY OF THE BLOCKBUSTER

Critics charge that too often the rationale for the blockbuster exhibition is to generate increased attendance for the host museum, or to provide a vehicle for public relations and increased membership. While this is partially true as increased attendance may help gener-

ate important financial support, these exhibitions also provide the opportunity for a large audience to experience cultures and works of art not accessible otherwise. International exhibitions often allow long-separated parts of an ensemble to be reassembled for comparison and enrichment.

Early blockbuster exhibitions such as London's *Great Exhibition of the Works of Industry of All Nations* of 1851, known as the Crystal Palace Exhibition, drew huge crowds with its one-hundred thousand plus exhibits.[1] The Manchester *Gems of the Art Treasures Exhibition*[2] hosted daily crowds to see the eleven-hundred paintings on display. Consisting mostly of Old Masters, the Manchester exhibition displayed two Raphaels now in the National Gallery of Art, as well as numerous other panel paintings. As a matter of record, neither Raphael has evidence of any damage or deterioration due to the exhibition or travel.

The list of similar enormous international exhibitions is lengthy: the *World's Columbian Exposition* in Chicago in 1893 with ten-thousand paintings and other works of art, the *International Fine Arts Exhibition* in Rome in 1911 hosting 1,231 works of art; the Paris *Exposition Universelle de 1900* with almost sixty-five hundred works of art,[3] are just a few examples. These enormous exhibitions with their antiquated methodology, primitive packing procedures, and lack of shipping coordination, make the National Gallery of Art's 1985-1986 *Treasure Houses of Britain* exhibition seem a modest undertaking with only eight hundred works of art transported using modern sophisticated technology.

Despite criticism from scholars, curators, and the conservation community, blockbusters continue unabated, with an increased growth in the public's enthusiasm for such exhibitions in the last decade. With museums becoming more dependent on extensive public visibility, the only potential for deceleration is the spiraling costs and the difficulty in finding support in a declining economy. As museums become more concerned about balanced budgets, the blockbusters will be assessed cognizant of current strained resources.

PACKING HISTORY

As seen in this publication's cover depicting a nineteenth-century newspaper illustration of paintings being delivered to the National Gallery, London, early packing systems were no more than straw in the bottom of a horse drawn cart, or shelves in a wagon where paintings were placed for transit. The need for better packing systems was recognized early. The unprecedented movement of works of art during World War II focused research on the transit problem.

Surprisingly, traveling exhibitions have had very little documentable damage. There may be several reasons for this other than the conscientious efforts of the packing and shipping professions. The condition documentation for many exhibitions lack the required precision to distinguish between recent damages due to transit and existing old damage. Given the number of major exhibitions and the number of paintings transported there is very little substantiating evidence, however, to support the premise of extensive damage resulting from exhibition shipments. The absence of significant damage may be attributed to packers consciously developing an understanding of safe packing and shipping methods. While packing professionals are to be commended for recognizing solutions, the connection between cause and effect is not always direct and is, therefore, often misunderstood.

Numerous studies contributed to major advances in the understanding of the theory and practice of packing and shipping. The advantages of a stable environment became quickly recognized worldwide. By the middle of the twentieth century, the packing of paintings had become better understood and more sophisticated, with workshops being held in the United States and elsewhere to train the increasing number of museum professionals. Many of these packing workshops are ongoing and have become part of today's conservation and museum training.

With the advent of long-distance international loans, the jet aircraft introduced new environmental concerns. The availability of space-age materials and a better under-

standing of their applications have brought about a rapid development in packing technology. Generally, the museum field has been slow to reduce the risks to their paintings by using this new packing technology. Although some museums and packing firms have incorporated the latest developments into their repertoire of materials and tools, the misuse of some modern materials such as foam packing materials can compound the risk to the painting rather than reduce it. In this publication Mervin Richard and Paul Marcon address the problems of tandem cushioning and the rebound phenomena associated with the improper use of foam packing materials. When properly applied, current technology can dramatically reduce the inherent risks to the painting. It is the application of this technology that this conference is to address.

HISTORY OF TECHNICAL STUDIES

When paintings are moved from the security of their institution, they are subjected to increased risk. Virtually every facility has its tale of mishandling and damage. While much of this risk is part of the shipping process, surprisingly, the handling and movement within the museum also imposes increased risk and potential for serious damage. With a greater understanding of the mechanism of damage, museum personnel can begin to take measures to reduce these risks. A brief study of the bibliography[4] included with this publication shows that prior to World War I little was published by the conservation field related to packing, shipping, or exhibitions. During the 1930s and 1940s, the few articles on the subject were important because they addressed the environmental problems and established basic guidelines for packing and shipping works of art. The Metropolitan Museum of Art was the first to articulate procedures for art handlers, packers, and shippers.[5]

Nathan Stolow's studies of exhibition conservation, policies, and environment control have resulted in two books on the subject.[6] His first book set the standard for packing in American museums. Several early authors[7]

reported their experiences thereby helping to establish criteria for solving problems relating to international shipments. Kenzo Toishi's research on relative humidity buffers initiated many of the scientific studies of the late 1970s and 1980s. Garry Thomson's essential book, *The Museum Environment* published in 1978[8] is the principal reference establishing the environmental standards for institutions. The newly established conservation training programs of the 1970s produced academically trained conservators with stronger scientific inclination toward studying contemporary methodology. Well-trained scientists are finding their way into the conversation field and are addressing difficult issues. Most notable among these researchers are Sarah Staniforth, Christine Sitwell, Timothy Green, and Stephen Hackney in England, and Waldemar Stühler for the Berlin museums. Applications for using silica gel have been investigated by Toshiko Kenjo and Steven Weintraub. Others such as Dennis Piechota and Nathan Stolow in North America have examined case design and packing problems. Needless to say, the contributors of this publication are among the leaders in the study of packing and shipping issues.

Only recently has rigorous scientific discipline been routinely applied to the study of packing and shipping problems. Miniaturized electronic devices for monitoring conditions and collecting and storing data have permitted real-time in-transit study of the conditions within the shipping case and the transit environment. Using this new technology, the National Gallery of Art began environmental monitoring of packing shipments worldwide. Recognizing a need to share research and resources, several years ago four institutions began joint studies leading to this conference—the Canadian Conservation Institute of Communications Canada, the Conservation Analytical Laboratory of the Smithsonian Institution, the National Gallery of Art, and the Tate Gallery.

PROBLEMS AND SOLUTIONS

Twentieth-century packing and shipping technology is far superior to that of our nine-

teenth-century predecessors, yet recently we have seen slat-side open crates with straw packing arrive in Washington containing national treasures from a major museum. While the problems have been well recognized, museums have been slow to apply current technology, partly due to a misconception regarding their reported costs and partly due to a lack of understanding of the application of these materials. Although the best safeguard may be to not subject the paintings to the rigors of exhibition, major international exhibitions have become an established part of museum programs. We can dramatically reduce the risks of packing and transit by properly applying current modern technology to improve environmental control and reduce risks from shock and vibration. These advances in the technology of packing and shipping may encourage unsophisticated institutions to assume undue risks, especially in the selection of unstable paintings for travel and it should be emphasized that *the best packing, most careful handling, and most exclusive transit cannot reduce the risks to an inherently unstable object.*

As the four institutions met for initial discussions, they agreed that an international conference to disseminate current packing procedures was overdue; there was a strong consensus that much could be learned from a brief period of intensive coordinated scientific study into specific problems.

It was not thoroughly understood how paintings respond to an unstable environment, especially in the area of shock and vibration. Critical questions on the use of packing materials require further study, and by applying exceptional expertise and available equipment, as well as each institution's considerable financial resources, many of these issues can be resolved. The research presented in this publication is measurable and qualifiable by applying scientific discipline and methodology and will provide new perspective on the performance of paintings and other works of art. A new understanding of the nature and behavior of artists' materials has been achieved through research and we have learned that the transit environment may be dramatically improved by properly applying existing technology supplemented by establishing specific criteria for selecting works of art for travel. Also needed is a clearer understanding of the response of the objects to their environment and each object's environmental threshold before it becomes unstable, which will increase the rate of deterioration. This conference and its publications will establish a standard for the research that must continue if we are to fully understand how to properly preserve our collections. ☐

NOTES

1. C. H. Gibbs-Smith, *The Great Exhibition of 1851* (London, 1950) 14-15.

2. Caldesi and Montecchi, *Gems of the Art Treasures Exhibition*, (1857). The National Gallery of Art has a copy of this rare book.

3. *World's Columbian Exposition, Revised Catalogue*, Department of Fine Arts (Chicago, 1893); Ludovic Baschet, *Exposition Universelle de 1990 Catalogue Officiel illustré de L'Exposition De'cennale des Beaux Arts* (Paris, 1900). Of the 6,489 works shown, over 4,600 were paintings.

4. Prepared by Michael Skalka of the National Gallery of Art and initially supported by funds from the Getty Conservation Institute.

5. Robert Sugden, *Care and Handling of Art Objects* (New York, 1946). Two other publications followed in 1948.

6. Nathan Stolow, *Controlled Environment for Works of Art in Transit* (London, 1966); *Conservation and Exhibitions* (New York, 1986).

7. Robert G. Rosegrant, "Packing Problems and Procedure," *Technical Studies in the Field of the Fine Arts*, Fogg Art Museum 10 (1941-1942).

8. Garry Thomson, *The Museum Environment*, (London, 1978).

PAINTINGS—THEIR RESPONSE TO TEMPERATURE, RELATIVE HUMIDITY, SHOCK, AND VIBRATION

Stefan Michalski

ABSTRACT: *This review of the mechanical properties of paintings places the conservation literature in the broader context of the industrial paint and polymer literature. The layers in paintings that create and carry most of the tension (varnish, paint, ground, and size) are all amorphous or semi-amorphous polymers. Short times (such as shock and vibration), low temperature, low humidity, high pigmentation, and aging increase both the stiffness and the likelihood of cracking of these layers, and the unifying concept is the glassy/rubbery transition. The stiffness data on oil paints, glue, acrylics, and resins is charted in terms of this transition. Low temperature and low humidity also shrink materials, and this data is summarized. All the tension models—experimental, simple equation, and computer—are consistent in their predictions. Extreme but plausible conditions of shock, temperature, and humidity may exceed the strengths of some new materials, but unfortunately the tolerance of old and weak paintings to moderate conditions remains unclear.*

If a stream of warm and dry air enters a gallery just below the pictures, the canvases, frames, and panels become altered in shape and size each day, returning more or less to their original state each night. Thus the colored films of the painting are submitted to an injurious strain, which may end, as the binding medium of the pigments becomes more brittle, in a multitude of minute fissures, and the final flaking off of portions of the paint.

Professor Church, c. 1872[1]

INTRODUCTION

For over a hundred years, most of the causes of cracking have been bandied about: humidity and temperature, expansion and contraction, strain, paint embrittlement, and multiple cycles. The symptoms were obvious—cracking and paint loss—but the causes were not: the literature to this day is marred by haphazard measurements and naive conclusions. In 1982 Mecklenburg[2] reported the first systematic unraveling of painting mechanics, others including researchers at the Canadian Conservation Institute (CCI) followed.[3] Aside from our own slowly accumu-

lating experimental evidence, we have discovered much useful literature from disparate fields. The methodical study of shock and vibration began with several British researchers such as Sitwell[4] in the 1980s, but the emphasis lay on crate performance. It was not until Green's[5] work that the difficult problem of painting response was addressed, then CCI and others followed. Many of the relevant phenomena have emerged, certainly not in complete detail, but positioned in context. Other papers in this volume will examine segments of the pattern in detail, but here

I wish to map out interrelations, to sketch boundaries between risk and safety, and to demonstrate how broad the base of information has become.

The only way unequivocally to prove that we know the mechanics of paintings will be to predict and then cause specific damage in real paintings. After the "exceptionally dry weather of 1929" and increase in the "flaking and blistering" of the panels at the National Gallery, London, a study was commissioned that included ten Flemish and Italian panels of "small intrinsic value."[6] These were sawn into strips and tested in various ways to humidity and bending. Alternatives are hindsight and modeling. In hindsight, one observes extant damage, considers all the forces that have acted on the painting, then relates the two. As will be seen, this can be a very powerful tool for humidity because, (a) there is extensive humidity damage in old paintings and (b) the history of humidity exposure can be known with reasonable accuracy. Temperature and shock allow some hindsight analysis, but vibration eludes the approach completely because large-scale exposure is so recent. Modeling solves this shortage, via experimental paintings or mathematical simulations. In any event, whether the paintings are real, almost real, or unreal, their study begins with a study of constituents.

TIME–TEMPERATURE–HUMIDITY INTERRELATION

The list of painting materials is short and familiar: resins, drying oils, egg, glue, acrylics, pigments, canvas, and wood. All the media are amorphous or semi-amorphous polymers. If rubbery they stretch without harm, but if glassy they break with very little stretching. It is this simple dichotomy—glassy/rubbery—that clarifies the interaction of temperature, humidity, shock, vibration, and age of the painting.[7]

Amorphous polymers have long, kinked molecules entangled like spaghetti. Some, such as linseed oil are crosslinked, i.e. here and there adjacent molecular strands are stapled to each other by a chemical bond. Temperature of the polymer determines the degree of molecular vibration: higher temperature, more vibration. If the polymer is warm enough and tension is applied slowly enough, the molecules bump past each other enough to let their kinks straighten out. The network can be pulled to twice its length without breaking, hence rubbery behavior. Glassy behavior occurs when the molecules don't vibrate enough to bump past each other during the application of stress. Note that time and temperature are intertwined: glassy behavior can arise from either too low temperatures or too little time.[8]

The transition from glassy to rubbery is also known as the "leathery" region. From a practical point-of-view for paintings, leathery behavior is often sufficient to avoid cracking, since as the term implies, considerable stretch is possible.

In the glassy regime, about three percent elongation is the elastic limit, beyond which the polymer either cracks (brittle) or flows and then cracks (ductile). Even ductile polymers become brittle if cold enough. The brittle/ductile transition is especially important in explaining the sensitivity of some acrylics to cold. It comes about if the molecules have secondary motions that assist slippage when forced, but which eventually become too slow to help.[9]

At long enough times or high enough temperature, rubbery behavior may give way to rubbery flow. This is very important to paintings since it represents a mechanism of permanent "forgiveness" to long-term strain, such as age shrinkage. Rubbery flow only occurs in uncrosslinked or lightly crosslinked polymers: the entangled molecules don't just unkink, they slide past each other to new positions. The net effect is similar to ductile flow, but there is no minimum force required, no yield point to reach.

Some solvents plasticize polymers by entering the molecular network and disentangle through "lubrication." Thus they allow the material to behave rubbery at lower temperatures and faster times. There may be added plasticizer in emulsion paints, naturally occurring plasticizer in oil paints, and inadvertent plasticization of many materials

by humidity. Even when moisture absorption is fairly small, the effects on transition can be profound, especially in size, glue grounds, and oil paints.

EFFECT OF PIGMENTS ON STIFFNESS

Pigments and fillers stiffen the material.[10] In a glassy binder the particles act as inert links between bits of polymer. Stiffness increases up to fivefold with pigmentation levels typical of artists' paints. (In leaner mixtures, stiffness decreases because of voids between particles.) In the transition and rubbery regime pigment effects are much greater. Each particle adsorbs a layer of polymer about 3 nm thick[11] which then acts more glassy, only the remaining binder acts rubbery. Paint manufacturers have long known that above about 30% pigment volume concentration (PVC) paints become much more brittle.[12] At this concentration, particle separation is about one-third of the average diameter, so the adsorbed layers coalesce if the particles are very fine, such as some blacks and Prussian blue (0.015 μm.)[13] Unfortunately, recipes below 30% PVC are runny, useful as glossy house paints[14] but not artists' paints. Artists' paints are 30%-60% PVC if buttery. (Artists' glazes, on the other hand, are similar to enamels, 1%-20% PVC.)

Fortunately, it is unnecessary to survey artists' manuals, or to analyze samples to estimate pigment concentration in artists' paints. The very method of traditional manufacture, grinding small amounts of oil into a pile of pigment until it formed a buttery paste, became the basis of the industrial *oil absorption test* and much data is available. The test determines the mix at which binder just fills the spaces between particles, also known as the critical pigment volume concentration (CPVC). It is typically in the range of 40%-60% PVC,[15] so artists' paints would have been at this ratio if stiff, or slightly lower if brushable. Glazes would be much lower, oil grounds with tooth would be slightly higher, and glue grounds (gesso) rise to 90% PVC.[16]

STRENGTH, ELONGATION, AND AGING

For over fifty years, the paint industry has been divided over whether to emphasize elongation at break or strength when predicting cracking. The issues become even more polarized because pigmentation generally increases strength but reduces elongation at break.[17] Intuitively, we know stiff materials tend to be strong but ultimately breakable with very little "give" (elongation at break). On the other hand, rubbery materials stretch a lot, then break, all with little force. The relevance of each to paintings can only be clear when specific events are considered.

Aging tends to make paints more glassy by chemical changes: crosslinking and loss of plasticizer. Glassier materials are stronger, all else being equal, but aging also degrades microstructure. Ultraviolet in daylight or exposure to damp can notch the surface or break the pigment–medium bonds, thus weakening the paint. In lead white oil paint, for example, elongation drops from leathery to almost glassy values during the first three months of outdoor exposure, and strength increases severalfold, as expected for a curing oil film. After three months, however, strength falls rapidly, while elongation remains low.[18] Microscopic flaws are developing. Thus all of the strength data on artists' materials to date must be seen as representative of unweathered paintings. Although paintings don't experience full rain and sun, centuries of moderate daylight along with the harsh cleaning of the past will have weakened them. Exactly how much needs to be studied.

Finally, time has one last effect on amorphous polymers, called "physical aging."[19] The randomly arranged molecules slowly rattle into a more closely packed system, resulting in a stiffer, glassier network.

SHRINKAGE

When the humidity drops, water molecules leave hygroscopic solids. The solid shrinks by an amount equal to the lost water. In isotropic solids such as glue and paint, shrinkage of each dimension is simply one-third of

225

volume shrinkage.[20] By 70% RH, oil medium has adsorbed 2.5% moisture, one molecule of water for each molecule of oil.[21] Since artists' paints are only half medium by volume (50% PVC), the net shrinkage coefficient between 70% RH and 0% RH becomes 0.006% per percent RH. Of course, this is an average figure. As Mecklenburg has shown, specific paints range from triple this value to one-half for lead white.[22] The pigments change the water absorption behavior of the oil medium.[23] Above 70% RH, moisture clusters in the oil medium and builds up on the pigment surface, so swelling is much greater.[24] Paints can also show anomalous behavior on the first few cycles,[25] or react differently along each dimension.[26]

For glue shrinkage below 70% RH, the various length change curves determined by Mecklenburg have slopes of 0.023-0.040% per percent RH,[27] whereas the weight change data implies 0.045-0.060% per percent RH.[28] Apparently, glue films shrink less in length than thickness, due to orientation effects during drying. If 0.03% per percent RH is taken as typical of glue, it is five times that of the average oil paint.

Shrinkage of glue ground has been modeled by the author,[29] consistent with the mechanical data of Mecklenburg.[30] The whiting particles are slightly separated by the glue bonds, not touching, so that shrinkage of the ground is proportional to these bond lengths. For typical gesso recipes, shrinkage is about one-twentieth that of glue alone, i.e. several times less than oil paints.

Wood's response to humidity is well documented and simple;[31] therefore museums have understood its significance. Canvas, on the other hand, has caused considerable confusion, because the fabric usually shrinks when its fibers swell. In 1924, Ramsbottom (Royal Aircraft Establishment, United Kingdom)[32] correctly identified that in painted canvas at moderate humidity, the paint "is primarily responsible for the tautness" whereas at high humidity "tautness is apparently dominated by the fabric and increases as the fabric further contracts." By the 1940s, industry knew that it was crimp in the woven yarns that made the textile shrink

when the fibers swelled.[33] In 1964, equations for tension in restrained fabrics appeared, along with ample data,[34] but it was not until Mecklenburg[35] presented the same arguments in 1982 that our field comprehended linen. The important fact is this: in a painting, at all but the highest humidities, linen in the warp direction is slack and in the weft direction usually slack. (Sometimes the weft threads have negligible crimp, so shrinkage in length at low humidity becomes significant.)[36] In most old paintings, however, the other layers in the painting generate and carry the tension. The linen just bridges the fragments.

Shrinkage by low temperature can easily be generalized: in the glassy state, polymers shrink 0.007-0.014% per degrees C (0.004-0.008% per degrees F). In the rubbery state this coefficient doubles.[37] The shrinkage of pigments (minerals) is typically 0.0007% per degrees C (0.0004% per degrees F),[38] negligible in comparison. Thus artists paints around 50% PVC would shrink half as much as pure medium.[39] Overall, varnishes, media, and size, at or near their glassy state, will shrink about 0.010% per degrees C (0.006% per degrees F), artists' paints will shrink about 0.005% per degrees C (0.003% per degrees F).

Glue as a glassy polymer should shrink about 0.010% per degrees C (0.006% per degrees F) but Mecklenburg and Tumosa have measured a value at 5% RH of only 0.0025% per degrees C (0.0014% per degrees C).[40] At a fixed relative humidity, the moisture content of many hygroscopic materials increases slightly at lower temperatures, e.g. wood (but not oil media).[41] In the case of wood, this "side effect" overrides thermal shrinkage completely.[42] In the case of glue, this swelling side effect amounts to a little less than thermal shrinkage itself, a fortuitous balance. Thus any reference to shrinkage at low temperature must stipulate whether humidity or moisture content is fixed.

The shrinkage of glue ground with low temperature has not been measured, but it can be estimated. Whiting particles shrink 0.0007% per degrees C (0.0004% per degrees F). The glue bonds are typically one-

twentieth the length of the particles,[43] given the response of the glue, the contribution of the bonds must be only 0.0001% per degrees C (0.00007% per degrees F), i.e. negligible compared to the whiting.

STIFFNESS

Oil Paints, Oil Ground

In the 1920s, Nelson[44] began the scientific study of the mechanical properties of oil paint, first investigating the role of time then of humidity. Unfortunately, very little information appears after him until the 1950s, and by the 1960s alkyds and emulsions had dis-placed oil as the media of interest. It is not until 1982 when Mecklenburg reported his studies of artists' oils that further data emerged.

In Figure 1, all the data on the effect of relative humidity on stiffness has been compiled on a master curve.[45] Although pigment radically alters paint stiffness as given by the pigment factor in Table 1, it does not change the shape of the curve: all oil paints double their stiffness between 70% RH and 0% RH. Above 70% RH the curves diverge depending on water sensitivity of the pigment. The least sensitive is titanium white, the most sensitive are zinc white, lead white, Prussian blue and azo red. (With complete wetting,

Table 1
Legend for Figures 1 and 2

Label No.	Description	Scale Source (Figure No. 1)
1	Artists' Prussian blue, safflower	(x 1100)
2	Artists' azo red, safflower	(x 580)
3	Artists' burnt umber, safflower	(x 370)
4	Artists' titanium white, linseed	(x 340)
5	Artists' lead white, linseed	(x 210)
6	Zinc white, linseed, 14% PVC	(x 180)
7	Artists' burnt umber, linseed	(x 58)
8	Lithopone, linseed, 20% PVC	(x 22)
9	Lead white, linseed, 21% PVC	(x 16)
10	Clear linseed	(x 1)
11	Clear stand oil	(x 1)
11E	Clear stand oil, minus leachables	(x 10)
A	Same paint as #3; TMA data	
B	Same as #6; creep data	
C	Leaded zinc, linseed; creep data	
D	Artists' burnt sienna; DMTA data	
E	Same as D, but acetone leached	
F	Same as #10; creep data	

1-5, 7: Mecklenburg 1982.

6, 8-10: Nelson and Rundle 1923a.

11, 11E: Talen; 1962.

A: Michalski 1989, unpublished.

C: Gutfreund 1965.

D: Hedley et al. 1990.

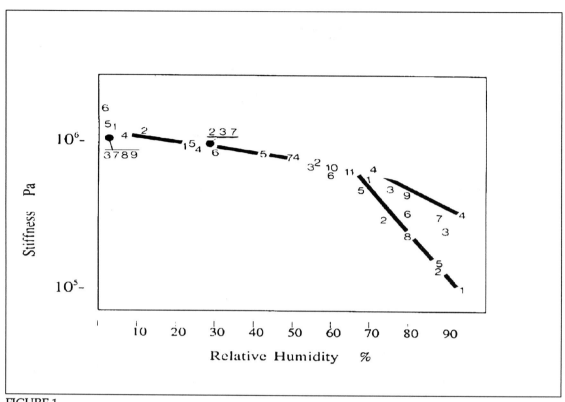

FIGURE 1

Change in stiffness of oil paints with relative humidity. Description, scale factor, and source for numbered points are given in Table 1.

zinc white is unique in its enormous swelling[46].)

Despite a spotty collection of data, the glassy/rubbery transition in oil paint can be pieced together in Figure 2. Nelson and Rundle[47] first looked at the transitions by measuring creep over time, as did Gutfreund[48] thirty years later. Brunt[49] provides the first (and only) measure of the time/temperature equivalence, and together with the creep data allows an estimate of the scales for Figure 2. Finally, in the last three years both Hedley and Odlyha,[50] and CCI have begun the modern thermo-mechanical studies necessary to clarify oil paint behavior. Complementing the mechanical data is the calorimetric (DSC) data by McGlinchey,[51] which confirmed that the fundamental glass/rubber transition starts near -30°C (-22°F) and ends before 0°C (32°F) for linseed, walnut and poppy oil, with or without pigments, with or without aging.

In Figure 2 several important features emerge. Full glassy response occurs only when linseed oil is very cold (-30°C [-22°C] for a ten-second event). The speeds typical of shock (0.01 s) are not fast enough to reach this behavior at room temperature. At room temperature, pure medium is fully rubbery but artists' paints show a stiff leathery behavior at best, especially very fine pigments such as Prussian blue. At one day to a week, a forgiving region of rubbery flow occurs in some paints (zinc white) due to the noncrosslinked fraction of the oil. This flow is not indefinite, but stops as the crosslinked portion asserts itself (much like behavior of polymer blends).[52] As Hedley and Odlyha[53] showed, this behavior can be erased by leaching, and presumably by age as well. The strong "dryer" lead white shows no such flow. Overall, oil paint is leathery over a wide range of conditions. Both cold and the rapid elongations of shock and vibration will cause much stiffer behavior, but full glassy response is unlikely.

228

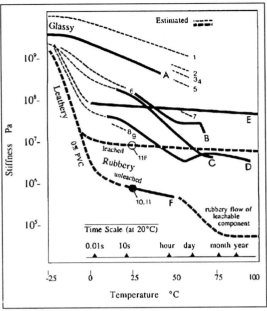

FIGURE 2
Change in stiffness of oil paints with time and
temperature at 50% RH. Numbered data points
and lettered graphs described in Table 1.

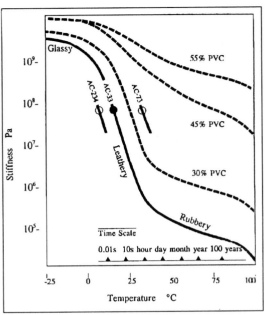

FIGURE 3
Change in stiffness of acrylic paint, AC-33, with
time, temperature, and pigmentation (titanium
white). Horizontal shift in curves shown for other
common acrylics. (Estimated from Zesel 1980 and Rohm
and Haas 1981.)

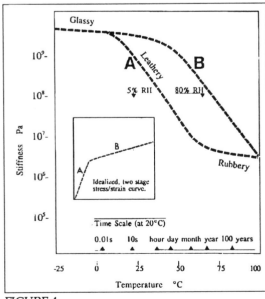

FIGURE 4
Change in stiffness of glue with time and
temperature, assuming moisture equilibrium
with 50% RH and room temperature (20°C, 68°F)
Horizontal shift in curves shown for low and high
humidity conditions. (Estimated from Yannas 1972,
Bradbury and Martin 1952, Eliassaf and Eirich 1960, Ueno and
Ono 1963, and Mecklenburg 1988.)

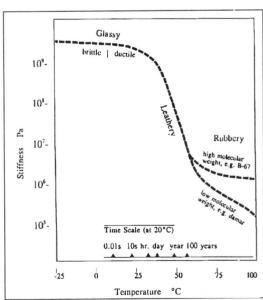

FIGURE 5
Change in stiffness of resin varnishes with
temperature and time. The curve is representative
of dammar, shellac, mastic, sandarac, and B-67
acrylic. (See notes 70, 71 for further information.)

Acrylic Paints, Ground

"Acrylic" refers to a family of polymers, and none of the pure acrylic polymers makes a particularly good paint medium; they are either too glassy or too rubbery. Therefore acrylic paints are formulated as copolymers that behave leathery to a moderately slow strain at room temperature. The different molecules are not just side by side as distinct chains, but combined into single chains. Although the softer component is referred to as an "internal plasticizer," it is not a leachable molecule.

Probably the singlemost common acrylic paint used over the last forty years is a co-polymer of 40% methyl methacrylate and 60% ethyl acrylate, known as Rhoplex AC-33 in the United States or Primal AC-33 in the United Kingdom.[54] Based on Zosel's data for a similar acrylic, Figure 3 shows the equivalent times and the effects of titanium white pigment.[55] Stiffness increases markedly above 40% PVC and peaks at 55% PVC, the very region of artists' paints. Iron oxide red behaved similarly, but other pigments, iron oxide yellow, carbon black, and phthalo blue[56] had even greater effects.

The brittle/ductile transition is known in acrylics better than any other polymer, because of studies by Wu.[57] He found it in a variety of acrylics 30°-50°C (54°-90°F) below the glass transition.

Over months and years, acrylics enter almost indefinite rubbery flow because they are not crosslinked. (Great age may crosslink them.) Together with their negligible humidity sensitivity, they should crack very little, however, artists' acrylics become glassy by about 5°C (40°F) or 0.01 s. This represents a serious vulnerability during transit, especially since acrylics seem so resilient to us at room temperature. In extreme but not impossible conditions, e.g. a .01 s shock at -10°C, the brittle/ductile transition may be broached as well.

Glue (Size) and Glue Ground (Gesso)

The behavior of glue (size, gelatin) is complicated. Stress–strain curves follow two stages, idealized in the inset of Figure 4 as A and B. This is not a simple ductile yield curve, but as Mecklenburg and Karpowicz have shown, it is two stage elastic behavior.[58] At moderate humidity, and time periods of a day, phase B takes over near 0.8% elongation. These two phases have been plotted as separate stiffness curves in Figure 4, with the shape of the curves based on the work of Yannas[59] and their dependence on humidity and time a synthesis of Mecklenburg[60] and several others.[61] Gelatin is also the only historic artists' material to have its stiffness measured biaxially,[62] and its delamination stresses monitored during drying.[63] These studies confirm the approach taken by our field.

The humidity response of glue is shown as a shift in the horizontal scales of Figure 4. Both phases, though, are glassy to shock and vibration at moderate humidity. Elsewhere in this publication Mecklenburg and Tumosa report particularly brittle behavior to shock at very low humidity and low temperature, indicating a brittle/ductile transition. For humidity fluctuations, it is the fact that phase A remains glassy for months at low-to-moderate humidity that dominates response.

Glue physically ages in hours in its rubbery phase, apparently due to reformation of some of the original collagen structure or crystallites,[64] not just loss of free volume. Pharmaceutical research showed the effect in terms of increased stiffness after exposure to high humidity.[65] Physical aging as measured quickly during high humidity is important not only as a direct effect, but also as an indicator of the much slower aging possible at lower humidity.

Altogether, three separate mechanisms can increase tension in glue after a high humidity cycle.

(a) If the glue layer is prevented from swelling by an adjacent layer, it may plastically compress while soft, then try to shrink on return to moderate humidity.

(b) It may physically age, not just by compaction of a random network but by formation of crystallites.

(c) Many months prior to the high humidity

cycle, the glue may have been stretched quickly to a high tension and held (e.g. keyed-out). Over many months it would eventually behave rubbery, so the tension would disappear ("stress relax") but the elongation remains unchanged. If the glue were released at moderate humidity, the old stretch would seem "frozen in" but if released at high humidity, the glue will quickly recover the "old" stretch as well as swelling due to moisture gain.

Karpowicz[66] showed this same phenomena for "old" drying strains, as large as 5% elongation, and the author found a similar 3%-4% strain frozen in the glue bonds of gesso.[67] Given the estimates of Figure 4, it does not appear that such strains are erased by rubbery flow for centuries at moderate humidity.

The short-term stiffness of grounds has been measured by Mecklenburg.[68] A model developed from the data predicts the inter-particle glue bond dimensions as a function of recipe. A typical recipe, 85% PVC, has a glue bond length 0.05 times the average particle diameter and 0.07 times its area.[69] The net result is that gesso appears to have similar stiffness to glue, but any calculated prediction must consider whether the elongation in the glue bonds enters phase B response. Given the small relative size of the glue bond, such elongations occur at very small total elongation of the ground.

Resin Varnishes

None of the natural resins has been characterized as to the width of their leathery region, or their time characteristics, but several authors have measured the temperature of the transition by other means, and 50°C (122°F) is typical.[70] Fortunately, the synthetic resins, i.e. acrylics, have been well characterized, and their behavior is taken as representative. The curve in Figure 5, represents both the most important varnish historically, dammar, and also the glassiest of the commonly used acrylic varnishes (iso-butyl methacrylate, B-67).[71] All other acrylic varnishes are softer.

Clearly varnishes are the glassiest layer in

paintings and although they might be dismissed as a sacrificial layer, the real risk lies in the initiation of cracks in the paint film below, especially with a heavy varnish. Fortunately, varnishes are not pigmented, so elongation at break can be upwards of three percent. Cold and shock may exceed the ductile/glassy transition in acrylics, whether or not dammar has such a transition is unknown.

Resin plus Oil

These mixtures were a very important part of nineteenth-century paintings, both as varnish and medium.[72] Although the mechanical data is sparse, parts of it are remarkable. The results of Nelson and Rundle[73] are graphed in Figure 6. With any mixture, the glassy–rubbery transition lies between that of its constituents, and since the oils and resins are so far apart, small changes in recipe make large changes in the transition temperature of the mix.[74] In fact, the old varnish terms *long-oil* and *short-oil* refer to varnishes long on oil (over two-thirds oil) and short on oil (less than one-half oil), and these mixtures were recognized as very different compromises between hardness and flexibility.[75] The long-oil mixes in Figure 6 are in rapid transition between glassy and rubbery states, because of strong plasticization by water and because the mix has its transition at room temperature. Hess documents an example of very wide "alligatoring" in a "too short oil" topcoat over a "too long oil" primer on interior furniture. It occurred only after "one winter in an unheated room."[76] Whether it was the low temperature that embrittled the top layer or damp that allowed the bottom to enter rubbery flow, or both, is unclear. In either case, very large drying strains must have been present due to solvent evaporation, which would only arise in paintings of poor technique.

PAINTING RESPONSE TIMES

Shock and vibration cause immediate mechanical response in the painting. Since paintings on canvas resonate in the range of

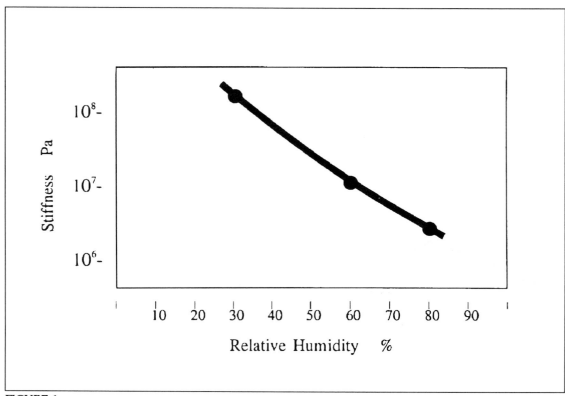

FIGURE 6
Change in stiffness of linseed oil and fossil resin mixture (2:2:1) with RH. (Nelson and Rundle 1923b.)

5-50 Hz, the duration of each tension fluctuation is on the order of 0.1-0.01 s. Shock impulses tend to the short end of this same spectrum, i.e. about 0.02 s.[77]

Temperature and humidity response times are most conveniently expressed as the time required for half of full response, i.e. half-times. This has two advantages: it avoids the imprecision of the asymptotic and frequently anomalous approach to equilibrium, and it emphasizes the rapid first half of the response. As an approximation three times the half-time gives about 90% of equilibrium.[78]

If thermal response times are calculated by well-established engineering procedures, the effect of thickness, the effect of room conditions, the location of temperature gradients, and many other parameters become clear.[79] Direct experiments confirm the techniques.[80] For the most common change, fluctuations of air temperature at the front, the half-time of low impasto paint and ground layers (1 mm [.04 in.]) is ten minutes. The whole paint layer warms and cools with negligible gradient, i.e.

the front and back maintain similar temperature throughout the change. A stretcher bar or wooden panel (2 cm [.79 in.]) is ten times slower, about two hours, and experiences some gradient (20% of total). If heating occurs by radiation, e.g. direct sunshine, these times will be much shorter and gradients very steep. Once inside an insulated crate, paintings follow the response time of the whole crate, which tends to be many hours, as discussed by Richard elsewhere in this publication.

The moisture response times can also be calculated[81] and confirmed experimentally.[82] Unlike the response to temperature, the response of different layers to humidity varies considerably. For practical purposes, however, the hygrometric half-time of linen, size, and glue ground ranges from minutes to hours, that of oil grounds and paints, hours to days, and finally stretcher bars and panels, days to weeks. Also unlike temperature, the most influential side of the painting is the back. In paintings on canvas, the linen and

FIGURE 7
Visible cracks in parts of Di Cione's *The Crucifixion* (fourteenth century, egg tempera, glue ground, panel) National Gallery, London. (These drawings were made from photographs contained in Bomford et al. 1990.)

size layers respond in minutes if air circulation is good, but historically a painting on a wall, or with a partial backing board in a leaky crate, would take up to an hour or more to respond due to restricted circulation.[83] A tight backing board, tight bag, or tight crate can increase this time to days and weeks.[84] Similarly in panels with uncoated backs, the moisture response will penetrate the back significantly within a few hours, although half-time of the whole piece is days.[85]

PATTERNS OF TENSION AND CRACKING

Extant Cracks in Paintings on Wood and Hardboard

The most striking feature of cracks on panel paintings is the rectilinear pattern, oriented by the wood grain. The primary cracks run perpendicular to the grain, as in Figure 7a. Repeated here is a brief explanation of conclusions by the author:[86]

(a) During any exposure to damp, (including the original application) the gesso is swollen, soft, and stress-free.

(b) Upon returning to the average humidity of the wood below, the gesso attempts to shrink, but cannot; tension arises in all directions.

(c) When both wood and gesso react to lower humidity, the wood shrinks across the grain and releases tension in the gesso, but not along the grain, hence, cracks form across the grain. Panels may also show secondary cracks along the wood grain (Figure 7b).

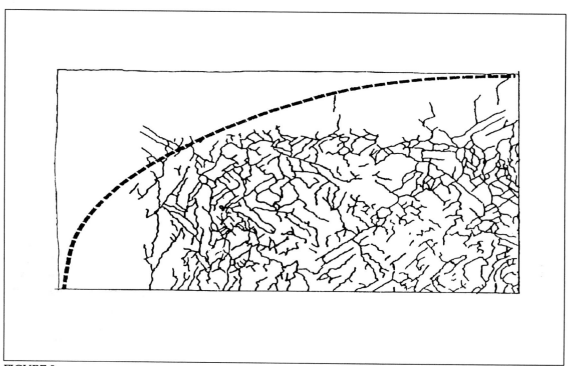

FIGURE 8
Visible cracks in top left quadrant of Krieghoff's *Jam of Logs on the Little Shawinigan* (nineteenth-century oil on canvas) Rideaugate, Ottawa. The dotted line represents the edge of the painted area and the edge of the oval frame liner.

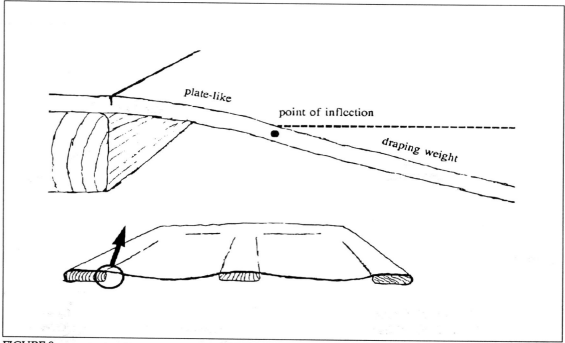

FIGURE 9
Cross section through a sagging painting on canvas. The painting drapes over most of its length, but near the bars it acts as a thin, stiff plate.

234

As noted by Hodge[87], a T-junction in cracks must have formed the top of the T first, so in Figure 7b the primary cracks formed first as in Figure 7a, then the strips of paint broke from side to side. The patterns in Figure 7a and b are particularly interesting because they come from the same piece of wood in Jacopo Di Cione's altarpiece, *The Crucifixion*.[88] Areas of the panel dominated by gilding, such as the sky and Christ,[89] respond to humidity primarily from the back of the panel, so the wood shrinks first, then the gesso reacts. Areas of gesso unprotected by gilding can react before the wood, so tension forms in both directions. Since gilding cannot influence any other agent so profoundly as it does humidity,[90] gilt panels like *The Crucifixion* are especially useful in establishing the historic importance of humidity to crack mechanisms.

In a description of Botticelli's *Primavera*, oil/tempera on glue ground,[91] Baldini indicated that "all the paint layers seemed to be cracked and in poor condition, but the actual damage was found to be mostly at the level of the oldest varnish."[92] This is not unusual, indeed cracks in varnish often run across the wood grain much like gesso cracks, but with much closer spacing. As to the paints, Baldini notes that the vegetation (mainly malachite) contains only fine, horizontal cracks.[93] Thus varnish, some paints, and ground all show the same primary crack pattern, but with variable spacing. The flesh tones in *Primavera* (mainly lead white) cracked quite differently: meandering primary and secondary cracks, or areas of fine cracks unrelated to the wood grain.[94] Many Y-junctions occur, which are the start of cracks, not the end like Ts. Lead whites had a poor reputation for checking in house paints too,[95] and these checks were often independent of wood grain. The stress cycle responsible for such independent cracking must be either faster or much larger than the cycling due to the wood, and specific to lead white. One fast possibility is overnight dewfall, not uncommon in historic buildings in Europe.[96] Alternatively, the problem may be lead white's inability to enter rubbery flow after curing (see Figure 2). Curing paints can develop up to three percent shrinkage,[97]

easily the dominant stress if never dissipated.

Modern panel paintings are frequently on 0.6 cm (0.25 in.) hardboard. Unlike wood, hardboard shrinks uniformly in all directions when humidity drops, causing random directional cracking. The ground delaminates easily if painted on the smooth side so cracks tend toward wide separation (1 cm-5 cm [0.5 in.-2 in.]) with no cupping and large-scale blind cleavage.

Extant Cracks in Paintings on Canvas

Virtually all paintings on canvas crack, and the only universal characteristic is some relation to the stretcher bars behind. Two features arise: cracks may be reduced over the stretcher bars, and a prominent crack may form along the stretcher bar edge. The author observed a clear example of crack reduction in Cornelius Krieghoff's *Jam of Logs on the Little Shawinigan* (oil paint, oil ground, Figure 8). This is a good example for two reasons: the pattern shows no influence of the oval image, therefore only the linen, size, and ground are relevant; and it shows no crack along the stretcher bar. Therefore, stretcher bar crack has a different set of causes from crack reduction (though some causes may overlap).

Historically, the most common temperature and humidity fluctuations were diurnal. As discussed in the section on response times, the stretcher bars have a temperature half-time of two hours (or less if radiated heat) whereas their humidity half-time is many days. Over the course of twelve hours, the humidity in the small gap between the bars and the canvas would change only a small fraction of the fluctuation in the room,[98] so the size, ground, and half of the paint would be protected from the diurnal humidity cycle, but not the temperature cycle, as some have proposed.[99] Of course, paintings with a considerable gap between the bar and the canvas, or with lean, permeable paint layers, would show less and less benefit from the bars. The Krieghoff had an oval gilded frame liner that moderated humidity from the front, hence the exceptional condition in the corners. Although different

humidity scenarios could explain the cracks, all point to the benefits of stable humidity, especially at the back of the painting, hence the value of airtight backing boards. In another location, a fine spiderweb crack pattern with no out-of-plane deformation is noted with a dimple of similar radius nearby showing no associated cracking. These damages represent glassy and brittle behavior in one instance and rubbery flow in another. The spiderweb crack may have been caused by a quick blow (0.01 s) from a blunt object at 5°C (40°F), and the dimple may have been caused by a hook from another painting pressing the painting while stacked in storage. In the first few minutes, the entire painting would have stretched elastically, but over many days, rubbery flow would occur. These incidents represent the two extremes in oil paint behavior (see Figure 2).

Although stretcher bar crack might result from the discontinuous humidity response, simple bending against the bar is more likely the cause. Historically, bending probably occurred when the painting was leaned against a wall, or held horizontal. In Figure 9, the loose painting drapes. Near the stretcher bars, however, it resists bending (Figure 9). The distance over which this inflexible behavior persists can be estimated as the point of inflection shown in Figure 9, and the strain in the paint at the edge of the bar can then be calculated.[100] For a medium-size painting (1 m [3.3 ft.] wide) of low impasto (0.1 cm [0.04 in.] horizontal and loosely sagging in the middle by 1 cm (0.4 in.), inflexible behavior acts for 7 cm if all layers are glassy, and elongation reaches 0.08%, not enough to crack in one event. Changing all layers to a typical leathery oil paint value shortens the inflexible distance to 1.6 cm and increases paint elongation to 0.36%, not enough to crack leathery paints. If, however, the painting is dropped a short distance on its back against the wall or floor, even 10 cm (4 in.), the effective weight of the painting increases forty times for one moment,[101] and paint can crack along the stretcher bar. Booth describes several improvements for old and new stretchers that the Tate Gallery has used to avoid such damage; they are blind stretchers, pan-

els, loose lining, and chamfering.[102]

Modeling of Humidity and Temperature Effects

The first useful model of paintings on canvas was developed by Mecklenburg[103] for tension versus humidity. Having measured the humidity dependence of each painting material as noted above, he calculated the tension in each layer and summed them. Despite being the simplest form of laminate model (additive elastic equilibrium) it predicted the tensions he then measured in a strip of a century-old painting. The success lay in his appropriate time scale: measurements were carried out over several days, so that the oils reached equilibrium in the rubbery plateau, while the glue remained glassy. Hedley[104] carried out similar measurements on other old paintings, confirming the model. In particular, he demonstrated the dramatic difference in pre- and postindustrial linens, due to the differences in crimp, as shown in Figure 10.

The paint industry has also begun modeling the effect of humidity and temperature on paint tension. Perera and Vanden Eynde[105] have not only produced graphs identical to those in Figure 10 for paintings, they have shown the same effect for decreasing temperatures. Bender[106] monitored tension in a stretched, two-coat paint layer. He demonstrated that the glassier layer dominated tension and that percent relaxation over time was independent of thickness. Although these studies do not use orthodox artists' media, their analogous results and emphasis on glass transition complements the approach taken by our field.

Daly and Michalski[107] modeled paintings physically with samples prepared in every stage of completion to compare the effect on each additional layer and different media (see Figure 10 for some of the results of this modeling). They demonstrate the negligible response of acrylic to low humidity. The short-term results resemble other studies, but the long-term data indicates new effects.[108] First, the tension dropped significantly over the first year as the glue and acrylic entered

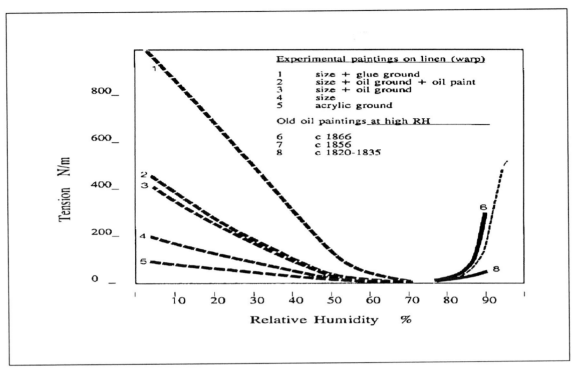

FIGURE 10
Change in tension of paintings with relative humidity. (From Daly and Michalski 1987 and Hedley 1988.)

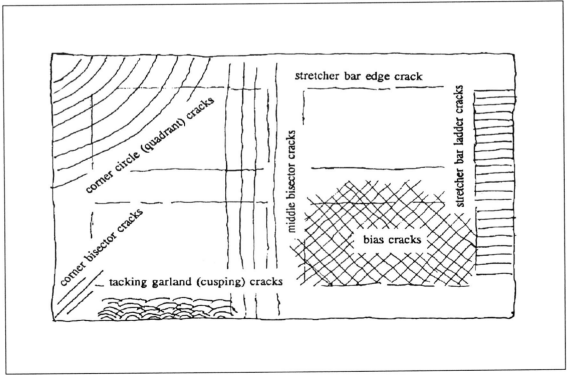

FIGURE 11
Typical large-scale crack patterns in paintings on canvas.

237

rubbery behavior. As a result, the oil assumes a larger proportion of the tension. (The samples were never taken above 70% RH over the years so the glue was not "reset" in tension.) Second, the tension began to climb after the first year, which in the oil, probably represents further curing. In the glue, it implies that physical aging supersedes any tendency to rubbery flow at these conditions (50% RH, 21 °C [70 °F]).

Berger and Russell[109] published considerable tension data from model and old paintings. Their early data from linen primed with an epoxy/gesso mixture shows little humidity response until the linen gets damp,[110] but some response to temperature, as expected for a coating dominated by epoxy. Indeed, the response to a large temperature shift agrees with the work on epoxies by Shimbo et al.[111] Later results by Berger and Russell[112] with acrylic and oil paint conform to the humidity response pattern in Figure 10.

Computer modeling was first introduced for paintings in the work of Colville, Kirkpatrick, and Mecklenburg.[113] Their humidity model predicted most of the initial stages in the crack pattern of Figure 11 that shows tacking garlands (cusping), keying-out cracks, parts of the circular corner cracks, and the orientation of center cracks parallel to the short dimension. It was a powerful proof not so much of the method (common engineering by then) but of the assumptions and material coefficients Mecklenburg had provided.

Modeling of Shock and Vibration

Virtually all the published work appears in this volume. Unlike the modeling of humidity, modeling of shock and vibration often leads to the unfamiliar, so its validity will depend on the reliability of the method rather than the emergence of familiar cracks. Fortunately, the success of the humidity and temperature models helps to provide this reliability.

If elongation or stress is applied in many small cycles, such as vibration, a crack can grow by imperceptible increments until it reaches a critical length, then sudden breakage occurs. Figure 12 graphs the number of

cycles to reach this sudden breakage in a glassy acrylic, both as pure medium, and as a mix with whiting, similar to ground.[114] The critical feature of Figure 12 is the threshold below which the material will tolerate almost indefinite cycling. In these and the many other polymers that have been studied, the threshold plateau begins at about ten million cycles. In terms of stress or elongation, the plateau does not occur lower than about one-fifth of the values for cracking in one cycle.[115] Of course, these values are for flawless pieces, the effect of existing cracks cannot be analyzed without considering specific structures.[116] At CCI, fatigue tests of model paintings are underway, starting with sized linen canvases (61 x 76 cm [24 x 30 in.]) brush-coated with an unusually lean glue ground (93% PVC). One was vibrated to an amplitude of 4 mm (0.16 in.) at its resonant frequency for one-hundred million cycles (25 Hz, 20 days). No cracking and no change in resonant frequency was observed. This result is plotted on Figure 12 as a point of "no effect" in terms of the approximate elongation in the ground.[117] The same painting was then vibrated 9 mm (0.35 in.) and showed no effect at one-million cycles (28 Hz, 6 hours) but between one- and ten-million cycles extensive cracking developed throughout the central region, and resonant frequency fell to 19 Hz. Stretcher bar cracks also developed at the middle of each long side, where the canvas had slapped the bar edge. It is important to realize that this study was an attempt to locate the fatigue threshold, even if it required vibration levels far in excess of transit environments, which it most certainly did (2.5 G, 28 Hz continuous). Even the vibration that fell below threshold was extreme (1 G, 25 Hz continuous). Thus, a painting with the most conceivably brittle layer, vibrated continuously for three weeks at levels possible only with no cushioning and terrible transit,[118] showed no damage.

Real panel paintings were incredibly "vibrated" in the 1931 National Gallery, London study.[119] Although forced much slower than any natural resonance of the panels, the bending was carried out for a significant ten-thousand cycles (pieces cut from one Flemish

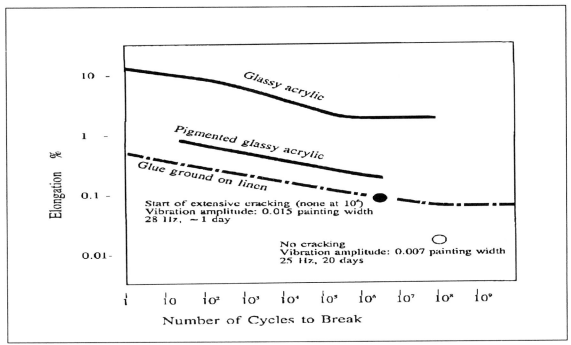

FIGURE 12
Number of cycles and elongations necessary to crack glassy materials by fatigue. (Acrylic data cited in Hertzburg and Manson 1980, gesso data by Michalski, CCI.)

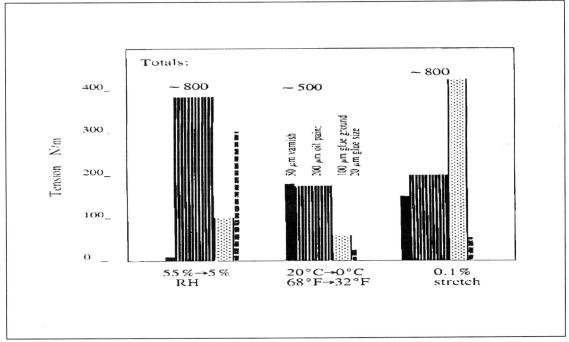

FIGURE 13
Histogram of tension increase in each layer of a "typical" oil painting after a drop in humidity, drop in temperature, or increase in stretch. This degree of stretch may occur by slight keying-out, moderate shock, or extreme vibration. It also occurs as a reduction in stretch when stretcher bars equilibrate to low humidity. Thus a painting exposed to daily low humidity increases tension as shown on the left, but if the low humidity is sustained for many days, this high tension is reduced by the approximate amounts shown on the right.

and one Italian panel, c. sixteenth century). No flaking or blistering was produced, despite bending of the same amount as the warping in the humidity tests. The researchers were surprised because the humidity tests had produced considerable damage, but the misconception lay in blaming curvature itself. It is the elongation of the paint that counts, and in this test as in any vibration of panels, it would have fallen well below threshold for fatigue. Vibration of panels, just as with canvas, remains a problem of indirect effects: abrasion, slapping, and dislocation of loose fragments.

Drop tests with experimental paintings modeled by Marcon and computer modeling by Mecklenburg (elsewhere in this publication) show some unprotected corner drops to be catastrophic to paintings on canvas. During impact, momentum forces the stretcher bars to scissor, which in turn stretches the painting violently. Thus, there are several unfortunate ironies in painting mechanics—the stretcher becomes a liability and not a support during impact, the canvas provides little support during humidity and temperature fluctuations, therefore the layers applied by the artist support the image both figuratively and literally.

Summary of Modeling

Some general equations emerge for tension in paint layers:

(a) *Painting tension=sum of tensions in each layer*

(b) *Each layer tension=sum of tensions from all previous events*

(c) *Tension from each event=(shrinkage or stretch) x (stiffness for that humidity, temperature, and time interval)*

Shrinkage occurs at curing, then later by physical aging and chemical aging (loss of mass). Fast shrinkage occurs with humidity drop and temperature drop.

Change in stretch of canvas paintings can be caused by keying-in/out, dilation of the stretcher bars with humidity change, slippage in the linen between cracks, shock, and

vibration. For panels, expansion of the wood stretches ground and paint.

In Figure 13, these equations have been applied to a theoretical model painting. It contains a natural resin varnish, a low impasto oil paint, a glue ground, and a size layer. The linen layer is ignored because usually it contributes nothing. The painting is assumed to have no tension in any layer at 55% RH and 20°C (68°F). Then three different events are modeled; drop in humidity to 5% RH over the course of one day, drop in temperature to 0°C (32°F) over the course of one hour, and stretching of 0.1% over a period of one second. The various parameters are taken from the data presented as typical values in this review. The oil paint is assumed to be one of the stiffer varieties (see Figure 2), and the resin varnish is assumed to have little response to low humidity. Figure 13 illustrates several key points:

(a) Humidity, temperature, and stretching (shock and vibration) can cause similar total tension, but the individual layers responsible vary markedly.

(b) At low humidity, the tension is mostly in the oil paint and the thin glue layer.

(c) The only layer to come anywhere near its elongation (or stress) at break as a new material is the glue ground at 0.1% stretch. Thus any stretch phenomenon is risky, e.g. shock, vibration, and keying-out.

Some crack patterns have been predicted by modeling (Figure 11). Tacking garlands were anticipated, but radial corner cracks are subtle. They occur due to the bias introduced by shrinkage of the stretcher bars. Their expansion and contraction with humidity can easily add or subtract the 0.1% stretch modeled in Figure 13, but they do so unevenly with patterning the result.

Figure 13 covers the common range of climate conditions, and the tensions are similar to those found by all researchers, but none exceed typical strengths of new materials. Some other phenomena must be a work:

(a) Fatigue cracking can occur at one-half to

one-fifth ultimate strength as long as the cycles occur quickly enough for the layer to act glassy. Daily temperature and humidity cycles would be eligible. This could explain crack reduction over stretcher bars, but experimental proof is lacking.

(b) Outdoor aging reduces oil paint strengths to one-fifth or less in about a year, as well as shrinking them markedly. The effect of being indoors for centuries is presently unknown.

(c) Curing strains can remain almost indefinitely in glue, ground, fast-drying oil paints, and varnish; modeling to date has not acknowledged this. Although much information has been ascertained, many questions remain.

CONCLUSION

What has the above revealed? It is not about the obvious—spearing by a forklift, six inches of water in a crate, or theft. The issues here are subtle, and the damage may easily be overlooked each time a painting is transported. Overall, four elements conspire to make paintings vulnerable to cracking: glassy behavior of the materials, pigmentation, fatigue, and the defects of age.

A temperature drop of 20°C shrinks paint layers, but it also significantly stiffens leathery polymers, i.e. oil, acrylic, and oil/resin paints. Combined with the speed of shock, these layers will act fully glassy and may also pass through a brittle/ductile transition; tension in the painting will increase.

Humidity fluctuation appears to be the historic cause of most extant cracks and delamination in paintings. At the very least, humidity fluctuations should be kept well below the range routinely experienced by the painting in the past, so that a few transit cycles become an insignificant part of many thousands.

Shock threatens paintings the most and is the agent most capable of damage in one event. It is also the agent most peculiar to transit. Avoiding the range of shock that reaches dangerous values is discussed in detail by others in this publication.

Experiments concerning vibration indicate that canvas paintings do not stretch enough to damage even the most fragile new gesso unless the canvas is subjected to unrealistically high levels. By this point, displacements are so large that indirect effects such as stretcher slap are the main problem, especially on large paintings.

The most mechanically vulnerable material in paintings is the ground because of overpigmentation. Glue grounds are glassy to all transit forces, oil and acrylic become glassy if subjected to cold and shock. As the layer with the lowest elongation at break, grounds are the first to crack. Because the layer is hidden, cracking from transit may not penetrate the paint layer until years later. For panels, elongation in the fragile ground layer depends solely on moisture, therefore panel paintings require moisture control much more than temperature control. Shock in panels is a risk to the wood rather than a direct risk to the paint. □

NOTES

1. Professor Church, "Chemistry of the Fine Arts-VI," *Cassell's Technical Educator* 3 (London, c.1872), 246-248.

2. Marion F. Mecklenburg, "Some Aspects of the Mechanical Behavior of Fabric Supported Paintings," (Washington, 1982) unpublished manuscript.

3. Debra Daly and Stefan Michalski, "Methodology and Status of the Lining Project, CCI," ICOM *Committee for Conservation 8th Triennial Meeting* Preprints, Sydney (1987), 145-152.

4. Christine Leback Sitwell, "Transporting Works of Art on Paper—Shock Test Results," *Conservation News* 32 (March 1987). Contains a bibliography of other British authors.

5. Timothy Green, Tate Gallery, personal communication of test results.

6. S.T.O. Stilwell and R.A.G. Knight, "An Investigation into the Effect of Humidity Variations on Old Panel Paintings on Wood," Appendix I (July 1931), in *Some Notes on Atmospheric Humidity in Relation to Works of Art* (London, c.1934). A limited edition distributed by the Courtauld Institute. A committee was formed in 1929 under the direction of the National Gallery, London. The Forest Products Research Laboratory (United Kingdom) carried out these tests. The paintings came from private donors approached by the gallery. The booklet also contains the first attempt to recommend a relative humidity for paintings (55%) made, ironically, by a public works engineer, J. Macintyre in "Some Problems Connected with Atmospheric Humidity," 7-16.

7. A. Zosel, "Mechanical Behaviour of Coating Films," *Progress in Organic Coatings* 8 (1980), 47-79. For a less technical and brief guide to the concepts of viscoelasticity applied to paint, see Loren W. Hill, *Mechanical Properties of Coatings* (Philadelphia, 1987). Given the recent date of the latter, it illustrates how unfamiliar the approach still is to industrial paint technologists.

8. Friedrich R. Schwarzl, "Viscoelasticity," in Vol. 17 of *Encyclopedia of Polymer Science and Engineering* 2nd ed., H. F. Mark and Jacqueline Kroschwitz, ed. (New York, 1989), 587-665. The best review of all the parameters that have been used to characterize viscoelasticity: creep, compliance, modulus, relaxation, retardation, etc. See pages 643-648 of the time-temperature shift superposition principle.

9. Souheng Wu, "Effects of Strain Rate and Comonomer on the Brittle-Ductile Transition of Polymers," *Journal of Applied Polymer Science* 20 (1976), 327-333. Wu has measured the activation energy of the brittle-ductile transition and finds that it falls between that of the α and β transitions.

10. Zosel 1980, 67-68.

11. Temple C. Patton, *Paint Flow and Pigment Dispersion* 2nd ed. (New York, 1979), 167. Patton calculates that the layer of linseed oil on carbon black is 2.5 nm thick, two layers of coiled linoleic triglyceride molecules. Zosel 1980, 65, found a range of 0.5-50 nm for the adsorbed layer.

12. Adolf C. Elm, "Some Mechanical Properties of Paint Films," *Official Digest* 25 (November, 1953), 751-774, and particularly 758-759.

13. Patton 1979, see spacing calculation, 136, and example of a fine carbon black, 138, with data on page 142; see also M. F. Dix and A. D. Rae, "The Structure of Prussian Blue and Analogues," *Journal of the Oil and Colour Chemists' Association* 61 (1978), 69-74.

14. Patton 1979, 186 shows enamels 15%-30% PVC, gloss paints 30%-40% PVC, semigloss 40%-50% PVC, flat paints 60%-70% PVC.

15. Patton 1979, 148, 161-169.

16. Stefan Michalski, "Crack Mechanisms in Gilding," in *Gilding Conservation* (Winterthur, 1991 [in press].

17. A. Toussaint and L. D'Hont,"Ultimate Strength of Paint Films," *Journal of the Oil and Colour Chemists Association* 64 (1981), 302-307. For further discussions on alkyd and acrylic paints see: Fred B. Stieg "Pigment Binder Geometry," *Pigment Handbook* 3, Temple C. Patton, ed. (New York, 1973), 205.

18. E. J. Dunn and C. H. Baier, *Official Digest* (1948), beginning on 743 for a study that measured recoverable elongation. See H. W. Talen, "The Influence of Pigments on the Mechanical Properties of Paint Films," *Journal of the Oil and Colour Chemists Association* 34 (October 1951), 455-472 for discussion on the curing period. See R. L. Eissler and L. H. Princen, "Effect of Some Pigments on Tensile and Swelling Properties of Linseed Oil Films," *Journal of Paint Technology* 40 (no. 518, March 1968), 105-111 for discussion on strength of zinc white linseed oil paints and titanium whites, after water exposure.

19. L.C.E. Struik, *Physical Aging in Amorphous Polymers and Other Materials* (Amsterdam, 1978).

20. The linear expansion coefficient $a' = 1-(1+a''')^{1/3}$ where a''' is the volume expansion coefficient, but for typical small values this simplifies to $a' = 1/3\ a'''$.

21. Harley A. Nelson and George W. Rundle, "Further Studies of the Physical Properties of Drying-oil, Paint and Varnish Films," *Proceedings, American Society for Testing*

Materials 23, Part 2 (1923a), 356-368, they discuss nine white linseed oil paints.

22. Mecklenburg 1982, also, Mecklenburg and Tumosa elsewhere in this publication, "Mechanical Behavior of Paintings Subjected to Changes in Temperature and Relative Humidity."

23. F. L. Browne, "Swelling of Paint Films in Water, III Absorption and Volumetric Swelling of Bound and Free Films From Air of Different Relative Humidities," *Forest Products Journal* 5 (February 1955), 92-96. Browne measured weight gain and expansion. The 65%-97% RH data clearly shows lead white swells least of all because it absorbs the least water.

24. Stefan Michalski, "A Physical Model of the Cleaning of Oil Paint," *Preprints of the IIC Dresden Conference* (1990), 85-92.

25. F. L. Browne, February 1955. At 80% and 90% RH, first time exposure of oil paints causes variable "springback" equivalent to as much as 50% of moisture expansion. I have plotted his data: the springback totals 1.0% paint volume, or 1.4% oil volume (30% PVC). Oil alone sprungback 2.3% volume, so pigments did constrain the effect.

26. F. L. Browne, "Swelling of Paint Films in Water, V Effects of Different Pigments," *Forest Products Journal* 5 (June 1955), 192-200. With water immersion total swelling was generally equal to the volume of water absorbed, but the expansion in thickness, length and width varied depending on several other factors, such as curing stresses in the paint and brushstroke direction. These effects would probably show in the 70%-100% RH response of paint, but not 0%-70% RH.

27. Mecklenburg 1982. Figure 4: 0.023% per percent RH, taking midpoint between hysteresis at 70% RH; Marion Mecklenburg, "Some Mechanical and Physical Properties of Gilding Gesso," paper presented at the *Gilding Conservation Conference Philadelphia* (1988a), personal communication concerning graphs, see *Gilding Conservation* (in press 1991.) Three full length cycles were monitored, my best fit to the curve in the range 5%-80% RH is 0.040% per percent RH; see also, Mecklenburg and Tumosa, "Mechanical Behavior of Paintings Subjected to Changes in Temperature and Relative Humidity" in this publication.

28. A. S. Marshall and S.E.B. Petrie, "Thermal Transitions in Gelatin and Aqueous Gelatin Solutions," *The Journal of Photographic Science* (1980), 128-134. Figure 4, cold dried gelatin, 1/3 slope of EMC curve is 0.045% per percent RH in the range 10%-70% RH. Hot-dried film only 0.030% per percent RH in the range 0%-60% RH; Marion Mecklenburg, "The Effects of Atmospheric Moisture on the Mechanical Properties of Collagen under Equilibrium Conditions," AIC *Preprints of the Sixteenth Annual Meeting* New Orleans (1988b), 231-244.

29. Michalski 1991.
Bond lengths are $[\{(1-PVC)/PVC+1\}^{1/3}-1]$ x particle diameter. Thus expansion coefficient gesso = expansion coefficient glue$/(1+1/[\{(1-PVC)/ PVC+1\}^{1/3}-1])$.

30. Mecklenburg 1988.

31. *Wood Handbook*, U. S. Department of Agriculture, rev. ed. (1987), see Table 3-4, page 3-11 for moisture content at different T, RH, Table 14-3, page 14-14 for coefficient of expansion of different species, in terms of moisture content.

32. J. E. Ramsbottom, "Aircraft Fabrics," *Physical and Physico-Chemical Problems Relating to Textile Fibres* (London, June 1924), 73-80. The papers in this monograph are all reprinted from *Transactions of the Faraday Society* 59, 20, Part 2 (1924).

33. F. T. Peirce, "Geometrical Principles Applicable to the Design of Functional Fabrics," *Textile Research Journal* 17 (March 1947), 123-147; G. E. Collins, "Fundamental Principles that Govern the Shrinkage of Cotton Goods by Washing," *Textile Institute Journal* 30 (1939), 46-61.

34. N. J. Abbott, F. Khoury and L. Barish, "10—The Mechanism of Fabric Shrinkage: The Role of Fibre Swelling," *Journal of the Textile Institute* 55 (1964), T111-T127.

35. Mecklenburg 1982.

36. Daly and Michalski 1987, Figure 8, see also Collins 1939, for discussion of longitudinal yarn and fiber shrinkage.

37. J.E.O. Mayne and D. J. Mills, "Structural Changes in Polymer Films. Part 1: The Influence of the Transition Temperature on the Electrolytic Resistance and Water Uptake," *Journal of the Oil and Colour Chemists' Association* 65 (April 1982), 138-142, see discussion page 142.

38. *Mark's Handbook for Mechanical Engineers* 6th ed., Theodore Baumeister, ed. (New York, 1978), see Table 12 "Coefficients of Linear Expansion (Thermal)," 4-7.

39. D. J. Mills and J.E.O. Mayne, "Structural Changes in Polymer Films. Part 2: The Effect of the Pigment Zinc Oxide on the Electrolytic Resistance and Transition Temperature; Some Comparisons with the Pigments Iron Oxide and Red Lead," *Journal of the Oil and Colour Chemists' Association* 66 (March 1983) 88-93, for discussion on expansion coefficients (dilatometer) of modified oil media that were unaffected by pigment.

40. Mecklenburg and Tumosa, elsewhere in this publication, "Mechanical Behavior of Paintings Subjected to Changes in Temperature and Relative Humidity."

41. N. A. Brunt, "Blistering of Paint Layers as an Effect of Swelling by Water," *Journal of the Oil and Colour Chemists Association* 47 (January,1964), 31-42. For an alkyd resin:

EMC/RH curve showed *no effect of temperature* between 20°C and 35°C.

42. *Wood Handbook* 1987, see Table 3-4, page s3-11 for moisture content at different T, RH and discussion on pages 4-26. The wood shrinks first because thermal response is fast, then as moisture equilibrates, the wood swells.

43. Given the formula in endnote 29, at 85% PVC, particle separation is 0.056, about one-twentieth of particle diameter.

44. Harley A. Nelson and George W. Rundle, "Stress Strain Measurements on Films of Drying Oils, Paints and Varnishes," *Proceedings, American Society for Testing Materials* 21 (1921), 1111-1134; Nelson and Rundle 1923a; Harley A. Nelson, "Physical Properties of Varnish Films Indicated by Stress-Strain Measurements," *Proceedings, American Society for Testing Materials* 23, Part I (1923b), 290-299.

45. Mecklenburg 1982; 1984, personal communication of stress-strain curves for Prussian blue; Nelson and Rundle 1923a, Figure 2; H. W. Talen, "Some Considerations on the Formation of Films," *Journal of the Oil and Colour Chemists Association* 45 (June 1962), 387-415, Figure 16. All modulus values were derived from the above studies by drawing a tangent on the published stress strain curves, passing through the origin.

46. Browne, June 1955.

47. Nelson and Rundle 1923a, Figure 1.

48. Kurt Gutfreund, "Study of the Deterioration of Paint Films by Measurements of their Mechanical Properties," *Circular 793*, National Paint Varnish and Lacquer Association (Washington, March 1965), 37, Figure 22.

49. N. A. Brunt, "The Linear Visco-Elastic Behaviour of Paint Films as a Function of Time and Temperature," *Journal of the Oil and colour Chemists' Association* 38 (October 1955), 624-654.

50. Gerry Hedley, Marianne Odlyha, Aviva Burnstock, June Tillinghast, and Camilla Husband, "A Study of the Mechanical and Surface Properties of Oil Paint Films Treated with Organic Solvents and Water," *Cleaning, Retouching and Coatings, Preprints of the Brussels' Congress* (IIC London, 1990), 98-105. The thermo-mechanical analysis was carried out by Odlyha (Birkbeck College, London).

51. Christopher W. McGlinchey, "Thermal Analysis of Fresh and Mature Oil Paint Films: the Effect of Pigments and Driers and the Solvent Leaching of Mature Paint Films," *Material Issues in Art and Archaeology II*, P. B. Vandiver, J. R. Druzik, and G. Wheeler, eds., Materials Research Society Proceedings (Pittsburgh, 1991), 93-103.

52. Zosel 1980, 62, Figure 14.

53. Hedley et al. 1990, 20-21, Figures 19, 20. The viscous flow nature of the unleached transition at 50°C was strongly supported by their loss tangent data.

54. Ethyl acrylate/methyl methacrylate copolymer has been identified in artists' acrylic medium sold by Grumbacher, Liquitex, Stevenson, and Winsor and Newton by R. Scott Williams, in "Commercial Prepared Painting Varnishes and Mediums," *ARS Report* No. 2672 (Canadian Conservation Institute, Ottawa, 29 September 1989; see also, G. G. Schurr, "Exterior House Paint," *Formulations Part 1*, Vol. 4 of *Treatise on Coatings*, Raymond R. Myers and J. S. Long, ed. (New York, 1975), 299); see Samantha Hodge, *Cracking and Crack Networks in Paintings.* Courtauld Student Project (London 1987), 54.

55. T_i for AC-33 is 16°C (61°F) where T_i is the nominal inflection point in the log E vs T curve, measured as the point where torsional modulus is 30 MPa. *Rhoplex Acrylic Emulsions and Acrysol Thickeners for the Adhesives Formulator*, Rohm and Haas (Philadelphia, August 1981); for the shape of the curve see Zosel 1980, 60, Figure 11; Wu 1976, 328, Figure 1; and Zosel 1980, 66, Figure 17, 53, Figure 6.

56. Zosel 1980, 68, Figure 18.

57. Wu 1976, 329.

58. Mecklenburg 1988b, Figure 9; Adam Karpowicz, "In-Plane Deformations of Films of Size on Paintings in the Glass Transition Region," *Studies in Conservation* 34 (1989) 67-74. "Frozen in" drying strains up to 5% were rapidly recovered by exposure to high RH. The terminology A, B, was coined in Michalski 1991 and has no molecular correlate however, I. V. Yannas, "Collagen and Gelatin in the Solid State," *Journal of Macromolecular Science—Reviews in Macromolecular Chemistry* C7, No. 1 (1972), 49-104 and pages 60-62 refer to gelatin and collagen as a block copolymer, and suggests multiple transitions in mechanical properties are to be expected.

59. Yannas 1972, Figure 15, curve 0.85.

60. Mecklenburg 1988b, Figures 8, 9.

61. My Figure 4 is slightly different from my earlier version based on an estimate of 5°C shift for each decade of time (Michalski 1991) due to better values of the time-temperature shift located in: Wataru Ueno and Ikuzo Ono, "Creep of Gelatin," *Journal of the Society of Materials Science Japan* 12 (1963), 341-346. See in particular Figure 4: between 28°C and 50°C the horizontal shift is about 6°-8°C per decade of time. Note also Figure 2, log E versus EMC, which shows the two phases A and B; E. Bradbury and C. Martin, "Mechanical Properties and Structure of Gelatin Films," *Proceedings of the Royal Society* A, 214 (1952), 183-192; J. Eliassaf and F. R. Eirich, "Creep Stud-

ies on Gelatin at 100% Relative Humidity," *Journal of Applied Polymer Science* 4, No. 11 (1960), 200-202.

62. Richard C. Weatherwax, Beverly Coleman, and Harold Tarkow, "A Fundamental Investigation of Adhesion. II. Method for Measuring Shrinkage Stress in Restrained Gelatin Films," *Journal of Polymer Science* 27 (1958), 59-66 outlines the equations for displacement and tension in a thin clamped plate.

63. A. T. Sanzharovskii and G. I. Epifanov, "Internal stresses in Coatings. III. Internal Stresses in Gelatine and Acetylcellulose Films Applied to Solid Substratums," *Vysokomol. Soedin.* 2 (1960), 1709-1714; S. A. Shreiner and P. I. Zubov, "The Effect of Internal Stresses on the Adhesive Properties of Gelatine Films," *Kolloid Zhur.* 22 (1960), 497-502; P. I. Zubov and L. A. Lepilkina, "Determination of Internal Stresses During Film Formation of Gelatine Films," *Kolloid Zhur.* 23 (1961), 418-422. Partial translations from the Russian are underway and will be available from CCI, Ottawa.

64. Yannas 1972, 59.

65. Robert A. Castello and Jere E. Goyan, "Rheology of Gelatin Films," *Journal of Pharmaceutical Studies* 53 (July 1964), 777-782.

66. Karpowicz 1989, Figure 3. Biaxial restraint (dried on aluminum, then delaminated).

67. Michalski 1991. Biaxial restraint (dried on glass, then delaminated).

68. Mecklenburg 1988a.

69. Michalski 1991.

70. Michael Schilling, "The Glass Transition of Materials Used in Conservation," *Studies in Conservation* 34 (1989), 110-116 has a discussion on preferred T values; W. Konig, *6th Congress* FATIPEC, (Wiesbaden ,1962) cites much lower values from old literature, cited in the review by Emil Krejcar and Otakar Kolar, "Ageing and Degradation of Paint Film Media," *Progress in Organic Coatings* 1 (1972-1973) 249-265; and D. N. Goswami, "The Relationship Between Glass Transition and Melting Temperatures of Natural Resins," *Journal of the Oil and Colour Chemists' Association* 63 (March 1980), 101-102 cites much higher values.

71. *Acryloid Thermoplastic Acrylic Ester Resins*, Rohm and Haas, (Philadelphia, May 1975), 12, Table 7; Schilling 1989, 114.

72. Leslie Carlysle, Ph.D Thesis, Courtauld Institute, (London, 1991)

73 . Nelson and Rundle 1923b, Figures 3, 4, 5. All varnishes are 27 gal. (US) oil to 100 lb. resin, give a ratio of about 2.2:1 by weight or volume.

74. Konig 1962 (endnote 70) Films of stand oil and "Albertol 11 L" resin mixtures were measured for index of refraction versus T. A sharp knee in the curves was identified as a glass transition. Oil -18°C (0°F); oil/resin 3:1, 8°C (46°F); oil/resin 1:1, 30°C (86°F); resin 80°C (176°F). A 2:1 ratio would therefore have a transition near room temperature.

75. Manfred Hess, *Paint Film Defects: Their Causes and Cure* 2nd ed. (Chatham, England, 1965) 442. This is the European definition for traditional resins (fossil resins, called "gum"). The American definition is slightly different, and both become relative for synthetic resins that need less oil to be "long."

76. Hess 1965, 318 and Figure 57.

77. Masaji T. Hatae, "Packaging Design" in *Shock and Vibration Handbook* 3rd ed., Cyril M. Harris, ed. (New York, 1988) 41-3, Table 41.1. Approximate sinusoidal rise time for drop of a wooden box is 0.004 x, carton 0.006 s. A wooden panel or stretcher bar hitting a hard surface will experience similar conditions. Duration of a half-sine pulse will be approximately three times as long, giving ~0.01-0.02 s.

78. Temperature and humidity response roughly follow an exponential decay function: $1-\exp(-kt)$. The half-time occurs at $kt= -\ln 0.5$, and 90% of response occurs at $kt= -\ln 0.1= -3.3\ln 0.5$. Humidity response may deviate considerably from this function at the last stages due to variable diffusion coefficient.

79. *ASHRAE Handbook: 1985 Fundamentals Volume* American Society of Heating, Refrigerating and Air-Conditioning Engineers, Atlanta 1985.) Jerald D. Parker, James H. Boggs, Edward F. Blick, *Introduction to Fluid Mechanics and Heat Transfer* (Reading, Mass. 1969.) *The following calculation assumes appropriate SI units throughout, as defined in* ASHRAE *Handbook 1985;* A 1°-10°C temperature difference between wall and air in a room 2 m high causes turbulent convection at the painting ($GBrPr=10^8 L^3 \Delta T$ exceeds 108) so heat transfer coefficient will be $h=1.31 \Delta T^3=2.8$ for a 10° difference (ASHRAE 1985, 3.13.) Thermal conductivity of paints is 0.26 (ASHRAE 1985, 39.3) so for L=1 mm thick with one exposed face $k/hL=93$ (ASHRAE 1985, 3.5.) Since this ratio is large, the temperature gradient is almost entirely across the air layer, and times will vary directly as the thickness of the paint (up to several millimeters). From Heisler charts (Parker et al 1969, 461; those in ASHRAE 1985, 3.5 are inadequate) the back of the paint will reach half the temperature difference when Fo=60. Thermal diffusivity α can be estimated as similar to acrylic resins and other polymers, 1.1×10^{-7} (Parker et al 1969, 587,) so $t=Fo\ L^2/\alpha =9$ minutes. For 2 cm of wood, k=0.12, $\alpha=1.3 \times 10^{-7}$ so $k/hL=2.1$. Half temperature response at the back means

Fo=2, so t=100 minutes, and the Heissler chart for temperature gradient (Parker et al. 1969, 460) shows only 20% of the temperature difference occurs across the wood. For 90% of response, calculation shows Fo numbers triple, so t triples, as expected. For temperature changes three times smaller or larger, t changes by only ~50%, because h varies as the cube root of temperature difference.

80. R. Keylwerth, "The Variation of the Temperature of Wood During the Drying of Veneers and Sawn Wood," *Holz Roh Werkst* 10, No. 3, (1952), 87-91. Once corrections are made for dimension and heating two sides, the seven minute half-time for midpoint of wood 1.2 cm thick agrees with the calculation methods of the previous endnote.

81. J. Crank, *The Mathematics of Diffusion*, 2nd ed. (Oxford, 1975); J. F. Siau, *Flow in Wood* (Syracuse, New York, 1971). The moisture transfer coefficient of air is negligible compared to wood and paint permeance. Half-times are therefore $0.2 L^2/D$, if one side exposed. See ASHRAE 1985, 5.10; see also Siau 1971, 4, 93; Crank 1975, 61, Figure 4.7 or page 239; ASHRAE 1985, 21.6; H. E. Ashton, "Predicting Durability of Clear Finishes for Wood from Basic Properties," *Journal of Coatings Technology* 52 (April 1980) 63-71; J. A. Berrie, "Water in Polymers," in *Diffusion in Polymers* (London, 1968) 259-313, Table 5.

82. Daly and Michalski 1987, and unpublished data. Canvas, sized canvas, glue grounds in typical artists' thicknesses show 90% response on the order of ten minutes. Full response of oil paintings undergoing relaxation treatments at 80% RH 20°C (68°F) takes hours to days, depending on thickness. Wood panels have been studied by many authors, see in particular, Stilwel and Knight 1931.

83. Stefan Michalski, "Leakage of Enclosures," in preparation. The hygrometric half-time of a leaky enclosure containing natural cellulosic buffer at room conditions is $t_{1/2}=250$ pf/N where pf is the volumetric packing factor and N is air exchange rate. The space between a canvas and a wall, or a partial backing board will leak at 50-500 changes per day, pf is 1 mm canvas/2 cm air, so half-times are 0.05-0.5 days. The stretcher bar is too slow to contribute at these leakage rates.

84. Leakage rates of fairly tight enclosures are 2-20 exchanges per day. Using the equation in note 83, and considering canvas first, half-times are 1.3-13 days. This is slow enough for stretcher bars to contribute, so half-times increase to 2-20 days. Tests at CCI of a painting with various backing boards confirm these estimates.

85. Crank 1975, 50, Figure 4.1 shows that at 0.1 and 0.4 of the half-time, moisture penetration is about 0.1 and 0.2 of the thickness. Based on information in note 81, 1 cm of wood will react 1 mm deep in 0.5 days at middle relative humidity, but at high relative humidity (overnight damp) this may increase to 2 mm. Refer to Stilwel and Knight

1931 (note 82) for further information on old panel curvature at 0.1 of half-time.

86. Michalski 1991.

87. Hodge 1987, 17.

88. David Bomford, Jill Dunkerton, Dillian Gordon, Ashok Roy, and Jo Kirby, *Art in the Making: Italian Painting Before 1400* National Gallery (London, 1989). The line drawings in Figure 7 were sketched from closeup photographs of Plate 137 (Christ) and Plate 107 (St. John the Evangelist). The x-radiograph showing the single wood piece is Plate 100, and placement of the two figures Christ and St. John the Evangelist is in Plate 126.

89. The wood under Christ's figure is in equilibrium with the adjacent gilded sky because the figure is relatively narrow compared to the thickness of the wood.

90. Gilding would reduce heating by radiation, and photochemical degradation, but in that case Christ's figure would show secondary cracks, but it does not.

91. Umberto Baldini, *Primavera, The Restoration of Botticelli's Masterpiece* (New York, 1986) 46-47, 49.

92. Baldini 1986, 49.

93. Baldini 1986, 74.

94. Baldini 1986, 4, 74, 75.

95. Schurr 1975, 285.

96. F. L. Browne "Swelling of Paint Films in Water X. Rate of Penetration of Water, Permeability to Water Vapor, and Penetrability to Air in Relation to Water Absorption," *Forest Products Journal* 8 (April 1957), 145-154. Basic lead white paint permeated up to 150μm in spots during thirteen hours. Burnstock's SEM photos showed pore formation peculiar to lead white exposed to water twenty-four hours, see Hedley et al. 1990.

97. L. L. Carrick and A. J. Permoda, "Shrinkage of Some Organic Film Forming Materials During Aging," *Official Digest* 28 (November 1951), 692-600. Linseed oil, trilinolein, trilinolenin with driers, on glass, were monitored for volume change (thickness) and all lost about 16% by volume, i.e. 5.3% each dimension if unrestrained, 3% for a 40% PVC paint. This would be a maximum value, since restrained curing will orient some molecules without residual stress. Browne 1955, found complex differences in area and thickness changes between free and bound oil paints.

98. The moisture resistance ratio of three coats lead white in oil to 1 cm wood is 500/180=2.8 (see note 81). Measured ratio in old panels was 5 (see Stilwel and Knight 1931).

Heat and mass transfer equations are analogous, so by the Heisler chart for temperature profile in Parker et al. 1969, 460, the surface of the wood near the canvas will change by only 10%-15% of the total humidity fluctuation during times less than the half-time of the wood.

99. Gustav A. Berger and William H. Russell "Deterioration of Surfaces Exposed to Environmental Changes," *Journal of the American Institute for Conservation* 29 (Spring 1990), 45-76. see Figure 14a for a good example of crack reduction in a nineteenth-century painting, it however states, "The area protected by the stretcher from fluctuations in temperature has not cracked." Their laboratory simulation Figure 14b, does indeed show crack reduction over the stretcher bars after temperature cycling. The priming (ground) is unspecified, but if it is either acrylic or the epoxy/gesso mix of their earlier studies (William H. Russell and Gustav A. Berger, "The Behaviour of Canvas as a Structural Support for Painting: Preliminary Report," *Science and Technology in the Service of Conservation*, Washington Congress [IIC, London, 1982] 139-145) then it would indeed show only thermal sensitivity not humidity sensitivity. Besides, the heavy lacquer applied to indicate strain cracking is itself a glassy layer designed to crack at extremely low elongations (0.03%-0.05%) and for which "rapid cooling will result in crazing of the brittle coating," cited from *General Instructions for the Selection and Use of Tens-Lac Brittle Lacquer and Undercoating*, Instruction Bulletin 215-C, Measurements Group, Inc, [Raleigh, North Carolina, 1982]). If the temperature fluctuations were less than a few hours duration, then the stretcher bars could have a direct effect.

100. *Mark's Handbook* 1978, 5-28 for formulas.

101. Hatae 1988, 41-43, Figure 41.1, Wooden box rise-time 0.004 s, height 10 cm (4 in.) yields 60 G, carton rise-time yields 40 G. At CCI, a medium-size experimental painting was tested with an accelerometer sitting on the top face of the painting at the outer edge of the stretcher bar. It was laid on the floor, and one edge lifted 10 cm (4 in.) and dropped. Peak acceleration at impact was 40 G. The linen corner tucks were softening the impact, otherwise agreement with prediction was good.

102. Peter Booth, "Stretcher Design: Problems and Solutions," *The Conservator* 13 (1989), 31-40.

103. Mecklenburg 1982.

104. Gerry Hedley, "Relative Humidity and the Stress/Strain Response of Canvas Paintings: Uniaxial Measurements of Naturally Aged Samples," *Studies in Conservation* 33 (1988), 133-148.

105. Dan Y. Perera and D. Vanden Eynde, "Moisture and Temperature Induced Stresses (Hygrothermal Stresses) in Organic Coatings," *Journal of Coatings Technology* 59 (May 1987) 55-63.

106. Howard S. Bender, "The Stress Relaxation Properties of Free Films as a Function of Time, Temperature and Film Thickness," *Journal of Paint Technology* 41 (February 1969) 98-103.

107. Daly and Michalski 1987.

108. Daly and Michalski, 1991, CCI unpublished data.

109. G. A. Berger and W. H. Russell, "Investigations into the Reactions of Plastic Materials to Environmental Changes. Part I. The Mechanics of the Decay of Paint Films," *Studies in Conservation* 31 (May 1986), 49-63.

110. Berger and Russell 1982, 139, note to Table 1: "Stiff hand priming with a mixture of glue-gesso and epoxy paint 1:1." In their Figure 4 a relative humidity change from 25% to 90% causes tension to drop from 140 N/m to 110 N/m (MD). Between 2.3 and 2.6 hours RH is kept high and tension climbs to 300 N/m as the damp linen takes over the tension. The linen takes 0.3 hours to extract all the moisture it needs from the air. This large stress change is not due to the small, coincidental temperature change, as Berger and Russell propose.

111. Masaki Shimbo, Mitsukazu Ochi, and Katsumasa Arai, "Internal Stress of Cured Epoxide Resin Coatings Having Different Network Chains," *Journal of Coatings Technology* 56 (No 713, June 1984), 45-51, and Figure 5; Berger and Russell 1982, 143, Figure 5 The 50 N/m spikes in hours 11-17 are implausible for a 1°C temperature fluctuation, and I believe they represent a 50°C temperature fluctuation due to the nearby electric heater cycling every fifteen minutes. The thermometer is too sluggish and too far from the heater to respond.

112. Berger and Russell 1990, 47-48, Figures 1 and 2.

113. James Colville, William Kilpatrick, and Marion Mecklenburg, "A Finite Element Analysis of Multi-layered Orthotropic Membranes with Application to Oil Paintings on Fabric," *Science and Technology in the Service of Conservation* Washington Congress of the IIC (London, 1982), 156-150.

114. Richard W. Hertzberg and John A. Manson, *Fatigue of Engineering Plastics* (New York, 1980), see acrylic (PMMA) data on page 60, Figure 2.19c, and acrylic bone cement data Figure 5.31, page 226.

115. Richard W. Hertzberg and John A. Manson, "Fatigue" in Vol. 7 of *Encyclopedia of Polymer Science and Engineering* 2nd ed., (New York, 1987), 378-453. See page 411. Most fatigue data is presented as FCP lines. These begin just after crack initiation and end near break, see Figure 14, page 391; Figure 25 page 403, Equation 23 page 414, also Figure 31, page 412. FCP curves typically begin around 10^{-6} mm/cycle at one-half to one-fifth of the critical stress intensity, hence it takes a million cycles at such levels just to pass through the early stages of crack

247

propagation.

116. Hertzberg and Manson, 1980, 227. The stress (or elongation) to break polycarbonate (both with and without glass fibers) in ten-thousand cycles at 10 Hz drops five-fold if a sharp notch is present.

117. Raymond J. Roark and Warren C. Young, *Formulas for Stress and Strain* 5th ed., (New York, 1975), 405-409. For a circular diaphragm radius a, without flexural stiffness, $\varepsilon = .965 \, (y/a)^2$ at the center, where y is the displacement at the center. In terms of a painting, a is half the painting width. Roark and Young also give the more complex equations for rectangular thin plates, but the simple equation above is close, and conservative since it overestimates ε.

118. *An Assessment of the Common Carrier Shipping Environment* FPL 22, Forest Products Laboratory, USDA (Madison, 1979) 13, Figure 5 shows that the peak vibration for a flatbed truck traveling on a variety of roads (construction, railway tracks) near 10-20 Hz was 1 G. This would not be sustained level, in fact, 90% of the time levels fell below 0.1 G. My 1 G test is tantamount to clamping the painting flat on the truck floor and driving on railway tracks for three weeks. This must not be confused with a loose painting bouncing around the same truck which would suffer severe damage from multiple shocks; see also, Paul Marcon, "Shock, Vibration, and Protective Package Design," elsewhere in this publication.

119. Stilwell and Knight 1931.

NONDESTRUCTIVE EVALUATION OF WORKS OF ART

A. Murray, R. E. Green, M. F. Mecklenburg, C. M. Fortunko

ABSTRACT: *The presence of cracks and flaws in the wood support of panel paintings present a potential hazard to the transportation of these objects. Unfortunately, many of these defects are not easily visible and assessing the transport risk of panel paintings is difficult. Several different nondestructive testing techniques are examined and evaluated in terms of their crack detection sensitivity as well as ease of use. One method, xeroradiography, shows promise in its ability to detect extremely small cracks using equipment compatible to that typically found in conservation laboratories.*

INTRODUCTION

The safe transportation of a panel painting is contingent on its internal integrity. Various nondestructive methods are being investigated and developed to detect voids, hidden cracks, and fine fractures in such paintings. These methods could be incorporated into the repertoire of techniques from which conservators draw to prevent the premature failure of objects as a result of such flaws. Computer analysis shows that cracks in wood promote severe stress concentrations that are aggravated by the mechanical constraints imposed by the construction of a panel painting.[1] The panel's structural condition must be mapped nondestructively in order to predict how it will respond mechanically over time or in different environments. Decisions can then be made on whether the object can be safely shipped to special exhibitions, and plans can be made for proper display, storage conditions, and conservation treatments. We have demonstrated the nondestructive evaluation capabilities of various techniques by examining standard panels of wood and actual panel paintings.[2] The standard "mock" panel paintings were made of white oak (*Quercus* sp.), tulip poplar, hard maple (*Acer* sp.), true mahogany (*Swietenia* sp.), black cherry, and western fir (*Abies* sp.). These panels con-tained voids of between 0.15 and 0.6 cm (0.059 and 0.2 in.) in diameter and cracks smaller than 0.02 cm (0.008 in.). The techniques for investigation included: x-ray radiography, xeroradiography, and ultrasonics. Results show that both x-ray radiography and xeroradiography, can easily find voids at least as small as 0.15 cm (0.0059 in.). Xeroradiography has the advantage, however, because its edge enhancement property enables flaws to be displayed prominently. At certain angles, cracks less than 0.02 cm (0.008 in.) were easily seen. The results of using these two techniques on a panel painting are discussed and compared below. Ultrasound techniques using an *all-air coupled system* and a *hybrid air-coupled/dry-coupled system* have shown encouraging preliminary results in finding voids and cracks.

The deterioration of panel paintings has been of interest for many years.[3] Panels become dimensionally less stable with changes in relative humidity, especially when they have been thinned and restrained during "conservation treatments." It is well known that by maintaining the relative humidity constant, the lifetime of these works of art will be prolonged. The studies being discussed at this conference are examining the risk caused by improper traveling conditions.

To determine whether panel paintings should be transported, it is important to ascertain their condition. The many techniques included in nondestructive testing enable the risk to be assessed. A panel painting may include many layers;[4] however, it is the condition of the wooden support layer that is the focus of this paper.

The structure of wood is well known.[5] The anomalies that exist naturally or that may evolve need to be studied to understand results from different nondestructive evaluation (NDE) techniques. Natural inhomogeneities in wood include seasonal growth rings, knots, and ray cells, which are sheets of cells that grow in a radial direction along the longitudinal radial axis of the tree. Voids are often created by insects, including the common furniture beetle, (*Anobium punctatum* in the anobiidae family), the death-watch beetle (*Xestobium rufovillosum*), the powder-post beetle (Lyctidae), termites, and ants.[6] The tunnels can be as small as 0.1 cm (0.04 in.) and can result in a completely riddled panel. The panel is then weakened, allowing cracks and breaks to occur more easily. Cracks also appear in panel paintings because of changes in the relative humidity that cause dimensional changes.[7] When restrained, wood compresses with water adsorption, crushing wood cells. Wood develops tensile stress and cracks with desorption. The structure of wood leads to severe anisotropic behavior as the dimensional changes are greater in the radial and tangential directions than in the longitudinal direction. Both the adsorption and desorption of water can, therefore, lead to warping and splitting of the wood. The expansion and contraction of the wood can also cause the ground and paint layers to crack, cleave and buckle if they are not flexible.

The wood industry has used a variety of nondestructive techniques (NDT) including: visual tests, ultrasonics, stress-wave measurements, vibration tests, x-ray radiography, computer aided tomography (CAT), collimated photon scattering, magnetic resonance imaging (MRI), acousto-ultrasonics (AU), acoustic emission (AE), microwaves, pulsed electric current, and even sniffer dogs. Many industrial x-ray studies have been concerned

with wood-boring insects. Ultrasonics has been compared with other methods to determine quality, strength, elastic constants, and degree of deterioration of wood. The theory, experiments, and viabilities have been discussed in many articles and proceedings.[8]

The museum conservation field has used many different nondestructive techniques on many materials. A few examples include: x-ray radiography,[9] which has been used extensively; xeroradiography,[10] on ceramics, porcelain, Egyptian faience, and underdrawings of paintings; ultrasound,[11] on murals, masonry, and wetted archaeological woods; infrared thermography,[12] to find deterioration in wooden panel paintings; x-ray computer tomography;[13] visible light; ultraviolet radiation; and other techniques. The first three techniques, x-ray radiation, xeroradiography, and ultrasound with various coupling techniques, have been used in this study. Previous work has shown infrared thermography to have only limited success in finding voids deeper than 0.6 cm (0.2 in.) from the surface of the wood. More progress has been made in discovering delaminations between the upper layers of panel paintings and in marquetry panels with infrared radiography.[14] Before this work, x-ray radiography and xeroradiography had not been compared while trying to map out the voids and cracks found in panel paintings; work with xeroradiography has been performed at the Canadian Conservation Institute and other institutions. Air-coupled and dry-coupled ultrasonic systems have not been used on wooden panel paintings or on other art objects.

The air-coupling technique provides an alternative to the conventional coupling methods. Coupling is needed between the transducers, the source of the ultrasonic wave, and the object to match the acoustic impedances, thereby allowing the ultrasonic wave to be transmitted through the material. Air is very difficult for the high-frequency wave (MHz) to traverse, but, water, oil, and grease are not.[15] Industry has been able to make use of ultrasound because of its more lenient requirements of acceptable coupling. Often the object may be submerged in a

water tank. Removable oils or greases are used, but may leave a residue. Special polymeric films have been used to couple, but a great amount of force needs to be used to maintain the couple. Rolling transducers, which use a polymeric film, do not provide a constant pressure. None of these coupling methods is safe enough to use on museum objects. The newer method of coupling, with special air-coupling transducers, has shown promise in overcoming these problems.[16] Of course, the technique of ultrasound is only in its preliminary stages, as the ultrasonic waves will be altered by the many inhomogeneities of wood discussed above. Thus, the results require careful interpretation. Work is now in progress to address this.[17] The potential dangers of insonifying objects also needs to be examined.

EXPERIMENTAL PROCEDURE

Samples

The samples used throughout the experiments were six panels of wood, each with dimensions 40 x 23.5 x 3.5 cm^3 (16 x 9.3 x 1.4 in.3). The six species of wood, with their densities[18] are:

white oak (*Quercus* sp.) (720 kg/m^3 or 0.0260 lb./in.3),

tulip poplar (460 kg/m^3 or 0.0166 lb./in.3),

hard maple (*Acer* sp.) (660 kg/m^3 or 0.0238 lb./in.3),

true mahogany (*Swietenia* sp.) (545 kg/m^3 or 0.0197 lb./in.3),

black cherry (530 kg/m^3 or 0.0191 lb./in.3),

and western fir (*Abies* sp.) (410 kg/m^3 or 0.0148 lb./in.3).

Results from the white oak and tulip poplar panels will be shown here as the other results have been reported previously. The panels were at approximately 12% moisture content.

To simulate voids and flaws in the panels, holes of different diameters (0.6, 0.4, 0.35, 0.2, and 0.15 cm [0.2, 0.16, 0.14, 0.08, and 0.059 in.]) were drilled into the sides of the panel at different depths from the surface, as shown in Figure 1. The holes closest to the surface were between 0.2 and 0.5 cm (0.08 and 0.2 in.) from the surface, the next closest were 1.0 cm (0.39 in.), and the furthest away were between 1.5 and 2.0 cm (0.59 and 0.79 in.) from the surface. On each side, a solitary 0.35 cm (0.14 in.) diameter hole was drilled 1 cm (0.4 in.) from the top surface. The cracks of different sizes and lengths in the sample

FIGURE 1
Angled view of half a wooden panel containing voids.

FIGURE 2
Panel painting: (a) photograph (b) x-ray radiograph (c) xeroradiograph. The image produced by xeroradiography is the mirror reflection of the original because of the processing method.

FIGURE 3
Panel of white oak: (a) x-ray radiograph (b) positive xeroradiograph (c) negative xeroradiograph (mirror image).

panels of white oak, hard maple, true mahogany, and western fir occurred naturally from swings in relative humidity.

An oak panel painting, probably made around the turn of this century, (Figure 2a) was x-ray radiographed and xeroradiographed (Figures 2b and 3c). The width and length of the panel were 20 x 30 cm^2 (7.9 x 12 in.2) respectively. The thickness was 0.7 cm (0.3 in.) at the edges, tapering to 1.2 cm (0.50 in.) in the center. This panel had a number of cracks along the grain, at the top and bottom edges of the panel (less than 0.1 cm or 0.04 in.) and some voids (around 0.1 cm or 0.04 in. in diameter). As this painting is part of a research collection at the National Gallery of Art in Washington strain gauges and metal wires had been attached to the back for another set of experiments. These gauges and wires are visible on the radiographs. The painting shows a winter scene of a house surrounded by trees with eight figures at the bottom. The pigment had been laid directly onto the wooden oak panel. A white pigment was used often, for example in the areas surrounding the figures, the house, and the trees. This allowed the picture to be seen on the radiographs.

Techniques

Each panel was x-ray radiographed with softer x-rays than in previous work, for results which were clearer and had more even contrast. The white oak panel is shown in Figure 3a. The top left-hand corner of the wooden panel had been removed for another set of experiments, before the x-ray radiographs and after the xeroradiographs were taken. A Dynarad 150 unit from Philips Electronic Instruments TORR was used. The settings used were 30 kV, 5 mA, and 20 minutes. The distance from the tube to the film was 209 cm (82.0 in.). The film (Kodak M industrial large) and a 0.1 cm (0.04 in.) sheet of lead, which lay under the film, were placed in a vacuumed envelope. Each wooden panel was xeroradiographed. A positive and a negative image of the white oak panel are shown (Figure 3b and c). A XEROX® 125 System was used. The plate could image only

half of each panel with some overlap, therefore two images needed to be taken for each panel. This caused the horizontal line seen in the xeroradiographic image. For the positive images, the settings were 42 kVp, 300 mA, for 0.4 seconds. For the negative images, the settings were 44 kVp, 300 mA, for 0.3 seconds. The panel painting was x-ray radiographed at the National Gallery of Art, Washington using the settings 25 kV, 50 mA, for 12 seconds. The xeroradiographs of the painting were taken using the same equipment as for the wooden panels and the settings 45 kVp, 10 mA, and 0.2 seconds. Both radiographs were taken from the front of the painting (Figure 2b and c).

The first ultrasonic setup used an all-air coupled configuration (Figure 4). The transducers could be positioned anywhere over the tulip poplar panel. A unipolar, burst pulser (3 W impedance, 450 V) generated the signal, which was then sent through an impedance-matching network (high-pass inverter). Both air transducers were 0.5 MHz, with 2.5 cm (1.0 in.) diameter face-plates and 5.1 cm (2.0 in.) focal lengths. They were both 2.0 cm (0.80 in.) away from the sample and were therefore defocused on the sample. They were also offset by 1.3 cm (0.50 in.) along the horizontal axis. One transducer sent the signal through the sample and the other received it after it traversed through the sample. The signal was then sent through a very low-noise bipolar amplifier, two precision attenuators (12 x 10 dB and 12 x 1 dB), a band-pass filter, and a linear detector. The transducer-transducer spacing was fixed by a "U-shaped" holder. The second setup was a hybrid air-coupled/dry-coupled through-transmission configuration on the white oak panel. The setup was identical to the previous one, however, the signal was transmitted through an air-coupled transducer (0.5 MHz, 2.5 cm or 1.0 in. diameter, 5.1 cm or 2.0 in.) focal length, and 2.3 cm or 0.90 in. from the surface) and was received by a dry-coupled transducer (ULTRAN WD 50-1, 113065, 0.5 MHz, and 0.953 cm or 0.375 in. diameter). Scissorlike tongs were used to hold the transducers. Both ultrasonic setups have been described in previous work.

EXPERIMENTAL RESULTS

The results showed that all voids were clearly seen with both radiographic techniques. The xeroradiographic technique displayed cracks at the bottom left-hand corner of the white oak panel, which were 0.06 cm (0.02 in.) at the widest point and 0.02 cm (0.008 in.) at the smallest point. Grain variations are better recorded with the xeroradiography. Results from the hard maple panel show that cracks smaller than 0.02 cm are clearer with xeroradiography than with the x-ray radiography. Other anatomical features of wood that are better shown with xeroradiography include grain variations (visible in Figure 3b and c), knots (of which both live and dead could be distinguished), mineralization pockets, and cutting defects; the last three have been shown in previous work.

The xeroradiographic images of the panel paintings showed cracks (less than 0.1 cm or 0.04 in.), voids (around 0.1 cm or 0.04 in. in diameter), vessel lines in the wooden support, and the white pigment (Figure 2). There appear to be two types of cracks, both less than 0.1 cm (0.04 in.); one at the top edge of the painting with an increase in density (a light line) and one at the bottom edge of the painting with a loss of material (a dark line). The cracks with an increase in density were probably in the wood prior to its painting and then filled up with the paint. The other cracks, which showed a decrease in density, were probably formed after the painting of the panel. The x-ray radiographs do not show the cracks as clearly. The voids, approximately 0.1 cm in diameter, were filled with pigment and, therefore, now show an increase in density. The strain gauges and wires appear on the left-hand side of the image, in the center above the roof in the painting, and on the lower right-hand side above the figures.

In the x-ray radiographic image, the pigment plays a greater part; more levels of gray are included than indicated in the xeroradiograph. This effect may be due to the differ-

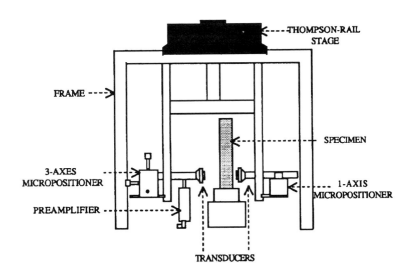

FIGURE 4
Experimental configuration of all-air-coupled ultrasound.

FIGURE 5
Results from all-air-coupled ultrasonic technique performed on tulip poplar.

FIGURE 6
Results from hybrid air-coupled/dry-coupled through-transmission ultrasonic technique performed on white oak.

ence in kilovoltages used; that of the xeroradiograph is almost two times as powerful, so that the xeroradiograph is not as influenced by the pigments. This makes the x-ray radiographs more difficult to interpret if the pigments hide what is of interest, which in this case, is the condition of the wooden support. For example, the extent of the crack at the center of the bottom edge of the panel painting is clearer on the xeroradiograph than on the x-ray radiograph, where the image is as dark as the crack and therefore hides the end of the crack. Note that not all the figures on the painting appear on either radiograph, most likely because of the different pigments used.

When using the all-air coupled ultrasonic system, various sections of the poplar panel were analyzed along a straight line, approximately one inch from the bottom edge, over the holes (Figure 5). Pieces of lead tape were placed onto the sample to give a reference for the analysis (not shown in x-ray radiograph). On the left-hand graph, the tape was placed at 1,400 mil and after 5,000 mil and for the right-hand graph, it was placed before 500 mil. Distinct decreases in signal occur over the solitary holes and over the pieces of lead tape. Over areas with many voids of different diameters and depths, the transmitted signal is smaller where there are larger diameter voids and less signal is allowed through, while the signal is larger where the voids are smaller and more signal is allowed through. Other results show that the signal is greater over areas where the beam is not skewed by the grain of the wood. Gradual decreases correspond to changes in grain.

The all-air coupled ultrasonic system worked for the lower density of tulip poplar, but not for the higher density woods such as white oak. This may be improved by using different transducers. Only the higher density woods had cracks and therefore to evaluate these types of voids, a different system, the hybrid air-coupled/dry-coupled system, had to be used. The results (Figure 6) show definite signal decreases around 1,600-2,200 mil and around 3,200-3,600 mil, corresponding to cracks, which were as small as 0.1 cm (0.04 in.). There is also a strong correlation

between signal size and the direction of the grain. There is a larger signal over areas where the grain is perpendicular to the edge of the sample. The opposite is also true. Any analysis using ultrasound to discover flaws will have to consider grain orientation, which causes beam skewing, and any other artifacts within the wood. Resolution may be adversely affected and other information about the sample may get hidden because of speckle caused by the inhomogeneities in the wood.

CONCLUSION

The x-ray radiography and xeroradiography detect the voids with the smallest diameter (0.15 cm or 0.059 in.), at all depths from the surface of the panels; the edge enhancement in the xeroradiograph technique does, however, make voids more visible. The xeroradiographic results also show the smallest cracks in the panels (less than 0.02 cm or 0.008 in.), which were not always clear in the x-ray radiograph. The other flaws, including knots (both live and dead), grain, and cutting defects, were more easily discernible with xeroradiography. This technique was able to show flaws in actual panel paintings and differentiate between the flaws that had occurred before and after painting the wooden panel. Either a positive or a negative xeroradiographic image may be more useful according to what the individual researcher is used to and why the artifacts are being viewed. It is, therefore, valuable to take both images. X-ray radiography remains a more easily accessible technique, but clearly is not as useful as xeroradiography.

The two ultrasonic systems have given promising preliminary results in showing cracks at various angles that cannot be detected with x-ray radiography and xeroradiography. Another situation that could benefit from using ultrasound occurs when the pigment does not allow the x-ray beam to penetrate the paint layer at all, so that the flaws within the wooden support layer cannot be found. The conventional coupling problem, that of matching acoustic impedances without causing harm to the object being exam-

ined, has been overcome using these systems. The all-air-coupled system is useful on lower density wood such as tulip poplar and distinguished voids as small as 0.15 cm (0.059 in.) in diameter. The hybrid air-coupled/dry coupled technique was able to map out the cracks of higher density woods, such as white oak. The system was able to show cracks of 0.1 cm (0.04 in.). ☐

ACKNOWLEDGMENTS

The authors would like to thank Donald C. Williams, senior furniture conservator, and Melvin Wachoviak, furniture conservator, Conservation Analytical Laboratory, the Smithsonian Institution, for providing the samples and for their instructive discussions; Mervin Richard, head of exhibitions and loans, conservation division, National Gallery, Washington for allowing us to have xeroradiographs, x-ray radiographs, and photographs of the panel paintings in the research collection; Pam Vandiver, senior ceramic scientist at the Conservation Analytical Laboratory, the Smithsonian Institution, for her comments on the xeroradiography technique and results; Eric Jensen, a summer cooperative student at the National Institute of Standards and Technology, Boulder, Colorado for his help with the ultrasound data collection; Wilma Savage, of Clinical Radiologists, Silver Hill, Maryland, for her work and interest in taking the xeroradiographs of the samples; Melanie Feather for her help with the x-ray radiography; and Ian Wainwright, David Grattan, and others at the Canadian Conservation Institute for our discussions on their work with xeroradiography and other techniques.

This research has been partially supported by the Conservation Analytical Laboratory, the Smithsonian Institution.

NOTES

1. Marion F. Mecklenburg, private communication, current research work ongoing at the Conservation Analytical Laboratory, the Smithsonian Institution.

2. In this paper, the term "previous work" refers to these two papers: Alison Murray, "The Nondestructive Evaluation of Wooden Art Objects," (M. S. in engineering thesis, The Johns Hopkins University, 1990); and Alison Murray, Robert E. Green, Marion F. Mecklenburg, and C. M. Fortunko, "NDE Applied to the Conservation of Wooden Panel Paintings," *Fourth International Symposium on Nondestructive Characterization of Materials in Annapolis, Maryland, June 11-14, 1990* (New York, 1991 [in press]).

3. Wendy H. Samet, "An Evaluation of Wood Panel Painting Conservation at the Walters Art Gallery: 1934 to 1980," *AIC Preprints of Papers Presented at the Sixteenth Annual Meeting,* New Orleans, 1988 (Washington, 1988), 161-175; and Richard D. Buck, *The Behavior of Wood and the Treatment of Panel Paintings* (Minneapolis, 1978).

4. Roger Van Schoute and Helene Verougstraete-Marcq, "Painting Technique: Supports and Frames," *Journal of the European Study Group on Physical, Chemical and Mathematical Techniques Applied to Archaeology (PACT)* 13 (1986), 19; Franz Mairinger and Manfred Schreiner, "Analysis of Supports, Grounds and Pigments," *PACT* 13 (1986), 172-173; and Cennino d'Andrea Cennini, *Il Libro del l'Arte,* trans. D. V. Thompson, in *The Craftsman's Handbook* (New York, 1960).

5. A. J. Panshin and Carl de Zeeuw, *Textbook of Wood Technology* 1, 3rd ed. (New York, 1970).

6. Roger M. Rowell and R. James Barbour, eds., *Archaeological Wood Properties, Chemistry, and Preservation,* Advances in Chemistry Series 225, (Washington, 1990), 86; and Panshin and de Zeeuw 1970, 362-382.

7. Buck 1978; Panshin and de Zeeuw 1970; Lorna F. Gibson and Michael F. Ashby, *Cellular Solids Structure and Properties* (New York, 1988), 278-315; and Donald C. Williams and Marc A. Williams, "Treatments for 'Dry' Wooden Objects," (paper delivered at the Symposium on Archaeological Wood: Properties, Chemistry, and Preservation, 196th ACS National Meeting, 25-30 September 1988).

8. Murray 1990; Roy F. Pellerin and Kent A. McDonald, eds., *Proceedings: Sixth Nondestructive Testing of Wood Symposium in Pullman Washington, September 14-16, 1987* (Washington State University, 1987).

9. Arturo Gilardoni, Ricardo Ascani Orsini, and Silvia Taccani, *X-Rays in Art, Physics, Technique and Applications* (Como, Italy, 1977).

10. William A. Ellingson, Pamela D. Vandiver, Thomas K. Robinson, and John J. Lobick, "Radiographic Imaging Technologies for Archaeological Ceramics," *Materials Research Society Symposium Proceedings* 123 (1988), 25-321; Patrizia Magliano and Bruno Boesmi, "Xeroradiography for Paintings on Canvas and Wood," *Studies in Conservation* 33 (1988), 41-47.

11. John F. Asmus and Steven T. Pomeroy, "Ultrasonic Mapping of Detachments in Mural Paintings by Vasari," *AIC Preprints of the Papers Presented at the Sixth Annual Meeting at Fort Worth, Texas, 1978* (Washington, 1978), 12-20; Mario Berra, Luigia Binda, Giulia Baronio, and Antonio Fatticcioni, "Ultrasonic Pulse Transmission: A Proposal to Evaluate the Efficiency of Masonry Strengthening by Grouting," *2nd International Conference on "Nondestructive Testing, Microanalytical Methods and Environment Evalu-*

ation for Study and Conservation of Works of Art, in Perugia, Italy, April 17-20, 1988 (Italy, 1988), I/10.1-19; S. Miura, "Ultrasonic Characteristic of Waterlogged-Wood," *Science for Conservation* 5, (1976), 14-18.

12. Bruce Frederick Miller, "The Feasibility of Using Thermography to Detect Subsurface Void in Painted Wooden Panels," (M. A. thesis, Oberlin College, 1976); and J.R.J. van Asperen de Boer, "Infrared Reflectography: A Method for the Examination of Paintings," *Applied Optics* 7, no. 9 (September, 1968), 1711-1714.

13. Eiichi Taguchi, Ichiro Nagasawa, Satoshi Yabuuchi, and Mamiko Taguchi, "Investigation of a Wooden Sculpture Using X-ray Computed Tomography," *Scientific Papers on Japanese Antiques and Art Crafts* 29 (1984), 43-50.

14. Murray 1990; Miller 1976.

15. J. Szilard, ed. *Ultrasonic Testing—Non-Conventional Testing Techniques* (New York, 1982).

16. C. M. Fortunko, M. C. Renken, and A. Murray, "Examination of Objects Made of Wood Using Air-Coupled Ultrasound," *1990 Institute of Electrical and Electronics Engineers (IEEE) Ultrasonics Symposium in Honolulu, Hawaii, December 5-7, 1990* (New York, 1991 [in press]).

17. C. M. Fortunko and Alison Murray, current research work ongoing at the National Institute of Standards and Technology, Boulder, Colorado, and at the Materials Science and Engineering Department, The Johns Hopkins University.

18. Anton Ten Wolde, J. Dobbin McNatt, and Lorraine Krahn, *Thermal Properties of Wood and Wood Panel Products for Use in Buildings* Forest Products Laboratory (Madison, Wisconsin, 1988), 17-18; and "Thermal Conductivity of Materials" in CRC *Handbook of Chemistry and Physics* 63rd ed.

TRAINING PROGRAM FOR THE TRANSPORTATION INDUSTRY

Protection of Works of Art in Transit

Sarah M.V. Rennie

ABSTRACT: *To prevent the occurrence of problems in transporting works of art, a training program has been developed to improve working relationships between art institutions and the transporters. This program has significantly improved communication and interaction resulting in improved safety measures for the artwork.*

INTRODUCTION

Registrars are famous for collecting information. Most of us have anecdotes about minor and major unscheduled variations to the transportation of works of art. Often they are good stories, but more importantly they are reminders of the need for communication and a good working relationship with the transport industry.

The training program that has been developed at the Australian National Gallery is the result of a minor incident that occurred while loading a courier accompanied consignment onto an aircraft at Canberra airport. The consignment was destined for Sydney and then on to Germany. While the courier was boarding the aircraft, I was overseeing the noncontainerized loading of the case into the cargo locker with an Australia Cargo supervisor. Airline staff had been notified of this art movement and they had organized straps for the aircraft loading. The porter asked how he was to use the strap to secure the case. Discussion ensued and the task of securing the case was completed. The events that took place revealed that despite advance planning, a breakdown in communication can have serious ramifications for the safety of works of art. This situation demonstrated the lack of knowledge concerning the fragility of

works of art and how they can be damaged by inadvertent mishandling. The moment of tension at the airport prompted the establishment of a training program.

While a registrar clearly understands the need to oversee the loading of a consignment, it is unreasonable to expect an airline handler to understand that role. The airline porter at Canberra Airport had every right to feel pressured and under scrutiny. He felt that an outsider was invading his territory and therefore questioning his expertise. These hostile feelings can be avoided through the development of mutual respect. The purpose of the training program is to demonstrate the integral role of the transportation industry and to provide a background and introduction to the museum's role in the protection of works of art in transit. In conjunction with conservation and registration staff, I developed the course, which has been running for over fifteen months. Initially the program was directed to the porters, aircraft load controllers, supervisors, and cargo sales staff of Australian Airlines in Canberra. The training has been extended to road transportation companies with whom we work on a regular basis. The program has proved to be successful and popular. We have observed

that the service provided by the industry has improved dramatically and the working relationship strengthened. An enthusiastic and positive response to the course has resulted in several Australian state galleries introducing the training program.

Gallery Background

The Australian National Gallery is located in Canberra, the federal capital of Australia. The collection of over eighty-thousand works of art is supported by a staff of 220 people. This collection has grown rapidly since its establishment under an Act of Parliament in 1975. The Gallery has an active exhibition and loan program within Australia and abroad. The transport and location section of the registration department manages the packing and transportation of some nine-thousand works of art per year.

The registration department comprises four sections: transport and location, central catalogue, lending program, and photographic services. This department is staffed by eighteen people while the conservation department numbers fifteen.

Transportation Industry Background

Unlike most state capitals, Canberra is located inland and is geographically isolated from international airports. Only two airlines, Australian Airlines and Ansett Airlines, operate jet aircraft out of Canberra. For the movement of works of art we use Australian Airlines almost exclusively, as the Gallery has negotiated a freight contract with that company. This contract provides significantly reduced freight and passenger rates within Australia with one cargo manager controlling national movements of art consignments. This is a relatively new contractual arrangement, but we believe it works to our advantage.

Historically, the Gallery has had a good working relationship with the airline industry. It has become common practice for Qantas Cargo to allow large consignments of art, such as the 1990 loan exhibition from the British Museum, to remain palletized. The

pallets are loaded directly onto trucks, transported the two-hundred-mile journey to Canberra, and then depalletized on the Gallery's loading dock. Our road transport needs are serviced by fine art carriers, the Australian Government truck fleet, and general freight carriers.

The logistics of moving works of art is never easy, and Australia suffers from the syndrome known as the *tyranny of distance.*[1] For example, the transport of Aboriginal bark paintings from settlements in the Northern Territory may involve the use of four-wheel-drive vehicles from the settlement to the nearest city and than a five-day truck journey or five-hour airline flight to Canberra. Despite these difficulties, the relatively small scale of this industry makes a training program viable.

TRAINING PROGRAM

Program Structure

Although Australia has a small, but growing museum packing and transportation industry, this is not the program's target audience. The targeted personnel are drawn from air and road general freight carriers who have a longstanding working relationship with museums.

The course, given at the Gallery, is organized every eight weeks for a duration of two hours. Transportation management has been cooperative and has encouraged staff participation. The number of staff attending has been restricted to less than ten to encourage interaction between both parties. Photographs, slides, and samples of documents and packing cases illustrate the points addressed.

The primary objective of the program is to outline what registration and conservation staff do and why we often make seemingly incomprehensible and overbearing demands on the transport industry. In doing so, we hope to nurture and develop an appreciation of the role of the museum and the transportation industry in the protection of works of art during transit.

The course examines:

The Registration and Conservation Departments

To establish an understanding of why museums strive to preserve works of art, we first review the role of the museum and outline the scale of the Australian National Gallery's loan program. A description of the role of registration in information management, risk management, and logistics is detailed.[2] Emphasis is placed on the registrar's requirement to ensure the legal protection of the collections through documentation, diligent recordkeeping, safe storage, handling, packing, and transportation of works of art.

In the safekeeping of collections, a conservator's role complements that of a registrar. Explanations are given of the conservator's knowledge of the composition of works of art and the processes that contribute to their deterioration. This develops the trainee's concept of the type of work undertaken to preserve cultural property.

A visit to the respective work places of these two departments is a visual reinforcement of these roles.

Loan Procedures and Processes

A description of the Gallery's loan policy and procedures provides the background of the processes to expedite a loan. The preliminary assessment of a loan request by curatorial and conservation staff is used to illustrate why a loan may or may not be approved. Reasons are given when a work is unstable and therefore unable to withstand the stress of travel.

Conservation staff describe the range of materials and techniques that are used in construction of paintings, works on paper, textiles, and sculptures, decorative, and ethnographic art. This general overview prefaces the more detailed description of the factors that affect the natural rate of deterioration of works of art. The analogy is made that just as people show signs of wear and tear so, too, do works of art. Research and knowledge of the impact of changes in tem-

perature, relative humidity, light, air pressure, and dust are cited.[3] An analogy used is that a stretched canvas acts like the sail of a windsurfer when exposed to the gravitational forces of air travel.

This information is complemented by a study of the documentation that encompasses the movements of works of art. The content and purpose of condition reports, loan agreements, receipts, and insurance documents are discussed in general terms. Values of works of art are never discussed.

Risk Assessment

After establishing a picture of the inhouse procedures that are designed to safeguard works of art, a general explanation is given of the risk assessment process that precedes the crate construction and reservation of freight space. The checklist of considerations include: the condition and nature of the work, the value, the proposed method of packing, the handling requirements, the distance of travel and climatic conditions expected, the proposed mode of transport and associated costs. This information enables the staff of the transport industry to appreciate the decisionmaking process and why their cooperation is integral to the safekeeping of the work. The myriad of detail attended to by museum staff can be in vain if the forklift driver is careless and damages a work by piercing a crate with the forklift tines. In knowing the risks, it is then essential to develop a strategy to minimize the risks.[4] This training program is part of that strategy.

Case Design

The design and construction of a packing case is the area of most interest to the transport industry. We look at the function of a case and the properties and relative merits of the materials used in case construction.

Examples of painting, bark painting, object, and work on paper cases are used to illustrate the different packing techniques. Comparisons with early case construction principles and materials illustrate such changes in case design. For example, we ex-

FIGURE 1
Aboriginal bark painting packing case for *L'Ete Australien à Montpellier* loan exhibition, 1990.

plain that *sizalation* paper would be used instead of reinforced tar paper and how devices such as an *OZclip* or *Doover*[5] secure a work to a traveling tray. The various advantages and disadvantages of using wood, polyethylene and polyurethane foam, and archival papers such as tissue and mylar for packing are also defined.

Transport staff acquire an understanding of why our cases are painted yellow. Although they recognize it as one of Australia's national colors they also learn that the highly reflective color reduces heat absorption and the paint cover protects the contents from water damage. Our crate labeling and sym-bols cannot be ignored or considered to be a cryptic code, but is information designed specifically to communicate to the handler instructions for its care. The positioning of recessed handles, skids, closing devices, and the use of customs seal devices not only requires forethought but complements and reflects our knowledge of the transport industry equipment. Because the external case design also depends on the equipment specifications of air and road transport vehicles, the trainees come to realize how critical their information is to us in our design process. A new perception of the Gallery's yellow cases is achieved. They are no longer just odd-looking cases but containers to protect fragile works of art.

Mode of Transport

The final area evaluated is the mode of transport and the logistics of dispatch. Although we acknowledge that consignments can be moved by air, road, sea, or rail, it is the merits of the air and road freight that are reviewed. References are also made to the studies into packing methods and environmental monitoring of cases during transit.[6] To illustrate the complexities of equipment, people, and documents integral to any shipment, we use a hypothetical case study of the dispatch of an international loan involving road and air transportation. This study stresses the importance of individual components encompassing the role of the courier, airline porter, and shipping agents and reveals the purpose of the pallet and shipping papers.

The cooperation and assistance of transportation staff is essential for managing the movement of works of art. This course reinforces their integral role. Requests from museum staff for information on the suspension system of a truck, or the aircraft type and number of transhipment points are more clearly understood. In the preparation of pallet or truck load plans, transport staff can see how their expertise facilitates the safe movement of an art consignment. In turn, they can advise and recommend changes to museum personnel.

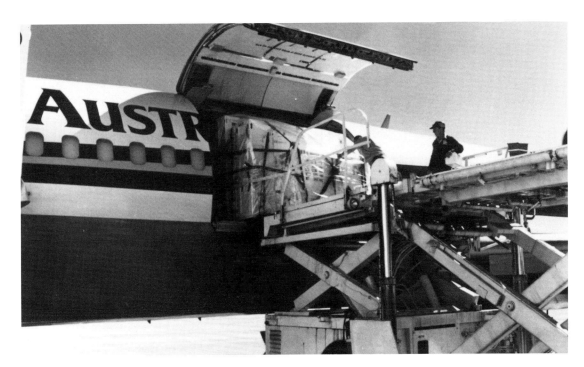

FIGURE 2
Australian National Gallery standard painting case.

FIGURE 3
Loading of art consignment at Melbourne Airport. Photo courtesy of Australian Cargo, Melbourne.

FIGURE 4
Unloading pallet of British Museum cases at Australian National Gallery, 1990.

Cooperation is required for couriers or museum staff to oversee the loading of cases, administer check-off lists, obtain pallet numbers, or confirm the direction of travel. This is not because museum staff question the expertise of transport personnel, rather it is part of their job to ensure the safety of the consignment.

CONCLUSION

We believe a mutual respect and understanding has evolved between the museum and transport world. This appreciation has resulted in a change of attitude. Transport staff are genuinely interested and concerned about doing the job well. A comment such as, *now I understand why you oversight the loading of truck,* is just one example of the positive feedback received.

The safety of our collections goes beyond the museum building and the work of museum staff. We rely on the skills and services of a range of professionals. To ensure the safety of works of art we must communicate and encourage an empathy between the museum and transportation industry. □

NOTES

1. Geoffrey Blainey, *The Tyranny of Distance: How Distance Shaped Australia's History* (Melbourne, 1966).

2. Registrars Committee—American Association of Museums, "Code of Ethics for Registrars," *Registrar* No. 2 (Winter 1984), 7-13.

3. David Saunders and Richard Clarke, "Monitoring the Environment within Packing Cases Containing Works of Art in Transit," ICOM *Committee for Conservation, 9th Triennial Meeting* Preprints, Vol. 1, Dresden (1990), 415-422; Timothy Green and Stephen Hackney, "The Evaluation of a Packing Case for Paintings," ICOM *Committee for Conservation, 7th Triennial Meeting* Preprints, Copenhagen (1984), 84/12/1-6; Ross M. Merrill, "In the Service of Exhibitions: The History, Problems and Potential Solutions of Cultural Materials in Transit," *Preprints of the American Institute for Conservation, 16th Annual Meeting* New Orleans (1988), 143-145; Sarah Staniforth, "Packing: A Case Study," *National Gallery Technical Bulletin* 8 (1984), 53-62; Sarah Staniforth, "The Testing of Packing Cases for the Transport of Paintings," ICOM *Committee for Conservation, 7th Triennial Meeting* Preprints, Copenhagen (1984), 84/12/17-16; Nathan Stolow, "Care of Works of Art in Transit and on Exhibition: Review and Assessment," ICOM *Committee for Conservation, 6th Triennial Meeting* Preprints, Ottawa (1981), 81/12/1-14; Nathan Stolow, *Conservation and Exhibitions* (London, 1987), 4-23, 174-194.

4. Peter Cannon-Brookes, "The Evolution and Implementation of a Transportation Strategy for Works of Art," *The International Journal of Museum Management and Curatorship* (1986) 5, 163-169.

5. Ozclip (Patent No. 4967993) from Corrigans International, P. O. Box 363, Mascot, NSW 2020, Australia; Doovers, from TED Australia, P. O. Box 140, Botany, NSW 2019, Australia.

6. Ross Merrill 1990, 143-145; Saunders and Clarke 1990, 415-422; Staniforth 1984, 53-62; Staniforth 1984, 84/12/7-14.

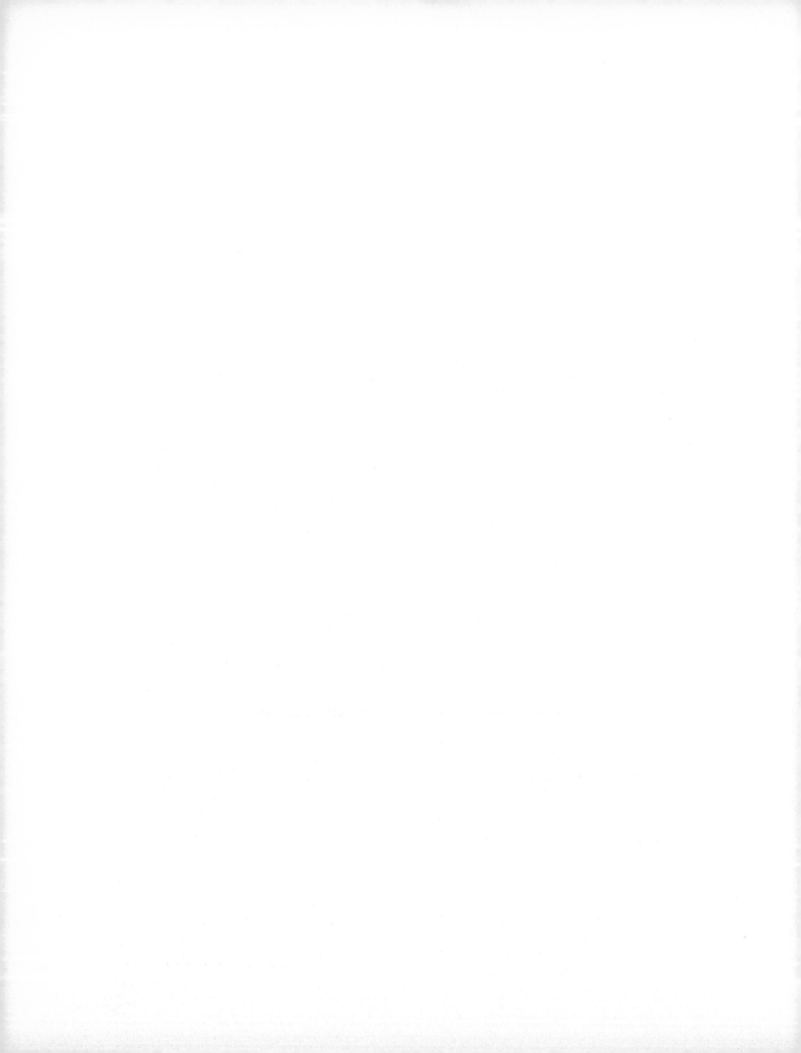

FOAM CUSHIONING MATERIALS: TECHNIQUES FOR THEIR PROPER USE

Mervin Richard

ABSTRACT: *Packing case design is a critical factor when preparing fragile objects for transport. Protection against shock can be maximized using dynamic cushioning curves. Foam cushions can be prepared for packing cases that provide optimal protection. A method for calculating correct foam usage is discussed.*

INTRODUCTION

Foam products are frequently used to cushion art objects inside packing cases. When correctly used, these materials can be highly effective for protecting objects from shock and vibration during transit. Foam packing materials provide shock protection by allowing the packed object to sink into the foam on impact thereby reducing the maximum rate of change of velocity (or the peak acceleration) experienced by the packed item. Protection against vibration is provided by the internal damping of the foam material that dissipates vibrational energy in varying degrees before it reaches the packed object.

Resilient foams, such as those made of polyethylene and polyurethane can provide protection against repeated impact because after they are compressed, they recover most, if not all of their original thickness. Other materials, for example, polystyrene, do not—or only partially—recover their original thickness. As a result, if nonresilient materials are used and multiple impacts are encountered, the object can become loose and shift inside the packing case. If this occurs, there may not be adequate protection available for subsequent impacts.

When an unpacked object is dropped, it will accelerate under the influence of gravity and its velocity will increase until it strikes the floor or some other surface. The amount of time it takes for its velocity to be reduced to zero (i.e. the rate of change of velocity) determines the peak acceleration experienced by the packed item. For example, a small, lightweight item is less likely to sustain damage if it lands on a feather pillow than if it strikes a concrete floor. The reason for this being that the pillow will compress on impact and, in doing so, will slowly reduce the velocity of the falling object to zero. When a velocity change occurs over a longer period of time, the peak acceleration, and the resulting impact force, is reduced. Objects striking a hard surface, on the other hand, stop suddenly, resulting in a high impact force.

FRAGILITY FACTORS

All art objects are vulnerable to damage if they are subjected to sufficient force. The degree of vulnerability is called a *fragility factor* or *G factor*. It is normally expressed in G's, which is a ratio between the acceleration due to the earth's gravity and the acceleration that results, for example, from impact. Ideally, an object's fragility factor should be known in order to design an appropriate packing case. Some fragility factors can be estimated using mathematical formulas and data on material properties but most mass-produced objects are tested to destruction in order to obtain more accurate results. The

cost of destroying a few objects is usually less than the cost of excessive packing.

For obvious reasons, destructive fragility tests cannot be performed on art objects and it is usually impossible to calculate their fragility. The structure of most objects is too complex and their fragility influenced by deterioration over time. As a result, packers must rely on practical experience. This author has used an estimated fragility factor of 40 G's when designing packing cases for paintings that seem fragile. Until accurate assessments of artifact fragility are available, some guidance can be derived from the knowledge of approximate fragility factors of other articles. (See Table 1.) It is worth noting that seemingly fragile articles, e.g., stereo equipment and televisions, can sustain fairly high G impacts.

SHOCK SEVERITY

An important aspect of the proper use of cushioning materials is to anticipate the severity of shocks that a package might encounter. One method of predicting this is based on package weight. Lightweight packages that can be thrown are more likely to be dropped from greater heights than those that require two people to carry them. Probable drop heights for a range of package weights and different handling operations are listed in Table 2.

DYNAMIC CUSHIONING CURVES

Dynamic cushioning curves provide a guide to the selection and use of cushioning materials. The general features of dynamic cushioning curves are illustrated in Figure 1. By referring to these curves, a package designer can easily determine the degree of shock that will be transmitted to an object when properly packed and dropped from a specific height.

The data for a dynamic cushioning curve is obtained by dropping a weighed platen from specific heights onto a sample of cushioning material. An accelerometer is used to measure the peak acceleration of the platen when it strikes the cushion. Both the thickness of the cushioning material and the drop height affect the peak acceleration on impact.

A standard test method for evaluating the shock absorbing characteristics of cushioning materials is ASTM D1596.[1]

In a dynamic cushioning curve peak acceleration in G's is plotted as a function of the static load (or static stress) on a cushion in kilograms per square centimeter (pounds per square inch[psi]). For a given material, drop height, and cushion thickness there is a static load that will provide optimum performance, i.e., the lowest possible acceleration. Graphically, this optimum static load is represented by the bottom-most point on the curve. (See point C, Figure 2.) At much lower than optimum static loads, the packed object will not cause sufficient compression of the cushion on impact resulting in higher levels of acceleration. It might be described as the foam being too hard for the weight of the object. (See point A, Figure 2.) At much higher than the optimum static load, the cushion may compress too easily and may bottom out, bringing the object to an abrupt halt as it strikes the inside of the case. (See point B, Figure 2.) Understandably, this also results in a much higher peak acceleration on impact.

Dynamic cushioning curves are surprisingly easy to use and their practical application is best explained using an example, a framed painting measuring 95 (height) x 75 (width) x 10 cm (depth), (37.40 x 11.61 x 3.94 in.) and weighing approximately 10 kg (22 lb.). A *double-case packing technique* will be used where the painting is first secured in an inner case that is then placed on foam cushions inside an outer case. The dimensions of the inner case are 100 x 80 x 15 cm (39.37 x 31.50 x 5.91 in.) and the total weight of the inner case with the painting inside it is 15 kg (33 lb.).

In this example the case will be designed to protect a painting with a fragility factor of about 40 G's, a reasonable estimate for more delicate paintings.

Step 1

Estimate the fragility of the object to be packed.In this example, 40 G's has been selected.

Step 2

Select the cushioning material for the packing case. In this example, it will be assumed that the only material available to the packer is polyester urethane foam having a density of 33 kg/m^3 (2 lb./ft.3).

Step 3

Weigh or estimate the weight of the items being packed and the packing case. In this example, the painting plus its inner case weighs 15 kg (33 lb.) and the total weight, including the outer case, is 70 kg (154 lb.).

Step 4

Determine the probable drop height that should be used in designing the packing case. Using the data in Table 2, the probable drop height for a case weighing 70 kg is 75 cm (30 in.).

Step 5

Refer to the dynamic cushioning curve for the selected cushioning material and drop height.

Step 6

Locate the point on the *peak acceleration* axis of the dynamic cushioning curve that corresponds to the estimated fragility arrived at in step 1, in this example, 40 G's. Draw a horizontal line through the curve at 40 G's. (See Line AB, Figure 3.) This horizontal line will often intersect the curves in two places.

Step 7

Draw a vertical line at the two points where the horizontal line described in step 6 intersects the cushioning curve. (See Line CD and EF, Figure 3.) All static loading values falling between the two vertical lines will provide

the required protection for the specified drop height. The optimum protection obtainable with the material corresponds to the static loading found at the very bottom of the curve. (See point G, Figure 3.)

At this point in the calculations, the packer can choose between two procedures for designing the foam cushions. In the first approach, *Procedure A*, the packer decides to design foam cushions that provide the best possible protection using the polyester urethane foam. The optimum performance of the foam cushions requires a static loading of .025 kg/cm^2 (.35 lb./in.2). (See point G, Figure 3.) The procedure continues as follows:

Alternate Procedure A

Step 8a

Determine the optimum static loading for the cushioning material by locating the bottom of the dynamic cushioning curve. In this example it is .025 kg/cm^2 (.35 lb./in.2).

Step 9a

Calculate the surface area of the cushioning material that should support the weight of the inner case. This represents the *load-bearing area (LBA)* of the cushion which is the weight of the Inner Case (step 3) divided by the Optimum Static Loading (step 8a) or for our example:

$$LBA = \frac{15kg}{.025kg/_{cm^2}} \quad \text{or}$$

$$LBA = \frac{33lb.}{.35psi}$$

$$= 600 \ cm^2 \ (93 \ in.^2)$$

Step 10a

Design cushions that provide a load-bearing area of 600 cm^2 (93 in.2) for each side. A single cushion of the 10 cm (4 in.) thick foam measuring 15 x 40 cm (5.91 x 15.75 in.) or two cushions measuring 15 x 20 cm (5.91 x 7.87

in.) may be used. Either is acceptable as long as the total surface area of foam contacting each side of the inner case equals 600 cm^2.

In the procedure outlined above, foam cushions were designed that provide the optimum shock protection possible with polyester urethane foam. The result is a packing case that should transmit only 22 G's to the painting inside when it is dropped from 75 cm (30 in.). The packing case exceeds the performance required to protect a painting having a fragility of 40 G's.

Alternate Procedure B

In the second approach, providing optimum protection for the packed painting is not the primary objective. Instead, the packer strives to simplify the packing case design while ensuring that the shock protection remains below 40 G's. Cutting the foam cushions designed in Procedure A and adhering them in the packing case would be a time-consuming process. Simply filling the space between the inner and outer case with foam would be easier, but the packer must determine that the foam's static loading provides the required 40 G protection. The weight and outer surface area of each side of the inner case are used to calculate the static load in each direction.

Step 8b

Select one side of the inner case and calculate its surface area. The bottom side of the sample inner case measures 100 x 15 cm (39.37 x 5.91 in.). Therefore, a surface area of 1,500 cm^2 (232 in.2) is in contact with the foam. The *static load (SL)* on the foam in the bottom of the case is equal to weight of the Inner Case divided by the Load-Bearing Area or:

$$SL = \frac{15kg}{1,500cm^2} = .01 kg/cm^2 \quad \text{or}$$

$$SL = \frac{33lb.}{232in.^2} = .14 psi$$

Since .01 kg/cm^2 (.14 psi) falls within the acceptable static loading range, the foam provides 40 G protection on the bottom of the packing case. As the dimensions on the top of the case are identical, the required protection would also be provided if the case were turned upside down.

Step 9b

Select another side and calculate the surface area. Both large faces of the inner case in this example measure 100 x 80 cm (39.32 x 31.50 x 5.91 in.). Therefore, the surface area is 8,000 cm^2 (1,240 in.2). The static load on the foam contacting the large faces of the inner case:

$$SL = \frac{15kg}{8,000cm^2} = .0018 kg/cm^2 \quad \text{or}$$

$$SL = \frac{33lb.}{1,240in.^2} = .026 psi$$

A static load of .0018 kg/cm^2 (.026 psi) falls outside the acceptable static load range indicating that a full sheet of foam contacting the large faces of the inner case would not provide the required 40 G protection. If the packing case was dropped on either of its large faces from a height of 75 cm (30 in.), a peak acceleration exceeding 70 G's would be transmitted to the inner case and the painting. (See point H, Figure 3.) To correct this problem, smaller foam blocks must be used on the large faces of the case.

Step 10b

Repeat *Procedure 9b* for the final two sides of the inner box, both measuring 80 x 15 cm (31.50 x 5.91 in.):

$$SL = \frac{15kg}{1,200cm^2} = .0125 kg/cm^2 \quad \text{or}$$

$$SL = \frac{33lb.}{185in.^2} = .18 psi$$

This static load falls within the acceptable static load range.

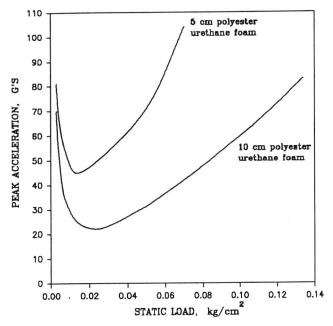

FIGURE 1
Dyanamic cushioning curves for 5 cm (2 in.) and 10 cm (4 in.) polyester urethane foam when dropped from a height of 75 cm (30 in.) . This foam density is 33 kg/m^3 (2 lb./ft.3).

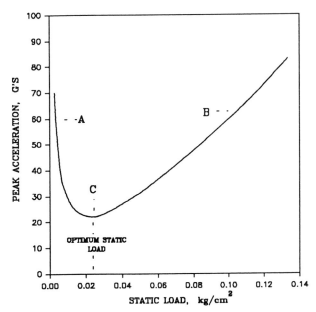

FIGURE 2
Dynamic cushioning curve for 10 cm (4 in.) polyester urethane foam when dropped from a height of 75 cm (30 in.). The foam density is 33 kg/m^3 (2 lb. /ft.3).

273

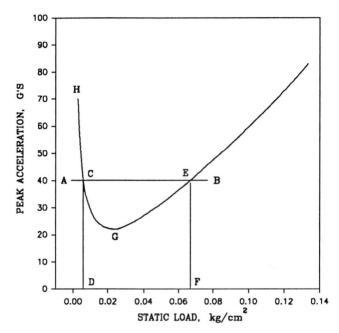

FIGURE 3
Dynamic cushioning curve for 10 cm (4 in.) polyester urethane foam when dropped from a height of 75 cm (30 in.). The foam density is 33 kg/m^3 (2 lb./ft.3).

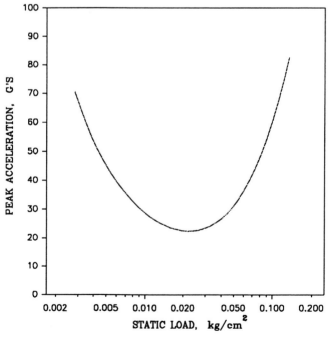

FIGURE 4
Semi-logarithmic version of the dynamic cushioning curve for 10 cm (4 in.) polyester urethane foam when dropped from a height of 75 cm (30 in.) The foam density is 33 kg/m^3 (2 lb./ft.3).

TABLE 1
Approximate fragility factors of typical packaged articles.

Extremely Fragile	15 - 24 G's	Missle guidance system, precision electronic test equipment
Very Delicate	25 - 39 G's	Scientific instruments, x-ray equipment
Delicate	40 - 59 G's	Computer display terminals, elecrtric typewriters, most solid state electronic equipment
Moderately Delicate	60 - 84 G's	Stereo equipment, televisions, computer floppy disk drives
Moderately Rugged	85 - 110 G's	Major appliances, furniture
Rugged	Over 110 G's	Table saws, sewing machines, machinery

TABLE 2
Probable drop heights based on package weight and handling methods.

Package Weight kg (lb.)		Type of Handling	Drop Height cm (in.)
0-9	(0-20)	1 Person Throwing	105 (42)
10-22	(21-50)	1 Person Carrying	90 (36)
23-110	(51-250)	2 Persons Carrying	75 (30)
111-225	(251-500)	Light Equipment Handling	60 (24)
226-450	(501-1000)	Medium Equipment Handling	45 (18)
Over 450	(1000)	Heavy Equipment Handling	30 (12)

LINEAR VS. LOGARITHMIC CURVES

Two types of graphic scales are commonly used for dynamic cushioning curves. A completely linear scale is usually found in the literature provided by manufacturers. Linear graphs are more easily understood by people lacking a strong technical background. At low static loadings (the left side of the graph), it can be very difficult to read because the curve rises so steeply. This problem was encountered in *Step 9b*. (See point H, Figure 3.) In technical literature, a logarithmic scale is often used for the static load axis. This approach makes it easier to read the data, even at very low static loadings, but it can be confusing for those unfamiliar with logarithmic scales. (See Figure 4.)

CUSHIONING PAINTINGS AND FRAMES WITH IRREGULAR SHAPES

The above example illustrates a situation where the cushioning material is in contact with the flat surface of the inner case or traveling frame. Therefore, the weight of the painting and inner case is evenly distributed on the foam cushions. When a painting frame with an irregular shape rests on the foam cushioning material, the calculation of the static load is not straightforward. The difficulty is that the weight of the painting and frame is supported by the frame sections that protrude the furthest and as the protrusions sink into the foam, the load-bearing surface area increases. To obtain the proper static load on the foam cushions, an estimate of the frame's surface area actually contacting the cushion must be used in the calculations. The alternative is to always use a double-case when packing paintings with ornate frames.

BUCKLING

When designing the size and shape of foam cushions for packing cases, it is important that cube-shaped or tall, slender, cushions be avoided. When the load-bearing area of the cushion becomes too small relative to its thickness, the cushion will *buckle* instead of compressing uniformly, reducing its effectiveness. The buckling properties of cushioning materials vary but as a general rule, the minimum load-bearing area must equal or exceed the square of 1.33 times the material thickness. Expressed mathematically:

$$\text{Minimum Load-Bearing Area} = (1.33 \; x \; \text{cushion thickness})^2$$

For example, a cushion that is 10 cm (2 in.) thick must have a minimum load bearing area of 176.9 cm (27.4 in.) in order to avoid buckling.

$$
\begin{aligned}
\text{Minimum Load-Bearing} & \\
\text{Area} &= (1.33 \; x \; \text{cushion thickness})^2 \\
also &= (1.33 \; x \; 1 \, 0 \; \text{cm})^2 \\
also &= 176.89 \; \text{cm}^2
\end{aligned}
$$

This equation shows that a cube-shaped cushion would not work because its load-bearing area would be 100 cm (10 x 10 cm), considerably less than the minimum required.

COMPRESSION CREEP

Compressive creep, sometimes called *drift*, is the gradual decrease in the thickness of a material over time. It is usually the result of an excessive load but can also result from excessive temperature. If a foam has an excessive load at normal temperatures, a 40% reduction in foam thickness may occur in as little time as thirty days. A correctly loaded foam material can usually be expected to lose about 10% of its original thickness due to creep. For this reason, package designers will often include an additional 10% thickness of cushioning material to accommodate this deformation.

Some manufacturers provide data on the compression creep properties of their cushioning materials. When creep data is not available, its effects can be reduced by ensuring that the foam is not loaded beyond the maximum static load that appears on the cushioning curves. Creep effects can also be reduced by choosing static loads near or below the optimum load range indicated on the cushioning curves.

CONCLUSION

Modern cushioning materials are capable of providing high levels of protection against shock when they are properly used. Dynamic cushioning curves provide a guide to the correct application of these materials and can be very useful when designing packing cases for fragile objects that require optimum protection. □

ACKNOWLEDGMENT

The author would like to acknowledge and thank Paul Marcon who provided assistance throughout the process of writing, fine tuning, and editing this paper and the editors of this publication, Marion Mecklenburg and Janice Gruver.

The author gratefully acknowledges the generous support of The Circle of the National Gallery of Art.

NOTES

1. *ASTM Method D 1596-88*, "Shock Absorbing Characteristics of Packaging Cushioning Materials, American Society for Testing Materials, 1916 Race Street, Philadelphia, PA 19103, (1988).

2. A good source for cushioning curves is the *Military Standardization Handbook: Package Cushioning Design*, MIL-HBK-304B, U. S. Department of Defense, Washington (1978).

CONTROL OF TEMPERATURE AND RELATIVE HUMIDITY IN PACKING CASES

Mervin Richard

ABSTRACT: *This paper reviews theories relevant to designing packing cases that provide stable interior environments, i.e. temperature and relative humidity. In addition, findings of ongoing research conducted at the National Gallery of Art, Washington, are provided that indicate that painting materials respond dimensionally to temperature independent of relative humidity.*

INTRODUCTION

Works of art are frequently constructed with hygroscopic materials, e.g. wood, paper, cotton, linen, glue, and ivory. As a result, they respond dimensionally to changes in temperature and relative humidity, hence a stable environment is important to the long-range preservation of the objects. In the past few decades, many museums and collectors have installed or upgraded equipment required to provide the appropriate environment for works of art. Ideally, similar conditions should be maintained when the works are transported. Various studies have shown that appropriate environments in packing cases can be maintained if basic guidelines are followed in the packing procedures.[1]

EQUILIBRIUM MOISTURE CONTENT

Hygroscopic materials adsorb moisture when the relative humidity in the surrounding air increases and desorb moisture when it decreases. Increasing the temperature of the material drives off moisture, while moisture is adsorbed when the temperature decreases. The quantity of water within a material at a particular temperature, relative humidity, and atmospheric pressure, expressed as a percentage of its ovendry weight, is called the *equilibrium moisture content* (EMC).

The relationship between temperature,

relative humidity, and the equilibrium moisture content of wood is shown in Figure 1. The graphic representation of this relationship is called an *isotherm* because the curve is limited to a specific temperature.[2] The shape of the curves vary from one material to the next, with variations even found in different species of wood, but the general sigmoidal shape of the curves holds for most hygroscopic materials.

The equilibrium moisture content of most hygroscopic materials is also influenced by a phenomenon called *hysteresis*. It has been found that when a hygroscopic material, like wood, is moved to a new environment, the equilibrium moisture content will be lower when starting from a dry environment than starting from one that is damp. (See Figure 2). The lower line represents the equilibrium moisture content of the wood as it adsorbs moisture. The upper line depicts a material during the desorption process.

Equilibrium moisture content versus relative humidity curves for various materials at room temperature are provided in Figure 3. For the sake of simplicity, the hysteresis phenomenon has been disregarded. From 30% to 70% RH, the equilibrium moisture contents of the materials in Figure 3 are approximately linear with respect to relative humidity. Using the absolute value of the slope of the

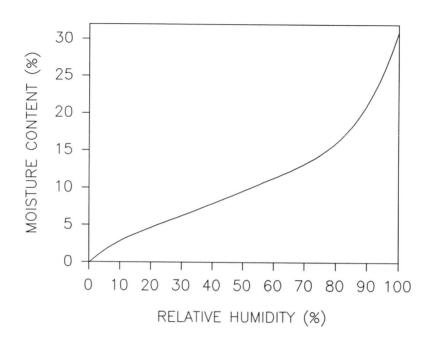

FIGURE 1
Relationship between relative humidity and the equilibrium moisture content of wood at room temperature.

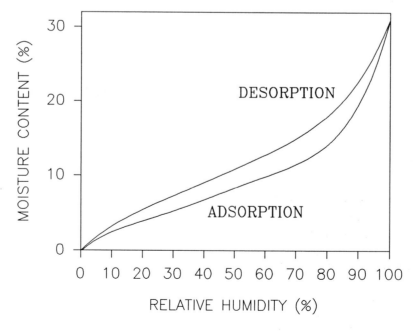

FIGURE 2
Effect of hysteresis on the relationship between the equilibrium moisture content of wood and relative humidity.

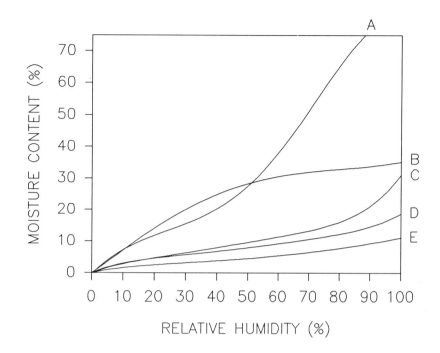

FIGURE 3
Relationship between relative humidity and the equilibrium moisture content of various materials. (A: Art-Sorb®; B: regular silica gel; C: wood; D: kraft paper; E: linen.)

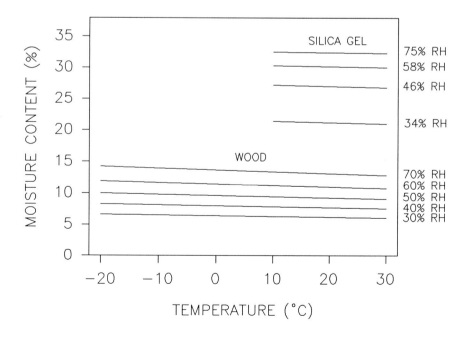

FIGURE 4
Relationship between temperature and the equilibrium moisture content of wood and silica gel. (Curves for silica gel taken from Stolow 1987.)

equilibrium moisture content versus relative humidity curves, α, it is possible to estimate the equilibrium moisture content changes that accompany relative humidity fluctuations.

Swelling and Shrinking of Hygroscopic Materials Due to Moisture

Hygroscopic materials typically swell and shrink when water and other polar liquids are exchanged with the environment. Nonpolar, nonwetting liquids have a lesser affect. The adsorbed liquid spreads the cellulose chains apart, increasing the volume of the cellulose perpendicular to the chains' length but having very little affect on the dimension parallel to the chain orientation. As a result, most hygroscopic materials exhibit anisotropic swelling and shrinking.

Wood is an excellent example of a material that exhibits anisotropic behavior. The swelling and shrinkage of wood in the longitudinal direction can usually be disregarded because it is so small. In the 6% to 14% EMC range, the coefficient for the dimensional changes in the tangential direction of wood varies from 0.002-0.0045 per percent EMC change (0.2-0.45% elongation per percent EMC variation). If the dimensional change is expressed as a function of relative humidity instead of equilibrium moisture content, the coefficient is 0.00034-0.00077 per percent RH change. The responses in the radial direction of wood are slightly less, ranging from 0.001-0.003 per percent EMC (0.00017-0.00051 per percent RH change). In going from 60% to 50% RH at room temperature, wood's equilibrium moisture content decreases approximately 1.8%. An oak board has a coefficient for dimensional change in the tangential direction of 0.0032 per percent EMC change. If a 50 cm (19.69 in.) wide, flat sawn board is moved from 60% to 50% RH, the board will shrink 0.29 cm (0.11 in.). If the wood is free to move and the changes occur slowly, it is extremely unlikely that any damage will occur. If the wood is restrained or its equilibrium moisture content changes too rapidly, cracks could develop, although it is unlikely that the stresses resulting from a 10% fluctuation in relative humidity would be sufficient to cause crack formation.

While the dimensional responses of wood are anisotropic, this is not the case with paint, ground, and glue size in paintings. These materials swell and shrink equally in all directions when moisture is gained or lost.[3] Wood's swelling in the radial and tangential directions as a result of a relative humidity change is also greater than found in rabbit skin glue, gesso, or paint. In some paintings, cracks in the various layers can develop parallel to the grain because of the stress imposed on the various layers by constant movement of the wood. In the longitudinal direction, however, there is very little expansion or contraction of wood due to relative humidity changes. Since the glue size, gesso, and paint respond in all directions, this means that the dimensional movement of these materials is restrained by the longitudinal wood when the relative humidity changes. The stress resulting from this restraint during desiccation can cause the formation of cracks perpendicular to the wood grain.

Equilibrium Moisture Content and Temperature

The equilibrium moisture content of hygroscopic materials is affected by temperature, an effect apparent in Figure 4. At a constant relative humidity, an increase in temperature will cause a decrease in the moisture content of the material. Simply stated, heating hygroscopic materials will dry them out. Conversely, the moisture content of most hygroscopic materials will increase as the temperature decreases.

Figure 4 graphs the equilibrium moisture content of wood and silica gel as a function of temperature. The curves, known as *isobars*, were extended for wood to -20°C (-4°F) based on the assumption that the relationship remains approximately linear.[4] The slopes of these curves have been defined as β.

Examination of the curves in Figure 4 reveals that wood at 20°C (68°F) and 50% RH has an equilibrium moisture content of 9.2% while the equilibrium moisture content is

approximately 10% at -20°C (-4°F) and 50% RH.[5] This implies that if the temperature is lowered while the relative humidity remains fixed at 50% RH, the wood will adsorb moisture.

While the equilibrium moisture content of wood maintained at constant relative humidity increases as the temperature decreases, this relationship is less evident in silica gel. The equilibrium moisture content of silica gel is essentially constant throughout a wide temperature range. This is one of the reasons why certain types of silica gel, especially Art-Sorb® and Arten Gel, are good humidity buffers.[6] A second reason is that silica gel has a very high moisture content over a broad relative humidity range.

The relative humidity in a sealed environment containing silica gel varies little with temperature. Therefore, if silica gel is enclosed with a hygroscopic material, e.g. wood, and the temperature drops, the relative humidity maintained by the silica gel will be higher than the relative humidity maintained by the wood alone. The wood will shrink because of the dropping temperature but the moisture transferred from the silica gel to the wood will partially counteract the thermal shrinkage.

Relative Humidity and Equilibrium Moisture Content Variations in Packing Cases

When works of art are transported in well-designed and constructed packing cases, little moisture is exchanged between the case interior and the surrounding environment if the transport time is only a few days. The rate of air exchange is affected by the permeability of the packing case materials, the tightness of the seams, the quality of the gaskets, exterior temperature fluctuations, and atmospheric pressure changes, particularly during air transports.

The moisture exchange between the packed objects and the air within the case is complex. As indicated, hygroscopic materials have characteristic equilibrium moisture content relationships with the air when the temperature and relative humidity change. In

most instances, however, the relative humidity variation after a temperature change inside a case containing considerable wood, no silica gel, and a small volume of free air will follow the basic formula:[7]

$$R2 = R1 + 0.35[T2 - T1]$$

This formula is based on Stolow's values for α and β and it implies that if a sealed container at 50% RH underwent a 20°C (36°F) temperature drop, the relative humidity would drop to 43%. The formula varies considerably when values taken from standard United States tables of α and β, are used.

If silica gel is added to the case, the relationship is:

$$R2 = R1 + 0.063\,\frac{WW[T2-T1]}{0.18\ WW + 0.6\ WS}$$

where

$R2$ = the final relative humidity
$R1$ = the initial relative humidity
$T2$ = the final temperature in °C
$T1$ = the initial temperature in °C
WW = the dry weight of the wood
WS = the dry weight of the silica gel

The formula above provides a reasonably accurate prediction of the final relative humidity in a sealed container when the temperature changes. If a packing case containing 1 kg (2.2 lb.) of wood and 1 kg of silica gel equilibrated to 50% RH is moved from 20°C to 0°C, the relative humidity will fall to approximately 48%.

The concept of falling relative humidity levels within packing cases due to temperature decreases has alarmed many conservators. Practical experience, training, and numerous publications have repeatedly emphasized the importance of maintaining constant relative humidity levels for all hygroscopic materials. As discussions above indicate, this rule does not have the same implications when the temperature changes. If a painting were moved from 50% RH and 20°C (68°F) into a very cold gallery, a lower rela-

INSULATION MATERIAL	INSULATION THICKNESS		THERMAL HALF-TIME	
	cm	in.	Theory	Actual
None	0	0	.4	1
*Polyester Urethane Foam-Flexible	2.5	1	1.6	-
Polyester Urethane Foam-Flexible	5.0	2	2.6	2.9
Polyester Urethane Foam-Flexible	10.0	4	4.6	4.4
Polyester Urethane Foam-Flexible	15.0	6	6.6	-
+Polyester Urethane Foam-Rigid	10.0	4	7.8	-
++Polyethylene Foam	10.0	4	3.0	-
#Polystyrene Foam-Rigid	5.0	2	2.6	3

TABLE 1

* The foam density is 33 kg/m^3 (2 lb./ft.3) and a thermal conductivity of 0.036 W/(m °C) or (0.25 BTU in./(h.ft.2°F) was used in the calculations.
+ The foam density is 33 kg/m^3 (2 lb./ft.3) and a thermal conductivity of 0.02 W/(m °C) or (0.14 BTU in./(h.ft.2°F) was used in the calculations.
++ The foam density is 36 kg/m^3 (2.2 lb./ft.3) and a thermal conductivity of 0.055 W/(m °C) or (0.38 BTU in./(h.ft.2°F) was used in the calculations.
The foam density is 33 kg/m^3 (2 lb./ft.3) and a thermal conductivity of 0.036 W/(m °C) or (0.25 BTU in./(h.ft.2°F) was used in the calculations.

tive humidity must be maintained if the equilibrium moisture content is to be kept constant.

In packing cases a second factor is probably more significant. The volume of air in a packing case is very small when compared to a large display case or a museum gallery. Air at a specific relative humidity contains very little moisture in comparison to a typical painting. An easel-size painting measuring 1.2 x 1.2 x 0.1 m (47.2 x 47.2 x 3.9 in.) wrapped in polyethylene could contain approximately 0.1 m^3 (3.53 ft.3) of air after subtracting the volume of the painting and its frame. At 20°C (68°F) and 50% RH, this volume of air contains 0.85 g (0.002 lb.) of water. Given that there are approximately twenty droplets per gram of water, this means that 0.1 m^3 (3.53 ft.3) of air contains only seventeen droplets of water. Even if a drastic temperature change caused all the water vapor to condense onto the painting, seventeen droplets is a small

amount relative to the size of the painting described. It is also likely that the condensation would form first on the polyethylene, instead of on the painting. At 0°C (32°F) and 50% RH, the same volume of air contains 0.24 g (0.0005 lb.) of water or approximately five droplets. When the temperature drops, the painting must adsorb twelve droplets of water from the air in order to maintain 50% RH. In fact, it will adsorb slightly more because the materials are in equilibrium with a lower relative humidity at the lower temperature.

A kilogram (2.2 lb.) of wood at 50% RH and 20°C (68°F) contains 84 g (0.185 lb.) of water. The small amount of water adsorbed from the air because of temperature drop would have a negligible effect on the equilibrium moisture content of the wood. Therefore, any dimensional changes caused by the adsorbed water would be extremely small. The necessity of trying to stabilize the relative humidity fluctuations that result from

MATERIAL	THERMAL CONDUCTIVITY		SPECIFIC HEAT	
	$\dfrac{BTU \; x \; in.}{h.x \; ft.^2 \; F}$	$\dfrac{W}{m \; {}^oC}$	$\dfrac{BTU}{lb. \; {}^oF}$	$\dfrac{J}{Kg \; K}$
* Aluminum—Alloy 2024	1332	192	0.22	921
+ Stainless Steel	113	16	0.12	502
++White Pine	0.84	0.12	0.6	2512
# Plywood	0.80	0.12	0.35	1465
++Oak	1.2	0.17	0.5	2093
§ Polyester Urethane Foam-Flexible	0.2-0.25	0.029-0.036	-	-
§ Polyether Urethane Foam-Rigid	0.11-0.17	0.016-0.025	-	-
§ Polyethylene Foam	0.35-0.40	0.05-0.058	-	-
¡ Polystyrene Foam-Rigid	0.21-0.28	0.03-0.04	0.19	795

* Data from *Handbook of Material Science* 2 (1975) 183-184.
+ Data from *Handbook of Material Science* 2 (1975) 68.
++ Data from *Handbook of Material Science* 1 (1975) 574.
Density is approximately 577 kg/m^3 (36 lb./ft.3); Data from N. Stolow, *Controlled Environment for Works of Art in Transit* (1966) 33.
§ Density is approximately 32 kg/m^3 (2 lb./ft.3); Data from *Modern Plastics Encyclopedia* 45, No. 1A, (1968) 354-355.
¡ Density is approximately 32 kg/m^3 (2 lb./ft.3); Data for thermal conductivity is from *Modern Plastics Encyclopedia* 45, No. 1A, (1968) 354-355; Data for specific heat is from Stolow 1966, 33.

the temperature variations during transit is questionable.

TEMPERATURE

Packing cases containing works of art are frequently exposed to temperature variations during transit and this affects the case's interior temperature. If a well-sealed packing case is moved from the warmth of the museum into a cold airport warehouse, its interior temperature will fall. The rate of change is determined by the temperature difference between the museum and the warehouse, the case's size, shape, air leakage rate, thickness of the case walls, the heat capacity of the contents, and the thermal conductivity of the case materials. If the packing case sits out-doors, it will also be affected by sunlight and wind. There are various ways to minimize temperature fluctuations in packing cases. Couriers can strive to keep packing cases away from harsh environments that are unusually hot, cold, wet, in direct sunlight, or exposed to wind. Quality case construction minimizes air leakage. Cube-shaped cases are affected less than large, slender cases. Finally, thick layers of insulating materials will slow the heat loss or gain of the interior.

Thermal Half-Time

Heat will flow between packing cases and the surrounding air whenever temperature differential exists. A packing case in equilibrium at 20°C (68°F) will immediately lose heat

when moved to a colder room. The cooling rate is very rapid at first but it slows as the case's interior temperature approaches that of the surrounding air. The rate of the temperature change is an exponential decay, a process clearly described by Thomson.[8]

Figure 5 depicts the typical interior cooling response of a packing case that is moved into a colder environment. The time required for the temperature to finally reach equilibrium with its new environment depends on the quality of the case construction, the heat capacity of the contents, the exterior surface area, and the quantity of insulation. The time period does not depend, however, on the temperature of the room. It took the case in Figure 5 approximately forty hours to reach equilibrium in a room at 0 °C (32 °F). Had the case been moved into a room at -20 °C (-4 °F), it also would have taken approximately forty hours for it to reach that temperature. Therefore, it is not practical to describe the rate of the temperature change in degrees per hour because it depends on the temperature difference between the case and the room. To make matters even more complicated, the cooling rate constantly changes as the case's interior approaches room temperature. Because the process is an exponential one, the temperature changes inside the packing case are predictable.

Returning to the example illustrated in Figure 5, the case took five hours to drop from its initial temperature to 10 °C (50 °F), exactly half the difference between the temperature of the two rooms. It took five more hours for it to drop to 5 °C, half the difference between 10 °C and 0 °C. This trend continued until the case reached equilibrium with the room.

In this example, five hours is the thermal *half-time*, also called *half-life*, of the packing case. The beauty of the thermal half-time is that its value is always the same for a specific packing case, regardless of the exterior temperature change. This makes the thermal half-time useful for comparing the performance of various packing cases. From the standpoint of its ability to minimize temperature fluctuations during transit, a case that has a half-time of five hours is better than one that has a half-time of two hours. The significance of this characteristic depends on the temperature and/or humidity sensitivity of the art work inside and the weather conditions anticipated during the journey.

Measuring thermal half-time for a packing case is not difficult. The simplest approach is to place a temperature recording device inside the case, give it time to reach equilibrium, and then move it to a new location having a very different temperature for a period of time that exceeds its estimated half-time. The recorded temperature history will reveal the time it took for the case to reach the midpoint between the initial and final temperatures.

While the procedure described above is simple and requires no mathematical calculations, the thermal half-time can be determined without waiting for the temperature to reach the midpoint. The mathematical expression required for the calculation is based on the fact that the change in temperature, dT, per change in time, dt, is equal to a constant, k, times the difference between the case temperature at time, t, and the room temperature, T_R:

$$\frac{-dT}{dt} = k \times (T - T_R)$$

Rearranging for integration:

$$\int \frac{dT}{T - T_R} = \int k \times dt$$

The definite integral, where T equals the initial temperature, T_0, $(t = 0)$ is:

$$\log_e \frac{T - T_R}{T_0 - T_R} = -kt$$

$$\frac{T - T_R}{T_0 - T_R} = e^{-kt}$$

At half-time, $t_{1/2}$, $\log_e \frac{T - T_R}{T_0 - T_R} = \log_e \frac{1}{2}$

Therefore,

$$t_{1/2} = \frac{1}{k} \log_e \frac{1}{2} = \frac{0.693}{k}$$

To summarize the terms:
$T=$ temperature of case at time t
$T_0=$ initial case temperature at time $= 0$
$T_R=$ room temperature at time t
$k =$ rate constant for exponential decay
$t_{1/2}=$ thermal half-time

Using these formulas, the value of k and the half-time for a specific packing case can be easily calculated using the initial and final room temperatures plus temperature readings of the case interior at any two points during the cooling process.

Thermal Behavior of Packing Cases

In the discussion above, it was shown that the thermal half-time is equal to 0.693 divided by a rate constant, k.

$$t_{1/2} = \frac{0.693}{k}$$

This relationship can be expanded to estimate the thermal half-time of packing cases without running experiments. Unquestionably, the safest approach for comparing the performance of various cases is to actually test them, but the formulas devised for making the approximations are reasonably accurate and the derivations of the formulas are useful for understanding the various factors that affect the thermal half-time of packing cases.

The formula, as provided by Stolow is:[9]

$$K = \frac{0.69H1}{At_{1/2}}$$

where
$K =$ thermal conductivity of the case walls
$H =$ thermal capacity of the case and its contents
$A =$ average surface area of the case
$1 =$ thickness of the case walls

A modified version of the formula was given by Wilson as:[10]

$$t_{1/2} = \frac{0.693Ms}{UA}$$

where
$M =$ mass of the contents
$s =$ specific heat of the contents
$U =$ thermal transmittance of the case walls
$A =$ mean surface area of the case
$d =$ the thickness of the case wall material
$k =$ the thermal conductivity of the material
$A_1, A_2, A_3 =$ the average surface areas for the three different faces of the case
$U_1, U_2, U_3 =$ the thermal transmittances of the three different faces of the case

As Wilson went on to develop:

$$t_{1/2} = \frac{0.693Ms}{2U_{1A_1} + 2U_{2A_2} + 2U_{3A_3}}$$

The thermal transmittance, U, for any material is defined as the thickness, d, divided by the material's thermal conductivity, k:

$$U = \frac{d}{k}$$

In packing cases composed of multiple layers, e.g. plywood, insulation, and possibly an inner case, the total value of U is:

$$U_{total} = \frac{1}{\frac{d_1}{k_1} + \frac{d_2}{k_2} + \frac{d_3}{k_3}}$$

Table 1 provides the thermal half-time for various packing cases based on Wilson's formula. The packing cases were assumed to be simple, 2 cm thick, plywood cases. The dimensions of the painting remained constant in all calculations, but the outer dimensions of the packing case varied with the thickness of the foam insulation. The total heat capacity of the painting, its frame, and the foam insulation were included in the calculations, but the heat capacity of the plywood used for the outer case was disregarded. This assumption could introduce error because the plywood case also exchanges heat with the surrounding air.

The total heat capacity of a system is the product of the *specific heat* of a material and its mass. Specific heat is the thermal energy

required to raise the temperature of a given mass of a material by one degree. Little heat is required to raise the temperature of some materials, e.g. copper or aluminum, while considerable heat is required to raise the temperature of others, e.g. water. This affects the thermal half-time of packing cases because the contents of the case must gain or lose heat in order to alter the interior temperature. A packing case filled with materials having considerable mass and a high specific heat will have a longer thermal half-time than a case containing little mass or materials with a low specific heat. Therefore, the thermal half-time of a case containing a painting on a thin copper sheet would be shorter than a similar case for a thick wooden panel. For the same reasons, packing two paintings in one case would improve its performance because the mass of the contents would double while the outer dimensions of the case would increase only slightly.

In experiments conducted at the National Gallery of Art, Washington, the thermal half-times of various packing cases were measured. The cases all contained a mock painting on linen having an oak frame. The total heat capacity of the mock painting was calculated from the mass and specific heat of the materials. The resulting value was used in the calculations for Table 1. The experiments evaluated packing cases containing no insulation, 5 cm (2 in.) polyester urethane foam, 10 cm (4 in.) polyurethane foam and 5 cm (2 in.) polystyrene foam. As apparent in Table 1, the experimental and theoretical results for the test cases evaluated are similar, except for the packing case with no insulation. The discrepancy can probably be explained by the fact that the total heat capacity of uninsulated packing cases and the thermal conductivity of the case walls have a large effect on the half-time. The thermal conductivity of the materials used in packing cases has a large impact on their thermal half-times. Materials having a low thermal conductivity are better insulators than those with higher conductivity values. For example, some polyethylene foams have a thermal conductivity as high as 0.055 W/(m°C), (0.38 BTUin./(h.ft.²°F), and they will conduct heat one and a half times

faster than a polyester urethane foam that has a thermal conductivity of 0.036 W/(m°C), (0.25 BTUin./(h.ft.²°F). Increasing the thickness of the insulating materials will reduce the heat flow rate in direct proportion to the thickness increase. Therefore, if the insulation thickness is doubled, the rate of heat loss or gain through the material will be reduced by one-half. This does not imply, however, that doubling the thickness of the insulation will necessarily halve the thermal half-time since thickness is only one variable in the equation.

The thermal conductivity and specific heat of various materials are provided in Table 2.

The shape of packing cases also affects their thermal half-times. The perfect packing case, from the standpoint of the thermal protection, would be a sphere. A sphere has the lowest exterior surface area for the volume it encloses. Spheres are hardly practical for packing works of art despite the fact that rolling them through the galleries would delight many museum technicians. From a practical standpoint, the ideal shape is a cube since it encloses considerable volume relative to its exterior surface area. As Wilson's formula reveals, reducing the outer surface area increases the thermal half-time because it reduces the surface area that is exposed to the surrounding air.

Thermal Response of Painting Materials

Virtually all materials expand and contract with changes in temperature. Increasing the temperature causes expansion and decreasing it causes shrinkage. The effects of temperature on nonhygroscopic materials, e.g. metals, are rarely overlooked by conservators and conservation scientists. The thermal expansion and contraction of hygroscopic materials, on the other hand, are frequently overlooked because larger dimensional responses usually result from the moisture content fluctuations that accompany temperature variations. This holds true when the hygroscopic material undergoes a temperature change in a large room or display case.

In an enclosed space containing little air, the situation is different. The moisture

288

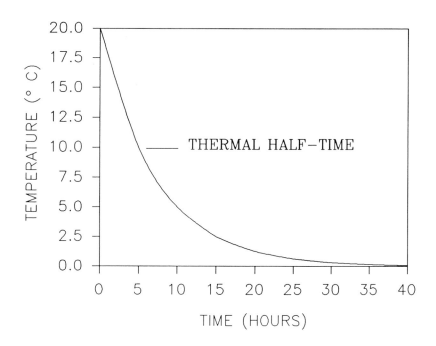

FIGURE 5
Exponential cooling of a packing case having a thermal half-time of five hours.

content of the air relative to its volume is far less than hygroscopic solids. As already stated, temperature changes will simultaneously affect the equilibrium moisture content of hygroscopic materials and the relative humidity of the surrounding air. When the air volume is small, very little moisture is exchanged before equilibrium is reestablished. Therefore, the dimensional responses that can be attributed to a variation in the moisture content are also small.

The linear coefficient of thermal expansion of most materials in paintings are on the same order of magnitude as many metals.[11] Thermal expansion and contraction can induce stress in the various materials and between layers but the temperature fluctuations commonly found in art transports would rarely cause damage if the materials are relatively free to move. Panel paintings that have existing cracks and are dimensionally restrained by cradles, battens, or frames, could be an exception if the temperature dropped too far below 0 °C (32 °F).

At lower temperatures, however, the stresses that build up in the paint layers are sufficient to exceed the breaking strength of the paint. This means that crack formation becomes an increased problem when the painting cools.[12]

WRAPPING MATERIALS FOR PAINTINGS

The foregoing discussions assume that the hygroscopic materials in the case have sufficient time to reestablish equilibrium, however, temperature changes in packing cases can be very rapid, particularly if no insulation is used in the case. As a result, the relative humidity of the air trapped in a sealed environment can change faster than the hygroscopic materials can adsorb or desorb the water vapor. If the change occurs too quickly, condensation could develop. It is for this reason that many conservators and scientists have recommended that paintings be surrounded with hygroscopic wrapping

materials and not relatively impermeable materials, e.g. polyethylene sheeting. This precaution is warranted for certain situations; if used appropriately, however, wrapping paintings in polyethylene may, in fact, be the best way to maintain a stable environment during transport.

When a painting acclimated to a specific environment is moved to a different one, it will adsorb or desorb moisture, depending on whether the new environment has a higher or lower relative humidity. This situation can also occur when a painting is removed from exhibition and packed in a case that has not been stored in an appropriate environment. While every effort should be made to store packing cases at the same relative humidity as found in the museum galleries, experience has shown that this does not always happen. A packing case equilibrated to 30% relative humidity will quickly draw moisture from a painting acclimated to 50% RH. If the painting is wrapped in polyethylene sheeting, this will not occur. The polyethylene isolates the painting from the environment created by the packing case. Very little moisture need be exchanged between the painting and the small volume of air within the wrapping to reestablish the appropriate relative humidity. This can be a very useful safeguard for paintings in travelling exhibitions where the lender lacks control. The only disadvantage of wrapping them in polyethylene sheeting is the slight risk of condensation under unusual circumstances.

The risk of condensation inside packing cases is one question being evaluated in a research project currently underway at the National Gallery of Art. Test paintings are wrapped in various materials and then packed in cases having different thermal half-times. Experimental runs have been made in an environmental chamber lowered from room temperature to either 2°C (36°F) or -18°C (-0.4°F).[13] Most of the tests have used paintings equilibrated to 50% RH. When the temperature in the chamber has dropped from 22°C (72°F) to -18°C (-0.4°F), the relative humidity inside the wrapping material has never risen above 65% RH, even

with packing cases insulated solely by the 1.9 cm (0.75 in.) plywood. If a greater temperature differential were encountered during transit or thinner plywood used in the case construction, the relative humidity surrounding the painting would climb higher, possibly reaching the point of condensation. For the safety of the paintings, packers must consider the transit conditions before opting to eliminate insulation from packing cases.

In a test using a wax-infused painting acclimated to 75% RH and packed without insulation, there is evidence that the dew point was reached and condensation formed, presumably on the polyethylene wrapping. When 10 cm (4 in.) of polyester urethane foam was added to the case containing the wax-infused painting equilibrated to 75% RH, the relative humidity inside the polyethylene wrapping remained below 90% RH. The added insulation increased the thermal half-time of the packing case, allowing more time for water vapor to diffuse into the hygroscopic materials before condensation could occur. While the wax-infused painting equilibrated to 75% RH was not tested in a case containing only 5 cm (2 in.) of polyester urethane foam, the results from other experiments suggest that if the painting is equilibrated below 70% RH, the half-time should be sufficiently long to prevent condensation. If extremely cold temperatures are anticipated in transit, a margin of safety would be provided by increasing the layer of insulation to 10 cm (4 in.).

An additional precaution that can be taken with paintings acclimated to high relative humidity levels is to wrap them in a hygroscopic material, e.g. kraft paper or tissue paper, and then wrap them with polyethylene. Should condensation begin to form, most, if not all of it, would collect on the paper while the polyethylene would isolate the painting's environment from the environment of the packing case.

Unpacking paintings too soon after transit through a cold environment probably poses the greatest risk of condensation. Moisture in warm air will quickly condense on the surface of a cold painting. Anyone who wears glasses has frequently experienced this when

walking indoors during winter months. Ironically, improving the thermal half-time of a packing case by adding insulation also means that more time is required for it to reacclimate in the museum. As a general rule, twenty four hours should allow enough time for well-insulated packing cases to readjust.

Even though the problem of condensation can be minimized by adding insulation to packing cases, extreme caution should be exercised when packing paintings above 70% RH. The stagnant air in a packing case is an ideal environment for the growth of mold and mildew at relative humidity levels around 70%. Relative humidity levels of this magnitude or greater can develop unexpectedly when a painting acclimated to relative humidity levels near 70% are packed in a very cool, damp room. If the packing case is then moved and stored at a much higher temperature, the relative humidity inside the case will rise because the hygroscopic materials will release moisture into the air. To make matters worse, the growth of mold and mildew accelerates at higher temperatures.

Wrapping paintings in absorbent, semipermeable materials, e.g. glassine or kraft paper, will reduce the rapid increase in relative humidity that initially occurs when the packing case is moved into a very cold environment. This happens because the wrapping material increases the surface area of absorbent material available to remove moisture from the air as the relative humidity rises. The effect appears to be significant only in cases that lack insulation. The increased thermal half-time resulting from added insulation affords the painting and frame time for moisture diffusion. While the experiments to date have included a wax-infused painting and paintings in a non-absorbing, polyethylene frame, paintings on metal supports have not been evaluated. This is a special situation requiring study where the painting will rapidly change temperature and it will not be absorbent.

CONCLUSION

Every effort should be made to minimize environmental variations inside packing cases containing paintings. Ideally, this would be accomplished by maintaining the appropriate temperature and relative humidity in all vehicles used for transport. While a large percentage of the vehicles used for art shipments have equipment to help stabilize temperature, equipment can fail. In addition, very few vehicles are equipped to control relative humidity in the cargo area.

A fairly stable relative humidity can be maintained in insulated, well-sealed packing cases. Since little air is exchanged with the environment outside the case, the moisture content of the hygroscopic materials inside insulated cases remains almost constant. This is particularly true when the packed paintings are wrapped in a relatively impermeable material like polyethylene. An added advantage of this approach is that the equilibrium moisture content of the painting inside the polyethylene wrapping will be isolated from the packing materials. This is extremely important in situations where packing cases are stored in inappropriate environments. All wooden cases stored at 30% RH for several months will equilibrate to that humidity. As a result of the low humidity in the case, moisture will be drawn from a painting unless it has the protection of a wrapping material such as polyethylene.

A risk in wrapping paintings in polyethylene is that condensation can develop if the temperature inside the case falls too rapidly and the painting is acclimated to a high relative humidity. The risk would be high for a painting acclimated above 70% RH and in a case having little or no insulation. Every effort should be made to avoid condensation, but if water did condense on a typical painting wrapped in polyethylene, the quantity of water involved is small. The water vapor contained in 0.1 m^3 (3.53 ft.3) of saturated air at 20°C (68°F) is only 1.7 g (0.0038 lb.) or about thirty four droplets. At 70% RH, the air contains 1.2 ml (0.00031 gal.) or twenty-four droplets and at 50% RH it contains 0.85 ml (0.00022 gal.) or seventeen droplets. Tests indicate that there is little risk of condensation with paintings acclimated to relative humidity levels below 70% when 10 cm (4 in.) of insulation was used in the packing cases, and it

seems likely that 5 cm (2 in.) would have been adequate. A margin of error can be obtained when packing paintings acclimated to high relative humidity that may be exposed to extremely cold temperature by first wrapping them with an absorbent paper layer followed by polyethylene sheeting. However, very special precautions must be taken with paintings at or above 70% RH because of the possibility of mold or mildew.

Various factors affect the rate of temperature change inside packing cases. Adding insulation and packing more than one painting together are the simplest ways to improve thermal half-times of packing cases. This improvement is advisable for several reasons: it reduces the risk of condensation; it improves the stability of the moisture content of the paintings; and it slows the painting's dimensional response to the changing environment. While the dimensional responses of paintings are relatively small, most of the expansion and contraction is probably caused by changes in temperature and not variations in moisture content. □

APPENDIX

Experiments Investigating the Thermal Response of Wood in Packing Cases

In experiments underway at the National Gallery of Art, Washington, environmental conditions inside packing cases are being monitored. The experiments are run in an environmental chamber that exposes the packing cases to fluctuations in the temperature and relative humidity. The cases are constructed with 1.9 cm (0.75 in.) plywood, reinforced with pine battens. Experiments have evaluated the case performance when several insulating materials of varying thicknesses were added to the case. The test paintings have been wrapped in various materials. Electronic sensors measure the temperature and relative humidity near the paintings, i.e. inside the wrapping material, and outside the packing cases. Minute dimensional movements of the frames, wooden stretchers, and wood veneers included with the wrapped paintings are being measured with strain gages. The white oak (*Quercus* sp.) veneers used in the experiments were taken from discarded furniture estimated to be approximately one hundred years old. The strain gages measure dimensional movement in the radial direction. The birch (*Betula* sp.) veneers are approximately twenty years old and the strain gages measure the tangential movement of the wood. The veneer thicknesses range from 1-3 mm (0.04-0.12 in.) and owing to their thinness, they are very responsive to temperature and moisture content variations.

As discussed in the main paper, wood responds dimensionally to changes in relative humidity. Wood shrinks when moved to an environment having a lower relative humidity, as shown in Figure A-1, and it expands when the relative humidity is increased. The dimensional response of the wood veneers used in the experiments was measured as a function of relative humidity using the strain gages. The coefficient of expansion for the radially-cut, oak veneers ranged from 0.00014-0.00015 per percent relative humidity and the tangentially-cut birch veneers ranged from

0.00015-0.00020 per percent relative humidity.[*] These values are lower than the average value of 0.00034 per percent relative humidity found in textbooks on wood behavior.[+]

It became clear in the early stages of the experimental work that changes in the moisture content of the wood were only partially responsible for the dimensional activity of the wood veneers included in the packing cases. Without question, temperature fluctuations were affecting the wood. In hindsight, the significance of the role of temperature in the wood's movement is not surprising. All materials respond to temperature fluctuations but with hygroscopic materials, the effects are normally discounted because it is assumed that the temperature changes will have such a large effect on the moisture content of the material that the dimensional responses due to the moisture content fluctuations will outweigh its thermal expansion or contraction. This assumption is valid when a hygroscopic material is surrounded by a large volume of air, but in a well-sealed packing case having little free air, a very small quantity of moisture is exchanged between the wood and the air before equilibrium is reestablished. This is particularly true when a painting is wrapped with a relatively impermeable material like polyethylene.

In its dimensional response to temperature changes, wood is an anisotropic material. Little dimensional movement is observed parallel to the wood grain while considerable expansion and contraction occurs perpendicular to the grain. In the longitudinal direction, the linear coefficient of expansion of wood is independent of the specific gravity of the wood and varies from approximately 0.000003 to 0.0000045 per degree C (0.0000017 to 0.0000025 per degree F). The linear expansion coefficients across the grain (radial and tangential) are affected by the specific gravity of the wood. Over an ovendry specific gravity range of 0.1 to 0.8, the radial and tangential expansion coefficients, α_r and α_t can be approximated using the formulas:

$\alpha_r = [(0.0000324 \text{ x specific gravity}) + 0.0000099]$ per degree C

$\alpha_\tau = [(0.0000324 \text{ x specific gravity}) + 0.0000184]$ per degree C

Expressed in degrees fahrenheit, the formulas are:

$\alpha_r = [(0.000018 \text{ x specific gravity}) + 0.0000055]$ per degree F

$\alpha_\tau = [(0.000018 \text{ x specific gravity}) + 0.0000102]$ per degree F

Based on the fact that white oak has an average specific gravity of 0.62, oak's radial thermal expansion coefficient is 0.00003 per degree C (0.0000167 per degree F) and its tangential thermal expansion coefficient is 0.0000385 per degree C (0.0000214 per degree F). This means that in the radial direction, an average piece of white oak subjected to a 40°C (72°F) temperature drop will shrink by a factor of 0.0012, assuming that the moisture content of the wood does not change. Expressed as percentage shrinkage, this is equal to 0.12%. In the tangential direction, the shrinkage will be 0.154%.

Figure A-2 shows the variations in temperature and relative humidity in an uninsu-

lated packing case containing a painting wrapped in polyethylene during one of the experimental runs. It can be seen in Figure A-2 that as the temperature dropped, the relative humidity initially increased because of the falling temperature of the air and then the relative humidity dropped as the hygroscopic materials began to absorb moisture from the air. Figure A-3 provides the dimensional response, in microstrain (strain x 10^6) of a radially-cut, oak veneer in two different experimental runs. The two runs were identical except that one of the radially-cut, oak veneers was coated with microcrystalline wax before starting the second run. It should be noted that the oak veneer did not respond to the temporary rise in relative humidity but immediately began to shrink. Within ten hours, the uncoated veneer's shrinkage, expressed in microstrain, was approximately -1,000 (0.1% shrinkage).

The dimensional response of the coated veneer, approximately -1,300 microstrain (0.13% shrinkage) exceeded the response of the same, uncoated veneer. The reason for the discrepancy is simple; wax is a good

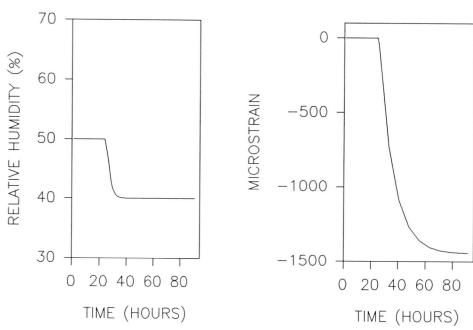

FIGURE A-1
Dimensional response of a thin, white oak moved from 50% RH to 40% RH.

moisture barrier and it kept the veneer from adsorbing moisture that would have caused some swelling of the wood fibers. The net dimensional response was shrinkage, even in the uncoated sample, because the thermal shrinkage exceeded the effects of the adsorbed moisture. Had similar measurements been made on the rather massive oak frame or a thick wooden panel, the adsorbed moisture would have had a much smaller effect. The oak veneers are very light in weight and the small quantity of adsorbed moisture affected their moisture content. The small quantity of adsorbed moisture would not significantly alter the equilibrium moisture content of a massive frame or panel. Therefore, thermal variations would be responsible for virtually all of the observed strain.

In the experiments, the radially-cut, oak veneers and the oak frame were subjected to a temperature drop of 40°C (72°F). This temperature change causes a strain of approximately -0.001 to -0.002 (0.1-0.2% shrinkage). The strain measured for the tangentially-cut, birch veneers was even greater. These dimensional changes are not large but they are not insignificant. Using the textbook figure of 0.034% shrinkage per percent relative humidity, a 6% RH change would be required to cause 0.2% shrinkage. As stated above, the hygrometric dimensional response of the radially-cut, oak veneers, as measured by Mecklenburg, was 0.015% shrinkage per percent relative humidity.** Using this value, a 13% RH change would be required to cause 0.2% shrinkage. An important consideration that must be taken into account when evaluating the dimensional responses of paintings due to temperature changes are the stresses that build up in the various layers. The paint, ground, glue size and support all respond to variations in both temperature and relative humidity. This is particularly complex in a painting on a wooden panel because wood's

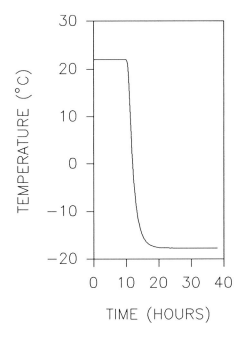 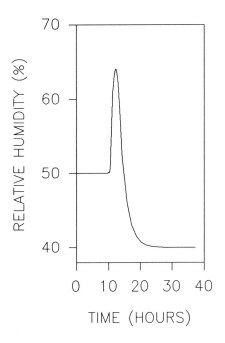

FIGURE A-2
Temperature and relative humidity inside the polyethylene wrapping of a painting packed in an uninsulated case. The packing case was maintained at 22°C (72°F) for ten hours and then the exterior temperature was lowered to -18°C (-0.4°F).

behavior is anisotropic.

It is beyond the scope of this paper to repeat the details provided by Mecklenburg.[++] However, it seems worthwhile to calculate the stresses that could develop in a wood panel as a result of a 40°C (72°F) temperature drop. The stress, σ, in a material that is completely restrained, i.e. a material that cannot freely expand and contract, is equal to the strain, ε, measured when the material is free to move times the material's modulus, E:

$$\sigma = E \ x \ \varepsilon$$

The unrestrained, radially cut, oak veneers shrank by as much as 0.002 (0.2%) as a result of this temperature drop. The cross-grain modulus, E, of oak is approximately 690 MPa (100,000 pounds per square inch). This means that a 40°C (72°F) temperature drop would generate a stress of 1.38 MPa (200 psi) in a

wood panel that is completely restrained by a totally locked cradle or inappropriate framing. Mecklenburg has shown that a stress of this magnitude is sufficient to extend an existing crack in the wood while it should not cause new cracks. The temperature change should not, however, extend nor generate cracks in a panel that is free to expand and contract.

This research shows that temperature changes in packing cases must be considered in their design and every effort should be made to use vehicles that have temperature controlled cargo areas. If care is taken in the selection of transport modes, it would be exceedingly rare that the temperature would actually drop as low as the test conditions described above. However, if there is any doubt about the reliability of the equipment used during transits through adverse climates, insulation should be added to packing cases. This is a very simple precaution that would

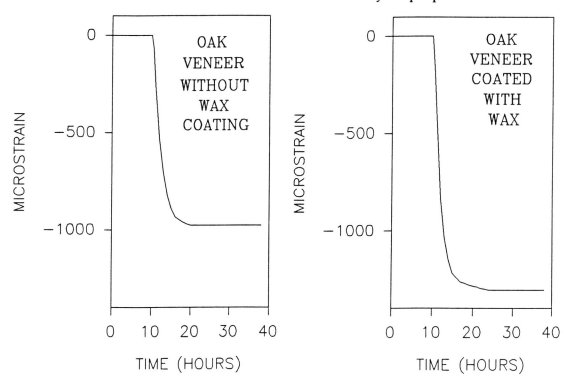

FIGURE A-3
Dimensional response of a thin, white oak veneer in two experimental runs. After the first run, the veneer was coated with microcrystalline wax. The veneer was placed inside the polyethylene wrapping of a painting packed in an uninsulated case. The packing case was maintained at 22°C (72°F) for ten hours and then the exterior temperature was lowered to -18°C (-0.4°F).

reduce the risk of damaging a painting because of temperature extremes.

* Marion Mecklenburg, "Mechanical Behavior of Paintings Subjected to Changes in Temperature and Relative Humidity" (1991) elsewhere in this publication.

+ Based on data in: Franz Kollmann and Wilfred Côte, *Principles of Wood Science and Technology* (1968), 210 and an assumption that a, i.e. the change in equilibrium moisture content per change in relative humidity, is equal to 0.18.

++ *Wood Handbook; Wood as an Engineering Material* USDA Agricultural Handbook No. 72 (1987), 3.25-3.26.

** Mecklenburg 1991.

ACKNOWLEDGMENTS

The research critical to this paper would not have been possible without the encouragement and financial support of the National Gallery of Art. In addition, much needed financial support was provided by The Circle of the National Gallery of Art and the Getty Conservation Institute who supported the initial research.

The author would like to acknowledge and thank Karen Tidwell who has provided invaluable assistance throughout the research project. Acknowledgments are also due to Marion Mecklenburg who helped with data analysis and editing; and to Janice Gruver who edited the final paper.

NOTES

1. Stephen Hackney, "The Dimensional Stability of Paintings in Transit," ICOM *Committee for Conservation 8th Triennial Meeting* Preprints, Sydney (1987), 597-600; Nathan Stolow, *Controlled Environment for Works of Art in Transit* (1966); N. Stolow, *Conservation Standards for Works of Art in Transit and on Exhibition* (1979); N. Stolow, *Conservation and Exhibition: Packing, Transport, Storage, and Environmental Considerations* (1987); Kenzo Toishi, "Humidity Control in a Closed Package," *Studies in Conservation* 4 (1959), 81-87.

2. Based on data in: *Wood Handbook; Wood as an Engineering Material*, USDA Agricultural Handbook No. 72 (1987), 3.11. Tables found in standard Canadian publications, e.g. *Canadian Woods, their Properties and Uses* (1951) and in the United Kingdom, e.g. *Kiln Operator's Handbook* (1961), give a higher EMC versus RH slope. This does not alter the conclusions drawn in this article but it can cause confusion.

3. Marion Mecklenburg, "Mechanical Behavior of Paintings Subjected to Changes in Temperature and Relative Humidity" elsewhere in this publication.

4. Data between 0°C (32°F) and 30°C (86°F) is based on the *Wood Handbook: Wood as an Engineering Material*, 3.11. The lineararity of the curves below 0°C (32°F) is based on: C. Hedlin, "Sorption Isotherms of Twelve Woods at Subfreezing Temperatures," *Forest Products Journal*, 17 (1967).

5. See note 2. The United Kingdom data provides 11% EMC at 50% RH, 20°C (68°F) and 12.5% EMC at 50% RH, 0°C (32°F).

6. Art-Sorb is a product of Fuji-Davison Chemical, Ltd., Nagoya-shi, Japan. Arten Gel is a product sold by Art Preservation Services, New York, NY.

7. Stolow 1987, 126-130.

8. Garry Thomson, "Stabilization of RH in Exhibition Cases: Hygrometric Half-time," *Studies in Conservation* (1977), 85-102.

9. Stolow 1966, 34.

10. Peter Wilson, "Temperature and Relative Humidity Control in Packing Cases," UKIC *Meeting on Packing Cases—Safer Transport for Museum Objects* Preprints, S. Staniforth, ed. (London, 1985), 1-3.

11. See Appendix and Mecklenburg 1991.

12. Mecklenburg 1991.

13. Numerous packing cases containing National Gallery of Art, Washington, paintings have been monitored during transit. To date, the temperature inside a packing case has not fallen below 11°C (57°F). In that particular shipment, the exterior temperature fell to 2°C (36°F) during the journey. The National Gallery, London, has also monitored shipments and their results were reported in: David Saunders and Richard Clarke, "Monitoring the Environment within Packing Cases Containing Works of Art in Transit," ICOM *Committee for Conservation 9th Triennial Meeting* Preprints, Dresden (1990), 415-422.

TEMPERATURE AND RELATIVE HUMIDITY CONDITIONS ENCOUNTERED IN TRANSPORTATION

David Saunders

ABSTRACT: *The variation of temperature and relative humidity throughout the world is discussed. Environments occurring at locations where museums are most likely to exist are included as well as the extremes in environments that might be encountered while paintings are in transit. The internal environments of trucks, trains, aircraft, and ships are examined with a discussion of the factors that affect the temperature and relative humidity of those environments. This paper also includes a section on environmentally controlled transport and the degrees to which protection is provided. The results of monitoring actual painting transport is reported.*

INTRODUCTION

Once the decision has been made to lend a painting to another institution, it must be accepted that the object will need to leave what we will assume to be a stable environment of the museum and pass through the prevailing exterior climate(s) before arriving at the receiving institution, where it will hopefully enter a well-controlled environment that will be similar, and preferably identical, to that of the original location.

The purpose of this paper is to summarize the exterior climatic conditions that are commonly encountered during transit, to indicate how these are modified by the vehicles used for the transportation, to outline the results obtained from monitoring within packing cases and, finally, to describe the effect these climatic conditions will have upon the materials used in the packing of works of art.

EXTERNAL CLIMATE

The World's Weather

Climatically, the world can be divided into a number of loosely defined regions, shown in Figure 1. There are few museums in those climatic zones described as "high mountain and plateaux (H)" or "arctic or ice cap (F)," which experience extremely cold temperatures throughout most of the year. In the subarctic (E) region the winters are long and cold, but during the short summer days the temperature may rise quite high. This type of climate is typical of central and northern Canada.

The majority of the world's art museums and galleries are to be found in the four temperate climatic bands. There are two cold temperate regions. The cool, temperate oceanic (D1), which experiences few extremes of temperature and rain during all months, includes northwestern Europe, the western seaboard of Canada, the southern tip of Australia and New Zealand, while continental cold temperate climates (D2) are characterized by hot summers and cold winters. Much of central and eastern Europe, eastern Canada and the northeastern region of the United States fall within this area. In addition, there are two warm temperate zones. The wet, warm temperate zone (C1) experiences rain at all seasons, but the hot summer is wetter than the mild winter: the southeastern region of the United States, much of Japan and the eastern seaboard of Australia fall within this region. The dry, warm temperate zone (C2) is also known as *Mediterranean* and

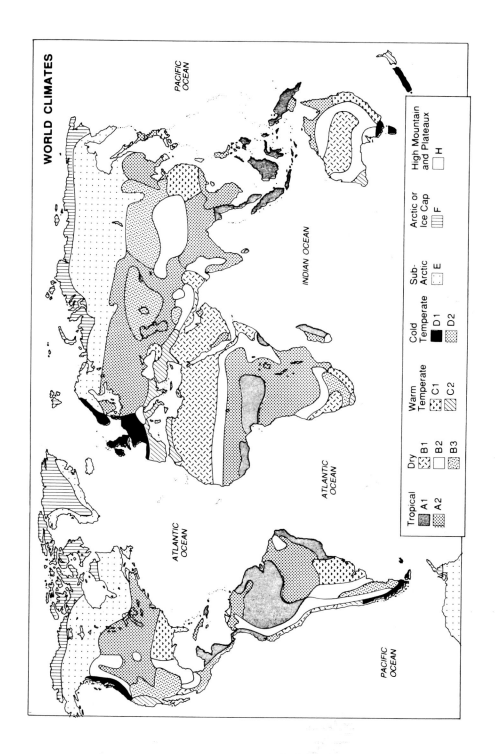

FIGURE 1
The world's climatic zones. Reproduced from *The World Weather Guide*[1] with the permission of Sheil Land
Associates.

is characterized by warm, dry summers and mild, wet winters. This type of climate is found around the Mediterranean and in California.

The so-called dry climates (B1, B2, and B3) again affect few major museums, although it is possible that objects will need to be transported across these desert regions, particularly those in central Australia and western United States. The temperature in these regions varies from extremely hot to bitterly cold at certain seasons or higher altitudes.

Finally, tropical climates can be hot and wet all year (A1) or have distinct wet and dry seasons, the so-called *tropical monsoon* climate (A2). While the perennially hot and wet climate is restricted to a region close to the equator, the monsoon climate is found more widely distributed, particularly in the Indian subcontinent and South America.

As a guide to the climatic conditions that prevail in these regions, Table 1 contains a summary of temperature and relative humidity data for cities within each region. More comprehensive data are available in specific meteorological publications.[1]

Potential Effects of Climate

The data in Table 1 illustrates several potential problems that may be encountered when transporting works of art. First, the external climate may be considerably different to that within the museum. For instance, many museums in North America and Europe maintain a temperature in the range 18°-24°C (64°-75°F) and a relative humidity of 45%-60% throughout the year. The climates in zones D and E, however, show average temperatures that vary from -15° to 30°C (5°-86°F) while exterior relative humidity is generally greater than the conditions maintained in the museum. Paintings will need to be packed in materials that can protect them from these exterior conditions.

Second, the climate in the sending and receiving cities may be very different, particularly if one is in the northern and the other in the southern hemisphere. For example, a transfer from Berlin to Sydney in February will be from a cold, damp winter climate to the hot and somewhat drier summer in Australia. Protection against the prevailing external environments in both locations will be required.

Third, the objects may need to be transported through a number of different climatic zones. For example, a shipment from New York to Los Angeles by road may pass from a cold, continental climate (D2), through the warm, wet temperate climate (C1) of the southern states and the dry climate (B3) of the western states, to the Mediterranean climate (C2) of California. The painting will need to be protected against these changes either by the use of appropriate packing materials or by the use of climate-controlled transportation.

Table 1 does not highlight the potential problem caused by precipitation, which may increase the local relative humidity or prove a hazard in itself. It is important, therefore, to protect paintings from the possibility that they may be left outside in rain and from the effects of increased relative humidity that may ensue.

The following sections describe the way in which the climate is modified by the means of transport used to move objects between museums.

TRANSPORT BY ROAD

Unconditioned Vehicles

The environment within stationary unconditioned vehicles is determined by the prevailing external conditions. The temperature within the vehicle will be increased by solar gain if it is parked in direct or reflected solar radiation. The temperature rise will depend upon the strength of radiation and degree of insulation of the cargo compartment of the vehicle and will clearly be greatest where the total solar radiation is most intense, in desert areas for instance. Conversely, the internal temperature may be reduced if there is air movement around the outside skin of the vehicle.

The conditions are further modified in a moving vehicle. In cold weather the temperature inside the cargo compartment may be in-

TABLE 1

A summary of world climatic conditions: average temperature and relative humidity for representative cities throughout the world.

City	Jakarta	Calcutta	Khartoum	Las Vegas	Tokyo	New Orleans	Buenos Aires	Sydney	Lisbon	Rome	Los Angeles	Cape Town	London	Paris	Christchurch	Vancouver	Berlin	Vienna	Chicago	New York	Quebec
Climatic zone	A1	A2	B1	B3	C1	C1	C1	C1	C2	C2	C2	C2	D1	D1	D1	D1	D2	D2	D2	D2	E
February T(°C) min[1]	23	15	16	1	-1	10	17	18	8	5	8	16	2	1	12	1	-3	-3	-7	-4	-17
February T(°C) max[1]	29	29	34	19	9	18	28	26	15	13	19	26	7	7	21	7	3	3	1	3	-8
February RH(%) AM[2]	95	82	28	56	71	85	83	71	80	86	74	77	85	87	71	91	89	80	79	70	80
February RH(%) PM[2]	75	45	15	25	48	66	63	65	64	64	53	54	72	73	60	78	78	66	69	58	70
May T(°C) min	24	25	25	11	12	20	8	11	13	13	12	9	8	10	4	8	8	10	10	12	5
May T(°C) max	31	36	42	32	22	28	18	19	21	23	22	19	17	20	13	18	19	18	18	20	16
May RH(%) AM	94	77	24	31	85	82	90	77	68	77	86	91	70	83	85	88	80	74	75	70	75
May RH(%) PM	69	62	13	12	62	62	74	63	57	54	59	65	57	55	69	63	58	52	60	54	65
August T(°C) min	23	26	24	19	22	24	6	9	17	20	16	8	13	14	2	12	13	15	18	19	12
August T(°C) max	31	32	37	39	30	32	16	17	28	30	28	18	21	24	11	23	23	24	26	27	23
August RH(%) AM	90	88	67	32	92	84	90	72	64	73	87	90	76	87	81	90	88	78	79	79	83
August RH(%) PM	61	82	41	15	66	63	74	56	49	43	54	65	62	61	66	62	61	54	60	60	73
November T(°C) min	23	18	20	2	6	13	13	16	11	9	10	13	5	5	8	4	2	3	1	3	-4
November T(°C) max	30	29	36	22	16	21	24	23	17	16	23	23	10	10	19	9	7	7	8	11	2
November RH(%) AM	92	80	34	49	83	83	79	65	81	87	62	74	85	91	64	91	92	84	79	75	81
November RH(%) PM	68	63	19	25	58	63	60	60	68	66	38	56	78	79	64	84	83	74	65	60	79

Notes

[1] Average maximum or minimum daily temperature for the month

[2] AM measurement made between 06:00 and 09:00; PM measurement made between 12:00 and 16:00

creased by solar gain or by heat generated by the engine or other part of the vehicle. The latter source of heat will clearly be strongly dependent on the construction of the vehicle, only being important when there is a possibility of heat transfer to the cargo compartment. In extremely cold conditions, the internal temperature is some 5°-10°C (9°-18°F) greater than the exterior.[2] In hot conditions, air movement across the exterior of the cargo compartment, caused by motion, gives a typical reduction of the internal temperature of 6°-9°C (10°-17°F).[3] No figures are available to indicate the degree of cooling caused by the evaporation of moisture from a wet vehicle.

Less information is available about the change of relative humidity that may occur in unconditioned vehicles. When the temperature inside the vehicle increases, the relative humidity will decrease. This decrease will be lessened if water vapor diffuses into the cargo compartment from the external environment. The opposite argument will apply for a decrease in temperature.

In general, less extreme conditions are experienced in moving vehicles. The movement of the vehicle has a mitigating effect on cargo temperature, particularly by increasing convection in hot weather.

Conditioned Vehicles

Theoretically, the use of a conditioned vehicle, that is, a vehicle with a climate-controlled cargo compartment, allows the conditions within the museum to be maintained throughout the transport. The ability of the conditioning system to maintain the desired temperature and relative humidity is related to its capacity and the extremes of climate with which it is expected to cope. Clearly the vehicle will be subject to solar gain in the same manner as an unconditioned vehicle. The system must be capable of dissipating the heat or moisture experienced in the hottest or dampest climate to be encountered during the journey.

It is important to ensure that the conditioning system is switched on and remains in operation throughout the transport, including overnight stops on long journeys, when the external temperature will be at its coldest. The climate-controlled vehicle cannot solve the problem that arises when sending and receiving institutions maintain different environments, although it might be feasible, if rather overzealous, to adjust the temperature and relative humidity set-points during the journey.

TRANSPORT BY AIR

There are several potential climatic hazards associated with air transport, both on the ground and in the air. On arrival by road vehicle from the museum, works of art will generally enter the cargo shed. Conditions in the shed are often uncontrolled or maintained at "human comfort levels" for the employees. Human comfort levels do not always coincide with those suitable for temperature or moisture-sensitive objects. Particularly during the summer, the shed may experience considerable solar gain.

After loading onto a palette or into a container and prior to loading onto the aircraft, cargo may be left outside on the *tarmac* for some considerable time, subject to prevailing external climatic conditions. The dangers here include precipitation and extremes of relative humidity and temperature, possibly exacerbated by solar gain or by conduction of heat to or from the ground, which may be at a very different temperature.

The cargo holds of aircraft may occasionally be conditioned to specific requirements, but generally the conditioning of temperature and pressure is only partial. On the ground the temperature in an unconditioned cargo hold will be subject to external conditions and to effects such as solar gain. Measurements have indicated that in extreme conditions a temperature gradient exists within the hold.[4]

The climatic conditions given in Table 1 are for ground level in the various cities. The dependence of temperature and pressure upon altitude is illustrated in Figure 2. As an aircraft gains altitude the temperature and

303

pressure drop. Because the relative humidity is pressure related, a change in relative humidity is also observed with altitude.[5]

The environment within conditioned cargo holds varies with type of aircraft. The hold pressure during the flight at altitude is generally not allowed to fall below 75-85 kN/m² (10.5-11.9 psi), compared to approximately 105 kN/m² (17.7 psi) at sea level.[6] Measurements in the cargo compartment indicate that the temperature decreases during a flight at altitude until it reaches a steady temperature in the range 5°-20°C (41°-68°F), while the relative humidity is also rather low, at 10%-25%.[7] When paintings are hand carried by air, they experience the environment of the passenger cabin. This cabin is generally pressurized to the same level as the cargo hold while, for passenger comfort, the temperature is maintained at a higher level. Be-

cause of this, the relative humidity in the passenger cabin may be very low, as little as 6%-10%.[8]

Packing cases need to be designed to ameliorate these extremes of temperature and relative humidity under conditions of low pressure. This may necessitate efficient seals which can withstand the pressure difference at altitude.

TRANSPORT BY RAIL

If paintings are moved by rail as cargo, the climatic conditions will be similar to those experienced in road vehicles. Heated cargo carriages have been used to transport objects through very cold climates.[9] During one of the journeys monitored on that occasion, the outside temperature fell to -30°C (-22°F), while the temperature inside the train was

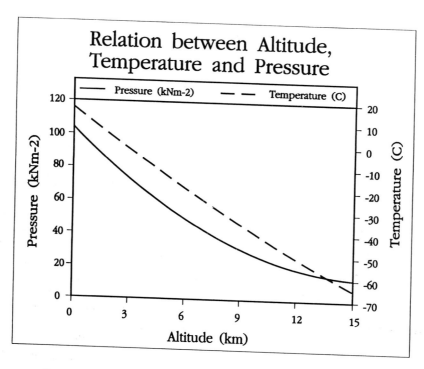

FIGURE 2
The relation between altitude, temperature, and pressure.

maintained at 15° (59°F) ± 5°C. The climate inside the packing case was extremely stable; both temperature and relative humidity remained within a narrow range.

If cased paintings travel on a passenger train, the carriages will be heated, or in modern trains, air conditioned. The temperature and relative humidity may, however, be maintained at human comfort levels rather than those desired for the preservation of the object in transit.

TRANSPORT BY SEA

Because of the comparatively slow speed of sea transport, relatively few paintings are now transported by this method: these tend to be those that are too large for even the most commodious cargo aircraft. The air temperature will depend on the location but has also been found to be related to the sea temperature.[10] Cargo on deck will be subject to the normal problems of solar gain while the low speed does not normally afford any cooling effect in the absence of wind.

The relative humidity can be extremely variable, but proximity to a large reservoir of water results in frequent high relative humidities.[11] This has been reported to give rise to mold growth in some instances.[12] Measurements made during a two-week sea journey from the northern to the southern hemisphere in May indicated that the external temperature varied between 13° and 31°C (55°-88°F), being highest in the tropics, while the relative humidity was erratic and ranged between 64% and saturation.[13] Similar figures were obtained for a journey across the Atlantic in June, although it was noted that fluctuations in relative humidity in the hold were less severe; the relative humidity here ranged between 58% and 72%.[14]

One particular feature of transport by sea that should be considered is that when a climate-controlled vehicle is loaded onto a ferry it is not always possible for the conditioning equipment to be left running while the vehicle is on the cargo deck. During a long crossing in extreme conditions, the temperature or relative humidity in the vehicle may equilibrate to the external climate.

MONITORING ENVIRONMENTAL CONDITIONS

Monitoring may be divided into three categories. First, general monitoring of the conditions that prevail inside road and rail vehicles, aircraft and ships; second, monitoring to assess the performance of packing cases in test circumstances and finally, specific monitoring of the conditions experienced by works of art in transit.

With access to the appropriate literature, it is possible to find results of monitoring experiments of the first type, conducted by the transport, armament, and food industries.[15] While there have been many studies that have sought to monitor the conditions within the case during laboratory climate tests, there have been far fewer sets of measurements made during routine journeys with paintings. There are a number of constraints, which make recording during a "real" art transport difficult, the main limitation being that of space within the case.

Until quite recently the main instrument for climatic monitoring in packing cases was the recording thermohygrograph. The major problem with using this type of instrument is that despite often elaborate precautions to isolate the device, the trace can be adversely affected, or, at worst, the thermohygrograph disabled by shock and vibration. One ever-optimistic conservator looking for a silver lining suggests that unusual pen movements may even be used crudely to assess shock and vibration.[16]

In most recently published studies, environmental measurements have been made using temperature and relative humidity probes connected to battery-powered solid-state memory recorders. One notable exception, where the journey is still considered sufficiently smooth to allow a recording thermohygrograph to be used, is transport by sea.[17] In several recent studies, the "Squirrel" data logger manufactured in Cambridge, England has been used.[18] This logger is particularly suitable for measurements inside packing cases because it is compact, uses a standard nine-volt battery, generates negligible heat, and is relatively simple to operate.

Furthermore, data from the logger are easily transferred to a personal computer for analysis and permanent storage.

At this time, new, even smaller battery-powered temperature and relative humidity recording devices are becoming available. There are, however, potential drawbacks with all solid-state loggers of this type. They will need to be tested for interference before being used in aircraft and may create delays when security checks are conducted at airports.

A series of studies have been made to assess the performance of packing cases exposed to extremes of climate in laboratory tests.[19] Further studies have been made of individual road and air transports to assess the temperature and relative humidity experienced during each stage of the journey, often to complement a laboratory assessment of the performance of a case design.[20] Less frequent are studies of journeys by air that combine the measurement of temperature, relative humidity, and air pressure. A log of these variables, as well as shock and vibration, was made on magnetic tape for a journey from Cape Town to London,[21] while more recently, a solid-state logger was used during a series of journeys from London to Tokyo and back.[22]

To date, there have been only two published reports of systematic studies of a significant number of journeys, the first conducted by the National Gallery of Art, Washington,[23] and the second by the National Gallery and National Maritime Museum, London.[24]

The program of measurement conducted by the National Gallery of Art examined thirty-one journeys by road, air, and a combination of road and air. Eleven sets of measurements from hand-carried cases were included in the thirty-one journeys. The study concluded that the environment within all the cases was surprisingly stable. The environment within hand-carried cases was extremely stable, with relative humidity variations of better than ± 2% being measured, compared to a variation of ± 5% relative humidity in double wooden crates transported as cargo.[25]

In the National Gallery, London study, the environment was monitored during twenty-three journeys over a period of two years. The data comprised measurements made during journeys by road, some of which included ferry crossings, and by air. A few air journeys also included intermediate takeoffs and landings. Relative humidity within the packing cases during actual journeys was found to show good stability, but the temperature was found to be less stable, as it tended toward equilibrium with the surrounding climate. The results suggested that adequate time (twenty-four hours) should be allowed for cases and their contents to equilibrate before unpacking and highlighted the problems associated with the different levels of temperature and humidity maintained in various museums, for which there was no easy solution.[26]

Several of the monitoring exercises have been used to calculate thermal half-times for packing cases, in order to provide a comparison between the thermal insulation properties of different materials and designs.[27] Data from other studies have been used to calculate the equilibrium moisture content of the works of art and of the materials within the packing case,[28] since for the preservation of works of art containing humidity-sensitive materials, the equilibrium moisture content is a better indicator of the stability of the environment than the relative humidity.[29]

EFFECT OF ENVIRONMENTAL CONDITIONS ON PACKING MATERIALS

Although no mention has been made in this paper of the design and construction of packing cases to protect works of art from extremes of climatic variation, shock, and vibration, their use has been implied by much of the discussion in the previous sections.

The materials used in these cases are of two general types. First there is a rigid outer shell to protect the paintings within from mechanical damage and to provide an initial barrier against the climate, particularly precipitation. Second, there is a layer, or layers,

TABLE 2

The dynamic cushioning properties of foams as a function of temperature. Figures are percentage increase of the value at 20°C (68°F).

Increase in Force (%)

Foam type	-40°C	-20°C	0°C	20°C	40°C	60°C
Expanded Polyethylene (Ethafoam)	28	10	2	0	10	30
Expanded Polyethylene (Plastazote)	52	29	9	0	18	39
Ethylene Vinyl Acetate (Evazote)	84*	49	18	0	12	28
Polyurethane (Polyether)	114	44	10	0	6	17
Bonded Polyurethane (Chipfoam)	102*	68	20	0	4	12

*Measured at -30°C (-22°F)

of more flexible material to support and cushion the object from shock and vibration and to act as an additional barrier to the outside climate by providing insulation against thermal change or buffering against variations in relative humidity.

The thermal coefficient of expansion for most of the case construction materials used is low enough to be disregarded under normal circumstances. For metal cases, some allowance might be needed for expansion and possible warping if the case is exposed to direct solar radiation or if left in subzero temperatures on an airport runway. For example, a sheet of aluminum 3 m (3.28 yds.) in length will contract by around .15 cm (.059 in.) if cooled from 20° to 0°C (68°-32°F), which may be enough to distort rubber seals and compromise the environment within a case. For this reason, it may be best to construct the side of a large metal case from several smaller panels.

The dynamic cushioning properties of the expanded foam materials used in packing cases are affected by changes in temperature. Table 2 shows the effect of temperature on the performance of some of the most com-

monly used materials. The performance is assessed by measuring the percentage increase in the force felt by an object when it is dropped from 90 cm. The data is normalized to an optimum loading at a temperature of 20°C (68°F).

Finally, the physical properties of certain materials may be affected by increased relative humidity. While the open cell polymeric foams used in packing might be expected to respond to changes in moisture content, data available for the foams listed in Table 2 suggest that these are unaffected by moisture. In contrast, the structural properties of paper-based products, particularly corrugated cardboard, are known to be moisture sensitive.[30] □

ACKNOWLEDGMENTS

I wish to thank Mervin Richards at the National Gallery of Art, Washington for supplying copies of references 2 and 15; David Fellowes and John Roffey of Kent Services Ltd. who supplied information on the effect of temperature and relative humidity on the cushioning properties of packing materials; the Meteorological Office at Bracknell for climatic information; and Sheil Land Associates1 for permission to reproduce Figure 1.

NOTES

1. E. A. Pearce and C. G. Smith, *The World Weather Guide,* 2nd edition (London, 1990); HMSO, *Tables of Temperature, Relative Humidity and Precipitation for the World,* Parts I-VI (London, 1958-1978).

2. F. E. Ostrem and B. Libovicz, "A Survey of Environmental Conditions Incident on to the Transportation of Materials," USDOT, Office of Hazardous Materials (Washington, 1971).

3. Ostrem and Libovicz 1971.

4. Ostrem and Libovicz 1971.

5. C. Karp, "Calculating Atmospheric Humidity," *Studies in Conservation* 28 (1983), 24.

6. Karp 1983, 24; O.E.H. Schroeder and F. M. Hamm, "Art in Transit," *Maltechnik-Restauro* 81, 4 (Callwey, Munich, 1975), 225; K. Toishi, "Jet Transport of Art Objects," in *Museum Climatology,* ed. G. Thomson, IIC London Conference (1967), 41; G. Martin, unpublished results (1990).

7. Toishi 1967, 41; S. Hackney, "The Dimensional Stability of Paintings in Transit," *International Council of Museums Committee for Conservation* Preprints, 8th Triennial Meeting (Sydney, 1987), 597; R. M. Merrill, "In the Service of Exhibitions: The History, Problems and Potential Solutions of Cultural Materials in Transit," *American Institute for Conservation Preprints of the Sixteenth Annual Meeting,* (New Orleans, 1988), 138.

8. N. Stolow, *Conservation and Exhibitions* (London, 1987), 193.

9. N. Stolow, "Some Studies on the Protection of Works of Art During Travel," *Recent Advances in Conservation: IIC Rome Conference 1961,* ed. G. Thomson, (London, 1963), 9.

10. Ostrem and Libovicz 1971.

11. Ostrem and Libovicz 1971.

12. Toishi 1967, 41.

13. P. Cannon-Brookes, "The Transportation by Sea from Southampton to Cape Town of Oil Paintings in a Container with Environmental Monitoring," *International Council of Museums Committee for Conservation* Preprints, 9th Triennial Meeting (Dresden, 1990), 401.

14. N. Stolow, *Controlled Environment for Works of Art in Transit,* (London, 1966).

15. Ostrem and Libovicz 1971; F. E. Ostrem and W. D. Godshall, "An Assessment of the Common Carrier Shipping Environment," *General Technical Report FPL 22* USDA, Forest Products Laboratory (Madison, Wisconsin, 1979).

16. Stolow 1987, 145.

17. Cannon-Brookes 1990, 401.

18. D. Saunders and R. Clarke, "Monitoring the Environment within Packing Cases Containing Works of Art in Transit," *International Council of Museums Committee for Conservation* Preprints, 9th Triennial Meeting (Dresden, 1990), 415; N. Kamba, "Variation in Relative Humidity and Temperature as Measured in a Packing Case," *International Council of Museums Committee for Conservation* Preprints, 9th Triennial Meeting (Dresden, 1990), 405.

19. Stolow 1963, 9; S. Staniforth, "Packing: A Case Study," *National Gallery Technical Bulletin* 8 (1984), 53; S. Staniforth, "The Testing of Packing Cases for the Transport of Paintings," *International Council of Museums Committee for Conservation* Preprints, 7th Triennial Meeting (Copenhagen, 1984), 84/12/7; T. Green and S. Hackney, "The Evaluation of a Packing Case for Paintings," *International Council of Museums Committee for Conservation* Preprints, 7th Triennial Meeting (Copenhagen, 1984), 84/12/1; A. Stephenson-Wright and R. White, "Packing: An Updated Design, Reviewed and Tested," *National Gallery Technical Bulletin* 11 (1987), 36.

20. Hackney 1987, 597; Stolow 1963, 9; Staniforth 1984, 53.

21. Schroeder and Hamm 1975, 225.

22. Martin 1990.

23. Merrill 1988, 138.

24. Saunders and Clarke 1990, 415.

25. Merrill 1988, 138.

26. Saunders and Clarke 1990, 415.

27. Saunders and Clarke 1990, 415; Green and Hackney 1984, 84/12/1; Stephenson-Wright and White 1987, 36.

28. Kamba 1990, 405.

29. Hackney 1987, 597.

30. Ostrem and Godshall 1979.

SOFT PACK—THE SOFT OPTION?

David Saunders, Christine Leback Sitwell, Sarah Staniforth

ABSTRACT: *The National Trust transport more than one-hundred paintings every year between houses located throughout England, Wales, and Northern Ireland, and conservators' studios, which may be far from the houses. It has not proved practical, nor financially possible, to provide packing cases for these paintings. They have been soft packed, that is, the corners of the frames have been cushioned and the package has been sealed using polyethylene. The monitoring described is to evaluate how well soft pack protects paintings in transit. Temperature, relative humidity, shock, and vibration have been recorded. Results recorded with National Gallery, London paintings packed in Dristyle cases are used as the benchmark. The protection offered by transit frames has also been evaluated.*

INTRODUCTION

The National Gallery, London has been involved in assessing the performance of packing cases and monitoring conditions that are experienced by paintings during transport for many years.[1] It has been possible to make discrete measurements of several environmental variables of interest; that is temperature, relative humidity and, occasionally, pressure. Unlike these factors, which change relatively slowly during transport, the measurement of shock and vibration demands that a continuous record be made of the acceleration experienced by the painting. The volume of data amassed is considerable and additionally requires the use of a continuous rather than periodic recording technique, such as magnetic tape. This equipment is generally bulky and requires considerable power for its operation. The aim of the program of research described in this paper was to provide a compact, battery-powered unit to monitor shock and vibration levels experienced by paintings in different packing systems and during transport by different vehicles. All the paintings studied were on canvas.

The National Trust has been concerned to discover whether the "soft packing" that it provides for its paintings during transport within the United Kingdom offers an acceptable level of protection. Temperature and relative humidity levels experienced by paintings during transport have been routinely monitored for several years, but until the development of the new National Gallery logging equipment, shock and vibration has not been measured. Results recorded with National Gallery paintings packed in Dristyle cases are used as the benchmark.[2]

Unlike a museum whose collection is housed in one location, the National Trust is responsible for a collection of eight-thousand paintings displayed in 120 houses scattered throughout England, Wales, and Northern Ireland. Within the National Trust, there are a number of circumstances when it is necessary to transport paintings either between houses, to conservator's studios, or to exhibitions. Major structural work within a house may necessitate the complete removal of paintings to another house with adequate storage facilities. The Trust does not have its own conservation studio and, therefore, relies on the services of private conservators and institutions who are seldom located near the houses. Approximately eighty paintings a year are treated and as the paintings are generally conserved during the winter months

(when the houses are closed to the general public), two major transport movements occur in November and March. There are requests for the loan of up to twenty paintings every year from the National Trust to exhibitions within the United Kingdom.

SOFT PACK

National Trust paintings are usually soft packed for transport within the United Kingdom. Soft packing involves the use of cushioning material and polyethylene sheeting to protect the frame and painting from handling and transport. The term soft pack describes a packing system that has been used by many museums for a number of years and no doubt has acquired a plethora of names.[3] Its major advantage is its cheapness which is an important consideration for any museum or organization with a limited budget. In addition, it is a simple system to use and can be undertaken in areas of limited space or access. For the Trust, this is significant as large packing cases can be awkward to move within houses and difficult to handle and pack due to lack of space and mechanical equipment.

Before the decision to soft pack a painting is agreed, certain criteria must be met. The painting must be in stable condition and properly secured in its frame to prevent movement during transport. Any painting with a very ornate frame is not considered suitable because of the possibility of damage to the frame due to handling and transport.

Certain recommendations are made for vehicles. First, they should ideally have an air-ride suspension system and, if the transport occurs in winter where there could be adverse weather conditions, a temperature controlled body. Second, the vehicle should be of sufficient size to accommodate the number of paintings being transported without excessive stacking. Ideally, cased paintings should not travel with uncased paintings but if this must occur, then the cased paintings must be secured away from the uncased paintings.

For soft packing, the Trust uses either Jiffy foam (a polyethylene foam in sheet form) or

AirCap for frames with plaster or carved molding.[4] A length of the cushioning material is cut, folded to provide a double or triple thickness, positioned over the corner and secured on the reverse with tape. The effectiveness of the corner cushioning material has never been assessed by testing for shock and vibration. Its primary function is to protect the frame from physical handling and in its position while it is secured to the side of the vehicle.

A continuous sheet of polyethylene covers the back and front of the painting and the edges are sealed with tape. To prevent the polyethylene from touching the canvas, cotton tapes are tied around the frame before the polyethylene is secured over the painting. The polyethylene covering protects the painting from rain, dust and any airborne pollutants. In addition, it is thought to provide a certain degree of environmental stability as it lessens the changes in relative humidity within the polyethylene envelope.[5]

TEMPERATURE AND RELATIVE HUMIDITY LOGGING

Temperature and relative humidity levels were monitored inside and outside the polyethylene using a Squirrel data logger.[6] The soft packing materials provide little or no thermal insulation. However, the air trapped inside the sealed polyethylene parcel appears to be well buffered by the moisture containing materials associated with the painting. The relative humidity varies with temperature change in a similar way to variations recorded inside packing cases. That is, relative humidity falls as temperature falls and rises as it rises. Garry Thomson predicts that for a volume of air in a case that contains an excess (more than 1 kgm^{-3} [.0623 lb./ft.3]) of wood, the relative humidity will change in the same direction as temperature by about 0.35% RH for each °C change in temperature.[7] In previous tests on packing cases we have found that the relative humidity changes by approximately 0.5% RH for each °C change in temperature.[8]

A painting that was wrapped in polyethylene for a journey from Kedleston Hall, a Na-

312

tional Trust house in Derbyshire to an exhibition at Christie's in London, showed relative humidity changes of up to 1% RH for each °C change in temperature that occurred during the journey. The temperature and relative humidity recording of the journey is shown in Figure 1. The minimum relative humidity recorded inside the polyethylene was 55% RH and the maximum was 62%. The temperature varied between 5° and 11°C. It is not possible to see a direct relationship between temperature and relative humidity, but the general pattern is that relative humidity falls as temperature falls and vice versa. There are unexplained changes in relative humidity recorded between 13.00 and 15.00 hours on 19 December 1990, which was when the painting was being removed from the truck and was placed for temporary storage in Shugborough, a National Trust house in Staffordshire, while more works were being collected for transport to the Christie's exhibition. It may be that the handling temporarily disturbed the polyethylene, allowing air from outside to leak into the package.

We now have numerous recordings of temperature and relative humidity inside the polyethylene of soft packed paintings, and all show similar behavior. There can be no doubt that minimum relative humidity changes are recorded when the temperature remains fairly constant, and these circumstances represent the minimum moisture content changes for the painting materials that we seek to protect, that is, wood, canvas, paint, and ground layers, and most importantly of all, glue size layers.

The importance of maintaining constant temperature and relative humidity as the way of ensuring constant moisture content has been emphasized in a theoretical paper by Hackney.[9] Other authors have shown how difficult it is to achieve in practice.[10] The recordings made on soft packed paintings clearly show us the importance of ensuring that temperature remains as constant as possible throughout journeys, and to achieve this, trucks should be thermostatically controlled. Relative humidity control is not needed as long as the polyethylene is well sealed.

Figure 2 shows the temperature and relative humidity variations recorded within the polyethylene during the transport of a soft packed painting from London to Kedleston Hall in a vehicle with thermostatic temperature control. Although the external temperature was low, as the transport occurred during the winter months, the temperature within the polyethylene remained almost constant. As a result the relative humidity trace shows little variation.

SHOCK AND VIBRATION LOGGING

The Need for New Shock and Vibration Logging Equipment

Records of shock and vibration on magnetic tape, or directly onto a chart recorder, have been made for different types of transport.[11] In addition measurements have been made within packing cases in drop and vibration table tests.[12] As already indicated, the equipment available until now has generally been bulky and has required considerable power to operate. Space constraints within the case, imposed by the need to minimize the cargo costs, and the desirability of using established data recording technology led to the development of the shock and vibration logging equipment described below.

Equipment and Procedure

The apparatus used to measure shock and vibration was developed in conjunction with the Engineering Department at Cambridge University and Eltek Electronics, and is represented diagrammatically in Figure 3.[13] The equipment is based around a modified Squirrel data logger, as used for the logging of temperature and relative humidity. The modified data logger has 128K of memory, as opposed to 16 or 32K in a standard Squirrel and is fitted with seven size C, 1.5 volt batteries which provide all the power required to operate both the logger and the associated amplifier unit. The battery life varies according to the measurement interval, but is in the region of one week for a typical experiment.

The remainder of the equipment com-

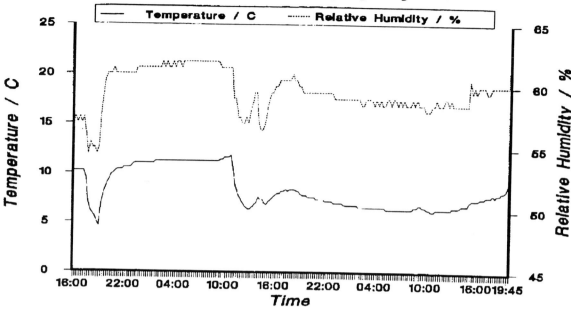

FIGURE 1
Temperature and relative humidity recorded during transport of a painting from Kedleston Hall to Christie's. Record begins at 16.00 hours on 18 December 1990.

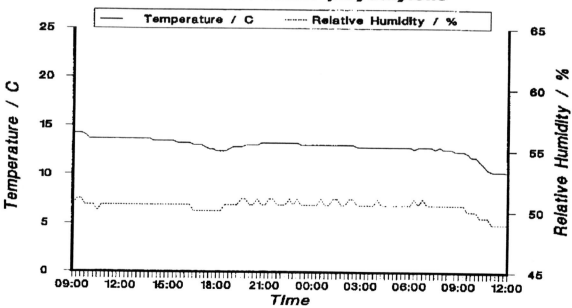

FIGURE 2
Temperature and relative humidity recorded during transport of a painting from Fine Art Services (FAS) warehouse, London to Kedleston Hall.

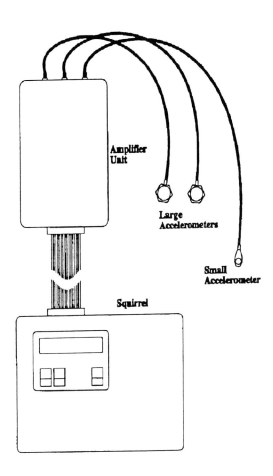

FIGURE 3
Diagrammatic representation of the new shock and vibration logging equipment.

prises up to three accelerometers and an amplifier unit. The three accelerometers used may be of two types. The larger accelerometers weigh 17.5 g (.617 oz.) and have a typical response of approximately 25 pCG^{-1} (pica-Coulombs per unit G). These are suitable for attaching to the frame of the painting or to the interior wall of a packing case, using either powerful glue or a threaded bolt to which they may be secured. The second type of accelerometer is much lighter, having a mass of only 1.5 g (.053 oz.) making it suitable for attaching to the rear of a canvas, usually using double-sided adhesive tape. Since the response of this accelerometer is only 1.5 pCG^{-1}, it is rather noisier than the larger accelerometer.

Each accelerometer is connected to the amplifier unit by a 2-3 m (6.6-9.8 ft.) cable with "microdot" connectors. The signal from the accelerometer passes through an amplifier and pre-filter before passing through a series of secondary filters that divide the signal into five frequency ranges. These frequency ranges have been selected to provide information in those frequency bands in which vibrations have been shown to be produced by differing types of transportation.[14] The five bands are as follows, 0-5 Hz, 5-10 Hz, 10-20 Hz, 20-50 Hz and 50-500 Hz. The amplification of the signal can be altered so as to provide a 100% reading corresponding to different inputs. This is achieved by changing the value of a pair of resistors in the amplifier unit. For ease of recalibration, six different combinations of resistors have been assembled on header units and may be interchanged to provide a range of responses. In the experiments described in the section which follows the amplifier was calibrated so as to give a 100% reading for an input of 3 G. Although by using this response setting severe shock, as might result from the dropping of the painting, would be offscale, it is possible to see in some detail the low magnitude vibrations experienced during the road journey.

Each of the signals from the three accelerometers are thus divided into five signals, a total of fifteen values, each associated with one of the fifteen channels of the data logger.

315

FIGURE 4
Two of the larger acelerometers attached to the frame of a painting prior to wrapping.

FIGURE 5
The squirrel and amplifier housed in a packing case.

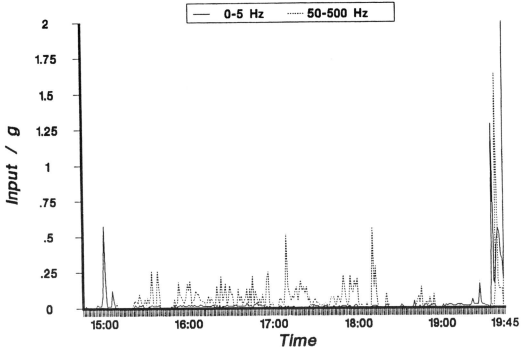

FIGURE 6
Vibration in the 0-5 and 50-500 Hz bands for the frame (vertical axis) during transport from Kedleston Hall to Christie's.

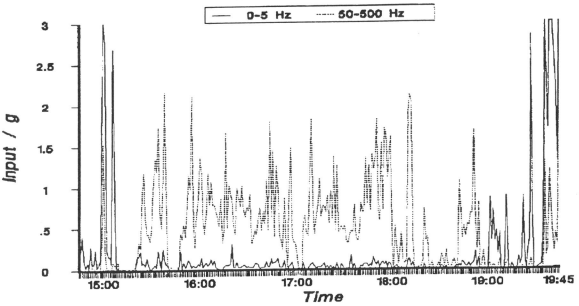

FIGURE 7
Vibration in the 0-5 and 50-500 Hz bands for the canvas during transport from Kedleston Hall to Christie's.

317

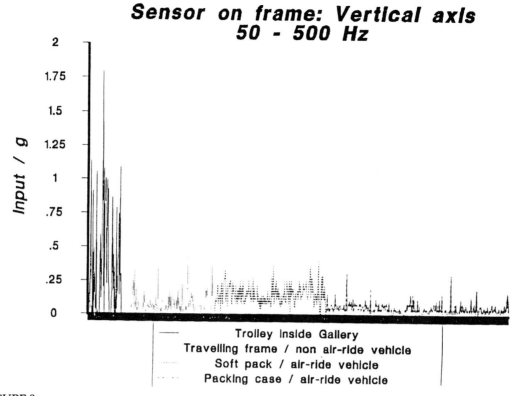

FIGURE 8
Vibration in the 50-500 Hz band for the frame (vertical axis) during transport of a painting using different packing methods and vehicles.

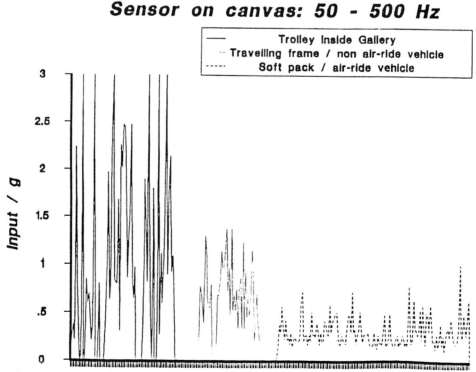

FIGURE 9
Vibration in the 50-500 Hz band for the canvas during transport of a painting using different packing methods and vechicles.

As these are instantaneous values, they need to be held in some way for sampling by the data logger. To achieve this, a capacitor associated with each channel holds the peak signal generated by the accelerometer for that frequency range until it is discharged by a signal from the data logger. The Squirrel can be programmed to allow the interval between discharges of the capacitor to be varied. This interval is usually set at one second. If the value from each channel was recorded by the Squirrel each second, the 128K memory would be exhausted after less than two and a half hours. To overcome this problem, the Squirrel may be programmed to record at a longer time interval, for instance every thirty seconds or every minute. The value recorded by the Squirrel at this time is the highest value transferred from the amplifier unit during the previous time period. The final record will thus be of peak G values for each of the frequency ranges for each recording time period.

The procedure for each experiment was broadly similar. Two of the larger accelerometers were mounted on a bracket that was secured to the frame of the painting to measure vertical and horizontal acceleration (Figure 4). In most of the experiments, the small, lightweight accelerometer was attached to the rear of the canvas to measure acceleration perpendicular to the canvas plane. In one experiment with a packing case a third large accelerometer was attached to the inner surface of the case to measure the vertical acceleration. This was then compared to the acceleration in this axis experienced by the painting frame.

The cables linking each accelerometer to the amplifier unit were restrained using adhesive tape and cable ties to prevent movement of the cable, which might create a spurious signal, particularly from the small accelerometer. The amplifier and Squirrel were contained either within the packing case or in a separate box attached to the soft packed painting. A typical installation of the amplifier and Squirrel in a packing case can be seen in Figure 5.

On completion of the experiment, the apparatus was dismantled, the data read from the Squirrel into a personal computer, and graphs prepared using a commercial spreadsheet program.[15]

Results

A number of movements by road were monitored. During each of the journeys a record of the times of departure, arrival, unloading, and unpacking was made for comparison with the logged data. Where possible, a description of the type of road surface encountered was also included in this record.

To compare the vibrations experienced by soft packed paintings with those for cased paintings or paintings attached to traveling frames, a number of journeys in vehicles fitted with conventional and air-ride suspension were monitored. Finally, a record was made of the vibrations experienced by a painting while it was moved through the National Gallery on a trolley.

As is inevitably the case with such studies, it is impossible to include all the data in either tabular or graphical form. The text and graphs which follow describe the main findings from the journeys studied.

Overall, the level of vibration experienced in transit was quite modest. Offscale readings, that is above 3 G's, were generally observed only during loading and unloading of the vehicle and while the paintings were being moved within the house or gallery. During loading and unloading there was considerable vibration in the 0-5 Hz range, due to handling of the painting, with little input in the higher frequency ranges. In contrast, during the journey by road the highest inputs are in the 50-500 Hz band, presumably corresponding to the high frequency vibrations from the road surface or motor. Little activity in the 0-5 Hz band is seen during the journey. Figures 6 and 7 illustrate the data for the frame (vertical axis) and canvas for a painting in a travelling frame during a journey in a vehicle with conventional suspension.

From Figures 6 and 7 it is apparent that considerably higher acceleration is experienced by the canvas than by the frame. This was generally found to be true in each of the

studies and for each frequency band, regardless of packing technique and vehicle. While the magnitude of vibration on the frame is less than about 0.5 G's except during the unloading, the canvas experiences vibrations of up to approximately 2 G's.

A comparison between the vibrations in the 50-500 Hz range (which is the range in which maximum activity is observed during the journey) experienced by paintings packed in different ways and traveling in different vehicles (Figure 8) and indicates that the lowest vibrations are experienced by cased paintings traveling in vehicles fitted with air-ride suspension. The sensor attached to the frame in the vertical axis registers vibrations of a magnitude of circa 0.1 G. In this study, a Dristyle case, of the type favored by the National Gallery and other institutions for some years, was used. Soft packed paintings or those attached to traveling frames experienced only slightly greater vibration, if transported in an air-ride vehicle, at approximately 0.2 G's in the vertical axis. Vehicles with conventional suspension gave similar vibrations but show periodic maxima of up to 0.7 G. It is interesting that by far the highest vibration, well above 1.0 G, is associated with the movement of the painting around the gallery on a trolley.

This is corroborated by a similar comparison of vibration of the canvas in the same frequency range shown in Figure 9. The magnitude of the vibrations is somewhat greater than for the frame. It was not possible to measure the canvas vibrations for any of the cased painting as they had been fitted with backboards. It is clear that most vibration is experienced by the painting moved on a trolley and least when an air-ride vehicle is the means of transport.

CONCLUSION

It is possible to maintain constant moisture content of soft packed paintings by controlling temperature within vehicles, providing the polyethylene is well sealed.

Levels of vibration recorded during transit are surprisingly low. Lower frequency vibrations are associated with loading and unloading while higher frequency vibrations are experienced during transport.

As expected, paintings transported in packing cases in air-ride vehicles experience the least vibration. If air-ride vehicles are used, soft pack or traveling frames do not result in paintings experiencing appreciably higher levels of vibration in transit.

Interestingly, this research confirms what many conservators have considered the most hazardous part of any journey, that is, movements within galleries or other buildings prior to packing or after unpacking are the source of the greatest vibration.

The next progression would be to extend this monitoring to include other methods of packing and other forms of transport, particularly air and sea journeys. □

NOTES

1. Sarah Staniforth, "The Testing of Packing Cases for Paintings," ICOM *Committee for Conservation 7th Triennial Meeting* Preprints, Copenhagen (1984), 84/12/1-6; Sarah Staniforth, "Packing: A Case Study," *National Gallery Technical Bulletin* 8 (1984) 53-62; Ann Stephenson-Wright and Raymond White, "Packing: An Updated Design, Reviewed and Tested," *National Gallery Technical Bulletin* 11 (1987) 36-41; David Saunders and Richard Clarke, "Monitoring the Environment within Packing Cases Containing Works of Art in Transit," ICOM *Committee for Conservation 9th Triennial Meeting* Preprints, Dresden (1990), 415-422.

2. The National Gallery stock cases were manufactured by EPS Logistics Technology. (Following an internal reorganization in 1985, the company name changed from Dristyle Products Ltd to EPS Logistics Technology.) Dristyle cases are now available on lease from Kent Services Ltd., Sheerness Enterprise Centre, Bridge Road, Sheerness, Kent ME12 1RH, Tel. 0795 660812.

3. Dorothy Dudley, Irma Bezold Wilkinson et al., *Museum Registration Methods* Washington (1979), 105-106.

4. One United Kingdom supplier of Jiffy foam and AirCap is Abbott's Packaging Ltd., Gordon House, Oakleigh Road South, New Southgate, London N11 1HL, Tel. 071 368 1266.

5. Stephen Hackney, "The Dimensional Stability of Paintings In Transit," ICOM *Committee for Conservation 8th Triennial Meeting* Preprints, Sydney (1987) 597.

6. Sarah Staniforth, "Solid-State Memory Recorders," *UKIC Conservation News* 22 (November 1983) 11-12; Squirrel SQ16 data logger (from Grant Instruments [Cambridge] Ltd., Barrington, Cambridge CB2 5QZ, Tel. 0763 260811).

7. Garry Thomson, "Relative Humidity Variations with Temperature in a Case Containing Wood," *Studies in Conservation* 9 (1964), 153-169.

8 . Staniforth 1984, 84/12/10.

9. Hackney 1987, 597-600.

10. Nobuyuki Kamba, "Variations in Relative Humidity and Temperature as Measured in a Packing Case," ICOM *Committee for Conservation 9th Triennial Meeting* Preprints, Dresden (1990), 405-409.

11 Christine Leback Sitwell, "Vibration Test Results on an Air Ride Suspension Vehicles and Design Considerations for a Racking System," ICOM *Committee for Conservation 8th Triennial Meeting* Preprints, Sydney (1987), 601-606.

12. Staniforth 1984, 84/12/10-15; Timothy Green and Stephen Hackney, "The Evaluation of a Packing Case for Paintings," ICOM *Committee for Conservation 7th Triennial Meeting* Preprints, Copenhagen (1984), 84/12/1-6; Timothy Green, "Shock and Vibration—Test Results for Framed Paintings on Canvas Supports," ICOM *Committee for Conservation 8th Triennial Meeting* Preprints, Sydney (1987), 585-596.

13. The vibration logging equipment was designed and built in collaboration with Dr. James Woodhouse and Brian Wootton at the Engineering Department of Cambridge University. The modified Squirrel was supplied by Lucien Hatfield of Eltek Limited, 35 Barton Road, Haslingfield, Cambridge CB3 7LL, Tel. 0223 872111.

14. Sitwell 1987, 601-606.

15. Results were analyzed and graphs produced using the SuperCalc5 spreadsheet package (from Computer Associates).

TRANSPORTS OF DELIGHT

Hiltrud Schinzel

ABSTRACT: *The transportation of contemporary paintings has presented difficulties not found in traditional paintings. This is a consequence of the artists' choice of the variety of new materials used in modern paintings as well as the methods of application of those materials. Much of the damage that occurs to such works of art result from handlers' lack of experience in moving contemporary art. Where small mishandling incidents often present no problem to more durable, traditional paintings, they can cause irreparable damage to modern art. This paper discusses special factors that must be considered when transporting modern paintings.*

Anyone involved with mounting temporary exhibitions will be as familiar as I with the potential dangers that every change of site imposes on a work of art, no matter what precautions may be taken at the time. The element of risk is offset by such precautionary measurements as careful packaging, the wearing of white, and I emphasize, clean gloves, and well-trained staff; yet damage does occur in transport, and everyone will understand the hesitations of lenders of art, who, while the exhibition boom lasts, will entrust their charge to a diminishing few recognized transport firms, stipulate particularly burdensome obligations, and on top of it all, send couriers along with the transport.

It can be said that the damage that occurs in transport is only a fraction of all the damage that works of art suffer. This is quite true. It is also true that artworks are extremely susceptible to damage even without changing sites, if they are stored in an inappropriate way. Perhaps there are statistical surveys to show the actual proportion of damage incurred in transport, including that to the packaging, because there is evidence to show that most damage in transport occurs during the process of packaging. The value of such a survey would be rather doubtful, for even a low percentage would be too much, if our goal is not to damage a single work. The fact then that works of art are not damaged exclu-

sively during transport is no excuse and even less a ground for complacency.

I realize that for many transporters, the moral appeal for the preservation of works of art has not fallen on deaf ears. They feel personally responsible for preventing damage, and every move in this direction is some investment, not least for the credibility of the transport firm. I am sure that innovations in the packaging industry have reduced the incidence of transport damage. These innovations include the development of acclimatizing-crates and improvements to the means of transport to lessen shock and vibration.

Yet to many of these new developments, there is another side of the coin. Frequently the disadvantages of modern packing materials emerge only after a certain period of experimental use, and then the initial euphoria all too often turns abruptly into total rejection. Both reactions are unwise. As always, the decision about which kind of packaging is the most suitable, must be based on individual cases. The tendency to favor the simple and well-tried, such as brown paper rather than foil because condensation may form or static electricity may build up on the latter, is a reaction of uncertainty, of taking the risks of familiar disadvantages rather than entering upon an experiment. In each case, the criterion must always be the work of

art, and an adequate means of packaging must be chosen for it; under no circumstance should we declare a particular kind of packaging the absolute optimum and apply it to any and every work of art.

Another unfavorable aspect to new developments in practice and materials is that they do not make it cheaper to transport art, which is surely a significant factor in times of decreasing budgets. In addition, as pressure on museums to economize increases, activity in loaned works and touring exhibitions will decrease. This is not necessarily to the disadvantage of the works of art, which have been subject to often unnecessary and untenable transport conditions for the sake of a measure of superficial publicity.

In summation, until now, the transporters have gone along with the demands their clientèle have placed upon them; they were able to meet them by developing and training staff in new practices. At the same time, human error was reduced and transport firms have been able to acquire recognition with the use of an arsenal of equipment in good working order. The interest of the firm and the client have met in the aspiration that only the best is just good enough for the work of art. This state of affairs must not be allowed to change, even if present reductions in public spending and changes in exhibition policy might threaten the balance of this relationship.

Each attendee has their own idea of how the situation might be improved. At this juncture, I would only like to give a warning, do not place too much hope in new developments in materials and gadgets, the cost of which stands in no relation to their effectiveness. It is my belief that art itself places various hurdles in our way.

Traditional art has not been subjected to the present fashionable exhibition boom comparable to the extent imposed on modern art. At the same time as the increase in traffic of modern art loans, there is a noticeable increase in snags and pitfalls in handling contemporary art. It is generally much less of a problem to transport traditional art than modern art. The hazards and dangers are fa-

miliar. With modern art we are confronted with unsuspected and new types of problems; you may anticipate precise recommendations. Let me disappoint you at the outset, that hoped for broad suggestions simply cannot be made, at least none that would apply to all situations.

Modern art is more vulnerable than old: disintegration sets in suddenly and then progresses at a pace. Contemporary work can no longer age with dignity. Unfortunately, neither the caution of transporters nor the preventive steps of restorers can stop the process; they cannot alter the state of affairs, for the damage is often latent in the work. The artist uses materials that were not conceived for art objects, or have not been tried enough, and mostly they are used in combinations that carry great risks. This is one side of the matter, and for works of this nature the best solution is *don't transport it*, because every move accelerates the process of decay.

Even if a painting is traditional in its material structure and consists of a support, primer, and paint layer (varnish is lacking in most modern painting), the painting is not secure if—as in most cases—the old painter's rule of "oily on dry" has not been applied. In any case, the order is reversed in the all-too-common use of prefabricated primed canvas where the primer is very oily. A possible result of ignoring such old craftsman's rules is strong tension between the strata of the painting where only a slight jolt may be enough to cause internal damage to the paint film. There would be a latent crack that could appear immediately following the transport, but might also take a certain time before assuming visible dimensions. This is all for the worse, for if the damage did become apparent immediately, it would often be better for those responsible, because they would become aware of the risks imposed by their actions. Perhaps then restorers would find a more receptive and understanding audience for their frequently urgent warnings. This problem with the material consistency of the picture will thwart every precursory measure.

The second point is damage caused by

outside circumstances. Damage of this kind is avoidable in theory, it is often unapparent that some works of art are extremely delicate. Even the greatest caution cannot eliminate little omissions. Who would consider that merely brushing past with a corner of an overall can leave irreparable traces on some sensitive surfaces or that "slight" marks may cause total damage. Damage of this kind is almost inevitable, because they are caused by the structural weakness of the work itself. Many contemporary works of art are unframed and unglazed and lack a protective varnish. Often, even the edges are painted, so there is no surface left to hold the work; a problem that reaches ridiculous heights when the frequently encountered large format works have to be moved. Thus, a standing favorite is paint flaking off or what we call *wheat-ear craquelée* right over the edges of the stretcher-frame intersection, where hands have intruded between stretcher and canvas. Very slight pressure from behind is enough to crack some paint surfaces. One frequent measure to prevent this is to affix a cardboard or cotton duck panel on the reverse, thus obliterating any hope of holding the picture.

The reason why the most negligible of scratches, abrasions, lesions, or fingerprints can lead to total writeoffs, is that the damage strikes at the core of the artistic content and confronts the restorer with insuperable problems. Many modern paintings are very severe in composition and have a homogenous, monochrome surface with no traces of brushwork and often the most delicate of colors, namely white and black. These qualities can be found in op-art, pop-art, hard-edge, minimal art, etc. Here every sign of damage becomes an element of the composition.

The effect of a work of art, however, consists not only in its composition, but also, for example, in gradations of gloss over the surface. Dirt, grease, and fingerprints always alter the reflective qualities of the surface and the brightness of the paint. Serial tests with the widest range of detergents and solvents have shown that this type of damage, consisting in alteration of surface gloss cannot be remedied in certain materials without a loss of substance. We cannot say which is the greater reduction of value, the restorer's interference and concomitant loss of original substance, or the damage itself.

The harm to modern art is very much worse because the eye is seldom distracted by pictorial narrative. In the absence of a picture story, all the expression goes into formed material. *What you see is what you see*, no more and no less, says Frank Stella.[1] As the material becomes the sole direct conveyor of ideas, the slightest alteration to it also alters the artistic message. This peculiarity in modern art infinitely multiplies any damage.

I do not believe that much can be done about the risks to such hypersensitive painting. If improvements are still possible in this area, then it is only in the sense of educating those responsible and transport staff about the various forms of susceptible picture surface, by simulating damage on models; in brief, by sensitizing the people concerned. It is they who will have to decide in each case which packaging is suitable when considering protective measures. What is required are human qualities.

Another problem with transporting modern art—other than those inherent in the artwork—is the question of what is actually the art and what might be an instance of damage. Many damages in works of art with structured surface consist of cracks. However, there are also many paintings where the artist uses combinations of materials that lead to the forming of cracks. These cracks are intended as an artistic aim. Often, only the artist can distinguish between intentional and accidental cracks.[2] These uncertainties lead to considerable complications before transport, when the state of the work is examined and high insurance claims could be made.

There are also other related considerations. Let us assume that in addition to the cracks ascertained before a transport new ones emerge in transit; now, the effect of the painting rests in its cracks, so has the journey improved it? The question is not as silly as it might first seem, in fact, there are artists who incorporate possible changes caused by aging into the concept of their works. Perhaps, then, the artist of our hypothetical picture

would not mind a few extra cracks; but it is not safe to rely on that, because eventually such an attitude must end in the complete destruction of the work. Also, there are tales of artists preaching the element of self-destruction in their work with great gusto and then suddenly changing their minds when they saw that all their work had disappeared without a trace.

The art trend I have just discussed differs from the preceding one by its less calculated or exact composition, and it could be generally said that the more emotional the effect of the work of art, the less damage will seem to be damage. This is true of the area comprising tachism, action painting, etc.

Knowledge of the essential directions of style, an idea of typical damage, and apprehension of the disturbance factor of certain types of damage, will—in my opinion—do more for damage prevention than some detailed instruction manual that would have to be issued anew for each picture. Such things do exist; it could conceivably say, for example,

When packing this work —

1. Stand crate upright

2. Remove lid

3. Loosen screws on retaining gear

4. Lower painting carefully into crate, taking care to . . .

with perhaps another ten detailed points to follow. The excessive detail of these instructions may be exhausting for you now, consider then, how condescending and presumptuous they must seem to practically oriented people like packing staff, apart from there being rigid regulations designed to put a stop to any initiative and encourage the really silly mistakes that arise when inflexible methods meet changing situations. This seems to be the greatest problem that besets transports of modern art. People need to develop a sensitivity to the material in hand; whether this can be learned or whether it is a quality one either has or does not have is altogether another question. (Of course manuals are better than nothing as long as

sensibility is altogether lacking, but it is to be kept in mind that they are only vehicles, not solutions.) If this feeling is to be developed at all, it is going to be much easier if not only the material's object value is understood, but also to a certain extent the work of art per se. I believe that ultimately, these things, i.e. the material, ideal, and material value, cannot be separated. This is substantiated in the packing of traditional art.

To take an example from a different sphere for a change, it is essential to know when packing a Greek vase that it is made of clay; to realize the fragility of the material, and that the article is irreplaceable; the handlers need to see how finely the material has been worked. Only then will they flatly refuse to lift the piece by the handles. A knowledge of art history is not indispensable, whereas a degree of sympathy for the object is. Admittedly I can eliminate the risk by ordaining *you shall not take a Greek urn by the handles,* but such abstract rules have only a limited validity for modern art in its wealth and diversity of material, and they are not necessarily always desirable since they choke the flexibility we need. Consider then that the effect of modern art frequently depends altogether on the material. Here I see a grand opportunity to nurture a feeling for the validity of modern art—a prime condition for its careful treatment.

Possibly these notions directly contradict your logical instincts, advising yourself to refrain from value judgments and to handle each article *sine ira et studio.* To dramatize this: people are not just machines, and clearly they will do what is close to their heart with more love than that to which they are indifferent; and indifference fosters carelessness. Preaching that thinking is out of place where modern art is concerned is counterproductive, if more thinking went on, perhaps modern art would enjoy better treatment. Am I suggesting we arrange courses in art history for those responsible? Not a bad idea at all, I think, and it might have been welcome if Professor Imdahl, a famous German art historian, had spoken to transport staff on modern art instead of the workers at the Bayer

works.[3] Once openly embraced, modern art has the great virtue of having a more direct effect than traditional art, which demands more traditional knowledge. Take advantage of the opportunity, above all, do so with people whose sensitivity to material gives them a headlong start in coming to understand modern art.

Perhaps you will agree with me that this is a feasible approach to prevent damage during the transport of certain currents of contemporary work. Everything that is still in some way compatible with the museum, that is, by inference, with society, still has chances to be understood and therefore conveyed. But what about pieces that lack material value, that represent to many no more than rubbish, dirt, and decay? This is the "art" that has produced rules that forbid value judgments to prevent aggressive reactions. Certainly there is a barrier to be bridged. I became aware again of the paradox between material and artistic value at the "documenta," where people unconcernedly set about to play with the materials that they knew well, but had been put into a context in a manner alien to them. They felt motivated to "test," only to be put in their proper place in no uncertain way by the warders. Many a masterpiece does without an aura, and the attempt to give it one must be an act of brutality.

This kind of art makes conscious use of everyday materials and invests them with social and mythical dimensions. But these articles are so familiar that any deeper meaning seems strange. The absence of "art"-identity in numerous works is the clue to much of the damage incurred, even including loss if a work or parts of it have strayed into the packaging material or, having been deemed worthless, is thrown away; once removed from its museum environment, it is often difficult to recognize it as a work of art, attesting to the degree of illusionism that modern art can attain! This characteristic of modern art underlines the "golden rule" quoted earlier, *to treat every piece, however incomprehensible it might seem, with the same care.* This is difficult and almost too much to ask, especially for people whose feeling for the materials is

more acute from the start to the extent that they approach it with respect. So my problem is that I am pleading for a heightened sensitivity while confronting my audience with things which are liable to insult this sensitivity by evoking and re-evoking associations of scrap, refuse, and rubbish. Even in this situation I see no alternative for reducing the frequency of incidents but to attempt to awaken at least a nonaggressive basic understanding for the works of art. A condition for such an understanding is an insight that art is not only gratifying, that it does not have to be beautiful as a matter of course. At any rate, this is not the central problem of art—art was and is, first of all, a mirror of reality.

An example is modern genre of "poetic archeology," an accumulation of objects from our daily existence presented in a museum context that attempts to take stock of our world, not one of the past, by means of this historical method of presentation. I fail to see any great difference between this and a Dutch genre painting of the seventeenth century in this sense; and the means of presentation is just as devoid of prejudicial value; no one takes offense to similar presentation styles, in a prehistoric or memorial museum. The exhibits in prehistoric museums usually come straight from some refuse dump, too, making these artifacts also just as much scrap or rubbish.

Of course, there are earlier depictions of the environment, but with the invention of photography, depiction by itself became superfluous. It is the old problem of direct and indirect communication. Where in earlier times, art aspired to imitate reality, its aim today is to *be* reality. We need not reproduce; art becomes production. To illustrate: the phenomenon of illusionism in baroque art shows that its concern was the rendering of reality. We all know the phenomenon of things that have been painted being taken to be present in reality. This is the illusionism I was referring to earlier when I pointed out the danger of a work of art being mistaken for a utility object. The distinctions between reality and seeming reality were as fluid in the baroque as they are today, modern art simply does without the great and basically

superfluous effort of the process of depiction and creates the work of art by the act of declaring it as such. Once that is understood, perhaps we can put an end to the unwrapping of Christo's wrappings,[4] Kosuth's chair will no longer be sat upon, and Beuys' blackboards replete with diagrams and scrawl will no longer be wiped dutifully to a pristine black. The risk of modern art being taken for a banal utensil is ideally excluded when we no longer dare to sit on the chair we happen to be sitting on, or walk on the floor where we are standing. This fundamental understanding must be instilled, then it will develop proportionate care in the treatment of our art objects. Only when it has been made clear that the environment as a whole is available as potential art material, will there be an openness for the alien and unexpected; for the scale of materials used is so wide that it is virtually impossible to work out generally valid rules for transport packaging. The only rules that are possible apply to properties of the materials, but this task could be solved by a thorough knowledge of these materials. What seems to be more important is to generate a broadened, nonaggressive attitude to modern art.

I apologize if I have robbed you of hope; hope, that is, of new and dizzy summits in the development of materials and practices. For me, the only prospect of progress lies in the direction of encouraging a sensitive approach, and here hard and fast rules achieve nothing, least of all rules that fetter empathy with the work of art or are intended never to allow even so much. The archenemy of modern art and the main cause of damage is ignorance, and to eliminate it, while also replacing it with respect, should be our goal. □

NOTES

1. Frank Stella in an interview with Bruce Glaser "Questions to Stella and Judd," *Art News* 1966, cited from *Minimal Art* ed. by Lucy Lippard and Gregory Battock (New York, 1968), 158.

2. For instance, works of Antoni Tàpies, Frank Stella, etc.

3. M. Imdahl, *Arbeiter diskutieren moderne Kunst* (1982).

4. Werner Hofmann, "Gegenstimmen. Intra Muros," *Suhrkamp*, 1979, 197: "to avoid misinterpretations Christo sends with his artworks notes for customers, transporters, and museum staff, where he quotes where packing materials begin and end. Nevertheless errors are told to have happened."

THE RELATIONSHIP BETWEEN SHIPPING AGENTS

How Do European Fine Art Transport Agents Differ from Their United States Counterparts?

ABSTRACT: *The following represents the conference sponsoring agents and provides a platform for the speaker, Michael Scott, an independent representative of the International Convention of Exhibition and Fine Art Transporters (ICEFAT).*

A question that has been put many times, and each time receives different answers is "How do European fine art transport agents differ from their United States counterparts?" Fundamentally there is no difference in respect to the care and responsibility taken to ensure that the items placed in their individual care are dispatched efficiently and safely. However, it is the service they provide that differs with each adapting their own systems.

The European fine art transport agent is contracted to organize the dispatch of an exhibition, and supplies his/her own work force to complete the packing, necessary trucking, forwarding, and customs clearances. This results in the overall control of all matters relating to shipment which is encompassed within one management team. For international shipment to and from the United States, however, the services listed above are brought together by using a freight forwarder/customs broker (agent), who will draw together the independent services of specialist trucking companies and specialist packing art handling companies to form a combined service.

Both systems have enormous advantages in performance; the European agent is able to keep the management control within a close environment that normally allows direct personal supervision of each specific aspect of the exhibition movement.

The United States system allows that agent (sometimes under the guidance of the museum registrar) the freedom of a greater diversification enabling the services of numerous specialist trucking and packing companies to be used that are selected specifically to best complement the needs and requirements of the exhibition.

These systems have been established over many years and while both have advantages and disadvantages, the primary factor is to know what to expect from the agent responsible for dispatching an exhibition.

To elaborate, the system used by the fine art exhibition agents within Europe will provide the following services: they will employ within their own company specialist fine art packers, that follow specifications and quality control of their management team. The requirements for vehicles will be answered by each transport department, which again could entail the specialist packing team being part of the vehicle crew when necessary. For instance, the collection or movement of highly fragile items, or items that have to be packed away from base, for example, on-site in museums or private collections, are given onward continuity of transport if packing is kept within one company. Because of its expertise in the dispatch of consignments by air or sea, the forwarding and customs brokerage arm of European agents is also preferred by the exhibition management team.

Interestingly, specialization within the fine art profession in Europe has evolved through the diversification of companies specializing in the dispatch of household items by others who were responsible for the dispatch of antiques purchased by tourists on the grand tour of Europe and by companies who then

opened primarily to fulfill the needs of shipping these objects home.

Most importantly, the additional service that the European agent is able and required to perform is compared to the function of the exhibition coordinator working from within the museum/gallery building. In some countries, the agent is more actively involved in assuming certain secretarial and administration responsibilities for the hosting museum. In the United States this could be aligned with the system of the guest registrar for major exhibitions.

This total service is a requirement within Europe in countries such as Germany, Holland, and France, and in a smaller way, the United Kingdom.

A vast majority of shipments handled within Europe require considerable border transiting, making customs procedural knowledge vitally important. This is especially the case in this changing time of customs-free movement within the European Economic Community, as these relaxations will undoubtedly be replaced by a Heritage control.

While this is, perhaps, an oversimplification of the European fine art exhibition agent, in many cases it could be taken as a norm.

The similarity continues as with all international shipments, the customs broker/forwarder is needed who provides expertise in customs law and procedures; this function is linked by the knowledge and coordination of international transportation by air and sea. The trucker becomes the link between the airport/port and the museum or packing warehouse, and the packer is responsible for case construction and packing. In the United States, these three elements within any one city can be controlled by three independent companies. In Europe the customs broker/forwarder acts as the pivotal element of a shipment and is controller of all of the necessary elements. This is where the advantages of the United States system appear as the agent is able to select specific companies to perform the services best suited to the exhibition while the European agent is sometimes restricted to their resources and equipment.

The all-encompassing agent—trucking—packing—company has not actively appeared in the United States. The European agent/customs/broker has to be licensed with the United States customs authorities and needs a broad knowledge of customs formalities, in fact, most customs brokers require a commercial bias, which has been converted to cover the needs of fine art shipments. These conversions, until just recently, have remained linked within large commercial customs brokerage companies. This has changed recently as smaller companies specializing in fine art compete with the larger corporates, but the specialization is still centered on brokerage and forwarding.

In Europe the vast majority of packer/trucker business must cross international borders. In the United States the domestic packing and transportation business is so large, in proportion to that of their international market, that a packer or trucker may not find it viable to devote precious resources, i.e. staff and management, to develop customs expertise.

Most Europeans find it hard to comprehend the differences of transportation by road and the role of the trucker. The basic logistical problems, due to the size of the United States together with the interstate licensing laws, makes the possibility of a combined transport service difficult as is operated within Europe. To overcome this, the Van Line System was developed with local companies working through license agreements, under the banner of large nationwide organizations. (This is not specific to the fine art trade, but is part of the everyday work structure within the United States.) Therefore, when an exhibition moves from Chicago to San Francisco to Houston to New York, while the overall carrier can be seen to be one specific van line, in reality, numerous local transport companies are providing the necessary equipment.

Even while I relay yesterday's procedure, changes take place and specialist trucking companies now offer a far wider range of personalized fine art transport than has previously been possible within the United States. Regular journeys through the United

States limited to art transport are now made, but the market is too large and the requirement to own sufficient equipment is so great, that it precludes the possibility that one company can or will successfully serve all of the United States.

The fine art packer is, within the United States, a relatively rare creature outside of major metropolitan areas. To specialize in fine art packing, a large work base is required and thus expert packers appear only in the largest cities throughout the United States where their services are normally coupled with that of providing warehouse storage and local city transport (not interstate).

The United States agent links the services needed for international exhibitions, however, invariably for internal transits within the states, the overall control of exhibition coordination reverts to the museum registrar, who is responsible for overseeing the liaison of the truckers and packers. ☐

LENDING PAINTINGS—THE CONSERVATOR'S VIEW

Sarah Staniforth

ABSTRACT: *Many museum staff members are involved from the time that a request to lend a painting is received to when it returns at the end of the loan period. This paper gives a conservator's personal view. It considers the problems of deciding which paintings are in a fit state to be lent, and the assessment of the borrowing institution's ability to care for paintings during the period of the loan. It examines the procedures for which the conservator is responsible before, during, and after the loan. Finally, it looks at the finances of lending paintings. The paper is intended to draw attention to the areas of uncertainty that still exist in all aspects of lending paintings.*

INTRODUCTION

The National Trust receives a large number of requests for the loan of paintings in its collections, but does not organize exhibitions, and therefore does not borrow paintings in return. This situation is, in many ways, a privileged one since we are under less pressure to agree to loans to facilitate relations with borrowing museums than conservators who work in museums with an active program of loan exhibitions. Therefore decisions about the suitability of paintings for loan can be made on conservation criteria, rather than having to make compromises because other forces are at work.

PREPARATION FOR A LOAN

Criteria for Assessing Fitness of Paintings (and Frames) for Loan

The first question that a conservator must answer is whether a painting and its frame is in safe condition to be lent. I mention frames at this very early stage because they are so often forgotten when the loan of paintings is discussed. In National Trust collections the frames are often works of art in their own right.[1] An extremely ornate and fragile frame may preclude a painting from loan because it cannot be safely secured for transport. In

these circumstances the loan of the painting may be refused or another frame may be specially constructed for the exhibition.

It would be very useful for conservators to have a set of rules against which they judge the fitness of a painting. One rule that the National Trust has is that no painting should be lent while the houses are open during the summer months of April to October. However, this is not because of conservation considerations, it is to ensure that visitors are not deprived of any of the contents of the house unnecessarily.

Many museums refuse to lend panel paintings. The reason usually given for making this rule is that panel paintings are more sensitive to changes in relative humidity than are canvas paintings. However, many museums control their environments to the same levels of temperature and relative humidity. Provided that packing cases maintain the moisture content of the painting during transit, then perhaps this is not a legitimate concern. It is of far greater concern to organizations like the National Trust, many of whose paintings collections are housed in historic houses in which the environment is far from the museum "ideal."[2] If paintings are lent from these houses, then relative humidity changes of 20% and more can be en-

countered. However, this problem can be avoided by providing a microclimate for the panel painting during the exhibition.

Concerns about panel paintings may then address the fragility of the wooden panel itself. If it has been thinned in the past, then it may not have enough inherent strength to withstand the shock and vibration that it may experience during transport and handling. A panel that is already cracked or has been repaired in the past may give additional cause for concern. Panels with unusual constructions, such as cross-grain additions or with cradles or battens that restrict movement cause concern about their stability.

Another rule that might be applied is not to lend unlined paintings that are more than one-hundred years old. The original canvas may have weakened to such an extent that the turn-over edges are on the point of failure. Loss of strength in the original canvas may have resulted in the surface of the painting becoming out-of-plane, which may lead to cupping and eventually to flaking paint. Conversely, some conservators may believe that recently lined paintings, and in particular those that have been wax-lined, will usually be safe to lend.[4]

The National Trust refuses to lend paintings more than once every five years. I can only put this rule down to anthropomorphism (on my part as much as anyone's, I freely admit) believing that paintings should be rested after the rigors of a loan! However, it is possible that, like other materials, paint and ground layers may experience fatigue cracking after a certain number of vibration cycles, suggesting that concerns about the cumulative effects of transport may not be misplaced.[5]

Stolow gives the following list of criteria for non-loan:[6]

(a) Wooden panel paintings very susceptible to relative humidity variations

(b) Unprimed canvases, or surfaces which may be easily soiled

(c) Powdery or flaking paint not readily treated

(d) Weak canvas support which for technical or aesthetic reasons cannot be lined

(e) Paintings on glass or similar fragile support

(f) Paintings which are excessively large in format

Simple rules are useful, but some are hard to justify considering current knowledge about environmental conditions during transport and at exhibitions, and the magnitude of shock and vibrations experienced. Stolow ends his section on loan criteria saying:[7]

There is a strong argument for re-thinking loan guidelines pertaining to fragile objects. The correlation between structural damage and environmental factors is not clearly established, requiring more study and research. Even objects declared "safe" and "fit" for travel suffer from the rigours of exhibition. Surprisingly, some works considered fragile have fared well.

We have to look closely at the actual condition of paintings when making decisions about their fitness for loan. Obviously a flaking painting cannot be lent without treating the affected areas. But we should also question the reason for the flaking. A painting may have a history of flaking if the support is particularly responsive to relative humidity changes and this might be a reason for recommending against lending.

Sometimes a painting may have blind cleavage which is very difficult to detect without resorting to sophisticated examination techniques.[8] Similarly, panel paintings may have fractures in the wood which are not yet visible on the surface of the painting. This might be detected by x-ray, but radiographs are hardly ever used diagnostically for determining fitness for loan.

Between the paintings with obvious structural problems and those with instabilities that do not yet show lies a whole gray area. How does the conservator judge whether raised paint is secure and will remain so during the period of a loan? How weak can a canvas become before giving rise to worries about the strength of turn-over edges? Decisions about whether paintings such as these are fit to lend come down to the experience

of the conservator, and are based on comparison with other paintings in similar condition and how they have fared on exhibition. This mental database is a vital tool of the conservator, but it is difficult to share!

Another important consideration, which has nothing to do with the safety of a painting, is its appearance. Some paintings may be in perfectly sound condition but their appearance can be poor if they have layers of discolored varnish and discolored retouchings. This poor appearance is often much more obvious in the good lighting conditions provided at an exhibition rather than the diffused daylight that is usually the illumination in historic house museums, where light levels have to be low to protect the more sensitive textiles and watercolors that are displayed alongside the oil paintings. Cleaning the painting for an exhibition can be done, but funds are often unavailable for this from the lending museum. One solution is for the borrower to pay, and more is said about this in the section *Who Pays?* In these circumstances time is of the essence, and although the National Trust will only consider loans when six months notice is given, this is often not long enough if a painting is to be cleaned and restored.

More quantitative criteria are needed to aid conservators in making decisions about which paintings are safe to lend. Let us hope that the great volume of new research into the physical properties of painting materials can be applied to helping with this problem.

Criteria for Assessing the Fitness of the Borrowing Institution

There are two aspects that have to be considered when assessing the borrower's ability to care for a painting during the period of a loan. The first is whether the environment in the borrowing institution is sufficiently similar to that to which the painting has become acclimatized, and the second is whether the borrowing museum has the facilities and staff to handle safely incoming loans.

Before agreeing to a loan most registrars will send out an environmental questionnaire requesting details about ultraviolet filtration,

type of lighting, light levels, temperature, and relative humidity levels. It usually also asks for information about security and fire precautions. It is up to the conservator to assess whether the stated environmental conditions correlate with those provided by the lender. The most that a lending conservator can expect is "as good as" or actually "as similar to"! It is pure hypocrisy, not to mention foolish, to expect a borrowing museum to provide "better" conditions than the painting usually experiences. The concept of the "ideal" museum environment is quite harmful in these circumstances.[9] However, there is a common fallacy that paintings that are exhibited in environmental conditions that are not usually recommended for museums, but to which they have become acclimatized, benefit from a "holiday" in the so-called "ideal" environment of 50% or 55% RH.[10]

Ideally a year's worth of twenty-four hour temperature and relative humidity data should be provided for the area in which the painting is to be hung to prove that the conditions are under control. Light readings and ultraviolet levels should also be available.

The crucial decision that has to be made when comparing environmental conditions to which a painting has become acclimatized with conditions in a borrowing museum is—how similar should similar be? If a painting has equilibrated to an average relative humidity of 65% and experiences maximum and minimum relative humidity ranges 10% above and below that figure, then will damage occur if it is transported to a museum that provides an average relative humidity of 55% with extremes 5% above and below? Is the average relative humidity more significant than the extremes? At the moment, conservators make decisions based on their own experience. For example, the National Trust has lent paintings from houses in which the average relative humidity differs by more than 15% from the average conditions offered by the borrowing museum. On the whole, we have not experienced problems with canvases, but flaking occurred on an area of restoration on a panel painting under these circumstances.[11] It is impossible to say whether it was the change in average condi-

337

tions that was the cause of the problem, or if it was the absolute value of low relative humidity level experienced in the borrowing museum. Again, we must look to the results that will be provided on the relationship between physical properties of paintings and environmental conditions to seek an objective method for making these decisions.

A facilities report should also be requested to ensure that the borrowing museum has, among other things, adequate provisions for handling incoming loans, safely hanging paintings, and storage of crates.[12] Experience of previous loans to a particular museum provides a good database of information for lenders. This knowledge is accumulated by couriers, who may be curators, registrars, or conservators. It is useful for registrars to ask couriers to complete questionnaires about experiences with borrowing museums to be used when future loans are considered. A loan may be turned down if on previous occasions a borrowing museum failed to provide sufficient art handlers to unpack and hang paintings safely. It may also be turned down if a painting is returned in a packing case that is found to have been stored in a noncontrolled environment that affects the relative humidity that the painting is exposed to during the return journey.

Preparing a Painting for Loan

There are two aspects to the conservator's preparatory work once a loan is agreed. Any necessary conservation work on the painting and frame and also any preventive measures should be undertaken to improve the welfare of the painting during the loan.

Conservation work may involve structural work, such as the consolidation of flaking paint, relining or panel work on the painting, and consolidation of gilding or repair of sprung miters on the frame. It may be surface work to improve the appearance of the painting. However, it is questionable how much structural work should be undertaken to enable a painting to be lent. Prophylactic lining, although recommended by some authors, represents a major intervention which should only be undertaken in very rare circum-

stances.[13] Such circumstances might include the loan of a previously unlined canvas painting against the conservator's advice or that the lining was imminent in any case. The wisdom of lending a panel painting immediately after structural work on the panel may also be questioned. A period of time should pass to assess the post-treatment condition of the panel, and for its response to environmental changes to be observed.

Preventive measures will mainly involve the framing of the painting, and such measures as checking to see if wedges have been firmly attached to the stretchers. The way in which the painting is fitted into the frame should be improved, if necessary. For example, canvases may be fitted into the frame in such a way that they cannot move. Backboards should be fitted, and this may involve building up the back of some frames. Some paintings, particularly those with delicate surfaces should be glazed. If it is known that the environment in the borrowing museum is significantly different from that to which the painting has become acclimatized, then it may be necessary to provide a microclimate within a vitrine, or even within a frame. The vitrine will need to be designed, made, and conditioned to the appropriate relative humidity. Similar provisions will need to be made if the frame is to be adapted.

The conservator is presented with a dilemma if a loan is arranged against their advice. A damage limitation exercise has to be undertaken. Particular attention must be given to the preparations for the loan and to the documentation. Careful monitoring must be made of any damage. The conservator of the borrowing institution should be alerted to possible dangers, and if possible they should see the painting before the loan commences.

Packing and Transport

The conservator should be involved with decisions about the type of packing case and the method of transport. However, it is difficult for all conservators to be experts in this field and there is plenty of advice available in the

literature.[14]

Smaller museums and historic houses may have great difficulties with the inaccessibility of their buildings. Vans arriving to collect paintings from National Trust houses have had to bounce their way across fields as the vehicles are too high to pass under arches, and sometimes have had to be pulled out of the mud! Once at the house, the packing cases may be too large to enter through doors or windows. Paintings may be hung in inaccessible positions, high on staircases, above large immovable pieces of furniture, over doors, fireplaces, or fitted into architectural surrounds with wooden fillets. There are rarely enough staff on site and sufficient assistance is essential in buildings where there are no picture lifts or loading bays.

All problems that are likely to occur when the painting is collected and packed must be anticipated by the conservator. If problems seem unsurmountable, then the loan may not be agreed on practical grounds. Excellent advance planning is essential to ensure safe removal and return of a painting.

It is worth making absolutely sure that vehicles sent to collect packing cases are large enough to take the load. On more than one occasion the National Trust has had works of art stranded because vehicles that are too small have been sent. Although this is not strictly a conservator's duty, it can cause a serious conservation problem if packing cases are left in adverse conditions, for example, in unheated sheds at airports.

Documentation

Condition reports to accompany the painting should be prepared and supported by adequate photographs or diagrams.[15] With the best will in the world, it is difficult to write a perfect condition report, and it can often be misinterpreted by another conservator. It is very helpful if the conservator who writes the condition report is also the courier, if not, it is essential that they should go through the condition report in great detail with the courier. Significant information about packing and environmental conditions should be in-

cluded when available.

THE PERIOD OF THE LOAN

The Outgoing Journey

The conservator should be present when the painting is packed to check its condition and, if the conservator is not the courier, the courier should be briefed on its condition and necessary precautions.[16]

At the Borrowing Museum

The courier, *in loco* conservator, should check hanging arrangements and environmental conditions. They should check that the condition of the painting has not changed during transport to the exhibition, nor on display during the exhibition .

The Return Journey

The condition of the painting should be carefully checked before packing for the return journey. If there is any change that necessitates conservation treatment, then this should be done before transport is attempted.

AFTER THE EXHIBITION

Monitoring Change

It is very important that the condition of the painting is carefully monitored after loans to try to establish the relationship between damage and events that occur during loans. This relationship adds to the conservator's mental database for assessing the suitability of borderline paintings for loan. We may find that it is the additional handling that paintings experience that is the chief cause of damage rather than the transport. It may be changes in environmental conditions. If we do not monitor changes and their causes, then we will not be able to make the links.

Linking damage to changes in environmental conditions assumes that the borrower keeps adequate records of environmental conditions during the exhibition. This requirement should be specified as part of the

loan agreement.

Repairing Damage

Damage to be repaired may range from mending holes torn in canvas from forklift truck tines penetrating a packing case, to minor abrasions around the edge of a painting that has slipped in its frame. Although these damages can be disguised, and the cost of the conservation treatment will be covered by insurance, there is the question of whether a percentage of damaged paintings is acceptable at all.

For a lender who does not borrow, I would say that no damage can be justified.

WHO PAYS?

Costs Only

The arrangement that most commonly occurs between borrower and lender is that the borrower pays for any expenses for conservation treatment and preparation of the painting for the loan, as well as for all insurance, transport, packing, and courier's expenses. Sometimes the conservation treatment may involve considerably more than structural work to make the painting safe to lend. Borrowers may ask, and be prepared to pay, for a painting to be cleaned and restored before the exhibition. This can certainly be seen as a benefit for the lender, particularly if their resources for conservation treatments are very limited. Sometimes the carrot of conservation treatment being paid for can lead a lender who has nothing to gain from the loan in terms of a *quid pro quo* exchange of paintings, to be persuaded to lend paintings in a condition that might be borderline. This can lead to entering the murky issue of how much conservation should be undertaken before a painting can be lent. For the National Trust, cleaning a painting for an exhibition can present problems when the painting returns to the house, particularly if the room in which it hangs contains other paintings that have not been cleaned. One cleaned painting in a room of paintings with discolored varnishes can look out of balance. The possibility of clean-

ing the others to regain harmony does not exist if funds are not available.

In addition to charging costs for necessary conservation work, some museums are making management charges for staff time involved in processing a painting for loan. The number of days spent on a single loan is phenomenal when the curator's, conservator's, and registrar's time is added together plus the time spent on courier duty. For the National Trust courier, duty usually takes ten working days for international loans. This is a large cost in staff time for an understaffed and underresourced organization. It would seem to be reasonable to expect to recoup some of these costs from the wealthy museums who hold loan exhibitions.

Fund Raising

A more dangerous idea, from the conservation point-of-view, has surfaced in recent years. Some collections are being lent as a means of raising money. The Courtauld Institute is reported to have raised over £900,000 when the stars of their collection toured Japan, Australia, and the United States. Other museums report less success. The *Treasures for the Fitzwilliam Museum* is said by the museum's director not to have made a major capital gain.[17] Mary Greene, a *Museums Journal* correspondent asks :[18]

> The question all tour organisers must ask is simply, is it worth it? Worth the calculated risk to the objects, worth the vast demands on staff time, the trips backwards and forwards at every leg of the tour?

A cost/benefit analysis that takes in depreciation in the works of art caused by damage occurring during traveling and exhibition might present a very different picture to the apparently rosy prospect of money in the pocket from gate receipts and sponsorship.

CONCLUSION

There can be no doubt that conservators need guidance on how to make decisions about whether paintings are in safe condition to lend. They must make judgments about the

risks involved in handling and transporting paintings and exhibiting them in environmental conditions different from those to which they have become acclimatized.

This paper merely serves to indicate the areas of uncertainty. Let us hope that research into the physical properties of paintings will help us to make our judgments in a more rigorous way and with more understanding.

However, we must not lose sight of the human element involved in lending paintings. Even a painting in perfect condition that is lent to a museum with environmental conditions that match those of the lending organization and is packed and transported to the highest standards, may suffer damage because of careless handling. As it is impossible to remove all risk of accidents, the borrowers' experience concerning facilities is, therefore, a very important consideration.

As our knowledge, understanding, and techniques in the field of exhibition conservation develop, it becomes evident that it is people who are the weak links in the management of loans. □

ACKNOWLEDGMENT

Christine Leback Sitwell has given me much useful advice with the preparation of this paper and I am very grateful to her.

NOTES

1. Hermione Sandwith, "National Trust Picture Frame Survey," *The International Journal of Museum Management and Curatorship* 4 (1985), 173-178.

2. Sarah Staniforth, "Temperature and Relative Humidity Measurement and Control in National Trust Houses," *ICOM Committee for Conservation 8th Triennial Meeting, Sydney* Preprints (6-11 September 1987), 915-926.

3. Christopher Brown, Anthony Reeve, and Martin Wyld, "Rubens' 'The Watering Place'," *National Gallery Technical Bulletin* 6 (1982), 27-39.

4. Therese Mulford, "The Touring of R. H. Dowling's *Aborigines of Tasmania*" in the 'Face of Australia' or Can Every Wax-lined Painting Travel Safely?" *Bulletin of the AICCM* 15 (Nos. 3-4 (1989), 17-20.

5. Stefan Michalski, April 1991, private communication.

6. Nathan Stolow, *Conservation and Exhibitions—Packing, Transport, Storage and Environmental Considerations* London (1987), 224.

7. Stolow 1987, 46.

8. John Asmus, "Holographic Interferometry of Painted Surfaces," *Contributions to the IIC Oxford Congress, Conservation of Wood in Painting and the Decorative Arts* Preprints (17-23 September 1978), 141-144; Bruce Miller, "Thermographic Detection of Voids in Panel Paintings," *Contributions to the IIC Oxford Congress, Conservation of Wood in Painting and Decorative Arts* Preprints (17-23 September 1978), 145-147.

9. Catherine Antomarchi and Gael de Guichen, "Pour une nouvelle approche des normes climatiques dans les musées," *ICOM Committee for Conservation 8th Triennial Meeting, Sydney* Preprints (6-11 September 1987), 847-851.

10. Neil Macgregor, "The Country House Comes Home," *The Burlington Magazine* 128, No. 999 (June 1986), 391.

11. Sarah Staniforth, "Exhibitions, Travel and the Safety of Works of Art," *The Burlington Magazine* 128, No. 1003 (October 1986), 749.

12. Elisabeth Batchelor and Wendy Jessup, "ICOM Museum Facilities Report," Report compiled for ICOM Committee for Conservation Working Group 12, "Care of Works of Art in Transit" 8th Triennial Meeting, Sydney, Australia (6-11 September 1987); Stolow 1987, 253-255.

13. Gustav Berger and William Russell, "Changes in the Resistance of Canvas to Deformation and Cracking (Modulus of Elasticity "E") as caused by Sizing and Lining," *ICOM Committee for Conservation 9th Triennial Meeting, Dresden* Preprints (26-31 August 1990), 107-112.

14. Tim Green and Stephen Hackney, "The Evaluation of a Packing Case for Paintings," *ICOM Committee for Conservation 7th Triennial Meeting, Copenhagen* Preprints (10-14 September 1984), 84/12/1-6; Sarah Staniforth, "The Testing of Packing Cases for Paintings," *ICOM Committee for Conservation 7th Triennial Meeting, Copenhagen* Preprints (10-14 September 1984), 84/12/7-16; Sarah Staniforth, "Packing: A Case Study," *National Gallery Technical Bulletin* 8 (1984), 53-62; Sarah Staniforth, ed., "Packing Cases—Safer Transport for Museum Objects," *Contributions to the UKIC One-Day Meeting* Preprints (21 June 1985); Peter Booth, Tim Green, and Christine Leback Sitwell, "Moving Pictures," *The International Journal of Museum Management and Curatorship* 4 (1985), 41-52; Christine Leback Sitwell, "Packing Paintings and Drawings: A Basic Primer for Museums," *Touring Exhibitions Group Occasional Paper No. 1* (1989); Mervin Richard, "Packing Delicate Art Objects for Transit," *ICOM Committee for Conservation 9th Triennial Meeting, Dresden* Preprints (26-31 August 1990), 410-414.

15. Stolow 1987, 37-46; Sitwell 1989, 4-5.

16. Peter Cannon-Brookes, "A Draft Code of Practice for Escorts and Couriers," *The International Journal of Museum Management and Curatorship* 1, No. 1 (1982), 41-60; John Buchanan, "The Courier's Art," *Museum News* 63, No. 3 (1985), 11-18; Shelley Sturman and Judy Ozone, "The Courier Experience," *ICOM Committee for Conservation 9th Triennial Meeting, Dresden* Preprints (26-31 August 1990), 423-427.

17. Mary Greene, "Eastern Promise," *Museums Journal* 91, No. 3, (March 1991), 30-33.

18. Greene 1991, 33.

SUPPLEMENTAL ENTRY

VIBRATION AND SHOCK IN TRANSIT SITUATIONS

A Practical Evaluation Using Random Vibration Techniques

P. J. Caldicott

ABSTRACT: *This paper reviews the art transit environment in terms of vibration and, to a lesser extent, shock and continues with a discussion of results from an experimental study in this area. The study was part of a larger multiclient research project to examine the use of random vibration techniques to simulate transit vibration and, thereby, evaluate alternative methods of shipping and packaging goods. The art transit work was commissioned by the Getty Conservation Institute and the Tate Gallery.[1]*

INTRODUCTION

Museums and art galleries are under increasing pressure to exhibit and loan works of art. In particular, this has led to the increased movement of paintings. There is insufficient scientific evidence to show how paintings are damaged by shipment. While the need for care is obvious, not enough is known of the cost/benefit relationship of different shipping or packing methods used in the transit of art.

The paper is intended to be understood by non-specialists. Technical terms are used sparingly and those used are explained in a glossary. Some of the more technical aspects are discussed in appendices.

THEORETICAL BASIS OF STUDY

There are many effects that can degrade the condition of a painting. The study focused its attention on the effect of vibration with particular reference to low-frequency vibration caused by handling or transit. Since at sufficiently high amplitudes every structure is damaged by vibration, it is prudent to assume that vibration during transit could contribute to the damage of paintings, for instance, by inducing cracking, crack propagation, or paint flaking. To test this, it is necessary to identify the art transit vibration environment. From this an attempt to identify whether any damage can be observed in this environment can be made. It would also be useful to identify whether a level exists below which no degradation to paintings will occur in either the short or long term.

Turning in more detail to the effects low-frequency vibration may have on paintings, a number of mechanisms are worth considering. For instance, canvas flexing is caused by vibration. Shocks can be considered as short periods of vibration. Both occur frequently in transit. The combined in-plane and out-of-plane flexing of a canvas resulting from a severe shock can be demonstrated to cause paint cracking. The cracks do not necessarily conform to any definite pattern although the weaker, less taut areas tend to be most cracked. Susceptibility to this type of damage will vary from painting to painting depending on the techniques and materials used in their creation as well as their fragility at any point in time.

Vibration causes paint and canvas to flex into a number of characteristic shapes or modes of vibration. Figure 1 shows the first three characteristic, or mode, shapes of a section of canvas for the out-of-plane direction.

Each canvas has an infinite number of mode shapes. However, the lower frequency mode shapes are the most important, generate the largest displacements, and are most excited by transit.

A canvas is supported by a stretcher which in turn is sometimes supported by a frame. Figure 2 shows the primary mode shape of a canvas with a stretcher and cross-bar in place. In reality the mode shapes are not as large in amplitude as those shown. One mode tends to predominate at any one time. The main mode of vibration, or indeed motion, is the primary mode. The higher modes are less excited and also contain much lower displacements than the primary mode.

Turning to the correlation between these mode shapes and painting damage, one point is immediately apparent. The regions of high curvature seen in the inward motion shown in Figure 2 correspond directly to commonly observed paint cracks corresponding to the edges of the stretcher bars. Provided the amplitude is sufficient, impacts will take place between the canvas and stretcher bars and could lead to paint cracking at this point. What is more difficult to establish is whether simple vibration or the results of the above impacts play any part in the formation of the many other observed patterns of cracking on paintings.

There are a number of mechanisms that could cause similar effects. These include physical handling which also flexes the canvas in its primary mode. Differential changes in moisture content between the canvas protected by the stretcher and that exposed between the members have also been given as an explanation for stretcher cracks. Thus it is not possible to state that vibration causes these cracks or those of a more general nature on paintings. However the frequency of occurrence and extent of motion observed during transit indicate that vibration should be treated as a potential contributor to paint cracking, especially in the longer term.

A further vibration effect is the force set up in the paint layer caused by changing velocity, i.e. acceleration. When a mass vibrates, it is subject to an oscillating acceleration. The result is an oscillating force that equals the oscillating acceleration multiplied by the moving mass. These oscillating forces can be small. At 1 G they are equal to the weight of the moving mass. At higher vibration levels the oscillating forces may be sufficient to cause local separations between layers of paint or between paint and canvas. Where adhesion is poor or damages are present, lower vibration levels may be sufficient to dislodge an already loose fragment from the surface of the canvas.

The tautness of a canvas on its stretcher is affected by many environmental factors such as temperature and humidity. These factors tend to operate slowly with few cycles compared with vibration effects. They are nevertheless known to cause long-term damage and as a consequence are carefully controlled, whenever possible, often at considerable cost. Vibration during transit may cause a very large number of similar cycles, thereby defeating the precautions taken in the museum.

A further concern is the observed decrease in tension of linen canvas as a result of cycling. This phenomenon has been observed both as a consequence of humidity cycling and also after prolonged periods of vibration. Yarns and woven materials are universally fibrous and depend on internal friction for their strength. Repeated changes in tension overcome this friction causing the material to lose tension. This emphasizes the similarity between these two factors and the susceptibility of paintings on canvas to relaxation effects.

It has not been shown that vibration will cause damage during typical transit conditions. There are nevertheless a number of hypotheses that could relate vibration to certain types of painting degradation. Given the complexity of the systems and the unpredictability of inputs, some precautions need to be taken to protect paintings from vibration as well as shock during transit.

TRANSIT ENVIRONMENT

Undoubtedly art transit is carried out more carefully than most commercial shipments. In general, people try to become aware of

good practice and ensure its implementation by sending a courier with a shipment. Experimental data for commercial and military transit environments have been collected and reported in the past but the quality and applicability of the data to art shipment are difficult to assess. A discussion of the characteristics of different art shipping methods is provided below. Comments on the quality and applicability of data in current literature are included in *Appendix II*.

The vibration levels in passenger, and most cargo, compartments on modern civilian jet airliners are very low in comparison to road shipment. Modern turboprop civilian aircraft fall into a similar category although single frequency sinusoidal vibration caused by propeller blade passing effects can normally be measured throughout the aircraft. The frequency of these vibrations depends on aircraft type but is normally below 100 Hz. An example of the vibration levels seen when at cruising altitude is 0.05 grms at 55 Hz. This was measured on a 1966 Belfast four engine turboprop transporter. The major hazard with civilian aircraft comes in the cargo handling areas. Even with couriers present, it is difficult to maintain adequate control due to such considerations as customs, immigration controls, and anti-terrorist procedures. The exceptions to air transport being relatively mundane are military aircraft and helicopters. Both can exhibit severe vibration levels and are not recommended for art shipment.

In many ways sea transport can be considered as a compromise between air and road transport. Ship motions are generally very low frequency, below 1 Hz, and can be considered as more of a pseudo-static loading than a dynamic response. Ship motions need only be of concern if cargo shifting is likely to cause the art to be toppled or crushed. In rough seas the pounding of waves or the slamming of the ship into the sea can produce greater inputs. Provided these occurrences are avoided whenever possible, inputs are normally low in relation to road transport. Ships do vibrate however. Typically this vibration is sinusoidal in nature, as with turboprop aircraft, and derived from propeller blade passing or main engine vibration if re-

ciprocating engines are used, e.g. diesel engines. Provided these vibrations do not have a frequency close to a sensitive frequency of a work of art, it is unlikely that the vibration effects will be any worse than road transport. The major concern over sea transportation is during loading and unloading when shock, temperature, and humidity are of concern for conservators.

Road transport is the most common method of shipment with both air-ride and conventionally sprung vehicles in use. The vibration environment of a truck is derived from two principal sources; the truck and the road surface. Together they make up what is probably the most severe transit vibration environment seen by paintings. Trucks used for art shipment should be well maintained. Good maintenance is by far the most important controllable factor in road transit vibration once a particular vehicle type has been chosen. The main factors include a smooth running engine and power train, well maintained suspensions and wheel bearings, and good, i.e. round and well balanced, tires. Much discussion has taken place over the relative merits of air-ride versus conventional suspension. The likely outcome is that air-ride vehicles will be shown to transmit less higher frequency, above 20 Hz, road inputs, and have lower shock levels than conventionally sprung vehicles. This has already been reflected in reduced vibration test specifications for some commercial and military organizations. The trade-off is likely to be that air-ride vehicles exhibit more low frequency, below 5 Hz, motion derived from both the road surface and maneuvering. Given this outcome, air-ride vehicles would appear the better choice for shipping paintings due to their lower shock levels. The road surface is the other main cause of vibration in a truck. This is a random vibration. It is difficult to be specific about what constitutes a typical input because there are few typical roads. Road transport on motorways/expressways will always be smoother than a potholed minor road. The author has made measurements over the rear suspension of trucks which have varied from 0.03 grms to 0.5 grms in the frequency range below 40 Hz.

The former is reported within, the latter was on a military truck traversing a surface that was sufficiently rough for the driver to leave his seat regularly and the payload area above the rear suspension to attain more than 5 G's. The shipment of art is unlikely to be as severe as the military example but individual potholes may produce peak acceleration levels of 5 G's. This is likely to cause the paintings to bounce on the payload area. The bouncing of paintings in the rear of vehicles is unlikely to be avoided totally, it is common in commercial transit, but can be reduced by using good roads wherever possible and by careful choice or control of drivers. Good driving is an important influence as it will reduce the likelihood of road accidents and sudden severe braking. Unless the accident is severe, good loading and cargo restraint systems should ensure that no damage is caused by load shifting.

Rail shipment is not a major shipment method for paintings. The main reasons are that trucks tend to be more convenient and avoid two additional sets of handling. In vibration terms rail transport is in a similar class to road transport. The vibration levels and character are fairly similar and if there are good railways there tend to be good roads. The major difference is that railcars suffer shunting loads and the rail vibration input has greater periodic content when the joints between rails are not welded.

As a final note, it is important to correct an often made inappropriate assumption. It is inappropriate to assume that a painting will see low vibration levels if the accompanying courier or truck driver perceives a low vibration level. Paintings and other works of art are sensitive to different types of vibration from those that cause most concern to humans. In vibration terms they have distinctly different modes of vibration and often experience distinctly different environments, for instance, the driver sits on his seat whereas the painting sits on the floor or in the cargo area.

STUDY CONTENT

To gain a sensible appreciation of the effects of transit random vibration, the study performed both road trials and laboratory tests.

All measurements were taken in terms of acceleration. This is relatively easy to measure with instrumentation and is the most common form of data considered by vibration specialists. In general terms canvas acceleration should be minimized to help preserve paintings.

The measurement setups used in the trials are shown in Figures 3 and 4.

The road based shipment trials were performed using a Momart Mercedes LP813, 2 axle 7.5 tonne truck equipped with all round air suspension. The vibrations on the truck and test structures were recorded when repeatedly traveling between two junctions on a motorway. This repeated journey was done in order to achieve a measure of consistency of road surface inputs.

This stretch of motorway was quite smooth, typically 0.03-0.04 grms for the rear of the truck. This is five times smoother than some data taken on another United Kingdom motorway and approximately ten times smoother than a rough road. The reported canvas vibration levels are therefore likely to be near the minimum achievable in road transport. If a repeat trial were to be performed, a more typical road surface would be recommended.

The laboratory trials were performed at Pira in the Distribution Test House. Vibrations were generated using an electrohydraulic shaker attached to either a vertical or horizontal vibration table. The shaker was controlled using a digital random vibration controller. The setup is shown in Figure 4.

STUDY RESULTS

General Points

The majority of the data collected relates to a single test canvas.[2] This obviously affects the conclusions that can be drawn from the work. The use of a single canvas brings consistency of response when considering several external variables. Each canvas does, however, behave differently and so care is

needed when inferring general rules.

The dynamic behavior of the principal test canvas is shown in Figure 5. The figure is a transfer function between the frame fore/aft direction and the canvas fore/aft direction, i.e. the ratio of the canvas response over the frame input in the major response direction. The main response frequencies indicate that the canvas has modes at approximately 12, 32, 42, 54, 73, and 105 Hz. These frequencies are probably not the first six modes of the canvas. The lightweight, 1 g, measurement accelerometer for the canvas was placed at its center. Thus it is probable that 12 Hz is the first mode of the canvas but that other modes, such as the second, are not present because the center of the canvas has no amplitude in that mode. Data below approximately 5 Hz and above approximately 100 Hz on the figure is not valid due to factors discussed in *Appendix III*.

A summary of results is shown in Tables 1 and 2. These related to the road trials and laboratory tests respectively. The tables present results in terms of root means square (rms) acceleration levels and kurtosis values and need to be analyzed with care because they give an incomplete view of overall vibration behavior. More complete data was considered in terms of Power Spectral Densities (PSD's) and transfer functions. An example of these is discussed below. The Forest Products (FP) and Tate Profiles mentioned are the vibration profiles used to excite the paintings. The derivation of these is given in *Appendix IV*. The PSD's of these profiles are given in Figures 6 and 7.

The worst vibration magnification seen during the trials was with the canvas face horizontal in its transit case.[3] For the FP profile the vibration was amplified by a factor of twenty to twenty-five. The amplification was sixteen for the Tate profile. The reason for the greater amplification can be seen when the canvas PSD's and transfer functions to the input are considered (Figures 8 to 11). Figures 8 and 10 show the main responses to be at 27 and 37 Hz. The Tate profile contains most of its energy in the region below 20 Hz whereas it is relatively constant in the FP profile. This would affect the ratios in the manner exhib-

ited. This is confirmed by Figures 9 and 11, the transfer functions between the input and the canvas, which show the transfer functions are the same for both inputs. Again, this should be the case for near linear systems with slightly different inputs.

In both cases the transfer functions peak at 27 and 37 Hz and show magnification factors of above one hundred at 37 Hz. This is a very large magnification. It is known that the canvas has a natural frequency at 37 Hz. The one hundred times magnification is nevertheless high. The reasons are explained by further use of transfer functions. Figure 12 shows the transfer function between the frame fore/aft and the canvas. At 37 Hz the amplification is about ten. Figure 13 shows the transfer function between the input and the frame fore/aft. At 37 Hz the frame is close to its own natural frequency in the transit case with an amplification again of about ten. Thus for the system from input to canvas there are two subsystems at or near resonance, the canvas in the frame and the frame in the transit case, each with magnifications of around ten. This gives the overall magnification of about one hundred. It is now easy to see why this peak is so predominant in the overall response.

The road trials produced definitive results in the sense that the responses measured were those of a canvas during road shipment. The problems are that the definitive results are only true for that vehicle on that road with that canvas. Results can be, and are, generalized from the specific. This needs to be done with care. During the study several potential misunderstandings were prevented by the use of laboratory results. Laboratory random testing enabled the consistent evaluation of several alternatives in a short period of time. The conditions used were close to those seen on the road trial and accurately simulated the generic vibration behavior of a truck in transit. It was possible to separate responses caused by inputs in different directions and the higher quality of results enabled a much better understanding of the vibration behavior of the systems to be developed. The results were readily comparable with those obtained from "real" measure-

ments and permitted evaluation of likely actual transit vibration levels and behavior. Potentially damaging behavior could be studied and repeated with ease.

The ability to carry through analyses of this type is typical of good laboratory data. In each case the transfer functions were relatively clean and free from the cross-axis effects and spiky curves typical of road data. Such a follow through is much more difficult and often impossible with road data. Thus laboratory data is providing better quality information than is normally available from road trials.

Main Results

The road and laboratory tests gave consistent indications of the relative merits of several shipping and packing alternatives. The canvas was stretched on a fixed cornered stretcher and framed. The shipping methods considered were:

- canvas horizontal (canvas flat)

- canvas parallel to direction of travel (canvas fore/aft)

- canvas perpendicular to direction of travel (canvas transverse)

- placing at front or rear of load platform

The packing methods considered were:
- bare canvas

- blanketed canvas

- backboarded canvas

- stretcher crossbar lined canvas

- backboarded canvas in transit case (in case)

By far the worst shipping orientation is with the canvas horizontal. This resulted in the input vibration being magnified by factors between fifteen and thirty. Road results show that transverse shipment is worse than fore/aft. The relevant magnifications were 11.6 and 6.4. Thus, the best shipping orientation is with the canvas vertical and with the plane of the canvas parallel to the direction of travel, which conforms to current general practice.

The road results show that a horizontal canvas receives better treatment near the front of the load platform whereas a vertical fore/aft canvas receives better treatment at the rear. The differences are 40% and 30%, respectively. This indicates that for the air-ride Momart truck there is probably not much difference between shipping at the front or rear of the payload area. This is not consistent with the behavior of "commercial" trucks where a distinctly better ride is normally present at the front of the payload area. This is partly because driver comfort is important and partly because a "commercial" truck is more stiffly sprung at the rear to cope with heavy payloads whose centers of gravity tend to be set almost directly above the rear wheels.

Road results indicated that the shipping of the canvas was similar whether it was shipped bare, blanketed, or backboarded. This is not consistent with the laboratory results which indicated that the addition of a backboard reduced vibration by approximately 30%. In general it is considered that the fitting of a backboard is beneficial as it reduces the level of response in the primary mode, and thus largest motion, of the canvas.

The stretcher crossbar lining technique uses a strong fabric stretched behind the canvas to act as a vibration damper. This worked well, see Figure 14, and is discussed by Green.[4]

It was found that when the canvas was shipped vertically, the transit case reduced canvas vibration. With the canvas shipped horizontally, the use of the case increased the vibration magnification from a factor of ten to sixteen. This was due to the painting bouncing on the foams within the case at a natural frequency of the backboarded canvas. This was discussed in more detail earlier. The use of the transit case was therefore beneficial only when shipped vertically.

An unforeseen behavior was present on the truck. This related to the lateral response of the sidewalls of the load compartment. The lateral responses of the truck were meas-

ured by an accelerometer placed close to the center of the sidewall panel. This showed a large response in the 7 to 12 Hz region and is not typical of the lateral input from a road into a vehicle. The response is typical of a panel with its first modes at about 8 and 12 Hz which is excited by an input force gradually decreasing with frequency. This forcing is consistent with that caused by road excitation. Thus the region of increased response is due to low frequency resonances (modes) of the truck sidewalls. The frequency range is typical of that seen for the primary mode of paintings and indicates a need for care. The use of a transit case with resonances above this frequency range would be beneficial for fragile canvases with primary modes between 6 and 15 Hz. A similar need for care will be required for all trucks as each have their own panel modes of vibration.

CONCLUSION

Using a limited test sample of one principal test canvas and one road vehicle plus laboratory random vibration tests, the study evaluated a number of alternative systems. The main findings were :

It is common practice that a painting should be shipped vertically with the plane of the canvas parallel to the direction of travel. The study confirmed that this is the best shipping orientation.

Canvas vibration is reduced by the use of a suitable backboard or the use of the stretcher crossbar technique.

Canvas vibration is further reduced by a transit case provided the canvas is vertical. Horizontal shipment using a transit case produced the worst vibrations seen during the study. This was an unexpected result arising from the interaction of two separate resonances. This highlights the need for testing.

No significant difference was apparent between the front and rear shipping locations for a painting in the air-ride Momart truck. This is different to general experience of commercial trucks where the most forward locations tend to give a distinctly better ride.

Vibration behavior is complex and regularly produces results that are different from those that might be predicted by experience or mathematical modeling. The horizontal transit case result above is a good example of this type of unexpected behavior. Testing is an important step in ensuring that unexpected vibration behavior does not cause unnecessary damage to paintings.

The laboratory random vibration methods demonstrated by the study were effective in: evaluating consistently a number of alternatives in a short period of time; enabling the development of a sound understanding of the vibration behavior of the systems being studied; demonstrating the vibration levels and behavior seen in "real" transit situations.

It is recognized that more work needs to be carried out. This will need to concentrate on the possible longer-term effects of vibration as well as potential short-term causes of damage. It is now feasible to include newly available electronic data recorders when paintings are transported. These can record shock, vibration, temperature, and humidity. If this opportunity were to be realized, a database of the art transit environment could be developed to help ensure painting safety and conservation for the future.

Given that the shipment of paintings will continue, if not increase, conservators of works of art need to be as confident as they possibly can be that all sensible steps are taken to reduce risks and ensure safe transit. □

APPENDIX I

Glossary

Accelerometer, A small transducer used to measure acceleration.

Blade passing effects, When the blade of a propeller or rotor passes a nearby object such as the hull of an aircraft or ship it transmits a pressure wave to it via the fluid in which it is immersed, i.e. the air or water. This pressure wave disturbs the nearby object and causes it to vibrate in sympathy with the passage of the blades.

Coherence, A mathematical measure of the degree of relationship between two signals. If the coherence between two signals is 1 they are related in a linear manner. If the coherence is zero they are unrelated.

Crest factor, The ratio between the peak value of a signal and its rms value.

Distribution environment, The shock and vibration environment seen by an item during its distribution, i.e. from the moment it is moved from a storage or display location to the moment it ceases its journey. This may be within as well as outside a gallery. The terms "shipping," "transit," and "distribution" environments are used synonymously in this paper.

G, An abbreviation for the acceleration due to gravity, i.e. 9.81 m/sec^2. For instance, an object seeing, say, 6 G will experience a force equal to six times its own weight.

gpk, An abbreviation for the peak value of acceleration measured in G.

grms, An abbreviation for the root mean square of acceleration measured in G.

Hz, An abbreviation for the unit of measurement of frequency, Hertz; 1 Hertz is 1 cycle per second.

Kurtosis, A measure of the roughness of a vibration signal. The higher the kurtosis value the rougher the vibration. For the purposes of the study, if the kurtosis value was between three and four then the painting was being fairly gently bounced around. If the value was higher than four then the painting was receiving more abrupt treatment.

Mode (of vibration), All structures vibrate in a sequence of natural ways. These ways are known as modes or resonances. Each mode has its own characteristic natural or resonant frequency and its own characteristic or mode shape. For instance, a simple mass on a spring bounces at its own natural frequency and in its own characteristic way or mode shape.

Natural frequency, See mode.

Power spectral density, A graph showing how the frequency content of a signal is split up, see Figure 8. It is particularly useful in identifying which frequencies of a signal or modes of vibration are important. The horizontal axis is frequency; the vertical axis is in units of measurement squared divided by the unit of frequency. The graphs in the paper have axes in Hz and g^2/Hz. These denote the frequency, Hz, and energy, or power, content of the signal per unit of frequency, g^2/Hz. The area under the graph is the total power of the signal. The term is usually abbreviated to PSD. Autospectral densities (ASD's) are generally held to be synonymous to PSD's.

PSD, An abbreviation for power spectral density.

Resonance, See Mode.

rms, An abbreviation for root mean square.

Root mean square, A measure of the energy content, i.e. amount, of a signal. The greater the rms level, the greater the possibility of

that signal causing damage to a painting.

Shipping environment, See "Distribution Environment."

Tonne, A metric ton, 1,000 kg, 0.984 tons.

Transfer function, A graph of the ratio between two signals against frequency, see Figure 9. They are particularly useful in identifying resonances or modes of vibration in systems.

Transit environment, See "Distribution Environment."

Transmissibility, The ratio between two acceleration signals. This is usually expressed as the ratio of the output divided by the input. Commonly used to denote the transfer function between two acceleration signals, see Figure 9.

APPENDIX II

An Appraisal of Shock and Vibration Data

Historically sine, or swept sine, vibration tests and drop, or impact, shock tests have been performed on paintings to evaluate their sensitivity to transit vibration. These techniques have been useful in ranking potential transit packing options. The relationship between the drop tests performed and transit "reality" is straightforward. They are directly related. The relationship between sine tests and transit vibration is less straightforward. There is no direct relationship because transit vibration is random in its nature.

In the last twenty-five years the analysis and use of random vibration has become more commonplace. This is largely due to the increasing availability of digital data capture and analysis equipment. During this period a body of data has been collected on the properties and nature of random vibration seen in transit situations. Unfortunately a common theme has run through this data. While there may appear to be a quantity of data available in the literature it is difficult to be certain of its quality because of the difficulty of obtaining good data. This is readily acknowledged by vibration specialists. Indeed those with the greatest investments in the technology, e.g. the automotive and, to a lesser extent, aerospace and defense industries, are those with the greatest concern for ensuring that high quality data is collected when the results are to be used for later laboratory simulation, e.g. electrohydraulic vibration tables such as that used in the study. A suitable illustration is the use of tape recorders. Vibration data is often recorded onto tape and then replayed for analysis or simulation. On replay tape drop outs occur which, while not affecting rms levels, do create sudden changes in output. These adversely affect measurements such as probability distributions and, most critically, power spectral densities derived from peak values.

It is much more difficult to make good shock measurements than it is to make good vibration measurements. Factors such as filter frequencies and phase shifts, dynamic range, unknown peak levels, triggering techniques, and digitization effects suddenly become much more difficult to evaluate. This results in shock and vibration specialists having even less confidence in reported shock results than they do in reported vibration results. In practice shock data is collected against specific needs and the measurements tailored to best meet these needs. Uniformity in shock reporting only becomes practical when used for a single purpose. To some extent packaging transit shocks falls into this category with results being reported in either equivalent drop heights or peak acceleration levels. Although there are pitfalls with the first of these, the simple reporting of peak acceleration levels needs to be treated with the most care. Shock pulses are usually classified according to three criteria, peak level, pulse duration, and pulse shape. The most important of these are peak, or equivalent peak, level and pulse duration. With these two criteria suitable approximations can be made by assuming an appropriate pulse shape for the

type of event occurring. A half sine shape is the most commonly assumed pulse shape. The not uncommon use of a simple peak "G" level is not useful because without a pulse duration it is not possible to evaluate the severity of a shock. For example tapping your fingernails on the surface of a table produces localized accelerations measured in hundreds of "G." Most shipped items would be severely damaged if they underwent a single 100 G peak, 50 millisecond, half sine pulse. While "real" shocks rarely conform to these three simple criteria they can normally be put in suitable equivalent categories for each criteria. Unfortunately this is not a straightforward process. It is often difficult even to decide when to change from calling vibration data "vibration" and when to call it that special vibration called "shock," This is especially true in the transit environment where, for instance, repetitive shocks and transit vibration can mean the same thing.

Given that care is needed when examining the literature, a number of sources are in circulation within art conservation circles. This includes "An Assessment of the Common Carrier Shipping Environment" as well as other mainly government related sources.[5] Unfortunately the best data is not widely available. This data has been collected by industry, e.g. truck and car makers, and kept internally.

The suitability of data also needs to be evaluated. Vehicles used for the road shipment of art can be notably different from those in general use. Within the United Kingdom both Momart and the Tate Gallery have trucks derived from 7.5 tonne commercial vehicles. The modifications are extensive and include heavy secure and insulated bodies as well as air-ride suspensions. The payloads carried are also much less than those of their commercial cousins. This light payload is likely to be significant. In commercial vehicles the payload area can have visibly greater vibration levels when the vehicle is unladen. The ratio of unladen/laden rear axle weight is of the order 1:5 for 7.5 tonne class vehicles. This is not true of the modified vehicles. These have a much smaller ratio which allows the ride to be optimized over a smaller

working range. This benefit is likely to be further enhanced by air suspension.

APPENDIX III

Analysis Techniques

The analysis of random vibration is a highly technical and fairly specialist area. Partly as a result of this there are a number of different analysis methods in current use. Each has its own advantages and disadvantages. The methods used in the study are set out below along with some of the reasons for choosing them over other methods.

Four principal analyses were used :

- root mean square (rms) level
- power (or auto) spectral density (PSD)
- transfer function
- probability density/kurtosis

The measurements were made in acceleration terms and the results analyzed in terms of "G." 1 G is the acceleration due to gravity i.e. 9.81 m/sec^2. Thus an object seeing 6 G will experience a force equal to six times its own weight. During processing any DC offsets were removed. Thus the rms level and standard deviations of the signal are equivalent.

Root mean square level is a measure of the averaged acceleration. It is measured as an rms rather than a peak or actual level because a random signal varies unpredictably with time. The rms level tends to remain steady and is directly related to the power, or energy of the signal. The peak and actual measures vary continuously and are inappropriate measures of random acceleration.

Power spectral density plots (PSD's) display the energy content of a signal split into individual frequency bands. The area under the curve is a measure of the total energy in the signal. A typical power spectral density is shown in Figure 10. There are four major peaks in the response shown. There are four major peaks in the response shown. These

are at approximately 8 Hz, 27 Hz, 37 Hz, and 47 Hz. Each peak is caused by either an increased forcing function or a resonance in the response. It is these peaks that represent the principal responses of the systems under investigation. By controlling and altering these systems one can understand what is causing the vibration and what methods are best for reducing or changing the vibration to help protect paintings.

Not all of the information on PSD plots are useful. There are regions where measurement noise is greater than signal level. Additionally there are regions where signal levels are sufficiently low to be unimportant. In most of the PSD's data below 5 Hz and above 50 Hz needs to be analyzed carefully. Below 5 Hz measurement noise could be greater than signal level. Above 50 Hz signal levels were prone to measurement noise and tended to be sufficiently low to be unimportant.

The PSD's used were averaged PSD's. Sufficient averages were taken to ensure that the PSD's were good representations of the data recorded. Averaged rather than peak valued PSD's were used to ensure that isolated events did not distort the data. Peaks in response were related to the averaged response separately using probability density and kurtosis measurements. Thus the PSD's represent typical vibration behavior and not the sum of the worst-case isolated events. This is important because the two can be different by factors of ten or more. Thus, the study concentrated on typical behavior, which occurs all the time and is relatively constant, rather than worst-case events which rarely occur twice and are never constant. In general worst-case events should be avoided where possible and typical behavior studied and understood to aid conservation.

Transfer functions are measurements of the ratio between two signals split into individual frequency bands. They are particularly useful in identifying resonances or modes of vibration in systems. The plots used were split into magnitude and phase. At resonance there is a characteristically shaped peak or trough in a transfer function often combined with a rapid change of phase. The resonances or modes of vibration of a system control the isolation or amplification of vibration passing through them.

There are several forms of the transfer function in use by vibration specialists. In technical shorthand transfer functions are denoted by the character "H." This is followed by a number or character to denote which form is being used if this is otherwise unclear. Each form has its own advantages and disadvantages. The H3 form of transfer function has been used. This is defined, in matrix notation, as

$$H\,3 = \sqrt{\frac{Gxx}{Gyy}} \; x \; \frac{Gxy}{|Gxy|}$$

The principal reason for using the H3 form is that it is unaffected by coherence. The systems under review are fairly nonlinear with numerous "gaps" or rattles. This leads to low coherence at the most important frequencies. The more common H1 or H2 results would be significantly different at these points. The H3 form relates the vibration passed from the input to the response directly in PSD terms. This makes data easier to interpret and a more accurate reflection of the vibration environment seen by paintings in transit.

Probability density and kurtosis measurements were taken to assess how roughly the paintings were being shaken for a given rms level. For instance, a square wave is likely to be much rougher on a painting than a sine wave of the same rms level. In that event only kurtosis measurements were reported. This was partly due to a lack of time during the study but more particularly because a kurtosis value summarized the most important features of a probability density plot in a single value. Once this result had been established it was possible to reduce the time taken to analyze test results.

The kurtosis of a signal is a measure of its roughness. For example, a random signal with a normal probability distribution has a kurtosis value of three. If it is rougher the kurtosis value will be greater than three. If smoother, it will have a value less than three. For the purposes of the study, if the kurtosis value was between three and four then the painting was being fairly gently bounced

around for the rms level of vibration seen. If the kurtosis value was higher than four then the canvas was receiving a more abrupt treatment.

APPENDIX IV

Derivation of Laboratory Vibration Profiles

In theory it is possible to generate any wave form using a digitally controlled actuator. In practice it is limited by a number of technical and economic considerations.

Most transit vibration is low frequency, below 100 Hz, with a mixture of broad band and narrow band frequency content. The broad band frequency content tends to be generic to the type of transit e.g. vehicles produce the highest accelerations from 1-5 Hz, a second region of excitation from 5-20 Hz and then fall away. The narrow band frequency content tends to be specific, e.g. truck engine firing pulses and ship propeller blade passing effects. These vary with speed and load as well as vehicle type.

Transit vibration is often simulated using fairly large electrohydraulic vibration tables. These are able to produce the high forces and large displacements, 25-50 mm, needed for low frequency vibration. The simulation is commonly sinusoidal in type but is gradually turning to random as relatively low cost random vibration controllers and good input data become available.

The study brought together vehicle vibration data and a large servohydraulic vibration table with random vibration controller to provide a simulation of transit vibration in the laboratory. This enabled consistent evaluation of several variables under controlled conditions in a short period of time.

Two random vibration profiles were used in the study. These were labeled Forest Products and Tate and are shown in Figures 6 and 7, respectively.

The Forest Products profile was derived from a truck road vibration spectral envelope.[6] The shape of the envelope has been re-tained and is similar to that given for railcars in the same reference. The rms level used was consistent with that recommended by the report for road transportation, i.e. 0.15 grms.

The Tate profile was derived from early analyzes of road data taken from the larger Pira study. This was then tailored to be closer to that seen on the Momart truck. The rms level used was consistent with that measured on the Momart truck on the M11, a United Kingdom motorway to north of London. This is a smooth to moderate road and resulted in an rms level of 0.18 grms.

Both profiles contained little or no narrow-band frequency content, used similar vibration levels and were tailored at the low-frequency end to ensure that they could be performed using vibrators with finite stroke. The main difference was that the Forest Products was more simplified and easier to reproduce with a lost cost random vibration controller. The Tate profile included a better representation of the increased low frequency vibration levels seen below 20 Hz in real life and a smaller region of increased vibration at approximately 90 Hz to represent some of the narrow-band frequency content. In retrospect, the author would have been inclined to omit the 90 Hz region of increased response. This would have retained both the generic increased low-frequency behavior and the Forest Products approach to simplify narrow band frequency content above 20 Hz.

The full rms levels were used to simulate truck vertical vibration. Following from the author's past experience of vehicle lateral behavior and in order to avoid excessive canvas vibration only one-third of the full rms level was used for tests where the direction of excitation was in the fore/aft direction of the canvas.

The crest factor used for the trials was approximately four. This is consistent with typical random vibration in the field although less than that which tends to occur in the rear of trucks. This led to the input vibration having a kurtosis value of approximately four.

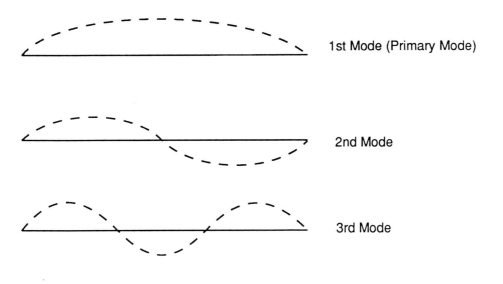

Figure 1 Typical Mode Shapes

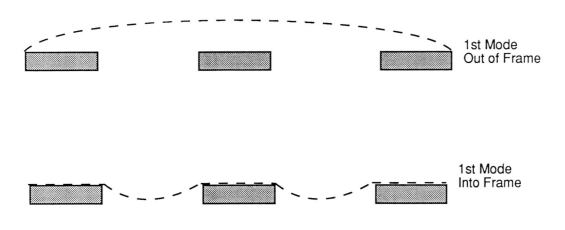

Figure 2 Primary Mode Shape with Stretcher

a) Recording Data During Shipment

b) Replay of Data into Measurement and Analysis Computer

Figure 3 Measurement Set up - Shipment

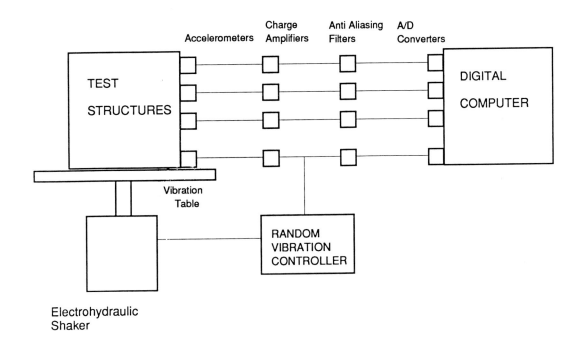

Accelerometers Charge Amplifiers Anti Aliasing Filters A/D Converters

TEST STRUCTURES

DIGITAL COMPUTER

Vibration Table

RANDOM VIBRATION CONTROLLER

Electrohydraulic Shaker

Figure 4 Measurement Set up - Laboratory

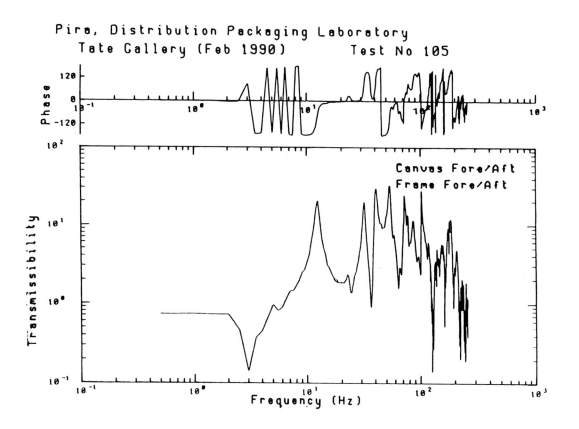

Figure 5 Dynamic Performance of Principal Test Canvas

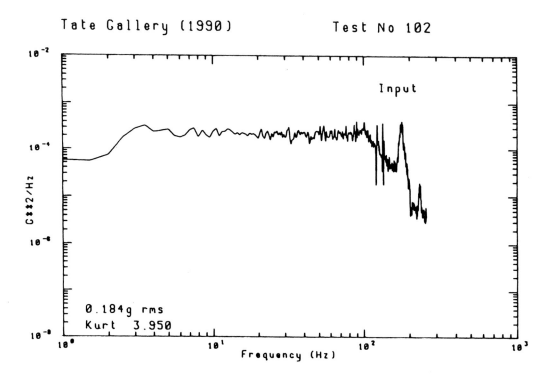

Figure 6 Typical 'Forest Products' Random Vibration Input

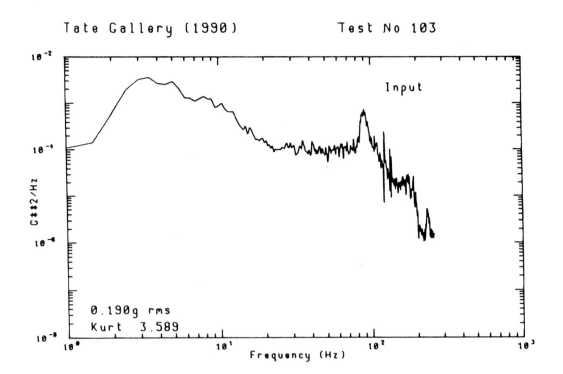

Figure 7 Typical 'Tate' Random Vibration Input

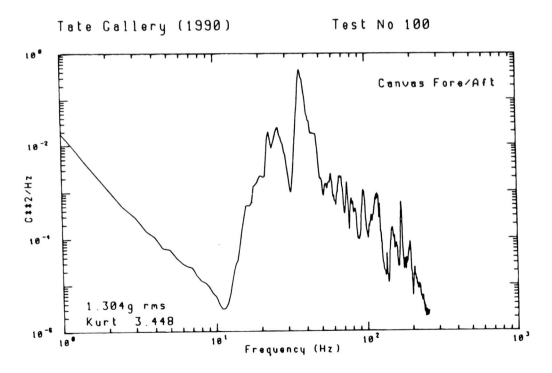

Figure 8 Forest Products - Canvas PSD - Test 100

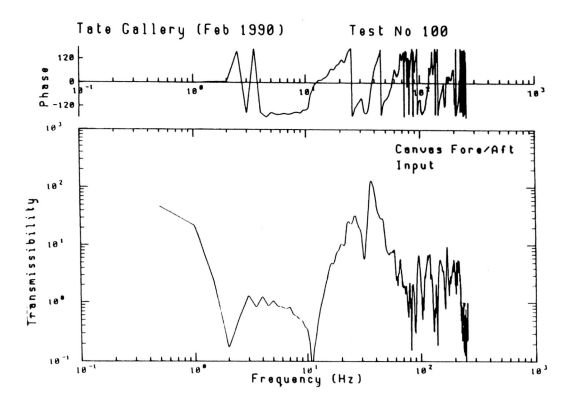

Figure 9 Forest Products - Canvas Transfer Function - Test 100

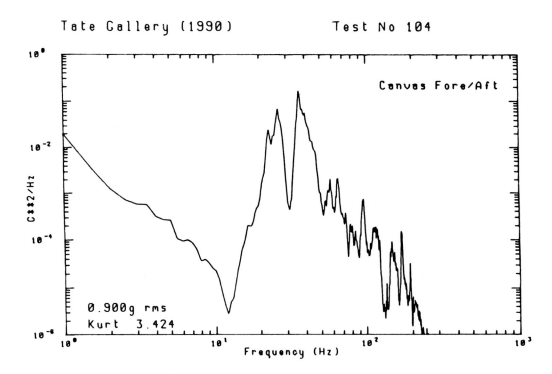

Figure 10 Tate - Canvas PSD - Test 104

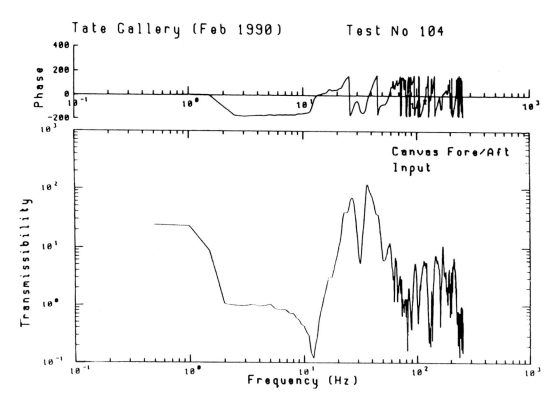

Figure 11 Tate - Canvas Transfer Function - Test 104

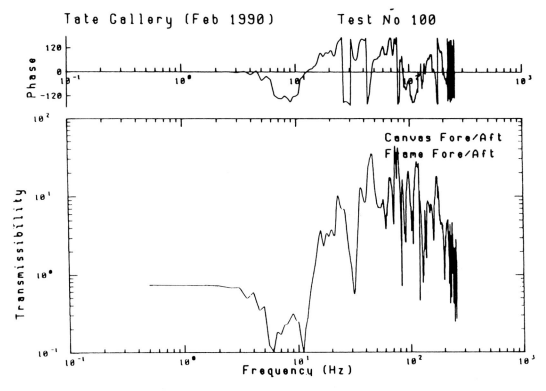

Figure 12 Canvas Transfer Function to Frame - Test 100

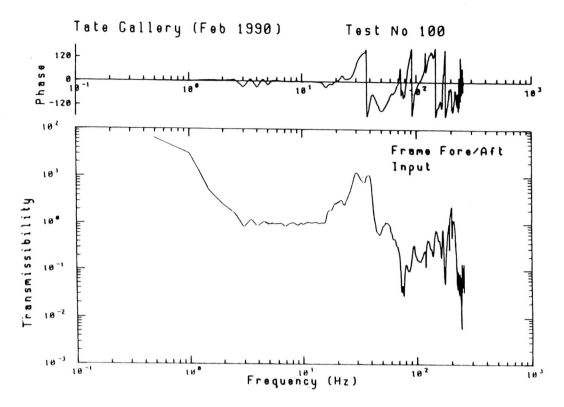

Figure 13 Frame Transfer Function to Input - Test 100

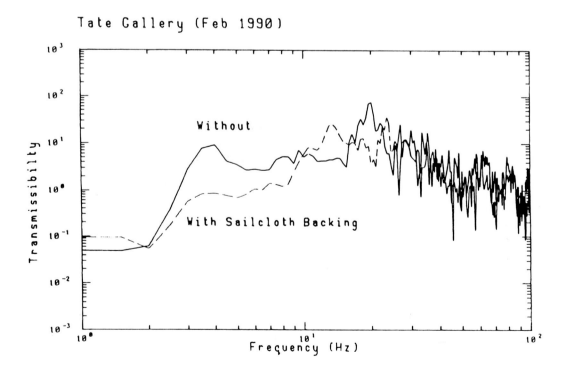

Figure 14 Large Canvas Transfer Function with and without
Stretcher cross-bar lining

TABLES

Notes to Tables

The tables provide a summary of the acceleration results from the road and laboratory trials. All results are average not peak values. The road trial results were taken on a smooth motorway/expressway.

1 - Journey Direction denotes the direction of travel on the motorway/expressway. Journeys occurred between Junctions 6 and 7 or 7 and 6.

2 - Description states

Packaging Condition of Canvas	e.g.	In Case
Direction of the Canvas	e.g.	Flat
and Location on Payload Area	e.g.	Front of Vehicle

The canvas is horizontal on the payload area when described as Flat. The canvas is vertical when described as Fore/Aft, i.e. the canvas is parallel to the direction of travel, or Transverse, i.e. the canvas is perpendicular to the direction of travel.

3 - Canvas acceleration measured at the center of the canvas in the direction perpendicular to the plane of the canvas, i.e. the in and out , or fore/aft direction, of the canvas.

4 - Truck accelerations were measured inside the truck at the center of the sidewall above the rear axles.

5 - The result for the canvas divided by the result for truck vertical. This is a measure of the magnification of vibration from the truck to the centre of the canvas.

6 - The vibration profile used to excite the canvas, Forest Products (FP) or Tate. See text and Appendix IV.

7 - Input vibration at surface of vibration table.

8 - Acceleration measured near a corner of the display frame holding the canvas. The directions vertical and fore/aft in the columns below relate to frame vertical and frame fore/aft.

9 - The result for the canvas divided by the result for the input. This is a measure of the magnification of vibration from the input at the vibration table to the output at the center of the canvas.

grms - an abbreviation for the root mean square of acceleration measured in g. A measure of how much vibration there is.

Kurt - an abbreviation for Kurtosis. A measure of how rough the vibration is.

TEST NO	JOURNEY DIRECTION (1)	DESCRIPTION (2)	CANVAS (3)		TRUCK (4) VERTICAL		TRANSVERSE		CANVAS TRUCK VERTICAL (5)	
			grms	Kurt	grms	Kurt	grms	Kurt	grms grms	Kurt Kurt
401	7-6	In Case, Canvas Fore/Aft, Rear of Vehicle	.25	4.0	.038	4.0	.045	3.8	6.6	1.0
402	6-7	In Case, Canvas Fore/Aft, Rear of Vehicle	.18	3.3	.028	3.4	.034	2.9	6.4	1.0
403	7-6	In Case, Canvas Tranverse, Rear of Vehicle	.43	3.1	.037	3.7	.046	3.4	11.6	0.8
404	6-7	In Case, Canvas Fore/Aft, Front of Vehicle	.25	3.3	.031	3.1	.042	3.3	8.1	1.1
405	7-6	In Case, Canvas Flat, Front of Vehicle	.63	3.1	.034	3.2	.053	3.4	18.5	1.0
406	6-7	In Case, Canvas Flat, Rear of Vehicle	.79	3.8	.030	3.1	.045	3.1	26.3	1.2
407	7-6	Bare Canvas, Fore/Aft, Rear of Vehicle	.55	4.5	.038	4.2	.049	3.3	14.5	1.1
408	6-7	Blanketted Canvas, Fore/Aft, Rear of Vehicle	.45	3.2	.029	3.4	.041	3.2	15.5	0.9
409	7-6	Back Boarded Bare Canvas, Fore/Aft, Rear of Vehicle	.63	3.4	.036	3.3	.051	3.3	17.5	1.0

Table 1 Summary of RMS Levels and Kurtosis Value Data - Road Trial Acceleration Results

TEST No	VIB TYPE (6)	DESCRIPTION (2)	INPUT (7)		CANVAS (3)		FRAME (8) VERTICAL		FORE/AFT		CANVAS INPUT (9)	
			grms	Kurt	grms	Kurt	grms	Kurt	grms	Kurt	grms grms	Kurt Kurt
100	FP	In Case, Canvas Face Down	.055	3.8	1.3	3.4	.040	3.3	.18	3.2	23.6	0.9
101	FP	In Case, Canvas Face Up	.052	3.6	1.14	4.3	.049	3.0	.10	3.0	21.9	1.2
102	FP	In Case, Canvas Vertical	.18	4.0	0.40	3.7	.29	3.3	.039	3.5	2.2	0.9
103	Tate	In Case, Canvas Vertical	.19	3.6	0.29	3.0	.26	3.1	.030	3.1	1.5	0.8
104	Tate	In Case Canvas Face Down	.057	3.8	0.91	3.4	.026	3.1	.11	2.9	16.0	0.9
105	Tate	Bare Canvas, Face Down	.058	3.8	0.99	3.4	.068	3.2	.11	3.7	17.1	0.9
106	Tate	Back Boarded Canvas, Face Down	.059	3.8	0.61	3.3	.063	3.0	.13	3.5	10.3	0.9
107	Tate	Back Boarded Canvas on 1" Felt, Face Down	.057	4.0	0.34	3.1	.011	3.0	.061	3.2	6.0	0.8
301	Tate	Bare Canvas on 1" Felt, Face Down	.063	4.2	.59	3.4	.012	3.3	.070	3.1	9.4	0.8
302	Tate	Bare Canvas on 1" Felt, Face Up	.061	4.2	.55	3.5	.010	3.4	.077	2.8	9.0	0.8

Table 2 Summary of RMS Level and Kurtosis Value Data - Laboratory Trial Acceleration Results

ACKNOWLEDGMENTS

The project on which this paper is based was made possible through the support and interest of the Getty Conservation Institute and Prosig Computer Consultants Ltd.

NOTES

1. P. J. Caldicott, "Evaluation of Painting Shipment Methods Using Ramdom Vibration Techniques for The Getty Conservation Institute and The Tate Gallery," *Consultancy Report* 51/MC/109. Pira International (1991).

2. T. Green, "Shock and Vibration—Test Results for Framed Paintings on Canvas Supports". ICOM *Committee for Conservation, 8th Triennial Meeting* 2, Preprints, Sydney (1989) 595.

3. T. Green 1989.

4. T. Green, "Vibration Control: Paintings on Canvas Supports", *Art in Transit Conference,* London (September 1991).

5. F.E. Ostrem and W.D. Godshall "An Assessment of the Common Carrier Shipping Environment," *Technical Report* FPL22, Forest Products Laboratory, USDA (1979).

6. Ostrem and Godshall 1979, 16-17.

Contributors

PETER CALDICOTT has a degree in engineering. He has fourteen years experience in the automotive, aerospace, defense, and power industries. He has industry experience in researching and consulting in shock and vibration techniques including test and mathematical modeling. At present, he is manager of the Distribution Packaging Test House at Pira International.

CHARLES G. COSTAIN graduated from Queen's University in 1976 with an M.A. in chemistry, with a minor in art conservation. From 1974-1974 he completed courses in technology and conservation in the M.A. Conservation Program. From 1976-1983, he was employed in the conservation branch of the Historic Parks and Sites Directorate of the Canadian Parks Service, working on archaeological material in the analytical chemistry section. He joined the analytical research services division of the Canadian Conservation Institute in 1983. He has been chief of the environment and deterioration research division of the Canadian Conservation Institute since 1987.

DAVID ERHARDT has a B.S. degree from the University of Miami and a Ph.D. in organic chemistry from the University of Maryland. He is senior research chemist at the Conservation Analytical Laboratory of the Smithsonian Institution, where he has been since 1979. He has a B.S. degree from the University of Miami and a Ph.D. in organic chemistry from the University of Maryland. His research interests include methods of analysis for the organic materials of museum objects, degradation processes, the museum environment, and materials used in the museum. Current research projects include a study of the effects on paint films of cleaning processes, and the effects of changes in temperature and relative humidity on the degradation processes of cellulose.

C. M. FORTUNKO holds a Ph.D. degree (1975) and B.S. degrees in applied physics from Stanford and Tufts Universities, respectively. From 1976-1980, he was a member of the technical staff and headed the functional design group at the Rockwell International Science Center. Between 1980-1983, he helped to establish the nondestructive evaluation group within the fracture and deformation division of the National Bureau of Standards (now NIST) in Boulder, Colorado. Between 1983-1988, he was chief scientist and engineering manager at the advanced systems and technologies division of the Aerojet Ordnance Company. He currently heads the composite material characterization group, which is a part of the material reliability division of the materials science and engineering laboratory at the National Institute of Standards and Technology. He has also consulted for a number of industrial and educational institutions.

ROBERT E. GREEN is director of the Center for Nondestructive Evaluation, professor and former chairman of the materials science and engineering department, and a staff member of the applied physics laboratory of The Johns Hopkins University. He has served as a Fulbright Scholar in Aachen, Germany, as a Ford Foundation resident senior engineer at RCA, scientific advisor at Aberdeen Proving Ground, consultant to the metallurgy division, polymers division, and the office of nondestructive evaluation at the National Bureau of Standards, and as materials sciences program manager at the Defense Advanced Research Projects Agency. He has published extensively, including serving as technical editor for the *Ultrasonics Volume of the ASNT Nondestructive Testing* Handbook, is on the advisory board of the newsletter *Materials and Processing Report* and on the editorial boards of the journals *Industrial Metrology* and *Research in Nondestructive Evaluation*.

TIMOTHY GREEN received his B.A. from Camberwell School of Arts in 1976, and Diplomas in conservation from the Courtauld Institute (1982) and the Tate Gallery, London (1983). He has been exhibitions conservator at the Tate Gallery since 1983. He has coauthored with Stephen Hackney on several ICOM articles and contributed "Moving Pictures II, Packing for Transport," in *The International Journal of Museum Management and Curatorship* 4, 1 (1985) and "Observation on the Vibration of Canvases" in the *UKIC One Day Meeting Preprints* (1985).

STEPHEN HACKNEY received a B.S. in chemistry and physics from the University of Manchester in 1969 and a Certificate in conservation from the Courtauld Institute of Art in 1972. He has been senior conservator of paintings at the Tate Gallery, London since 1972. He has published with Timothy Green "The Evaluation of a Packing Case for Paintings" and "The Dimensional Stability of Paintings in Transit for ICOM Triennal Meetings (1984 and 1987, respectively). His article, "Framing for Conservation at the Tate Gallery," appeared in *The Conservator* 14 (1990).

ROBERT HISCOX received his degree from Cambridge University in 1964 and subsequently entered Lloyd's of London as a broker for Durtnell & Fowler. In 1965 he joined Roberts & Hiscox Ltd., managing and members agents at Lloyd's where as an underwriter he developed an account in fine art. Mr. Hiscox is now the largest insurer of fine art in England. He is chairman of Roberts & Hiscox Ltd., Hiscox Holdings, Beazley Furlonge & Hiscox Ltd., Payne Hiscox Ltd., Harrison Holdings, and the Lloyd's Underwriting Agents' Association.

WILLIAM R. LEISHER received B.A., B.F.A., and M.A. degrees from Michigan State University (1965-1972) and studied conservation at the Intermuseum Conservation Laboratory in Oberlin, Ohio from 1972- 1974. From 1974-1980 he served as assistant conservator at the National Gallery of Art, Washington. Subsequently, he served as head of conservation of the Los Angeles County Museum of Art from 1980-1985. Currently he is executive director of conservation of The Art Institute of Chicago as well as an associate member of the American Institute for Conservation of Historic and Artistic works and chairman of the National Institute for the Conservation of Historic and Artistic Works.

PAUL J. MARCON graduated with a B.S. degree in mechanical engineering from the University of Ottawa in 1983. He is a member of the Association of Professional Engineers of Ontario and has been working as conservation scientist in the environment and deterioration research section of the Canadian Conservation Institute since 1984. His current area of research is the investigation into the problems of shipping works of art. He also serves as an advisor to Canadian museums and institutions on conservation environments for buildings/facilities in areas such as climate control, preventative conservation, and training seminars.

NANCY McGARY holds a B.S. degree in art education from the University of New Hampshire and an M.A. in arts administration from New York University where she has also pursued conservation studies at the Institute of Fine Arts. She received certification in non-profit organization management from the School of Public Service. She is associated with The Metropolitan Museum of Art and the Whitney Museum of American Art in New York City, where her responsibilities have encompassed all aspects of collection management and exhibition organization. She lectures for museum studies programs and is a frequent speaker at meetings of professional museum organizations. She is guest editor of the forthcoming publication on museum packing for the Mid-Atlantic Association of Museums and has published "Opting for Off Site Collection Storage," in *Registrar*.

MARION F. MECKLENBURG holds B.S., M.S., and Ph.D. degrees in structural engineering from the University of Maryland. He has worked for twenty years as a paintings conservator in the United States. He joined the Smithsonian Institution in 1987 and is currently assistant director for conservation research at the Conservation Analytical Laboratory. He is a visiting professor in the department of materials science, The Johns Hopkins University, where he coordinates the joint Conservation Analytical Laboratory-Johns Hopkins University graduate program in materials science. His research areas are in the mechanics of materials and the effects of the environment on the mechanical properties of materials.

ROSS M. MERRILL graduated from the Pennsylvania Academy of the Fine Arts in Philadelphia and returned to Fort Worth, Texas where he worked as registrar for the Fort Worth Art Center Museum and as exhibition preparator for the Kimbell Art Museum. Upon graduation from Oberlin College with an M.A. and a Professional Conservation Certificate from the Intermuseum Conservation Association, he became head of conservation at the Cleveland Museum of Art. In 1981 he joined the National Gallery of Art as head of painting conservation and assistant chief of conservation and in 1983 he was appointed chief of conservation. He is vice-chairman of the National Institute for the Conservation of Cultural Property and serves on the board of the Intermuseum Conservation Association, Oberlin.

STEFAN MICHALSKI received a B.S. in physics from Queen's University, Kingston in 1972 and trained as an artifacts conservator there from 1977-1979. He has been employed at the Canadian Conservation Institute since 1979 in the conservation research services division. Currently a senior conservation scientist at CCI in the environment and deterioration research division, he has published articles on the development and assembly of a relative humidity control module and on the history and theory of suction table use in conservation. He is currently consultant to Canadian museums on architectural, mechanical, and display case aspects of environmental control and is carrying out research on response of paintings to relative humidity, solvents, and temperature.

ALISON MURRAY is a full-time doctoral candidate in the department of materials science and engineering, at The Johns Hopkins University, where she received her M.S. in engineering in 1990. She graduated from McGill University, Montreal, with a degree from the department of chemistry. She is a recipient of a Smithsonian Fellowship and is in the Conservation Science Program offered jointly by Johns Hopkins and the Conservation Analytical Laboratory at the Smithsonian Institution. She worked as a summer student in 1985-1986 at the Canadian Conservation Institute.

SARAH M.V. RENNIE received a B.A. degree in art history and geography from the University of Canterbury in New Zealand in 1983, followed by an M.A. degree in art history in 1985. From 1985-1988 she worked in the registrar's office of the National Gallery in New Zealand. She is currently assistant registrar in charge of transport and location at the Australian National Gallery in Canberra.

MERVIN J. RICHARD received a B.A. in chemistry and art history from the University of Delaware (1971-1975) and an M.A. in conservation from Oberlin College (1975-1978). While a graduate student (1975-1978), he studied the practical and theoretical aspects of conservation at the Intermuseum Laboratory, Oberlin. From 1978-1980, he was employed as a conservator of paintings at the Intermuseum Laboratory. From 1980-1982, he was an assistant conservator of paintings at the Philadelphia Museum of Art. From 1982-1984 he was a conservator of paintings for the Winterthur Museum, and an adjunct professor of the University of Delaware/Winterthur Museum art conservation graduate program. Since 1984, he has been the head of loans and exhibitions conservation at the National Gallery of Art, Washington where he now also serves as deputy chief of conservation. He is the co-chairman of ICOM working group on the care of works of art in transit.

DAVID SAUNDERS has a B.S. desgree in chemistry, and a Ph.D. in organometallic chemistry. Since 1985 he has been with The National Gallery, London as a conservation scientist where he is presently studying the effect of the environment on paintings and painting materials. He is particularly interested in methods for long-term recording of the environment, both within the museum and during the transport of paintings. He has published with Richard Clarke findings on this research in the ICOM Dresden (1990) Preprints and presently is editor of *Studies in Conservation*.

HILTRUD SCHINZEL studied restoration at the Academy of Fine Arts, Vienna, Austria, received her masterclass training in conservation and technology, and studied paper restoration at the Albertina, Vienna. She received her Ph.D in art history, archeology, and prehistory at the Ruhr-University, Bochum, Germany. She is presently a private conservator specializing in contemporary art and damage cases in Düsseldorf, Germany and is an assistant at the city museum in Bochum. She has also headed a privately funded research project for the restoration of contemporary paintings in Düsseldorf.

CHRISTINE LEBACK SITWELL received a graduate degree in art conservation from the University of Delaware/Winterthur Museum. She was awarded a Smithsonian Fellowship to study as an intern in the conservation department of the Tate Gallery, London in 1977 and has remained in England working as a private exhibition and paintings conservator and, most recently, as assistant advisor for paintings conservation for the National Trust.

MICHAEL R. SKALKA received a B.A. in psychology from Bloomfield College in 1976, a B.A. in art history from Rutgers University (1982) and an M.F.A. in museum studies from Syracuse University in 1984. His work and academic focus has been in the area of exhibition organization, management, and computer technology applications for museums. He is presently conservation administrator at the National Gallery of Art, Washington.

CHARLES S. TUMOSA earned his Ph.D. in chemistry from Virginia Polytechnic Institute and State University in 1972. For eighteen years he supervised the criminalistics laboratory of the Philadelphia Police Department and joined the Smithsonian Institution in 1989. His publications have been in the areas of chemistry and forensic science with emphasis on the analysis of trace materials. Currently he is head of analytical services at the Conservation Analytical Laboratory, Smithsonian Institution.

Glossary

Abrasion, Damaged areas of paint, resulting from the scraping, rubbing, and grinding away of the upper paint layers.

Accretion, Accidental deposit on the surface of an object or picture. In paintings, often fly specks.

Aging, In the context of this publication usually refers to the chemical change occurring to materials over time; i.e. chemical alteration or degradation over periods of time.

Air-conditioned, Ideally the control of temperature, relative humidity, and ventilation of the air in an enclosed environment. Often this term is used only to mean control of the temperature.

Air-coupling technique, The use of air as a medium for acoustic transmission in certain techniques for non-destructive analysis.

Alligator crackle, A pattern of crackle produced by shrinkage in a rapidly drying upper layer lying over a slow drying still plastic lower layer. The pattern of traction crackle is a characteristic complex branching in which apertures are abnormally wide and disfiguring.

Band-pass filter, An electronic device or component that permits the transmission of an electronic signal at a specific frequency or frequency band.

Batten, A wooden strip attached to the reverse of a wood panel painting for the purpose of providing additional structural support. Battens can be found attached to the panels either parallel or perpendicular to the grain of the panel. Several battens constitute a cradle.

Beam, A slender, usually horizontal member of a structure functioning as a support for a floor or bridge deck. Beams are usually designed to resist bending.

Blanching, Pale milky cast on an old coating of varnish or paint, indicating the change which occurs in an aged coating after a solvent has been applied and then has evaporated, leaving a milky look, usually irregular in distribution.

Blister, A convexity or bulge in the paint surface indicating cleavage of paint and/or ground layers, either from each other or from the support.

Bloom, A hazy, bluish white cloudiness, which appears on parts or all of the surface of some varnish films, resulting from the breakdown of the consistency of the coating by moisture or other pollutants.

Bole, A fine earthy clay, white, yellow, or red, used in gilding and sometimes in artists' grounds. When ground with diluted egg white and applied to a wood surface, it makes a smooth ground for the laying of gold leaf. In early times terre verte (a pale green earth) was ground in this way and used as bole. The purpose of the red-orange bole is to give brilliance and warmth to the gold.

Buckling, (1) The appearance of waves or bulges in a canvas that has slackened on its stretcher. (2) Cleavage from the support in which the ground and upper layers of the painting give way or crumple up under pressure from shrinkage of the canvas support and are pushed up along the edges of cracks.

Byproducts, The residual material or information resulting from an operation designed to give other results. The chemical breakdown of materials can be said to produce degradation byproducts.

Canvas, A cloth made from cotton, hemp, flax (commonest material for canvases of any age,) or sometimes silk, traditionally used as a paint support (though hemp fiber is rarely found.) The term also means a fabric support prepared for painting and the finished painting itself.

Chalking, The loss of pigment in a paint layer by powdering off. This effect results from either an insufficient quantity of binding medium in the paint when originally applied or a loss of the binding medium as a result of damage or deteriorating conditions.

Check, A rupture in wood running along the grain from the edge of a board or panel for a part of its length.

Cleavage, Separation between paint layers, paint and ground layers, or ground and support. It occurs where adhesion between layers has deteriorated. Common treatment takes the form of local or total infusion with an appropriate adhesive.

Climate controlled, Usually referring to air-conditioning of an internal environment. Climate control of transport vehicles such as trucks usually means heating or cooling. *See also* Air-conditioned.

Compliant, To give way or deflect as a result of an applied forces.

Compression, The dimensional response of a material subjected to crushing forces as opposed to tensile forces which tend to pull a material apart. Materials subjected to compression tend to get smaller.

Compression creep, The continued deformation of a material subjected to a constant compression force or stress.

Compression set, The permanent deformation of a material resulting from either very high compression forces of those applied over a very long time. This term is usually used in the context of wood behavior.

Convection crackle, In a paint surface, a type of age crackle which predominates in areas affected by barriers (e.g. stretcher bars) or bottlenecks (e.g. behind keys) which impede the flow of moist warm air at the reverse of the painting. The crackle will often be less or absent in the areas of the barriers themselves, where a more stable micro-climate is maintained.

Crackle, The network of fine cracks which develops in grounds, paint layers, and surface coatings of paintings on the aging or drying of the materials. Age cracks usually penetrate both the paint layer and ground. They are caused by strain from movement of the support. Drying cracks or youth crackle are caused by the failure of the film to withstand its own contraction during drying or by the artist's incorrect use of his paint. They usually do not penetrate the whole structure from support to surface.

Cracks, Fissures formed in materials resulting from excessive stress or force.

Cradle, A wood structure fixed to the back of a panel painting consisting of wood strips having slots and being joined with glue to the back of the panel parallel to its grain. Designed to prevent warping, with changes in the humidity, it often forces the panel to crack.

Crazing, A series of tiny breaks in the paint film which do not expose the underlying surface.

Creep, The continued deformation of a material subjected to a constant force or stress.

Cross section, Either a microscopic slide of a material used for the microscopic examination or referring to the area of a tensile test specimen whose plane is perpendicular to the direction of the applied stresses as in cross-sectional area.

Cupping, The cuplike deformation observed in the islands of paint formed by cracks in the design layer of a painting.

Database, A collection or compilation of information resulting from various experimental, literature, or other sources.

Deformation, The distortion of materials or structures subjected to stresses or forces.

Diurnal, Recurring every day.

Doover, A plastic fixing device for attaching two dimensional works of art to traveling frames, storage, and installation systems based on a principle of triangulation.

Double-packing case, A packing technique using an inner case within an outer case, that serves to eliminate the difficulty of providing protection for elaborate and fragile frames from damage due to either impact or abrasion.

Draw, A system of wrinkles radiating from a corner of a stretched fabric or parallel wrinkles running into a stretched fabric from an edge.

Ductile, A material is said to be ductile if it is capable of large plastic deformations. A ductile material requires a considerable amount of work to cause failure.

Dynamic, A system or structure is said to be dynamic if the application of forces results in motion to the system. A vibrating painting is a dynamic system.

Dynamic cushioning curve, Curves used in determining the correct amount of cushioning material to optimize the resistance to impact.

Elastic, A material is said to behave in an elastic manner if it returns to its original dimensions once a previously applied force is removed.

False crackle, Any pattern resembling that of crackle which is not caused by the normal drying or aging of the materials found in a painting. False crackle may be a system of ruptures produced mechanically or may be painted on the surface.

Finite element analysis, A computer structural analysis technique where a structure is modeled by numerically constructing it from a finite number of discrete elements. The resulting approximation yields fairly accurate results.

Flaking, The breaking away or detachment of one or all paint and ground layers from the support in either small particles or larger areas. *See* Blister, Buckling, Cleavage, Crackle. Flaking is an extreme stage of the cross referenced terms listed.

Floating signature, A name or initials placed on top of the surface coating of a painting or on top of a layer which is not part of the original work.

Fragility, A qualitative measure of an objects ability to withstand impact. Fragility is usually measured in G's or acceleration.

G, A unitless measure of the magnitude of an impact. The ratio of the acceleration resulting from an impact to the earth's gravitational constant.

Gauges, As in strain gauges. Electronic resistance devices, attached to the surface of a structure, used in the measurement of small deformations or strains, *also* gages.

Gesso, A pale creamy white priming composed of burnt gypsum (plaster of Paris) mixed with glue. Gesso has come to have a wider meaning today and now includes grounds made from chalk (whiting) or other inert white pigments, bound with glue size usually parchment size, calf skin glue, rabbit skin glue, and isinglass. Gesso in its various combinations provides a ground layer for oil and tempera paintings.

Glassy, A description of the mechanical behavior of a materials. A material is said to be glassy if it has a high resistance to deformation, breaks suddenly without ductile deformation and shows a propensity to brittle cracking. Severe desiccation, cold temperatures, and high rates of loading can cause materials to act in this manner.

Granular, A paint structure which consists almost entirely of pigment particles with little or no vehicle. Used generally in describing the condition of materials which have lost their cohesiveness.

Grime, Dirt of any kind. It may be on the surface of an object or buried under a surface coating.

Ground, In picture construction, the opaque coating applied to the support after sizing to give it the correct properties for receiving paint or gold leaf. The common ingredients are glue or oil, as a medium, inert fillers, earth colors, white or red lead, and driers. The ground used on commercially prepared canvas is often called priming. *See* Priming.

Half-time, The time required for an internal environment to reach half the difference between the initial internal temperature and the external temperature. The time required for an internal environment to reach half the difference between the initial internal relative humidity and the external relative humidity. Half-time is a useful measurement of the effectiveness of thermal insulation and the effectiveness of buffers used in the control of relative humidity.

Humidity, A term relating to the quantity of water vapor present in air. *See* Relative humidity.

Impact, The sudden application of intense forces to a structure. Dropping an object results in a high impact if it hits a hard surface.

Impasto, A thick often opaque, area of paint which protrudes above the surface to which it has been applied.

Inpainting, The introduction of new paint material into the areas of loss in an original construction.

In-plane, Relating to events occurring in the plane of a structure such as the plane of a painting defined by its edges.

Interstices, The crevices between the threads of a canvas support.

Load cell, A mechanical or electrical device used to measure the forces experienced by a material during a stress-strain test.

Keying-out, The expansion of a painting by driving wedges or keys into the inside of the corners of stretchers.

Keys, Thin triangular pieces of wood tapped into the corner of a stretcher. The stretcher members are forced apart, thus tightening the canvas.

Lacuna, A gap or cavity caused by the loss of a flake of paint or ground from the surface of a painting.

Lining, The sticking of a fabric (traditionally a fine linen canvas) to the reverse side of a canvas picture. The purpose of lining is to counteract structural weakness in the original canvas itself and/or to secure cleavage between the paint/ground and canvas layers.

Mechanical cracks, Although similar in appearance and character to age cracks, they are often caused by external local pressures.

Medium, The material that holds together pigment particles in paint.

Modeling, In structural analysis, any technique used to determine the deformations and stresses a structure encounters when subjected to either external or internal forces. Numerical modeling usually refers to computer oriented analytical techniques. Closed form modeling usually refers to purely mathematical techniques.

Modulus, The slope of the elastic section of a stress-strain test. The modulus of a material is a measure of its stiffness, relating the stress required to deform the material.

Moisture barrier, A layer with high water vapor impermeability (such as beeswax) which is often applied as the last stage of treatment to the back of a glue paste relining. Wax-resin linings acts as its own moisture barrier. It is also applied to the reverse and edges of panel paintings to protect them from changes in atmospheric humidity.

Out-of-plane, Relating to events, such as deformation or vibration occurring out of the plane of a painting defined by the edges. This term usually refers to events occurring perpendicular to the plane of the painting.

Overcleaning, Taking off original paint during cleaning a picture or object. Sometimes called "skinning."

Overpainting, Additions which partially or wholly cover original paint.

Ozclip, A multi-purpose, metal, hanging, traveling and storage fitting designed as a permanent attachment to framed works of art.

Paint, Finely ground pigment, suspended as discrete particles in a film-forming material or medium, having the property of drying to a continuous adherent film when applied to a surface or ground. Generally, the pigments used to make the various types of paint (watercolor, encaustic, tempera, oil) are the same. The binding media differ in each. Water-soluble gums and glues are used for watercolor, wax for encaustic, egg yolk plus water and/or oil for tempera, and drying oils for oil paints.

Panel, A stiff primary or secondary support of wood, metal or composition board.

Pentimento, A phenomenon in paint involving increased translucency of upper layers and emergence of tones beneath, theoretically caused by a progressive change in refractive index of an oil medium. As the index of refraction rises, more light can penetrate through the paint layer, and the drawing and underpaint once concealed show through.

Plastic, In mechanics, the behavior of a material deformed beyond the yield point. Materials subjected to plastic deformation are permanently deformed with the removal of previously applied stresses. *See* Ductile.

Plasticizer, A material, either inherent or added to plastics or paints to make them more flexible.

Pre-stress, Stress applied to a material or structure prior to service use or testing . Expanding a stretcher applies a non-uniform pre-stress to all layers of a painting.

Pre-tension, The application of a tensile pre-stress to a material or structure prior to service use or testing. *See* Pre-stress.

Priming, Layer following the ground layer providing modified color base and/or textured surface on which to paint. Priming and primer, meaning a preparation coating for canvas, is synonymous with ground. *See* Ground.

PVC, Pigment volume concentration. The ratio of pigment, by volume, to the total volume of a paint. The same ratio of volume of chalk or filler to the total volume of a gesso. In artists' paints, the pigment is between 40% and 60% of the total volume of the paint.

Raking light, Light rays directed parallel to the surface of a object or picture. Used in examination of objects, especially paintings, to indicate buckling and other irregularities of conformation.

Reforming, The treatment of blemishes in a surface coating by the application of a solvent which swells the coating and redistributes it on the surface.

Relative humidity, The ratio of the partial pressure of water vapor present in the air to the saturation vapor pressure of water vapor at the given temperature. The ratio of the amount of water vapor in the air to the maximum possible at a given temperature.

Relining, The lining of a canvas painting which has been lined previously. Removal of the old lining canvas and adhesive and mounting on a new lining canvas and adhesive and mounting on a new lining canvas with new adhesive.

Resonance, The effect produced when the amplitude of oscillation of a body is greatly increased by a periodic force at the same or nearly the same frequency. In this case, the periodic force is the vibration from transportation modes.

Risk assessment, An evaluation of the potential risk to an object from transport.

Rubbery, A material is said to be rubbery when exposed to high relative humidity or high temperature. The material, when tested, exhibits low strength and very high elongation to failure.

Shock, A structure is said to experience shock if it is subject to a impact.

Size, In its broadest sense, size means any material which is used to seal a porous surface. A term frequently applied to a glutinous mixture of gelatin, skin glue, starch, resin or gum in water. Raw canvas is normally "sized" before application of the ground or priming.

Split, A rupture in wood running along the grain from end to end of a panel or board causing complete separation.

Static, Still, restrained from motion. A structure is said to be in static equilibrium when the sum of all applied external forces equals zero.

Strain, The ratio of deformation of a stressed material to its original dimensions. The strain times one hundred is the percent elongation of a material specimen tested in tension.

Strength, The strength of a material is the maximum sustainable stress prior to failure.

Stress, The applied force in a test material divided by the cross-sectional-area of the specimen. The normalized forces in a structure, e.g. Force per unit area.

Stress relaxation, The decay of stress in a material subjected to a constant displacement or strain.

Stress stiffening, The geometric effects on the structural stiffness due to large displacements. The out-of-plane stiffness of a painting does not remain constant but increases with increases in the out-of-plane displacement. This is why larger displacements of paintings results in increases in the resonant frequency.

Stretcher, A wooden frame over which canvas paintings are stretched. The corners are jointed but not fixed. By driving in keys or various kinds of springs, the stretcher may be expanded and the canvas tightened.

Stretcher crease, The appearance on the paint surface of the form of the stretcher bars as areas of relatively uncracked or uncupped paint (generally in a picture where the surface exhibits crackle). The edges of the stretcher are marked in the paint surface by fairly continuous parallel straight cracks.

Support, The physical structure of a painting which holds or carries the ground and paint film. Any material such as fabric, wood, metal, or paper on which a painting is executed.

Surface coating, A transparent layer or series of layers applied over the surface of a painting for protection and for a uniform reflection and surface texture. Consists usually of natural or artificial resins, waxes, or oils.

Tarmac, Asphalt paved, aircraft parking area, or apron found at airports.

Transfer (or transposition), The removal of the support from the reverse of the paint and ground layers and subsequent mounting of these on a new support. In some cases the ground is removed where it is in bad condition, and a new ground is applied to the reverse of the paint film. This method originated in France in the middle of the eighteenth century when many panel paintings were transferred to canvas.

Units of measurement: See chart.

Varnish, A surface coating containing resinous matter either dissolved hot in a drying oil (oil-resin varnish) or cold in a solvent (solvent-type or spirit varnish).

Visco-elastic effects, Time dependent mechanical behavior. A material is said to exhibit visco-elastic effects if it is prone to creep or stress relaxation. *See* Creep and Stress relaxation.

Vibration, Rhythmic or random oscillation of an object resulting from transportation vehicles.

Wedges, *See* keys.

Yield, A material is said to yield if it exhibits plastic deformation.

Yield point, The transition of a material from elastic to plastic behavior.

Unit of Measurement

	SI	**ENGLISH**
Frequency	Hertz (Hz)	Cycles Per Second
Force	Newton, Gram Force (N)	Pound Force
Length	Millimeter, Meter, Centimeter (m, cm)	—, Foot, Inches., (ft., in.)
Mass	Gram, Kilogram (g, kg)	Slug
Modulus	Pascal	Pounds Per Square Inch (PSI)
Pressure/Stress	Pascal, Newtons Per Square Meter	Pounds Per Square Inch (PSI)
Strain	Unitless	Unitless

SELECTED BIBLIOGRAPHY

Michael Skalka

Articles

Abbot, N. J., F. Khoury, and L. Barish. "10-The Mechanism of Fabric Shrinkage The Role of Fiber Swelling." *Journal of the Textile Institute* 55 (1964).

"Advances in Test Measurement." *Proceedings of the Fifth Annual ISA Test Measurement Symposium* 5 (October 1968).

"Air Transport." *Registrars' Report* 1 (October 1977).

American Society for Testing and Materials. "Method D 2221-68: Creep Properties of Package Cushioning Materials." *1983 Annual Book of ASTM Standards* 15.09 Philadelphia, 1983.

_____. "Method D4169-82: Performance Testing of Shipping Containers." *1983 Annual Book of ASTM Standards* Philadelphia, 1983.

_____. "Method D1596-78a: Shock Absorbing Characteristics of Package Cushioning Materials." *1983 Annual Book of ASTM Standards* 15.09 Philadelphia, 1983.

_____. "Method D 1083-53: Standard Methods of Testing Large Shipping Cases and Crates." *1983 Annual Book of ASTM Standards* 15.09 Philadelphia, 1983.

_____. "Method D 1276-68: Water Vapor Transmission of Shipping Containers by Cycle Method." *1983 Annual Book of ASTM Standards* 15.09 Philadelphia, 1983.

_____. "Method D 1372-64: Package Cushioning Materials." *1983 Annual Book of ASTM Standards* 15 Philadelphia, 1983.

_____. "Method D 4168-82: Transmitted Shock Characteristics of Foam-in-Place Cushioning Materials." *1983 Annual Book of ASTM Standards* Philadelphia, 1983.

Arni, P. C., G. D. Cochrane, and J. D. Gray. "The Emission of Corrosive Vapors from Wood." *Journal of Applied Chemistry* 15 (1965), 305-315, 463-468.

van Asperen de Boer, J. R. J., G. Thomson, ed. "Humidity in Walls in Relation to the Preservation of Works of Art." *IIC London Conference on Museum Climatology* (September 1967).

Bambos, G. "The Hazards of Vibration During Transport." *UKIC Meeting on Packing Cases, Safer Transport for Museum Objects* Preprints, London (June 1985).

Bauhof, W. A. "The Package Engineer in the Museum." *Museum News* 44 (December 1965), 27-28.

Beale, A. "Materials and Methods for the Packing and Handling of Ancient Metal Objects." *Bulletin of IIC-AG* (1969), 4-9.

Berger, G., and W. H. Russell. "Deterioration of Surfaces Exposed to Environmental Changes." *Journal of the American Institute for Conservation* 29 (1990).

Berger, G., and W. H. Russell. "Investigations into the Reactions of Plastic Materials to Environmental Changes, Part 1, The Mechanics of the Decay of Paint Films." *Studies in Conservation* 31 (May 1986).

Berger, G., and W. H. Russell. "An Evaluation of the Preparation of Canvas Paintings Using Stress Measurements." *Studies in Conservation* 33 no. 4 (1988).

Bickle, L. W. "The Use of Strain Gages for the Measurement of Propagating Strain Waves." *Procedural Technical Committee on Strain Gages* Westport, CT, October 1970.

Blackshaw, S. M., and V. D. Daniels. "Selecting Safe Materials for Use in the Display and Storage of Antiquities." *ICOM Committee for Conservation 5th Triennial Meeting* Preprints, Zagreb (1978).

_____. "The Testing of Materials for Use in Storage and Display in Museums." *The Conservator* 3 (1979), 16-19.

Booth, P., T. Green, and C. L. Sitwell. "Moving Pictures." *International Journal of Museum Management and Curatorship* 4 (March 1985), 41-52.

Boustead, W. M., G. Thomson, ed. "Dehumidification in Museum Storage Areas." *IIC London Conference on Museum Climatology* (September 1967).

Bradley, S., S. Staniforth, ed. "Safe Materials for Use in Construction of Packing Cases." *UKIC Meeting on Packing Cases, Safer Transport for Museum Objects* Preprints, London, June 1985.

Brommelle, N.S. "Lighting, Air-conditioning, Exhibition Storage, Handling and Packing." *The Conservation of Cultural Property*, Paris.

Browne, F. L., "Swelling of Paint Films in Water, III, Absorption and Volumetric Swelling of Bound and Free Films from Air of Different Relative Humidities." *Forest Products Journal* 5 (February 1953).

Browne, F. L., "Swelling of Paint Films in Water, V, Effects of Different Pigments." *Forest Products Journal* 5 (June 1955).

Browne, F. L. "Swelling of Paint Films in Water X, Rate of Penetration of Water, Permeability of Water Vapor, and Penetrability to Air in Relation to Water Absorption." *Forest Products Journal* 8 (April 1957).

Brunt, N. A. "Blistering of Paint Layers as an Effect of Swelling by Water." *Journal of the Oil and Colour Chemists Association* 47 (January 1964).

Buchanan, J. "The Movement of Art: Questions and Answers." *Art Gallery* 16 (June 1973), 8-9, 82.

Buck, R. D. "Notes on the Effect of Age on the Hygroscopic Behavior of Wood." *Studies in Conservation* 1 (1952), 39-44.

_____. "Use of Moisture Barriers on Panel Paintings." *Studies in Conservation* 6 (1961), 9-19.

_____. "Some Applications of Mechanics to the Treatment of Panel Paintings." *Recent Advances in Conservation* London, 1963, 156-162.

_____. "A Specification for Museum Air Conditioning." *Museum News* 43 (December 1964), 53-57.

————. "Hazards of International Shipment." *Bulletin of IIC-AG* 6 (May 1966), 15-16.

Bullard, D. J., B. J. R. Blench, and B. V. Harper. "A Costume Display Case for a Museum Loan Service." *Costume* 4 (1970), 49-52.

Cadorin, P. "Inadequate Precautions for Temporary Exhibitions." *Museum* 34 (1982), 48-50.

Cannon-Brookes, P. "The Transportation of a Consignment of Paintings from Cape Town to Southampton by Sea." *ICOM Committee for Conservation 5th Triennial Meeting* Preprints, Zagreb (1977).

————. "Museums and Fine Art Transporters." *Museums Journal* 77 (1978), 174-176.

————. "Organization and Administration of Temporary Exhibitions." *Samab* 13 (1979), 233-245.

————. "Report on the International Art Exhibition Organiser's Manual." *ICOM Committee for Conservation 6th Triennial Meeting* Preprints, Ottawa (1981).

————. "A Draft Code of Practice for Escorts and Couriers." *International Journal of Museum Management and Curatorship* 1 (March 1982), 41-60.

————. "The Evolution and Implementation of a Transportation Strategy for Works of Art." *International Journal of Museum Management and Curatorship* 5 (1986), 163-169.

Carrick, L. L., and A. J. Permoda. "Shrinkage of Some Organic Film Forming Materials During Aging." *Official Digest* 28 (November 1951).

"Circulating Exhibitions." *Registrar's Report* 1 (1979).

Coleville, J., W. Kilpatrick, and M. F. Mecklenburg. "A Finite Element Analysis of Multi-layered Orthotropic Membranes with Applications to Oil Paintings on Fabrics." *IIC Science and Technology in the Service of Conservation* London, 1982, 146-150.

"Conserva-tips. Handle with care: How to Pack Museum Artifacts." *History News* 36 (May 1981), 44.

"Conserva-tips: How to Double-Crate Artifacts for Shipment." *History News* 36 (June 1981), 40.

Cornelius, F. du Pont. "Movement of Wood and Canvas for Paintings in Response to High and Low Humidity." *Studies in Conservation* 12 (1967), 76-79.

Cox, T. "Conservation." *Pictures, A Handbook for Museum Curators.* Part D, Sections 1 and 2, London, 1956.

"Criteria for Packing Works of Art for Traveling Exhibits." *Newsletter of the Canadian Conservation Institute* 5 (November 1974), 3.

Cursiter, S. "Control of Air in Cases and Frames." *Technical Studies in the Field of Fine Arts* 5 (1936), 109-116.

"Custom Packing in Foam." *Bulletin of IIC-AG* 4 (April 1964), 8.

Daly, D., and S. Michalski. "Methodology and Status of the Lining Project, CCI." *ICOM Committee for Conservation 8th Triennial Meeting,* Preprints, Sydney (1987).

Damfilov, A.V., and Y. G. Ivancheva. "Mechanical Properties of Pigmented Oil Films." *Journal of Applied Chemistry* 20 (1947), 676-683.

"Delicate-Please Package with Care: Crystal Diagnostic Equipment." *Package Engineering* (May 1980), 58-59.

Di Matteo, C. "The Pitfalls of Transport." *Museum* 34 (1982), 46-48.

Diamond, M. "A Micro-micro-climate." *Museums Journal* 73 (1974), 161-163.

Dore, J., S. Staniforth, ed. "Packing Costumes and Textiles for Transport and Display." *UKIC Meeting on Packing Cases, Safer Transport for Museum Objects* Preprints, London, June 1985.

Douglas, R. A. "A Commonsense Approach to Environmental Control." *Curator* 15 (June 1972), 139-144.

Eissler, R. L., and L. H. Princen. "Effect of Some Pigments on Tensile and Swelling Properties of Linseed Oil Films." *Journal of Paint Technology* 40, no. 518 (March 1968).

Elm, A. "Some Mechanical Properties of Paint Films." *Official Digest* 25 (1953), 750-774.

Fall, F. K. "New Industrial Packing Materials: Their Possible Uses for Museums." *Museum News* 44 (December 1965), 47-52.

Feller, R. L. "Transportation of a Panel Painting by Courier in Winter." *IIC-AG Technical Papers* Los Angeles, May-June (1969), 13-14.

"Fibreglass and Plastic Case for Shipping Art Objects." *Australian Packaging* 18 (1970), 20.

Foley, J. T., "Transportation Shock and Vibration Descriptions for Package Designs." *Sandia Laboratories* Albuquerque, July 1971.

Foley, J. T., M. B. Gens, and C. G. Magnuson. "Current Predictive Models of the Dynamic Environment of Transportation." *Proceedings of the Institute for Environmental Sciences* (1972).

Fortunko, C. M., M. C. Renken, and A. Murray. "Examination of Objects Made of Wood Using Air Coupled Ultrasound." *Institute of Electrical and Electronic Engineers Ultrasonics Symposium* Honolulu, 1990. New York, 1991, In Press.

Fourie, A. L. "Storage and Packing: A Review." *South African Museums Association Bulletin* 2 (1974), 110-117.

Fowler, H. R. "A Showcase Trolley System." *Museums Journal* 68 (1969), 32.

Frankfurther, A. "On Making the World Safe for Art." *Art News* 62 (1964), 23.

Ganzer, K. M., and L. Rebenfeld. "Laboratory-Scale Continuously Variable Humidity Control with Saturated Salt Solutions." *American Laboratory* (March 1987), 40-47.

Garcia, A. R. "The Packing of Cultural Objects: Three Mexican Experiences." *ICOM Committee for Conservation 5th Triennial Meeting* Preprints, Zagreb (1978).

_____. "The Packing of Works of Art." (In Spanish) *Churubusco-1978* (1979), 163-174.

Garver, T. H., G. Thomson, ed. "Control of Atmospheric Pollutants Maintenance of Stable Climatic Conditions." *IIC London Conference on Museum Climatology* (September 1967).

Gens, M. B. "The Dynamic Environment of Four Industrial Forklift Trucks." *The Shock and Vibration Bulletin* no. 45 part 4 (June 1975).

Georgiou, B., S. Staniforth, ed. "The Hazards of Vibration During Transport." *UKIC Meeting on Packing Cases, Safer Transport for Museum Objects* Preprints, London, June 1985.

Glenney, T. "Packing Them In." *Art and Antiques* (February 1985), 13.

Gordon, J. B. "Packing of Michelangelo's 'Pieta'." *Studies in Conservation* 12 (May 1967), 57-69.

Gorman, L., and S. West. "Major Loan Exhibitions and the Conservator." *AIC Preprints of Papers Presented at the Tenth Annual Meeting* Milwaukee (1982).

Green, T. "Shock and Vibration-Test Results for Framed Paintings on Canvas Supports." *ICOM Committee for Conservation 8th Triennial Meeting* Preprints, Sydney (1987), 585-596.

_____., S. Staniforth, ed. "Observations on the Vibration of Canvases." *UKIC Meeting on Packing Cases, Safer Transport for Museum Objects* Preprints, London, June 1985.

Green, T., and S. Hackney. "The Evaluation of a Packing Case for Paintings." *ICOM Committee for Conservation 7th Triennial Meeting* Preprints, Copenhagen (1984).

Grosseschmidt, H. "On the Repair of Damage from Transportation." (In German) *Mitteilungen 1980/81 Deutscher Restauratoren-Verb* (1980-1981), 26-27.

Gruenbaum, G., and J. Miltz. "Static Versus Dynamic Evaluation of Cushioning Properties of Plastic Foams." *Journal of Applied Polymer Science* 28 (1983), 135-43.

Gutfreund, K. "Study of the Deterioration of Paint Films by Measurement of Their Mechanical Properties." *Circular 793* National Paint Varnish and Lacquer Association, Washington, March 1964.

Hackney, S. "The Dimensional Stability of Paintings in Transit." *ICOM Committee for Conservation 8th Triennial Meeting* Preprints, Sydney (1987), 597-600.

Hedley, G. A. "Some Empirical Determinations of the Strain Distribution in Stretched Canvases." *ICOM Committee for Conservation 4th Triennial Meeting* Preprints, Venice (1975).

_____. "The Stiffness of Lining Fabrics: Theoretical and Practical Considerations." *ICOM Committee for Conservation 6th Triennial Meeting* Preprints, Ottawa (1981).

_____. "Relative Humidity and the Stress/Strain Response of Canvas Paintings: Uniaxial Measurements of Naturally Aged Samples." *Studies in Conservation* 33 (1988), 133-148.

Hedley, G., M. Odlyha, A. Burnstock, J. Tillinghast and C. Husband. "A Study of the Mechanical and Surface Properties of Oil Paint Films Treated with Organic Solvents and Water." *IIC, The Brussels Congress* London, 1990.

"High-Value Antiques Protected by PE Wrap." *Packaging Review* 93 (1973), 37.

Hitchcock, A., and G. C. Jacoby. "Measurement of Relative Humidity in Museums at High Altitudes." *Studies in Conservation* 25 (1980), 78-86.

Hoadley, R. B. "The Dimensional Response of Wood to Variations in Relative Humidity." *IIC The Oxford IIC Congress* London, 1978.

Hochmuth, T. "Report on Impact Stress on Freight." (In German) *Siemens* 8 (1956).

Holden, C. "Notes on the Protection of Modern Works of Art During Handling Packing and Storage." *The Conservator* 3 (1979), 20-24.

Hoppe, W., and J. Gerock. "Shocks on the Loading Surface of Trucks." (In German) *Versuchs-und Forschungsingenieur* 4 (1974), 32-36.

Hoppe, W., J. Gerock, and A. Aigner. "Shocks in an Aircraft Cargo Space." (In German) *VDI-Nachrichten* 37 (September 1976).

Hopwood, W. R. "Choosing Materials for Prolonged Proximity to Museum Objects." *AIC Preprints of Papers Presented at the Seventh Annual Meeting* Washington, 1979.

Hours, M. "Rapport Sommaire sur la Construction et l'Utilisation d'un Container Special Destine au Transport de 'la Joconde'." *Bulletin du Laboratoire de Recherche des Musees* 8 (September 1978), 45-52.

Hudson, D. S. "The Artmobile: Fine Art on the Road." *Curator* 9 (1966), 337-355.

"ICOM Guidelines for Loans." *ICOM News* 27 (1974), 78-79.

"The Care of Wood Panels." *Museum* 8 (1955), 139-194.

Jones, R. F., and W. L. James. "Calculating Cushion Requisites." *Modern Packaging* 29 (February 1956), 137-144.

Karp, C. "Calculating Atmospheric Humidity." *Studies in Conservation* 28 (1983), 24-28.

Karpowicz, A. "In-Plane Deformations of Films of Size on Paintings in the Glass Transition Region." *Studies in Conservation* 34 (1989).

Keck, S. "Photographic Recording of the Condition of Paintings." *Museum News* 25 (February 1948), 7-8.

————. "Mechanical Alteration of the Paint Film." *Studies in Conservation* 14 (1969), 9-30.

Kenjo, T. "A Rapid-Response Humidity Buffer Composed of Nikka Pellets and Japanese Tissue." *Science for Conservation* 27 (1982), 19-24.

Kuzmitch, L. A. "A New Method of Investigating Stressed State of Artistic Works in Restoration and Conservation Practice." *ICOM Committee for Conservation 5th Triennial Meeting* Preprints, Zagreb (1978).

Kuzmitch, L. A., and A. A. Zaitsev "Protection of Works of Art by Envelopment." *ICOM Committee for Conservation 5th Triennial Meeting* Preprints, Zagreb (1978).

Lacy, R. E. "A Note on the Climate Inside a Medieval Chapel." *Studies in Conservation* 15 (1970), 65-79.

Lange, H. "The Construction of a Thermobox." *Museums Journal* 79 (1979), 27-28.

Lange, H., and A. Ketnath. "Cases for the Transportation of Works of Art." (In German) *Meddelelser om Konservering* 2 (1978), 333-339.

Leisher, W. "Humidity-Temperature Requirements for Museum Collections." *AAM Energy Workshop Resource Booklet*, Washington.

Lillico, C. A. "The Possibility of Extending Gallery Environmental Conditions to a Work of Art During Transit." *ICCM Bulletin* 7 (1981), 48-61.

Little, D. B. "Safeguarding Works of Art: Transportation, Records and Insurance." *History News* 18 (1963), 101-104.

Lucewicz, K., and B.L. Marconi. "Report of the Main Packing Centre Regarding Transport by Trucks and Railroad." *ICOM, Committee for Conservation* Amsterdam (1969).

Macleod, K. J. "Relative Humidity: Its Importance, Measurement and Control in Museums." *Canadian Conservation Institute Technical Bulletin* 1 (April 1975).

Magliano, P., and B. Boesmi. "Xeroradiography for Paintings of Canvas and Wood." *Studies in Conservation* 33 (1988).

Marconi, B. L. "Condition and Transportation of Polish National Treasurers between Canada and Poland." (In Polish) *Ochrona Zabytkow* 14 (1961), 33-38.

_____., G. Thomson, ed. "Some Experience in Transporting Polish Works of Art Across the Atlantic." *IIC London Conference on Museum Climatology* (September 1967).

Marconi, B. L., K. Lucewicz, and H. Zimakowski, N. Stolow, ed. "Report on Vibration, Mechanical Hazards, for Surface and Air Transport for Works of Art." *ICOM Committee on Conservation* Amsterdam (1969).

Marriner, P. C. "Criteria for Packing Works of Art for Traveling Exhibitions." *Canadian Conservation Institute Newsletter* (November 1974), 3-5.

McGlinchey, C. W., P. B. Vandiver, J. R. Druzik, and G. Wheeler, eds. "Thermal Analysis of Fresh and Mature Oil Paint Films: The Effect of Pigments and Driers and the Solvent Leaching of Mature Films." *Material Issues in Art and Archaeology II* Materials Research Society Proceedings, Pittsburgh (1991).

Mecklenburg, M. F. "The Effects of Atmospheric Moisture on Mechanical Properties of Collagen Under Equilibrium Conditions." *AIC Preprints of the Papers Presented at the Sixteenth Annual Meeting* New Orleans (1988), 231-244.

Mecklenburg, M. F. "Some Mechanical and Physical Properties of Gilding Gesso." *Postprints of Papers presented at the Gilding Conference* Philadelphia, 1988. In Press.

Michaels, P. "Lender Beware." *Museum News* 43 (September 1964), 11-12.

Merrill, R. M. "In the Service of Exhibitions: The History, Problems and Potential Solutions of Cultural Materials in Transit." *AIC Preprints of the Papers Presented at the Sixteenth Annual Meeting* New Orleans (1988).

Mills, E., S. Staniforth, ed. "The Principles of Shock Protection Systems." *UKIC Meeting on Packing Cases, Safer Transport for Museum Objects* Preprints, London, June 1985.

Miltz, J., and G. Gruenbaum. "Cushioning Properties of Urea-Formaldehyde Foam." *Journal of Cellular Plastic* 17 (1981), 213-19.

Miura, S. "The Distribution of Temperature and Humidity in a Case Made of Acrylic Resin Which Contains Zeolite as a Buffer." *Science for Conservation* 17 (1978), 11-15.

_____. "System Analysis of RH control in a Showcase." *Science of Conservation* 21 (1982), 55-59.

Morris, J. W., S. Staniforth, ed. "Packing of 3-Dimensional Objects." *UKIC Meeting on Packing Cases, Safer Transport for Museum Objects* Preprints, London, June 1985.

Motsinger, R. N., P. K. Stein, ed. "Flexural Devices in Measurement Systems." *Measurement Engineering* 1 (1964).

Mueller, M. F. "Psychrometric Behavior in Closed Packages." *Modern Packaging* 22 (1949), 163-167.

Nelson, H. A., and G. W. Rundle. "Stress Strain Measurements of Films of Drying Oils, Paints and Varnishes." *Proceedings of the American Society for Testing Materials* 21 (1921).

Nelson, H. A., and G. W. Rundel. "Further Studies of the Physical Properties of Drying-Oil Paint and Varnish Films." *Proceedings of the American Society for Testing Materials* 23, part 2 (1923a).

Nelson, H. A. "Physical Properties of Varnish Films Indicated by Stress-Strain Measurements." *Proceedings of the American Society for Testing Materials* 23, part 1 (1923b).

Noonan, C. "Solving a Humidity Control Problem." *CMA Gazette* 8 (Spring 1975), 21-25.

Nordqvist, J. "The Conservator as a Courier." *Meddelelser om Konservering* 3 (October 1983), 241-252.

O'Brien, F. E. M. "The Control of Humidity By Saturated Salt Solutions." *Journal of Scientific Instruments* 25 (1948), 73-76.

Oddy, W. A. "An Unsuspected Danger in Display." *Museums Journal* 73 (June 1973), 27-28.

Organ, R. M., G. Thomson, ed. "Humidification of Galleries for a Temporary Exhibition." *IIC London Conference on Museum Climatology* (September 1967).

Osborn, E. C., and L. M. Morley. "Principles of Packing Temporary and Traveling Exhibitions." *Temporary and Traveling Exhibitions Museum and Monuments.* Chapter 5 (1963).

Ostrem, F. E., and B. Liboviez. "A Survey of Environmental Conditions Incident to the Transportation of Materials." *PB 204 442* Department of Transportation, Office of Hazardous Materials (1971).

Ostrem, F. E., and W. D. Godshall. "An Assessment of the Common Carrier Shipping Environment." *U. S. Department of Agriculture, Forest Products Laboratory* (1979).

"Packing and Shipping—A Continuing Story." *Intermuseum Conservation Association Newsletter* 5 (1967), 4.

"Packing Paintings for Shipment." *Information Bulletin* 4 Oberlin, OH, February 1958.

Packman, D. F. "The Acidity of Wood." *Holzforschung* 14 (1960), 178-183.

Padfield, T. "The Control of Relative Humidity and Air Pollution in Show-Cases and Picture Frames." *Studies in Conservation* 2 (February 1966), 8-30.

_____. "A Himalayan Legend Describes an Early Example of Science Applied to the Packing and Transport of a Work of Art." *Proceedings of Adelaide Conference of the Institute for Consvervation of Cultural Material* (1986).

_____., G. Thomson, ed. "Design of Museum Showcases." *IIC London Conference on Museum Climatology* (September 1967).

Padfield, T., D. Erhardt, and W. Hopwood, G. Thomson and N. Brommelle, ed. "Trouble in Store." *IIC Science and Technology in the Service of Conservation* Washington (1982).

Perkins, John "Design Consideration for Microprocessor Based Environmental Monitering and Control Systems." *IIC-CG Twelfth Annual Conference Winnipeg* (1986).

Piechota, D. V. "Marvelseal 470: A Barrier Film." *AIC Newsletter* 11 (September 1986), 8.

Piechota, D. V., and G. Hansen. "The Care of Cultural Property in Transit: A Case Design for Traveling Exhibitions." *Technology and Conservation* 7 (1982), 32-46.

Preiss, L. "Recommended Procedures for the Packing and Transport of an Ethnographic Collection." *ICCM Bulletin* 6 (March 1980), 24-30.

"Preserve Your Pictures: A Handbook on Care and Preservation of Works of Art." *American Federation of the Arts Quarterly* 1, 4 (1963).

Rawlins, I. "The War-Time Storage in Wales of Pictures from The National Gallery, London, Part II: Some Technical Problems." *The Honourable Society of Cymmrodorion* (1946), 185-193.

Ricard, S. S. "Constitution et Utilisation d'une Exposition Itinerante: Le Paysage en Orient et en Occident." *Musees et Collections Publiques* Paris, April—June 1961, 77-82.

Richard, M. J. "Elements for Effective Packing." *The Museologist* 45 (1984), 18-23.

Richard, M. J. and R. M. Merrill. "The Treasure Houses of Britain Exhibition." *AIC Preprints of the Papers Presented at the Fifteenth Annual Meeting* Vancouver (1987).

Rogers, G. de W. "The Environment and Collections." *Canadian Conservation Institute Newsletter* 4 (August 1974), 5-6.

_____. "The Ideal of the Ideal Environment." *Journal of IIC-CG* 2 (Fall 1975), 34.

Ronca, G. "The Prediction of Stress Relaxation and Incipient Instability in Lining Canvases." *ICOM Committee for Conservation 5th Triennial Meeting* Preprints, Zagreb (1978).

Rosegrant, R. G. "Packing Problems and Procedures." *Technical Studies in the Field of Fine Arts* 10 (January 1942), 138-156.

Royal Ontario Museum. "In Search of the Black Box: A Report on Proceedings of a Workshop on Micro-Climates." *The Royal Ontario Museum* (February 1978).

Ruggles, M. "Transportation and Conservation of Twenty-Three Mural Paintings. An Exercise in Logistics and Presentation." *AIC Bulletin* 13 (May-June 1973), 17-29.

Sack, S. P. "A Case Study of Humidity Control." *Brooklyn Museum Annual* 5 (1963-64), 99-103.

Schilling, M. "The Glass Transition of Materials Used in Conservation." *Studies in Conservation* 23 (1989).

Schroeder, O. E. H., and F. M. Hamm. "Art In Transit." *Maltechnik Restauro* 81 (October 1975), 225-227.

Serjeant, D. "Conservation Problems in International Art Exhibitions." *International Journal of Museum Management and Curatorship* 4 (1985), 77-78.

Shikher, M. G. "Deformation Properties of Linseed Oil Films." *Journal of Applied Chemistry* 12 (1932), 1884-1891.

Silverman, F. "Sharing the Wealth." *Museum News* 59 (November/December 1980), 18-21.

Sitwell, C. L. "Conservation Problems Related to Fine Art Exhibitions and their Transport." *The Conservator* 7 (1983), 29-33.

_____. "Technical and Practical Consideration in the Design of Packing Cases for Paintings." *AIC Preprints of the Papers Presented at the Eleventh Annual Meeting* Baltimore (1983).

_____. "Vibration Test Results on an Air Ride Suspension Vehicle and Design Considerations for a Racking System." *ICOM Committee for Conservation 8th Triennial Meeting* Preprints, Sydney (1987), 601-606.

_____., S. Staniforth, ed. "Results from Shock Testing." *UKIC Meeting on Packing Cases, Safer Transport for Museum Objects* Preprints, London, June 1985.

Smith, J. "They Moved 500,000 Things and They Broke Only a Jar." *Museum News* 43 (1965), 19-23.

Sneyres, R. V. "Note on the Transportation of the 'Descent from the Cross' by Rubens." *Bulletin Institut Royal du Patrimoine Artistique* 6 (1963), 52-56.

Staniforth, S. "Solid State Memory Recorders." *UKIC Conservation News* 22 (November 1983), 11-12.

_____. "The Testing of Packing Cases for the Transport of Paintings." *ICOM Committee for Conservation 7th Triennial Meeting* Preprints, Copenhagen, (1984), 84.12.7-84.12.16.

_____. "Packing: A Case Study." *National Gallery Technical Bulletin* 8 (1984), 53-62.

_____. "Packing of Two-Dimensional Objects." *UKIC Meeting on Packing Cases, Safer Transport for Museum Objects* Preprints, London, June 1985.

Stephenson-Wright, A. and R. White. Packing: An Updated Design, Reviewed and Tested." *National Gallery Technical Bulletin* 2 (1987), 36-41.

Stevens, W. C. "Rates of Change in the Dimensions and Moisture Contents of Wooden Panels Resulting from Changes in the Ambient Air Conditions." *Studies in Conservation* 6 (1961), 21-24.

Stewart, D. "Conservation in the Service of Mobile Exhibits." *ICOM Committee for Conservation 8th Triennial Meeting* Preprints, Sydney, (1987), 607.

Stolow, N. "On the Moving of Works of Art." *Canadian Art* 17 (1960), 289-290.

_____. "Some Studies on the Protection of Works of Art During Travel." *IIC Conference on Recent Advances in Conservation* Rome, (1961).

_____. "Report on Controlled Environment for Works of Art in Transit." *IIC Committee Meeting, Washington and New York* (1965).

_____. "Fundamental Case Design for Humidity Sensitive Museum Collections." *Museum News* 44 (February 1966), 45-52.

_____. "The Action of Environment on Museum Objects. Part I: Humidity, Temperature, Atmosphere Pollution." *Curator* 9 (1966), 175-185.

_____., G. Thomson, ed. "Standards for the Care of Works of Art in Transit." *IIC London Conference on Museum Climatology* (September 1967).

_____., Coordinator "Report of Working Group on Care of Works of Art in Transit." *ICOM Committee for Conservation* Amsterdam, (1969).

_____. Contributions by B. Wennberg and P. Canon-Brookes "Environmental Control during Transport of Early Italian Painting from Canada to Japan." *ICOM Committee for Conservation 3rd Triennial Meeting* Preprints, Madrid, (1972).

_____. "Conservation Policy and the Exhibition of Museum Collections." *Journal of Indian Museums* 32-33 (1976-1977), 18-27.

_____. "The Conservation of Works of Art and Exhibitions." *Museums Journal* 77 (1977), 61-62.

_____. "The Microclimate: A Localized Solution." *Museum News* 56 (November/December 1977), 52-63.

_____. "The Effectiveness of Preconditioned Silica Gel and Related Sorbents for Controlling Humidity Environments for Museum Collections." *ICCROM Conference on Climatology* (November 1978).

_____. "Conservation Standards for Works of Art in Transit and on Exhibition." *Museums and Monuments* XVII. (1979).

_____. "Care of Works of Art in Transit and on Exhibition: Review and Assessment." *ICOM Committee for Conservation 6th Triennial Meeting* Preprints, Ottawa (1981).

_____. "Condition Reporting for Major International Exhibitions." *ICOM Committee for Conservation 6th Triennial Meeting* Preprints, Ottawa (1981).

_____. "Procedures and Conservation Standards for Museum Collections in Transit and on Exhibition." *Techical Handbook for Museums and Monuments* (1981).

Stout, G. L., C. M. Richard, and R. P. Sugden. "Packing and Handling of Art Objects." *Museum News* 25 (September 1948), 7-8.

Stühler, W. "Schwingunstechnische Untersuchungen an Gaengigen Kunst-Transportbehaeltern." *Mitteilungen des Verbandes Deutscher Restauratoren* (1985).

Sugden, R. P. "Routine Museum Packing." *Museum News* 24 (September 1947), 7-8.

"Suggestions to Persons Selecting Traveling Exhibitions." *American Federation of the Arts Quarterly* 1, 4, (1963), 12-20.

Talen, H. W., "The Influence of Pigments on the Mechanical Properties of Paint Films." *Journal of the Oil and Colour Chemists Association* 34 (October 1951).

Thomson, G. "Humidity Control in a Closed Package." *Studies in Conservation* 4 (1964), 153-169.

_____. "Relative Humidity-Variations with Temperature in a Case Containing Wood." *Studies in Conservation* 9 (November 1964), 153-169.

_____. "Planning the Preservation of Our Cultural Heritage." *Museum* 25 (1973), 15-25.

_____. "Stabilization of Relative Humidity in Exhibition Cases: Hygrometric Half-Time." *Studies in Conservation* 22 (1977), 85-102.

Toishi, K. "Humidity Control in a Closed Package." *Studies in Conservation* 4 (1959), 81-87.

_____. "Damage to a Japanese Painting During Transit." *IIC Newsletter* 1 (1960), 18-19.

_____. "Ideal Air Conditioning for Cultural Assets." (In Japanese) *Kukichowa-to-Reite* (Air Conditioning/Refrigeration) 6 (1966), 2-10.

_____. "On Air Conditioning for Museums." (In Japanese) *Kenchikusetsubi* (The Magazine of Building Equipment) 25 (1974), 11-13.

_____., G. Thomson, ed. "Relative Humidity in a Closed Package." *IIC Recent Advances in Conservation Conference* Rome (1961).

_____., G. Thomson, ed. "Jet Transport of Art Objects." *IIC London Conference on Museum Climatology* (September 1967).

Toishi, K., and S. Miura. "On the Control of Temperature and Humidity at the Time of the 'Mona Lisa' Exhibition." *Hozon Kagaku* (Science for Conservation) 14 (March 1975), 1-7.

Toishi, K., and T. Kenjo. "An Attempt to control Relative Humidity of a Sealed Package." *Science Papers on Japanese Antiques and Art and Crafts* 12 (1956), 28-36.

_____. "Difference of Wood Materials as Buffers Against Changes of Atmospheric Humidity." *Science for Conservation* 6 (March 1970), 25-36.

Toishi, K., T. Kenjo, and R. Ishikawa. "About Temperature and Humidity within Exhibit Galleries and Repositories." *Science for Conservation* 8 (1972), 7-24.

Toussaint, A. and L. D'Hont. "Ultimate Strength of Paint Films." *Journal of the Oil and Colour Chemists Association* 64 (1981).

"Too Many Exhibitions—and Usually of the Wrong Kind." *The Burlington Magazine* 99 (July 1977), 471.

"Van Transport." *Registrars' Report* 1 (December 1977).

Volkmer, J. "Special Problems in the Packing and Handling of Modern Art." *IIC-AG Annual Meeting* Los Angeles (1969).

Vulliet, P., ed. "Proceedings: Western Regional Strain Gage Committee." *Society for Experimental Stress Analysis* (1968).

Wakefield, H. "Travelling Exhibitions." *Museum* 23 (1970-1971), 146-153.

_____., G. Thomson, ed. "Methods of Packing in the Victoria and Albert Museum." *IIC Conference on Recent Advances in Conservation* Rome (1961).

Walden, I. "The Large Scale Removal of Museum Specimens." *Museums Journal* 71 (1972), 157-160.

Weatherwax, R. C., B. Coleman, and H. Tarkow. "A Fundamental Investigation of Adhesion, II, Method for Measuring Shrinkage Stress in Restrained Gelatin Films." *Journal of Polymer Science* 27 (1958).

Weintraub, S. "A New Silica Gel and Recommendations." *AIC Preprints of the Papers Presented at the Tenth Annual Meeting* Milwaukee (1982).

Weiser, H., W. Milligan, and J. Holmes. "The Elimination of Sorption-Desorption Hysteresis in Hydrous Oxide Systems, Part I." *Journal of Physical Chemistry* 46 (1942), 593-594.

Wennberg, B. "Report on Preliminary Study of Damage to Paintings During Transport and Temperature Exhibition by Photographic Enlargement." *ICOM Meeting* Amsterdam (1969).

Werber, K. "Experience on the Transport of Paintings." (In German) *Neue Museumskunde* 3 (1978), 197-203.

Werner, A. E. "Conservation and Display (1) Environmental Control." *Museum Journal* 72 (1972), 58-60.

Westerudd, O. "Transportation and Handling of Art and Other Exhibits." *ICOM Committee for Conservation 8th Triennial Meeting* Preprints, Sydney (1987), 611.

Wexler, A., and S. Hasegawa "Relative Humidity—Temperature Relationship of Some Saturated Salt Solutions in the Temperature Range of 0-50° C." *Journal of Research, National Bureau of Standards* 53 (1954), 19-26.

Wilson, P. "Mathematical Predictions of Transit Case Performance; 'Topplability,' Thermal Insulation, Weight and Volume." *ICOM Committee on Conservation 8th Triennial Meeting* Preprints, Sydney (1987), 617.

Wilson, P., S. Staniforth, ed. "Temperature & Relative Humidity Control in Packing Cases." *UKIC Meeting on Packing Cases, Safer Transport for Museum Objects* Preprints, London, June 1985.

Zimakowski, H. "Report on Air Transport Conditions." *ICOM Committee for Conservation* Amsterdam (1969).

Zippel, B. "Polyurethane Foam as a Packing Material." (In German) *Kunstoffe* 56 (1966), 361-363.

Zosel, A. "Mechanical Behavior of Coating Films." *Progress in Organic Coatings* 8 (1980).